Performing Exile

Performing Exile:
Foreign Bodies

Edited by Judith Rudakoff

intellect Bristol, UK / Chicago, USA

First published in the UK in 2017 by
Intellect, The Mill, Parnall Road, Fishponds, Bristol, BS16 3JG, UK

First published in the USA in 2017 by
Intellect, The University of Chicago Press, 1427 E. 60th Street,
Chicago, IL 60637, USA

Copyright © 2017 Intellect Ltd.

All rights reserved. No part of this publication may be reproduced,
stored in a retrieval system, or transmitted, in any form or by
any means, electronic, mechanical, photocopying, recording, or
otherwise, without written permission.

A catalogue record for this book is available from the
British Library.

Cover designer: Eleanor Rathbone
Cover photograph: Judith Rudakoff
Author photograph: Christopher Gentile
Copy-editor: MPS Technologies
Production manager: Katie Evans
Editorial assistant: Elise A. LaCroix
Typesetting: Contentra Technologies

Print ISBN: 978-1-78320-817-3
ePDF ISBN: 978-1-78320-818-0
ePUB ISBN: 978-1-78320-819-7

Printed and bound by Bell and Bain Ltd, Glasgow

This is a peer-reviewed publication.

Contents

Acknowledgements	vii
I. Introduction Judith Rudakoff	1
II. A Theoretical Primer on Exile	15
On the Paradigms of Banishment, Displacement, and Free Choice Yana Meerzon	17
III. The Essays	37
Chapter 1: Theatre, Reconciliation, and the American Dream in Greater Cuba Lillian Manzor	39
Chapter 2: *Three Angry Australians:* A Reflexive Approach Tania Cañas	59
Chapter 3: Exilic Solo Performances: Staging Body in a Movement/Logos Continuum Yana Meerzon	75
Chapter 4: Foreign Bodies in the Performance Art of Jorge Rojas: Cultural Encounters from Ritual to Satire Elena García-Martín	93
Chapter 5: Lingering Cultural Memory and Hyphenated Exile Seunghyun Hwang	111
Chapter 6: Carrying My Grandmother's Drum: Dancing the Home Within Sashar Zarif	125
Chapter 7: Blood Red: Rebecca Belmore's Vigil of Exile Tara Atluri	143

Chapter 8: *Yaffa Mish Yaffa* (Yaffa Is No Longer Yaffa) 161
 From Diaspora to Homeland: Returning to Yaffa by Boat
 Yamit Shimon

Chapter 9: Belonging and Absence: Resisting the Division 177
 Elena Marchevska

Chapter 10: *Caryatid Unplugged*: A Cabaret on Performing and Negotiating 195
 Belonging and Otherness in Exile
 Evi Stamatiou

Chapter 11: Exile Builds Performance: A Critical Analysis of Performing 217
 Satirical Images across Cultures through Media
 Sanjin Muftić

Chapter 12: Resignifying Multilingualism in Accented Canadian Theatre 233
 Diana Manole

Notes on Contributors 251

Acknowledgements

I would like to thank the following people for their thoughtful comments on early versions of the Introduction to this book: Jennifer H. Capraru, Serena Dessen, Brian Fawcett, Diane Roberts, Alan Rudakoff QC, and Myles Warren. I must also acknowledge the geneology research provided by John Diener, the important contributions of editorial assistant Elise A. LaCroix, the input from Professor Walid El Khachab (York University), and from Professor Kamal Al-Solaylee (Ryerson University), and the guidance and support of Intellect Books personnel, particularly Katie Evans. As well, I offer my gratitude and respect to the contributing artists and scholars who made this book possible.

I. Introduction

Judith Rudakoff

Over the past decade, most of my dramaturgy practice has focused on creating tools to encourage people to tell their own stories.[1] Along the way, I've encountered people whose place of origin is no longer accessible to them because of political, social, economic, religious, and other barriers. Encouraging, facilitating, and developing self-reflexive artistic material with participants such as youth-at-risk, refugee or immigrant communities, those marginalized due to gender, ability, age, in fact any displaced or dislocated individuals, has been both challenging and fulfilling.[2]

Art, I suggest, is a weapon in the war against cultural obliteration. Further, narratives that emanate from personal experience, when shared with a wide public, can inspire others to do the same, and as a result, to validate and value their own stories.

When I work as a developmental dramaturg, one of the questions I ask the primary creator on any project is "what is your creative obsession?" I then define creative obsession as the theme or idea that permeates everything an artist generates. Over the years, I have realized that my own creative obsession is finding home, which I identify as a place or condition of safety, freedom, belonging, and agency which might be found within a community, a union of two or more people, or a movement.

I do not claim a direct link to the experience of first generation exile. I position myself as a witness, and, in some cases (where friends are involved), as an ally to survivors of the upheaval, the rootlessness, the resettling, and the recalibrating that comes with adapting to living in exile.

To clarify my own position within this project, and as context for the centrality of finding home in my creative work, here then are some specific thoughts on my relationship to exile.

Diaspora, Family, and Exile

I am not a refugee, asylum seeker, or immigrant. I was born in Canada and have built my life here. My parents were also born in Canada, in Montréal, Québec, where they resided until they died. I grew up in a middle class neighbourhood, went to a private parochial middle school, a well-funded public high school, and graduated with degrees from three Canadian universities before working as a dramaturg in Canadian theatre. I have taught playwriting, dramaturgy, and contemporary Canadian theatre for three decades at a Canadian university.

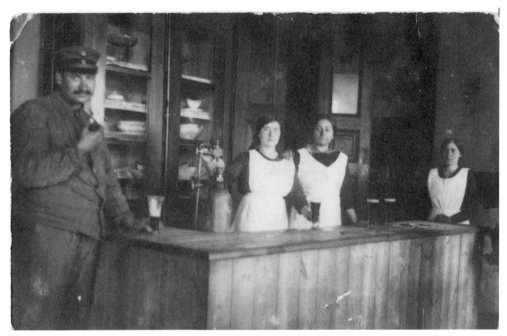

Figure 1: My maternal grandmother (second from left), in the local tavern where she worked. Photo credit: Unknown.

Let's scrutinize that idyllic snapshot of privilege and belonging.

My family history is a patchwork of grudgingly told anecdotes marred by paucity of detail.

The following facts comprise most of what I know of my antecedents.

My parents were the children of Jewish immigrants to Canada. My maternal grandfather arrived at the Port of Montréal via New York's Ellis Island in 1921 from Zareby Koscielne, the *shtetl* ("small village" in Yiddish) in Poland where the family lived. All I know about my family's life in this *shtetl* is that each time there was a local dispute about occupied territories, the control of the village alternated between Russia and Poland. My maternal grandmother, who worked as a bar maid at a local tavern (this is one of the very few personal details she shared with me about her life in Poland), had to switch language of daily use frequently, speaking either Russian or Polish to serve the current clientele, which was mainly comprised of soldiers.

When they left Eastern Europe to avoid the worsening socio-political situation, only part of my grandmother's family could afford passage. My brother and I don't know how many siblings were left behind or if they survived the subsequent local pogroms[3] and more far-reaching wars. My grandparents refused to talk about those who stayed. Those siblings who immigrated to North America were split up by the authorities at Ellis Island: one brother

remained in New York City; one was accepted nowhere but Buenos Aires, Argentina because (we were told by my mother, but I have no definitive proof) of his declared communist leanings; one sister went to St Louis, Missouri; and my grandmother was settled in Montréal.

My paternal grandfather arrived in Montréal from Russia by ship in 1908, and was joined by his wife and two sons on September 30, 1910 via the *SS Tunisia* that sailed from Liverpool, England. I know these facts through the research efforts of retired Ottawa business owner, John Diener, who contacted me initially as part of his own genealogical research, when he identified my paternal grandmother in one of his family photographs.[4]

My paternal grandparents' original point of departure with their two sons was the *shtetl* of Dashev, in what was then Russia, and now is located within the Ukraine. Three more sons, including my father, were born in Canada. There was possibly also a daughter, who died young.[5]

I know nothing more about my history and have no way of tracing any of the paternal family back farther than my great grandfather, as our surname, Rudakoff, was likely that of the Russian landowner on whose land my family members lived and worked. They were Jews and therefore officially known only by the landowner's surname. Another possible derivation of our surname is that because a number of our family members had red hair, the Yiddish language nickname for the family might have been *roite kopp* or redhead. In an attempt to make the name more local or familiar to the authorities, the Russian transliteration could have been Rudakov, a recognizable Russian surname.[6]

I have one brother. After my parents died, he cleaned out the storage locker of their apartment in Montréal. Most of what he found was junk (my father, a child of the Great Depression, was a lifelong hoarder): dozens of pairs of black socks, hundreds of tiny plastic boxes of mints, expired tubes of toothpaste. He also discovered five large, dusty boxes filled with mouldy, disorganized, unlabelled photographs, some of which date back to the 1800s. We cannot identify the majority of the people in the photographs. This is our legacy.

Whenever we approached our grandparents with questions about our past, they understandably refused to engage in conversation. That was the past, filled with despair. They wanted to live in the present, where life was better. There was no way to cajole them into sharing more than brief and fragmented memories with us. Our parents would not speak of our family history either, partly because they too knew little other than the names of our relatives. Also part of our legacy is my mother's hastily scrawled chronology of our maternal ancestry, with a few notes on people's marital status and one or two references to occupation, jotted down grudgingly at the urging of my brother. My mother's note includes the sentence "I have pictures in locker to match up all the relatives," but despite our repeated offers to catalogue the photographic archive with her help, she declined to undertake the project.

My brother and I are, therefore, effectively cut off from our history. We have no sense of where we came from (other than the names of the two *shtetls* that were the point of departure for our grandparents), a confusing list of possibly misspelled relatives' names, and our grandparents' dates of arrival in Canada.

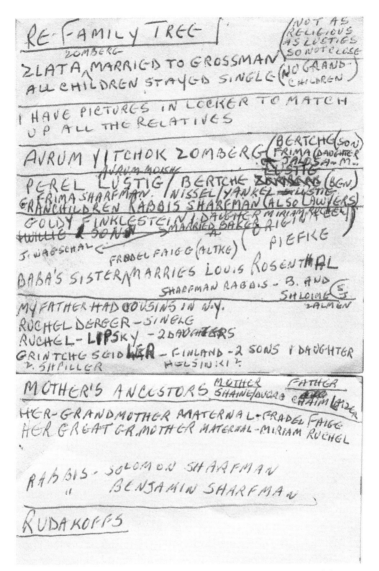

Figure 2: My mother's hand-written family history notes. Photo credit: Judith Rudakoff.

If you are a child of diaspora, and if your ancestral country of origin was hostile (or itself an adopted homeland), are you living in exile? Yes, to be sure, but without any nostalgic longing to return. My ancestors left Russia and Poland to avoid the threat of attack on the basis of their Jewishness. They were not Poles, but Polish Jews. They were not Russians, but

Russian Jews. As for my immediate family, we were Canadians to be sure, but in our home province of Québec, we were not *pure laine* (pure wool), a term used in Québec to designate "true" Québécois who can trace their lineage back to the original French settlers.[7]

Though I had an intensive culturally specific education,[8] I was never a Zionist. Israel never represented home to me.

Home, for some living in exile, is not a place, but rather is represented by people, traditions, and beliefs. In some unfortunate cases, out of a need to re-invent and establish home, an obsession emerges to preserve anything that helps solidify a sense of sameness, which becomes equated with safety. This need can create deplorable by-products: xenophobia and racism.

My first significant experience outside the so-called Golden Ghetto where I grew up (Côte Saint Luc, a predominantly Jewish, middle class suburb of Montréal) occurred when I entered CEGEP[9] at the age of seventeen. My orthodox family was openly hostile towards my widening circle of friends from different backgrounds, and many confrontations ensued. My protestations that the world was larger than our little enclave were dismissed. As I moved farther outside my family's range of control and experience, tensions mounted. At university, my multi-ethnic, culturally diverse group of peers alarmed them. I was not permitted to bring non-Jewish friends into the house. I was instructed to date only within my own culture. While I had no control over the former, I wholeheartedly rejected the latter.

My last surviving grandparent, my maternal grandmother, disowned me when I declared that I was going to marry outside our faith. In a misguided attempt to preserve and protect familiar security, she exiled me. My parents threatened to do the same, but reluctantly accepted my partner of choice, though they never truly welcomed my spouse into the family. My brother, still living at home at the time of my marriage, related my mother's frequent description of her relationship to her problematic daughter, "I can't chew her up and I can't spit her out." This sounds more poetic in Yiddish, but the meaning is clear: I was now relegated to life on the border of belonging and not belonging to my immediate family.

Clearly my family's dysfunction and the impact of their actions on my life can (or should) in no way be compared to the suffering of exiles the world over. I had the power and privilege to make my life into what I wanted it to be. I had freedom of choice. I disengaged from my family. I could live (and, subsequently, work) according to my own goals and inclusive beliefs. And so I did.

Curatorial Criteria and Process

The chapters in this book examine the performances of artists living in exile who did not, for the most part, have the privilege that I have had. Many have experienced the full impact of Othering, displacement, disenfranchising. For them, artistic endeavours focus on the location of home, reimagined, restored, reclaimed, or even rejected.

While the contributors to this collection may differ in their definition of, perspective on, relationship to, and experience of exile, they all offer committed and probing engagement with exilic performance that emanates from a wide variety of geographical locations. Further, they represent the worlds of scholarship and art by discussing work in styles that range from in depth critical and theoretical analysis to autoethnographic exploration through documentation of performance. The nature of exile as a psychological condition provides another lens, expanding the concept to include those who have been displaced but have the ability to return to their homeland; those who left their homeland freely, but harbour a nostalgic longing for an imagined place; those whose ancestors' diasporic route has located them in a place where even after generations, they are (or identify as) foreign bodies; and those who, as Indigenous people, have been marginalized by acts of settler colonialism that create exilic conditions in the homeland by redefining rights and privileges, and assuming and imposing power.

To establish a context for the terminology applied in the individual chapters, I have included what I am calling a Theoretical Primer on Exile, contributed by (in addition to her chapter in the collection) theatre scholar Dr. Yana Meerzon, who has published widely on the topic of exilic performance. In this essay, Meerzon engages with key terms and concepts, and delves into distinctions between such labels as exile, refugee, immigrant, and asylum seeker.

The initial call for proposals for this book invited the international community of scholars and artists to contribute chapters that would focus on live performance either about living in exile, or created by artists living in exile. The type of artistic work I encouraged potential contributors to examine included, but was not limited to:

- creation and presentation of performances that reflect the artist's or artist collective's expectation and experience in a new country following forced displacement
- the blending of new with established performance work into original mash-ups that address the cultural clash between country of origin and country of residence
- radical adaptations of plays from an established canon created from the point of view of the exiled artist/s

The abundance of abstracts I received emanated from Africa, Asia, Australia, Europe, and North America,[10] and represented performance by artists who identified as being from Azerbaijan, Bosnia, Canada, Chile, Cuba, Egypt, El Salvador, Germany, Greece, India, Iran, Kenya, Lebanon, Mexico, Netherlands, Palestine, Poland, Romania, Russia, South Korea, Spain, Sweden, Syria, and the United States. Most of the submissions interpreted exile as a socio-political imposition.[11]

The curating process was challenging. My selection criteria were based on the following principles:

- blending autoethnographic and external perspectives on research and analysis

- including contributors and subject matter that reflect a diversity of international cultural and geographic affiliations
- providing a mixture of established and emerging voices

Given the strength and diversity of the submissions, I could easily have filled two volumes, and the essays that I ultimately selected are meant to provide a sounding of voices rather than a comprehensive examination of exilic performance.

The Contributors

The chapters of this book represent documentation and analysis of the work of artists for whom the notion of "foreign bodies" resonates.[12] Some are living far from their country of origin because life-threatening political oppression required them to flee (Cañas, Manole). Others left their homeland as economic refugees, seeking stability and a better standard of living (Stamatiou). Some who immigrated to a new country are able to return home at will (García-Martín), while for others the journey is complicated and, at times, impossible (Manzor). For those who can (and have) returned home as visitors, their land of origin is often encountered as a site of nostalgic remembering, a place which has altered beyond recognition (Shimon, Zarif). Some are the children of refuge-seeking exiles and asylum seekers, living on the border between their ancestral homeland and their parents' adopted home (Hwang, Meerzon). For others, the fluid identity of belonging and not belonging to one or more countries has created a new relationship with the notion of foreignness (Muftić, Marchevska). Some are subject to the atrocity of colonial exile, living in an ancestral homeland altered by generations of settler imperialism (Atluri).

Lillian Manzor focuses on the ways in which theatre in Spanish in Miami, Florida enacts the reconciliation process between Cuban exiles and their American home, and how adaptations can lead audiences to question their role in the so-called American Dream, as well as the nostalgic view of home and homeland. Manzor analyzes the socio-cultural and historic context of *Un mundo de cristal* (2015), a loose adaptation of Tennessee Williams' *The Glass Menagerie* by Cuban-born, Miami-based director/playwright Alberto Sarraín.

Tania Cañas explores the placement of refugee narratives within what she terms a "restrictive, highly problematic, predetermined discursive framework,"[13] which positions individuals to argue their credibility and humanity through performance for the Other, not the performance of self, and the resulting depoliticizing and devaluation of autonomous voice. Referencing her own exile experience and through her own theatrical work (*Three Angry Australians*, 2015), Cañas examines the complexity of exilic refugee narratives, especially those performed as acts of daily resistance. Cañas also interrogates the issue of who has the imperial power to welcome, and investigates borders as inventions and extensions of Western modernity.

Native Russian speaker Yana Meerzon presents the theory that for the exilic actor, the process of semiotization is rejected: the displacement narrative reveals itself through disembodiment of the actor from their character. Further, she posits that the exilic performer can become a type of stage-object, inviting the voyeuristic gaze of the audience "focusing its attention on the peculiarities of this actor's biography, their story of origin and flight, reflected in this actor's vocal and bodily features." Meerzon discusses these and related ideas using the examples of Lebanese-Québécois theatre artist Wajdi Mouawad (*Seuls*, 2008), French choreographer of Hungarian origin Joseph Nadj (*Last Landscape*, 2005), UK-based artist of Bangladeshi descent Akram Khan (*Desh*, 2011), and Canadian daughter of Bengali immigrants from India, Anita Majumdar (*Fish Eyes*, 2005).

Elena García-Martín examines the performance work of Mexican-born artist, curator, and educator Jorge Rojas, who creates and performs work which combines cultural traditions and artistic models ranging from pre-Hispanic to cosmopolitan, questioning notions of national, tradition, and identity. Focusing on two of Rojas' pieces (*Tortilla Oracle*, 2009, and *Lucha Libre*, 2008), García-Martín discusses cultural symbolism in Rojas' work through traditional and contemporary conventions that range from sacred Aztec and Mayan ritual to the popular convention of the wrestling match.

Seunghyun Hwang analyzes Korean-American playwright Young Jean Lee's work as she challenges audiences to rethink the nature of race and gender stereotypes through theatrical performance that uses multiple narratives to confront the conflict between traditional Korean cultural values and contemporary American culture in what Hwang terms a "third time-space." Focusing on Lee's acclaimed play *Songs of the Dragons Flying to Heaven* (2006), Hwang debunks the "dilemmatic portrayal of diasporic Asian women between remembering and keeping homeland values and de-fantasizing and re-imagining homeland values."

Born into an Azerbaijani immigrant family living in exile in Iran, dance artist Sashar Zarif fled his first adopted home during the Iranian Revolution of 1979. He experienced war, torture, imprisonment, and, ultimately, escaped to Turkey, followed by eventual immigration to Canada. Delving into his own cultural background and the traditional and contemporary dance practices that have influenced his creative work in a frank and deeply personal autoethnography, Zarif cites examples from his repertoire, linking them to his past, and suggesting that identity is not a product, but rather an ongoing process of blending memories and experience.

Tara Atluri engages with Canadian Aboriginal performance artist Rebecca Belmore's use of the theatrical (such as *Vigil*, 2002, a commemorative public performance on a street corner in Vancouver's Downtown East Side neighbourhood, honouring the lives of missing and murdered Aboriginal women) to stage the bitter ironies of Aboriginal female exile.

Israeli scholar Yamit Shimon documents and analyzes a public performance event in which she participated titled *From Diaspora to Homeland: Returning to Yaffa by Boat* (2015), which was produced by *Zochrot* ("remembering" in Hebrew), an NGO working to promote acknowledgement and accountability for the ongoing injustices of the *Nakba*, the Palestinian catastrophe of 1948, and to create the conditions for the return of the Palestinian refugees. This sailing event brought together eighty Israeli Jews and Palestinians aboard a tourist ship

to participate in the symbolic return of Palestinian refugees to Jaffa, Israel. Shimon examines the performance as a means of rethinking, experiencing, and reconstructing contemporary Jaffa with the presence of the Palestinian exilic community, as well as theorizing the event as a "performative archive of exile."

Macedonian-born interdisciplinary artist and Performance Studies scholar Elena Marchevska looks at two distinct forms of feminist performative political practice that present the intersection of autoethnography and larger social and cultural contexts: Tanja Ostojić's *Looking for a husband with EU passport* (2001–2005), and Lena Šimić's *Blood & Soil: we were always meant to meet..."* (2011–2014). Both works represent an "aesthetic exploration of women's experiences of belonging and Otherness in borderland after the Yugoslavia war crises." Marchevska investigates the ways in which these two artists have engaged with borders and boundaries, and how the experience of exile is constructed through their bodies.

Greek performer-scholar Evi Stamatiou documents and discusses her performance piece *Caryatid Unplugged* (2013), which probes the relationship between her own exilic presence in the UK (as a result of the Greek economic crisis), and that of the ancient Greek marble column (The Caryatid) which was forcibly removed from Athens during the Ottoman occupation and now "belongs" to the British Museum. Stamatiou grapples with two central questions in the performance: What if I am forced to return to my homeland? What if I can never return to my homeland? Further, she engages with "vulnerability, risk and ridiculousness of the performance's dramaturgy within contemporary critical discourses around radical democratic politics and the public sphere."

Born in Bosnia, director/writer Sanjin Muftić identifies as a migrant (having lived as a refugee in Ethiopia, as an immigrant in Canada, and now residing in South Africa). He writes about the performance work he creates as a vehicle for the blending of multiple perspectives, histories, cultural representations, and for seeking connections between distant and diverse homes. Muftić presents a critical analysis of the devising of *Top Lista You-ZA-Nista* (2015), a mixed-genre theatrical performance that combined an archival Yugoslavian sketch comedy television show with current South African socio-economic issues while working with a group of young, South African, emerging theatre artists.

Romanian-born scholar, writer, translator, and director, Diana Manole examines the role of linguistic competencies, ethnic and minority stereotyping, and the attitude towards exilic art and performers. Particularly, she discusses the role of multilingualism (Arabic, English, and American Sign Language) in the work of Syrian-born artist Nada Humsi, specifically in her play *My Name is Dakhel Faraj* (2014).

This collection is not a map of exile, but rather presents a route through varied and distinct experiences of and about foreign bodies. How the expression and analysis of the performance of exile represented in these chapters is understood will largely depend on the gaze of the reader.

Toronto, Canada
June, 2016

Notes

1 For example, *Common Plants* an umbrella project for a diversity of creative undertakings including "The Ashley Plays," "Roots/Routes Journeys to Home," "Photobiography," which are documented at length in *Dramaturging Personal Narratives: Who am I and Where is Here?* (Bristol, UK: Intellect Books, 2014), and online at www.yorku.ca/gardens, accessed April 15, 2016.

2 I explain this in *Dramaturging Personal Narratives: Who am I and Where is Here?*, referring to particular projects, and in so doing delineating my common practice: "All contributors, through written or orally transmitted informed consent protocols, agreed to participate in the project or projects being undertaken, and to the subsequent publication of research and creative outcome. Participants were, through this protocol, also offered the option of anonymous participation, which some chose. Throughout any engagement with marginalized groups, strict attention was paid to ethical oversight. Further, there was constant monitoring of the relationships between participants and dramaturgy personnel by the host organizations." Rudakoff, *Dramaturging Personal Narratives*, 7.

3 "Pogrom is a Russian word designating an attack, accompanied by destruction, looting of property, murder, and rape, perpetrated by one section of the population against another. In modern Russian history pogroms have been perpetrated against other nations (Armenians, Tatars) or groups of inhabitants (intelligentsia). However, as an international term, the word 'pogrom' is employed in many languages to describe specifically the attacks accompanied by looting and bloodshed against the Jews in Russia. The word designates more particularly the attacks carried out by the Christian population against the Jews between 1881 and 1921 while the civil and military authorities remained neutral and occasionally provided their secret or open support. The pogroms occurred during periods of severe political crisis in the country and were linked to social upheavals and nationalist incitement in Eastern Europe. (Similar events also occurred during that period, though on a more limited scale, in the context of the antisemitic movements in Germany, Austria, Romania, and the Balkan countries, and of nationalist and religious fanaticism in Morocco, Algeria, and Persia).

The Jews of Russia were the victims of three large-scale waves of pogroms, each of which surpassed the preceding in scope and savagery. These occurred between the years 1881 and 1884, 1903 and 1906, and 1917 and 1921. There were outbreaks in Poland after it regained independence in 1918, and in Romania from 1921."

To view full source, go to http://www.jewishvirtuallibrary.org/pogroms-2, accessed March 1, 2016.

4 After much deliberation, we came to the conclusion that we are not blood relatives, but that perhaps our ancestors either came from the same area of Russia, or met early in their lives as new Canadians. Diener's meticulous research unearthed the ship manifests and Canadian census form that informed me of when and where my paternal grandparents arrived in Canada. For that I am extremely grateful.

5 I know this from my cousin Arnold Rudoff's attempt to build a Rudakoff family tree, but there are no further details. Note that his surname is slightly different from mine: his father changed the spelling in an attempt to simplify the spelling and pronunciation of the name.

Introduction

6 An old joke about Jewish immigrants entering North America through Ellis Island tells a similar tale. A man is walking on the street in New York City. A man recognizes him from the shtetl and hails him… "Hey Yankel XXX, is that you?" Yankel shakes hands with the acquaintance and says, "Here in America, I am no longer Yankel XXX, I am Sean Ferguson." "How can that be?" asks his friend. "Well," says Yankel XXX, when I got to Ellis Island, we all got in line for the interviews. The authorities assigned us English-sounding versions of our real names to use in our new lives. I got up to the front of the line, and when the man interviewing me asked me my new name. I got so frightened and flustered that I forgot my English name and said, in Yiddish, "*Shoin Fargessen*" (Already forgotten), and so, I became "Sean Ferguson."

7 "Of, relating to, or designating a French Canadian, esp. a francophone Québécois descended from the original French settlers." *OED Online* (Oxford University Press, December 2015). To view full entry, go to http://www.oed.com.ezproxy.library.yorku.ca/view/Entry/265903?redirectedFrom=pur+laine&, accessed January 15, 2016.

8 In the parochial school I attended, from kindergarten up to Grade Seven, we studied history, religion, literature of the Jewish people in Yiddish and Hebrew. We simultaneously completed the Protestant School Board of Greater Montréal approved curriculum in English and French. I was proficient in four languages upon graduation.

9 This is a mandatory publically funded provincial college program that bridges high school leaving and entering university. The acronym CEGEP stands for *collège d'enseignement général et professionnel*. I attended this two year program at McGill University in downtown Montréal. Subsequently, the province discontinued CEGEP programs that were housed at universities, and increased the number of stand-alone institutions to meet the demand.

10 Countries represented were Australia, Bosnia, Canada, Cuba, Denmark, Egypt, Germany, Iran, Israel, Italy, Poland, Romania, Russia, South Africa, South Korea, Spain, Sweden, United Kingdom, and United States.

11 Only one proposal focused on disability as a form of exile, and a second proposal examined mental health issues and the relationship of an individual to a defined community.

12 Note that throughout the book, in order to preserve authentic voice, I have, for the most part, not altered either spelling or grammar in quotations, e-mails, transcriptions of conversations, or in excerpts from theatrical material. In rare cases, I have edited slightly to ensure clarity.

13 This quotation, and the quotations that follow in this chapter, are drawn from the original abstracts submitted by each contributor.

II. A Theoretical Primer on Exile

On the Paradigms of Banishment, Displacement, and Free Choice

Yana Meerzon

In his famous address "The Condition We Call Exile, or Acorns Aweigh," delivered in December 1987, at a conference on exile held by the Wheatland Foundation in Vienna, Joseph Brodsky, the Russian-American Poet Laureate and a Nobel Prize winner, elegantly distinguished between *migration* as a multitude of displaced people seeking refuge in places different to their home, and *exile* as a psychological, philosophical, and existential condition that defines this experience of migration as displacement, loss, and homelessness. Brodsky did recognize as ethically problematic comparing the misery thousands of migrants experience during their flight and his own plight as a writer in exile, despite the fact that similarly to "a *Gastarbeiter* or a political refugee," an exilic intellectual is also "running away from the worse toward the better. The truth of the matter is that from a tyranny one can be exiled only to a democracy."[1] As naïve as such a statement might sound today (given the inability of many democratic states to provide a sought-after asylum to refugees, who often land within the bureaucratic labyrinths of detention centres or temporal-spatial limbo of refugee camps), Brodsky insisted on speaking of exile as the "ultimate lesson" in humility, "especially priceless for a writer because it gives [them] the longest possible perspective."[2] Exile reminds an intellectual, a writer, or an artist of their major ethical duty: to "be lost in mankind," "to become a needle in that proverbial haystack," "to put down your vanity," and to "measure yourself not against your pen pals but against human infinity," so the writer could finally speak out of the position of humbleness, not from "envy or ambition."[3] Hence, Brodsky concluded, exile is "a metaphysical condition," and "to ignore or to dodge it is to cheat yourself out of the meaning to what has happened to you, to doom yourself into remaining forever at the receiving end of things, to ossify into an uncomprehending victim."[4] In this philosophical reading of exile, Brodsky invited an exilic artist to rethink their personal significance and responsibility. Being in a position of privilege, Brodsky claimed, an intellectual, an artist, or a writer in exile has an obligation to speak on behalf of literature and arts, their ability to appeal to humanity. Literature, "like poverty, is known for taking care of its own kind" and is the "greatest [...] teacher of human subtlety,"[5] a cure to the distracting force of progress that leads civilizations to wars, social and economic disasters, humanitarian and environmental catastrophes.[6] Accordingly, to Brodsky, the function of exilic literature and arts is to provide a perspective, retrospectively, and retroactively, on the history of mankind and its current moment, as one of history's variables. Exile encourages retrospection: the gaze of an exilic artist is simultaneously turned into one's past and one's future.[7]

Taking Brodsky's argument further, I propose to keep the concept *exile* to speak of forced or chosen displacement in metaphorical, philosophical, and psychological terms, specifically

when it comes to our attempts to understand what plight this condition offers to an artist or an intellectual. I further demonstrate that the term *exile* cannot be put on the same scale with other concepts we use to describe very many experiences of migration. Unlike *exile*, the terms *refugee, asylum seeking*, or *economic immigration* bear legal connotations and find use in the official language of Western jurisprudence.[8] Ironically, however, very often people forced to seek asylum fall victims to this legal vocabulary and systems, used by the states to manage migration. Although this vocabulary is regulated by international laws and conventions, including the 1948 Universal Declaration of Human Rights,[9] the 1951 Geneva Refugee Convention,[10] the 1990 International Convention on the Protection of the Rights of All Migrant Workers and Members of Their Families,[11] the 2000 United Nations Convention against Transnational Organized Crime and the Protocols Thereto,[12] the 2001 Guiding Principles for International Displacement,[13] as well as laws on immigration particular to individual countries, it does not really provide an appropriate language to discuss the concrete, individual experiences of migration. The term exile seems to be open enough to invite abstract and metaphorical readings of the experiences of migration; and it seems to be sufficiently precise to point at the complexity of this condition. A brief glance at the terminology we use to discuss migration and exile can aid one in distinguishing between the legal meanings these concepts bear and a metaphorical significance the concept of exile sustains. As my point of departure, I propose to look at the *Glossary on Migration* developed by the International Organization for Migration[14] and the *Glossary of Migration Related Terms*, put forward by The United Nations Educational, Scientific and Cultural Organization (UNESCO).[15] This glossary distinguishes between Asylum Seeker, Displaced Person, Migrant, and Refugee (among others) to refer to social, physical, economic, and cultural conditions of migration.

<p align="center">*** </p>

The term *migration,* often overused and misused by media and news agencies in relation to the current refugee crisis in Europe, refers to

> [...] the crossing of the boundary of a political or administrative unit for a certain minimum period of time. It includes the movement of refugees, displaced persons, uprooted people as well as economic migrants. [...] The dominant forms of migration can be distinguished according to the motives (economic, family reunion, refugees) or legal status (irregular migration, controlled emigration/immigration, free emigration/immigration) of those concerned.[16]

Stephen Castles further distinguishes between *internal migration* as movement of people within one country "from one area to another" and *international migration* as "crossing of frontiers" of different countries.[17] He suggests, however, that such rigid distinction should be viewed as reductionist, since even the frontiers themselves can migrate, a well-known fact in the history of the post-soviet geopolitics.[18] International migration, as Castles reminds us,

is the major factor in today's globalization and creation of multi-ethnic states. "The great majority of border-crossings do not imply migration: most travelers are tourists or business visitors who have no intention for staying for long."[19] Different countries have different regulations for hosting economic migrants, including temporary workers and economic immigration in Canada, guest-workers in Germany, and long-term temporary immigrants in Australia. Accordingly, as Castles writes, it is very difficult to come up with any conclusive, inclusive, or even accurate definition of migration, as each definition carries and presents

> [...] the result of state policies, introduced in response to political and economic goals and public attitudes. International migration arises in a world divvied-up into nation-states, in which remaining in the country of birth is still seen as a norm and moving into another country as deviation. That is why migration tends to be regarded as problematic: something to be controlled and even curbed.[20]

As a result, different countries and their governments create various systems of control and navigation of peoples' movement, all recognized under an umbrella concept of *international migration*. These systems and types include:

Temporary labour migrants (also known as *guest workers* or *overseas contract workers*) [...].
Highly skilled and business migrants: people with qualifications as managers, executives, professionals, technicians or similar, who move within the internal labour markets of transnational corporations and international organisations, or who seek employment through international labour markets for scarce skills [...].
Irregular migrants (or *undocumented/illegal migrants*): people who enter a country, usually in search of employment, without the necessary documents and permits [...].
Refugees: according to the 1951 United Nations Convention relating to the Status of Refugees, a refugee is a person residing outside his or her country of nationality, who is unable or unwilling to return because of a well "founded fear of persecution on the account of race, religion, nationality, membership of a particular social group, or political opinion" [...].
Asylum seekers: people who move across borders in search of protection, but who may not fulfil the strict criteria laid down by the 1951 Convention [...].
Forced migration: in a broader sense, this includes not only refugees and asylum seekers but also people forced to move due to external factors, such as environmental catastrophes or development projects. This form of migration has similar characteristics to displacement.
Family members (or *family reunion/family reunification migrants*): people sharing family ties joining people who have already entered an immigration country under one of the above-mentioned categories [...].
Return migrants: people who return to their countries of origin after a period in another country.[21]

Causes for migration can vary from one's need to leave the home country due to physical or other threat, to peoples' desire to better their economic and social well-being, i.e., increase their income.[22] Using "migration system theory," Castles explains how the migration patterns work: one's desire to better their economic situation leads to establishing certain configurations in labour movement, including postcolonial subjects moving to the former colonies, forms of military recruitment, and seeking temporary work. This labour movement leads to the migrants' desire to stay permanently in a new country, which in its own turn helps create migratory or social chains and networks that allow the family members of these migrants to travel more safely.[23] Providing a brief historical overview of the patterns in migration, from the early nineteenth century to the 2000s, Castles concludes that migration is not only the major factor of globalization, it is also a force that aids "eroding the power of the nation-state."[24] Consequently, the state feels threatened as it finds it more and more difficult to control peoples' movement, which results in increased security measures and border-control functions. This failure on the part of the nation-states to accommodate and integrate large numbers of people within their territory and economic systems leads to the larger phenomena of *displacement* and *statelessness*.[25]

The Glossary of Migration Related Terms defines *displacement* both as the result of economic development "direct displacement, which leads to actual displacement of people from their locations and indirect displacement, which leads to a loss of livelihood," and as "the forced movement of people from their locality or environment and occupational activities. It is a form of social change caused by a number of factors, the most common being armed conflict. Natural disasters, famine, development and economic changes may also be a cause of displacement."[26] Displacement, together with climate change and war conflicts, functions as the major catalyst for creating *refugees* and *asylum seekers*, the categories of migrants also found in Castles' typology of migration (see the list above).

Historically, the word *refugee* can be traced to the fourteenth- century France as derivative from French *refugié*, indicating someone fleeing from home and seeking "shelter from danger or trouble."[27] Both concepts – refugee and asylum seeker –imply negative semantics of weakness, racism, and illegality, Alison Jeffers claims, although differentiated legally and linguistically.

> In Germany refugees are called *fluchtling* while asylum seekers are *asylbewerber*;[28] the French for asylum seeker is *chercher d'asile* while refugees are *refugiés*, and in Spain the term for an asylum seeker is *solicante de asilo* and refugee is *refugiado*. In most English-speaking countries, people waiting for their claim to be heard are called asylum seekers, and can only be granted the title refugee if their claims for asylum are considered successful.[29]

These negative connotations explain the emergence of the slogan "refugee crisis,"

> not simply [as] a crisis of numbers but one that goes to the very heart of questions about the nation state, identity and belonging. This can be seen in the language used to describe

refugees who come from a sedentary place, from "us" who have no need to flee, to "them", those who live an uncomfortable, insecure and less favourable existence.[30]

According to the 1951 Geneva Convention, the word *refugee* refers to any person who, due to

[…] a well-founded fear of being persecuted for reasons of race, religion, nationality, membership of a particular social group or political opinion, is outside the country of his nationality and is unable or, owing to such fear, is unwilling to avail himself of the protection of that country; or who, not having a nationality and being outside the country of his former habitual residence as a result of such events, is unable or, owing to such fear, is unwilling to return to it.[31]

Based on the regulations developed by The United Nations High Commission for Refugees (UNHCR) and the Executive Committee of the High Commissioners Programme, a person can be granted a *refugee* status if their case contains three essential elements:

[…] there must be a form of harm rising to the level of persecution, inflicted by a government or by individuals or a group that the government cannot or will not control; the person's fear of such harm must be well-founded…; the harm, or nationality, political opinion or membership in a particular social group (the nexus).[32]

In other words, the word refugee should be understood, first and foremost, within the legal connotations it bears. The same applies for the notion of *asylum seeker*: within the legal systems, "refugee is the term used to describe a person who has already been granted protection," whereas *asylum seekers* are the people

[…] who move across borders in search of protection, but who may not fulfil the strict criteria laid down by the 1951 Convention. Asylum seeker describes someone who has applied for protection as a refugee and is awaiting the determination of his or her status. […] Asylum seekers can become refugees if the local immigration or refugee authority deems them as fitting the international definition of refugee.[33]

Finally, many countries use the term *immigrant* to describe one more type of migration. Specific to Canadian law and practices, for example, the Immigration, Refugees and Citizenship Canada (IRCC) recognizes political refugees, skilled workers, investors, entrepreneurs, and self-employed people as "immigrants," eligible to seek employment in Canada. The IRCC-defined "skilled immigrant" is expected to have completed a Canadian or foreign educational credential, must demonstrate a sufficient knowledge of English or French, and must have at least one year of continuous full-time paid work experience in one's primary occupation.[34] The term *immigrant theatre artist*, which I have previously introduced in my writing to discuss the work of exilic artists in Canada,[35] refers to a newcomer to Canada who holds a post-secondary diploma in theatre, has work experience

in the trade, and aims to earn a living in Canada or Québec by working in theatre in English and/or in French.

As mentioned above, the word *exile* does not really appear within legal vocabulary. Neither the Human Rights nor Refugee Conventions refer to it, nor is it mentioned in Castles' study, dedicated to explaining the regulations related to international migration. The word *exile*, as Nancy Berg suggests, is more than just a reference to a legal clause; it bears emotional and psychological connotations, it speaks to peoples' personal experiences and collective memory, it creates history and it "requires some response, some engagement on the part of the speaker, the listener, the reader."[36] The word *exile* holds a special place in philosophy, literature, arts, and academic discourse. In the following, I aim to briefly outline the historical, conceptual, and literal meanings we attribute to the concept of exile. I also wish to demonstrate that without paying special attention to exile as the existential condition of being, as it is experienced by an exilic individual, who is "less passive, and more capable of creativity and decision-making" than an asylum seeker or a refugee would be,[37] it is next to impossible to fully understand the true misery of any displacement, including (in)voluntary migration, asylum seeking, and refugee.

According to the *Cambridge English Dictionary*, "exile" means either a person or a condition of "being sent or kept away from their own country, village, etc., especially for political reasons."[38] The *Oxford English Dictionary* defines exile even more loosely as "the state of being barred from one's native country, typically for political or punitive reasons" and "a person who lives away from their native country, either from choice or compulsion."[39] In its Biblical terms, exile refers to a condition of living "away from your own country," waiting for return home, and to the "people that have to leave their own land, often for a long time; the times when the Israelites went from the land of Israel."[40] Today, the condition we call *exile* – derived via the Middle English *exil* from the Latin *exilium* – encompasses both one's enforced removal from home as well as one's self-imposed absence from a native country. Similarly to migration, *exile* can be internal or external, as well as forced or chosen.

In the situation of a *forced internal exile*, we are dealing with political dissidence and resistance, well exemplified in the case of the Russian Soviet nuclear physicist Andrei Sakharov (1921–89), who created the Soviet hydrogen bomb and later became a peace and human rights activist. After Sakharov received his Peace Prize in 1975, he was stripped of his Soviet honourary titles. Together with his wife, Helena Bonner, Sakharov was sent to the town Gorkij, where he lived till 1985 under strict surveillance administrated by the state.[41]

As an act of banishment and expulsion, *external exile* results in a state of loss, sorrow, and personal marginality.[42] It nevertheless becomes a solution to a perceived threat, be it confinement, civil war, poverty, ethnic discrimination, or physical or psychological persecution. Julia Kristeva calls external exile by choice as "the height of the foreigner's autonomy,"[43] which suggests a person of nomadic consciousness and practice. As a

psychological condition, exile is often understood as a state of mourning, nostalgia, and depression.[44] It can manifest an exilic subject's humiliation and challenge, but also can reveal one's dignity. Paradoxically, exile can also provoke a state of happiness and pleasure, as it can provide a sense of continuity. With artists and intellectuals, exile can trigger new discoveries; it can even lead to economic fulfilment. Most importantly, exile can serve as an invitation to grow up, to recognize, and to welcome one's capacity for creativity, for innovation, and reinvention of self.

Accordingly, I define exile in a wide spectrum of possible scenarios: from exile as banishment to exile as nomadism; exile as impossibility of return and as a desire for constant voyage resulting in a transient state of individual mobility; and exile as search for home and as one's escape from it, specifically in the case of the second-generation immigrants who tend to grow up within the cracks of dominant culture, negotiating life lessons as taught differently at home and at school. In fact, unlike any other legal vocabulary employed to define migration, the word exile bears the weight of the exilic subject's personal experience and responsibility.

In the period of the Greek Democracy, exile took the forms of physical and emotional torture as well as death from hunger and thirst in the desert. The democratic state used exile as a form of punishment and as a mechanism of self-defence. A tool to protect the individual privileges and freedoms of citizens from abuse by those who governed, exile served as a "powerful form of boundary, since the act of expulsion constitutes a concrete expression of group identity through the physical removal of what the community is 'not.'"[45] The act of political exile secured the expulsion of "the tyrant from the community."[46] It ensured the moral and the economic wealth of the group. The Athenian democratic law shaped the political identity and the immunity of its polis, as well as its "conceptual definition of what the Athenians 'were not' with an actual act of separation, thus vividly enacting the creation of community through the exclusion of an 'other.'"[47] The political exile – an act of removal and banishment set up for us by the historical narrative of the Greeks – remains the most powerful paradigm of physical, spatial, and temporal separation from one's native land. Accordingly, the word *exile* evokes the meanings of trauma, muteness, impossibility of reconciliation, and the deficiency of any personal or collective closure. It also signifies a displacement and a falling out of time phenomenon.

Following this tradition, Edward Said defines exile as a metaphor of death, and suggests a view of the exilic journey as a crossing of the River Styx from the world of the living (the homeland) to the world of the dead (the new land); a circumstance "irremediably secular and unbearably historical; that [...] is produced by human beings for other human beings; and that, like death without death's ultimate mercy, [...] has torn millions of people from the nourishment of tradition, family, and geography."[48] In his definition, Said reinforces a long-standing tradition of seeing exile as regret, doubt, sorrow, and nostalgia.

Echoing Said, Bharati Mukherjee views exile as "the comparative luxury of self-removal [that] is replaced by harsh compulsion."[49] To Mukherjee, once in exile "the spectrum of choice is gravely narrowed; the alternatives may be no more subtle than death, imprisonment, or a one-way ticket to oblivion."[50] This view of exile, in other words, recognizes the consequences of the exilic act as traumatizing, degrading, and disenfranchising. It also suggests that the exilic state may be understood as an experience of agony offering no possibility for self-realization. In the age of global migration, it becomes difficult to accept this longstanding view of exile only as territorial, historical, and personal loss. In a time of cultural shifts, one needs to recognize that the exilic journey can rest on changing premises that are much broader, more complicated, and unpredictable than just expulsion from one's native land. These premises endorse and attest to the condition of the modern exile as a manifestation of intellectual and cultural discomfort. Today, *exile* encompasses both one's enforced removal from home and one's self-imposed absence from a native country; it is often claimed to become the new norm of social being. This norm, I argue, is still an illusion. No subject of global cosmopolitanism or of *symbolic citizenship*[51] can escape the mechanisms of the state's manipulation and its scrutiny of the individual. Global cosmopolitanism cannot provide us with a shield to defend ourselves from the linguistic and cultural shocks that we experience in a new land, whether as tourists, economic migrants, political exiles, or war refugees. Symbolic citizenship cannot guarantee a traveller their personal presumption of innocence. As Homi Bhabha states, "in the context of the world dis-order in which we are mired, symbolic citizenship is now practically defined by a surveillant culture of 'security' – how do we tell the good migrant from the bad migrant?"[52] Symbolic citizenship cannot help with the personal journey into acceptance, integration, and "arrival" into the adopted land.

As much as it is difficult to definitively explain the concept *migration*, it is equally problematic to find consensus among scholars who look at the notion of exile. For example, in his book *Reflections of Exile*, Edward Said distinguishes between groups of exiles, refugees, expatriates, and *émigrés*.[53] Darko Suvin proposes another account of these groups. He differentiates between political exiles, people banished from their homes for ideological reasons; *émigrés*, single people or families who left their countries for economic reasons; refugees, large numbers of people forced to flee in groups because of war, conflicts, or other persecutions; and expatriates, those nomads who live in expectation of going back to their home countries as soon as political or economic conditions become agreeable.[54] All these groups, as Suvin states, can be classified as *(im)migrants* who must be dealt with by the "target" society and who very often settle together to create a community or *diaspora* in order to better survive in a new land.[55]

Perhaps more accurately than Said's or Suvin's classifications, Mukherjee's distinction between *exiles-immigrants* and *exiles-expatriates*[56] describes the relationships between an exile and their newly adopted country. In both cases, a flight from one's native country is seen as a journey caused either by a traumatic experience or a desire for adventure and exploration. At the moment of landing, this journey turns into a narrative of a newly acquired

identity, a story of translation and adaptation, and an account of integration and adjustment. Exiles-immigrants, as Mukherjee suggests, are "more likely to be discharged on a beach and told to swim ashore, or dropped in a desert and told to run, if they survive at all."[57] Thus, they adopt new citizenship and willingly accept all forms of personal transformation. The exile-immigrant becomes a member of an ethnic community established before and for them by earlier settlers in the new land. The diasporic narrative, therefore, represents "a conscious effort to transmit a linguistic and cultural heritage that is articulated through acts of personal and collective memory. In this way, writers become chroniclers of the histories of the displaced whose stories will otherwise go unrecorded."[58] The other type, the exile-expatriate, consciously resists complete integration either into their newly found country, rejecting an opportunity to become the chronicler of their displaced community, subscribing instead to the creative opportunities of expatriation. The exile-expatriates are often characterized by their "cool detachment" from the everyday hardships of exilic being. They lack the exile-immigrant's troubled engagement with the present social condition. The exile-expatriates remain freely floating islands, difficult to confine or define within the normative bureaucratic language of the state's administration.[59] Ultimately, expatriation in the forms of both forced and self-imposed exile serves these people as "the escape from small-mindedness, from niggling irritations"[60] of their home culture or the culture of their adopted homeland.

To offer a slightly different insight into the problem, I suggest using the word exile exclusively in application to attempts to examine and better understand individual experiences of displacement, which find their representation in the work of exilic intellectuals, philosophers, and artists, i.e., within the constructed fictional worlds of literature, theatre, film, and fine arts, and on the pages of personal memoires, academic papers produced by the scholars of humanities, and philosophical tractates. Edward Said identifies these artists and academics as *intellectuals in exile*, who in their artistic and scholarly work strive beyond the accepted norms, criteria, and demands of the artistic, philosophical, or literary discourses produced in their new homelands. These artists and intellectuals find themselves in a constant state of negotiation, seeking continuity between their past and present experiences, between their professional skills and the expectations of the new audiences, and between their habitual artistic language and a new creative parole. This personal journey of redefining what one calls home and where one finds homeland, a journey of recognition and change, becomes the subject matter of the works produced by many artists living in exile. As Eva Hoffman explains,

> [...] there are two kinds of homes: the home of our childhood and origin, which is a given, a fate, for better or for worse, and the home of our adulthood, which is achieved only through an act of possession, hard-earned, patient, imbued with time, a possession made of our choice, agency, the labor of understanding, and gradual arrival. The experience of enforced exile paradoxically accentuates the potency of what is given, of the forces that have shaped us before we could shape ourselves.[61]

To work in one's second language and to search for other (possibly nonverbal) means of creative communication, to address not only the audiences of one's ethnic community but the large groups of international readership or spectatorship, becomes, for example, the artistic and existential goals faced by an artist and an intellectual in exile. This search for an expressive language of the exilic experience is particularly pertinent to "an intellectual as an outsider"[62] (someone who is dependent on their linguistic forms of expression not only in everyday life but also [and more importantly] in their professional domains). Said describes this challenge as a condition of marginality and solitude, but also of pleasure and privilege.[63]

An artist or an intellectual in exile is someone who consciously chooses not to belong to "any place, any time, any love,"[64] and who rarely defines themself in spatial terms but sees exile as an existential voyage unfolding in temporal dimensions. As Kristeva states, "the space of the foreigner is a moving train, a plane in flight, the very transition that precludes stopping. As to landmarks, there are none"[65] and thus the temporal dimensions of exilic experience dominate its spatial coordinates. In these aspects, exile becomes an invitation to grow up, to recognize and welcome one's capacity for creativity, for innovation and reinvention of self. Intellectuals and artists in exiles, both voluntary and involuntary, often risk being misunderstood because of language barriers. They face the potential humiliation of having to exist outside of their social class and familiar discourse, and thus need to search for new means of self-expression. They face cultural loss, breaking with the past mythologies and the necessity of coming to terms with the values of an adoptive nation. Such experiences can stimulate the exiles' personal creativity, so they begin to experience exile as an exercise in alterity, in which social, psychological, and artistic challenges can dictate "an immense force for liberation, for extra distance, for developing new structures in one's head, not just syntactic and lexical but social and psychological."[66] Accordingly, *exilic identity* rests with the sentiment and the practices of the exilic voyage, which often includes the major transformation of the exilic subjects themselves. Either in the space of one's own lifetime or within the temporal span of the life of the exilic subjects' children, the exilic artist undergoes a transformation from the clash of cultures to hybridity, a condition that becomes a cultural antonym to the state that originated it. The elements of the individual discourse mixed with the narrative of the dominant or adopted culture form the basis of this exilic identity. The exilic transformation leads to a series of progressions: the exilic subject's linguistic, cultural, and ideological challenges eventually lead to the forms of one's personal and professional integration, adaptation, and change.

This view of exile as a permanent journey in time, space, and language allows one to speak of exile as a range of everyday performances, described by Erving Goffman as dramatic realization of self,[67] and as professional performative appearances that the exilic artist makes whether on stage, in images and sounds, on screen, or in language. Accordingly, I speak of an *artist in exile* as someone who, whatever the reasons for their flight, chooses to continue their creative quest in the adopted language targeting new audiences, not necessarily directing their artistic utterances at the community of their former compatriots.[68] An exilic artist is aware of and embraces the linguistic, cultural, and economic challenges of the new land not as

obstacles but as stimuli for creativity and personal growth. This artist engages in making the unfamiliar (the strange) familiar in their everyday and professional narratives. By adapting Mikhail Bakhtin's concepts of heteroglossia, dialogicity, and chronotope as the definitions of the multivocality and multitemporality of exile, Nikolay Evreinov's views on theatricality as a form of life creativity, and Jacques Derrida's *différance* as a separation of identity and time, the exilic work re-emphasizes the exilic artist's creative efforts. By embracing the three fundamental issues an exilic subject faces – language, identity, and construction of a new narrative (literary, dramatic, theatrical, or existential) – exilic performance becomes an example of Victor Turner's *liminal spaces* and *imaginary communitas*.

This tension between continuity and difference defines the experience of the exilic quotidian and the practice of the *exilic performative*,[69] which originates at the intersection of an exilic artist's original cultural and professional knowledge (which this artist preserves and advances in their newly adopted country) and demands, tastes, and expectations of their adopted audience. I consider each manifestation of the *exilic performative* as an example of the exilic artist's call for remaking one's identity and thus performing the act of self-fashioning.

Exilic theatre privileges the position of the outsider. It cherishes the state of liminality and thus it neither seeks any influential role within the culture of the dominant, nor identifies itself with the culture of that linguistic and cultural community to which an exilic artist belongs. Exilic theatre tends to engage with the culture of the dominant and to develop itself both within and separately from the administrative frames of the adopted state. It privileges the sporadic, mobile, and flexible lifestyle of the artistic communitas. It reserves the right to float freely between languages, traditions, and cultural referents, and thus it presents an administrative challenge to cultural and institutional bodies. Exilic theatre acts as the expression of borderlessness, flexibility, imbalance, and free movement between separate cultural, ethnic, and communal entities. In this sense, exilic theatre can be rendered cosmopolitan, built by the artists who are both the citizens of the world and its observers.[70]

In its aesthetics, *exilic theatre* is marked by two equally strong tendencies for self-reflectivity (as in autobiographical performances) and for universality, both in its philosophical claims and in its search for new artistic means to convey the sense of displacement. Exilic theatre often relies on the dominance of a philosophical or poetic utterance: an utterance that embraces theatre performances based on plays written in verse and in rhythmicized or stylized prose; performances based on nonverbal forms of expression, physical and movement-based work, abstract image and sound, as well as creating meta-theatrical and meta-performative constructs. I argue therefore that both the act of creation (the process of writing plays, staging theatre and dance productions, and making films) and the products of exilic creativity (the plays, the productions, and the films themselves) serve as examples of exilic transcendence. In their subject matter, exilic artists often focus on individual experiences of the flight and longing for return, as these phenomena are exemplified in the processes of coming to terms with one's artistic identity. This identity originates within the exilic artist's gradual move from seeing oneself as an ethnocultural and thus national subject

in the past, at home; to recognizing oneself as a representative of a certain profession – a poet, a theatre director, a writer, a dancer, or a filmmaker – someone whose life abroad, in the artist's present, must be defined by what this person does, and not by what place, language, or cultural heritage this artist belongs to. Hence exilic artists tend to simultaneously speak to three distinct audiences: (1) the larger audiences of their adopted country, thus aiming their works at international and domestic readership; (2) the diasporic audiences of their home-country's community abroad; and (3) their former home-country's audience.

Conclusion

To finish this short foray into the difference between the concepts of migration and exile, I would like to quote a contemporary exilic artist, the Serbian/Croatian performer and theatre-maker Natasha Davis, who currently lives and works in the United Kingdom. Having experienced many forms of migration (as a migrant, a stateless citizen in Greece, and a highly skilled worker in Syria), today Natasha Davis prefers to speak of her experience in the language of exile. For her,

> The story of exile begins with a rupture. The history of living elsewhere takes its roots in repetition of this rupture. The arrival into the new world prompts the exile's desire to rebuild the pattern, which in its own turn encourages repetition. Repetition, be it a device of rhetoric or a form of artistic composition, suggests the process of return, the work of revisiting and clarifying meaning.[71]

It is important therefore to remember that unlike many legal definitions and terms that we associate with displacement, *exile* is the only concept that invites us to speak about this condition in terms of humanitarian and ethical values. The word exile not only allows us to identify foreigners and strangers in the bodies of refugees and migrants,[72] but also makes us recognize their fundamental eminence as human beings and as Other. The word exile forces us to acknowledge and accept our own responsibility towards this Other; it makes us see the Other within ourselves.

It is not by chance that many scholars of philosophy, social sciences, cultural studies, and performance (including Jacques Derrida, Giorgio Agamben, and Judith Butler) recognize the work of Emmanuel Levinas as central to our attempts at explaining the impact migration has on our humanity. Abi Doukhan identifies the philosophical paradigm of exile as ground-forming in Levinas' discussion of hospitality and welcoming of Otherness.[73] At the core of Levinas' philosophy, much as in Joseph Brodsky's aesthetics, is the metaphysical reading of exile as "a de-centering, a de-positing of [Self] as center of the universe," because "the self must itself experience exile […] if an encounter with the exilic dimension of the other is to be possible."[74] This recognition of self as Other, self in exile, is the basis of our personal humanity and ethics, the only way to universal hospitality, open borders, equality, and

cosmopolitanism. This recognition of self as Other must begin, however, with our realization that that there is an impossible to cross border, a wall, between oneself and the Other. This wall, the other outside self, must be seen, acknowledged, and responsibility must be taken for it. Only after that, can one also recognize their own self as forever split between the I and the Other, the core of the exilic self. This is how Doukhan explains Levinas' thought:

> The other appears in my field of vision, as physical body, as a face rich in features and expressions. And yet something of that other escapes me. I perceive, constitute the other as a body within my world, and yet, along with this body, I sense that something in that other escapes me, I sense that I can never gain full knowledge of him or her.[75]

In this sense the Other always remains exterior to my world; it stands as stranger to my personal experience. In this, Doukhan sees the fundamentals of Levinas' exilic philosophy, in which the condition of exile is read as existential and universal, true to any phenomenological or *precarious experience* of the world.[76] Such reading of exile presents its disadvantages: as it removes any political traces from this concept, makes it essentialist and impersonal. It also contains fundamental truth: in the world deprived of spiritual guidance, with religious doctrines often turning into the mechanisms of oppression, neo-nationalism, and fundamentalism, the ethics of personal responsibility remains the only measuring stick and the mechanism of accountability that both the state and the individuals can practice when it comes to searching for better conditions of our life together, in the world defined by international migration and new cosmopolitanism. This reading of exile as a condition of personal responsibility of self for Other bears no legal connotations or weight; but should be used, I argue after Levinas, as the major guiding ethical principle when the state institutions and their representatives begin to deal with the multitudes of migration. By exercising their authority over people, these institutions and their representatives must remember that the multitude is made of individual experiences, and that mass migration is made of very personal, exilic journeys.

Notes

Parts of this chapter, in earlier versions, have been published in Yana Meerzon, *Performing Exile – Performing Self: Drama, Theatre, Film* (Hampshire: Palgrave Macmillan, 2012).

1. Joseph Brodsky, "The Condition We Call Exile," in *On Grief and Reason: Essays* (New York: Farrar, Straus, and Giroux, 1995), 24.
2. Brodsky, "The Condition We Call Exile," 25.
3. Ibid.
4. Brodsky, "The Condition We Call Exile," 25–26.
5. Ibid., 23.

6 Ibid.
7 Ibid., 27.
8 The key contested point in the legal and scholarly debates concerning involuntarily/forced migration is that the formula "voluntary = economic migrants" and "forced = refugees or trafficked persons" is extremely simplistic and does not account for the multitude of complex migration situations. Oliver Bakewell, "Research Beyond the Categories: The Importance of Policy Irrelevant Research into Forced Migration," *Journal of Refugee Studies* 21, no. 4 (2008): 432–53; Alison Crosby, "The Boundaries of Belonging: Reflections on Migration Policies into the 21st Century," *Inter Pares Occasional Paper Series*, no. 7 (June 2006): 1–13, http://www.statewatch.org/news/2006/jul/boundaries-of-belonging.pdf, accessed May 1, 2017. This binary and these debates have some historical roots, see Rieko Karatani, "How History Separated Refugee and Migrant Regimes: In Search of Their Institutional Origins," *International Journal of Refugee Law* 17, no. 3 (2005): 517–41.
9 http://www.un.org/en/universal-declaration-human-rights/, accessed October 30, 2016.
10 http://www.unhcr.org/1951-refugee-convention.html, accessed October 30, 2016.
11 http://www.ohchr.org/EN/ProfessionalInterest/Pages/CMW.aspx, accessed October 30, 2016.
12 https://www.unodc.org/unodc/en/treaties/CTOC/index.html, accessed October 30, 2016.
13 Although the UN Guiding Principles on Internal Displacement have not been signed by any country, they have been incorporated into the internal legislation of many states that are dealing with a high number of displaced people on their territory, http://www.unhcr.org/protection/idps/43ce1cff2/guiding-principles-internal-displacement.html, accessed October 30, 2016.
14 Richard Perruchoud and Jillyanne Redpath-Cross, eds., *Glossary on Migration* (International Organization for Migration: Geneva, 2011), http://www.epim.info/wp-content/uploads/2011/01/iom.pdf, accessed October 30, 2016.
15 http://www.unesco.org/new/en/social-and-human-sciences/themes/international-migration/glossary/, accessed October 30, 2016.
16 *Glossary of Migration Related Terms*, http://www.unesco.org/new/en/social-and-human-sciences/themes/international-migration/glossary/migrant/, accessed October 30, 2016.
17 Stephen Castles, "International Migration at the Beginning of the Twenty-First Century," *International Social Science Journal* 52, no. 165 (2000): 269.
18 Ibid., 270.
19 Ibid.
20 Ibid.
21 Ibid., 270–71.
22 Ibid., 272–73.
23 Ibid., 273.
24 Ibid., 278.
25 Ibid., 279.
26 http://www.unesco.org/new/en/social-and-human-sciences/themes/international-migration/glossary/displaced-person-displacement/, accessed October 30, 2016.

27 Alison Jeffers, *Refugees, Theatre and Crisis: Performing Global Identities* (London: Palgrave Macmillan, 2011), 4.
28 J.M. Peck, "Refugees as Foreigners: The Problem of Becoming German and Finding Home," in *Mistrusting Refugees*, eds. E.D. Valentine and J.C. Knudsen (Berkeley: University of California, 1995), 109.
29 Jeffers, *Refugees, Theatre and Crisis*, 6.
30 Ibid., 6. For more information on the practices of exilic, migrant, and refugee theatres, see: M. Balfour et al., *Applied Theatre: Resettlement: Drama, Refugees and Resilience* (Methuen, 2015); M. Balfour, ed., *Refugee Performance: Practical Encounters* (Bristol: Intellect Press, 2013); Emma Cox, *Theatre & Migration* (Palgrave, 2014); Emma Cox, "Refugee Performance: Practical Encounters," *NTQ* 30, no. 3 (2014): 302–03; Emma Cox, *Performing Noncitizenship: Asylum Seekers in Australian Theatre, Film and Activism* (Anthem Press, 2015); and Emma Cox, "Mare Nostrum, or On Water Matters," *Performance Research* 21, no. 2 (2016): 141–49; "Performance and Asylum: Embodiment Ethics," ed. Helen Gilbert and Sophie Nield, special issue, *Research in Drama Education* 13, no. 2 (2008); Helen Gilbert and A. Johnston, ed., *In Transit: Travel, Text, Empire* (New York: Peter Lang, 2002); and Silvija Jestrovic and Yana Meerzon, eds., *Performance, Exile and 'America'* (Basingstoke: Palgrave Macmillan, 2009). The forthcoming work by Stephen Wilmer on stateless citizens in the journal *Critical Stages* (December, 2016) and with Palgrave (2017) is also of special importance.
31 http://www.unesco.org/new/en/social-and-human-sciences/themes/international-migration/glossary/refugee/Article 1A (2), accessed October 30, 2016.
32 http://www.unesco.org/new/en/social-and-human-sciences/themes/international-migration/glossary/refugee/, accessed October 30, 2016.
33 http://www.unesco.org/new/en/social-and-human-sciences/themes/international-migration/glossary/asylum seeker/, accessed October 30, 2016.
34 http://www.cic.gc.ca/english/immigrate/skilled/noc.asp, accessed October 30, 2016.
35 Yana Meerzon, "Theatre and Immigration: From the Multiculturalism Act to the Sites of Imagined Communities," *Theatre Research in Canada* 36, no. 2 (2015): 181–96.
36 Nancy Berg, *Exile from Exile. Israeli Writers from Iraq* (Albany, NY: SUNY Press, 1996), 3.
37 Ibid., 4.
38 http://dictionary.cambridge.org/dictionary/english/exile, accessed October 30, 2016.
39 https://en.oxforddictionaries.com/definition/exile, accessed October 30, 2016.
40 http://www.easyenglish.info/bible-dictionary/exile.htm, accessed October, 2016.
41 https://www.nobelprize.org/nobel_prizes/peace/laureates/1975/sakharov-facts.html, accessed October 16, 2016.
42 Paul Tabori, *Anatomy of Exile: A Semantic and Historic Study* (London: Harrap, 1972), 27.
43 Julia Kristeva, *Strangers to Ourselves,* trans. Leon Roudiez (New York: Columbia University Press, 1991), 7.
44 On the subject of nostalgia and exile, see Svetlana Boym, *The Future of Nostalgia* (New York: Basic Books, 2001); Svetlana Boym, "Estrangement as a Lifestyle: Shklovsky and Brodsky," in *Exile and Creativity: Signposts, Travelers, Outsiders, Backward Glances*, ed. Susan Rubin Suleiman (Durham and London: Duke University Press, 1998), 241–63; as well as Daniel

Meyer-Dinkgräfe, *Observing Theatre: Spirituality and Subjectivity in the Performing Arts* (Amsterdam: Rodopi, 2013).
45 Sara Forsdyke, *Exile, Ostracism, and Democracy: The Politics of Expulsion in Ancient Greece* (Princeton: Princeton University Press, 2005), 7.
46 Ibid.
47 Ibid., 7.
48 Edward Said, *Reflections on Exile and Other Essays* (Cambridge: Harvard University Press, 2000), 174.
49 Bharati Mukherjee, "Imagining Homelands," in *Letters of Transit*, ed. André Aciman (New York: New York Public Library, 1999), 73.
50 Ibid.
51 Avishai Margalit, *The Decent Society*, trans. Naomi Goldblum (Harvard: Harvard University Press, 1996), 158–60.
52 Homi K. Bhabha, *The Location of Culture* (London: Routledge, 2004), xvii.
53 Said, *Reflections on Exile*, 181.
54 Darko Suvin, "Immigration in Europe Today: Apartheid or Civil Cohabitation?" *Critical Quarterly* 50, no. 1–2 (2008): 207.
55 Ibid., 207–08.
56 Mukherjee, "Imagining Homelands," 71–72.
57 Ibid., 71.
58 Azade Seyhan, *Writing Outside the Nation* (Princeton: Princeton University Press, 2001), 12.
59 Ibid., 72.
60 Ibid.
61 Eva Hoffman, "The New Nomad," in *Letters of Transit*, ed. André Aciman (New York: New York Public Library, 1999), 60.
62 Edward Said, *Representations of the Intellectual: The 1993 Reith Lectures* (London: Vintage, 1994), 53.
63 Ibid.
64 Kristeva, *Strangers to Ourselves*, 7.
65 Ibid., 8.
66 Christine Brooke-Rose, "Exsul," in *Exile and Creativity: Signposts, Travelers, Outsiders, Backward Glances*, ed. Susan Rubin Suleiman (Durham and London: Duke University Press, 1996), 40.
67 Erving Goffman, *The Presentation of Self in Everyday Life* (New York: Doubleday, 1959), 30.
68 For different definitions of the artist in exile, see (among others): Ha Jin, *The Writer as Migrant* (Chicago: University of Chicago Press, 2008); Nico Israel, *Outlandish: Writing Between Exile and Diaspora* (Stanford: Stanford University Press, 2000); Wojciech H. Kalaga and Tadeusz Rachwał, ed., *Exile: Displacements and Misplacements* (Frankfurt am Main: Peter Lang, 2001); George Lamming, *The Pleasures of Exile* (Ann Arbor: University of Michigan Press, 1992); Michael Seidel, *Exile and the Narrative Imagination* (New Haven: Yale University Press, 1986); and Magda Stroińska and Vittorina Gacchetto, *Exile, Language and Identity* (Frankfurt am Main: Peter Lang, 2003).

69 For further definitions of exilic performative, see Yana Meerzon, *Performing Exile – Performing Self: Drama, Theatre, Film* (Hampshire: Palgrave Macmillan, 2012), 3.
70 On cosmopolitanism and globalization in theatre, see Helen Gilbert and Jacqueline Lo, *Performance and Cosmopolitics: Cross-Cultural Transactions in Australasia* (Houndmills: Palgrave Macmillan, 2007) and Dan Rebellato, *Theatre & Globalization* (Houndmills: Palgrave Macmillan, 2009).
71 Natasha Davis and Yana Meerzon, "Staging an Exilic Autobiography," *Performance Research* 20, no. 5 (2015): 63.
72 Sara Ahmed, *Strange Encounters: Embodied Others in Post-Coloniality* (London: Routledge, 2000) and Hannah Arendt, "We Refugees," in *Altogether Elsewhere: Writers on Exile,* ed. Marc Robinson (Boston and London: Faber and Faber, 1996), 110–19 (originally published in *Menorah Journal* 33, no. 1 [1943]: 69–77).
73 Abi Doukan, *Emmanuel Lévinas: A Philosophy of Exile* (London: Bloomsbury, 2012), 3.
74 Abi Doukan, "From Exile to Hospitality: A Key to the Philosophy of Emmanuel Levinas," *Philosophy Today* 54, no. 3 (2010): 235.
75 Ibid., 236.
76 Judith Butler, *Precarious Life: The Powers of Mourning and Violence* (London and New York: Verso, 2004), 128–53.

III. The Essays

Chapter 1

Theatre, Reconciliation, and the American Dream in Greater Cuba

Lillian Manzor

Miami is one of the few cities in the United States with a thriving theatre scene in Spanish. As the capital of Cuban exiles, it is often portrayed in the media as the place in which this exile community, traditionally constructed as homogenous, has maintained an antagonistic relationship with the "homeland." Media representations, however, have completely overlooked the role theatre has played in the reconciliation process between two communities that have been politically separated for over fifty years. One of the most innovative plays staged in Miami in Spanish in 2015 was produced by a protagonist of this reconciliation process: theatre director and playwright Alberto Sarraín. The play in question is *Un mundo de cristal*, a loose adaptation of Tennessee Williams' *The Glass Menagerie* by Cuban-born and Miami-based Alberto Sarraín and José Cabrera.[1] Sarraín's production of *Un mundo de cristal* (September 12, 2015) was staged in Akuara Teatro, a 66-seat performing space that is a transformed warehouse in the Red-Bird Arts District of South West Miami.[2] Akuara is a non-profit organization that works with professional theatre artists to present "teatro de arte" (art theatre as opposed to commercial theatre) in Spanish in Miami. Its audience is primarily though not exclusively Cuban from different generations. Akuara has teamed up with professional theatre photographers and videographers who document their work as well as with scholars, like myself, who collaborate in their productions as literary and cultural advisors. This chapter presents an analysis of *Un mundo de cristal* and its socio-cultural and historical contexts to argue for the ways in which this "adaptation" radically questions the Cuban exile's experience in the United States and different generations' exilic (de)construction of "home." Through an analysis of the adaptation process, of the play's scenography (designed by an exiled Cuban visual artist), and of its music track (iconic songs by Cuban musicians residing on the island), I will demonstrate how this contemporary "adaptation" leads the audience to question not only its participation in the "American Dream" but also its nostalgic view of "home."

Miami–Cuba

It is important to provide a short introduction to this very complex urban space many call Miami-Cuba. A bilingual city since the mid-1960s, Miami, Florida is the cultural, economic, and political centre of the US Cuban ethnic enclave. An economic and cultural gateway to the Caribbean and South America, Miami could best be characterized as a "contact zone." Mary Louise Pratt describes the term as that "space in which people who are geographically

and historically separated come into contact with each other and establish ongoing relations, usually involving conditions of coercion, radical inequality, and intractable conflict."[3] In this contact zone called Miami, the Cuban/Latino population stands out for being drastically different from other US cities with a predominantly Latino population. For example, it is rather common for white Latinos/as to say that they have never experienced discrimination – neither racial nor linguistic.[4] Indeed, it was not until I left Miami for graduate school in Southern California that I experienced both forms of discrimination intersectionally with gender. And it was not until much, much later that I could actually articulate those experiences in relation to different levels of social formation.[5] I was born and grew up in the small Cuban town of Ciego de Avila. My family emigrated to San Juan, Puerto Rico when I was ten years old (via Madrid and Detroit), and eventually settled in Miami in the mid-1970s. In all of these cities, I was "white." It was in Southern California that I acquired the language to theorize the ways in which Latinas like myself were racialized as non-white regardless of our phenotype.

The very name of Miami-Cuba captures the nature of this space as a contact zone; Portes' excellent study of Miami describes the city as an anomaly for social scientists since it defies traditional methodological tools. He aptly argues that, Miami, while part of the United States, is not like any of the other urban centres. Furthermore, it does not

> [...] fit very well more recent descriptions of a "social mosaic" composed of established ethnic groups that maintain certain elements of their culture under the hegemonic umbrella of a white Protestant elite. In Miami, the fragments of the mosaic are loose and do not come together in any familiar pattern.[6]

As a result, the categories hegemonic and subaltern occupy very unstable and shifting positions. In fact, at least in reference to the Latino/Anglo contact – which is very different from the Black/Anglo and the Haitian/Anglo contacts[7] – it could be said that there is not one hegemonic class or ethnicity, not one mainstream. Instead, we have a series of parallel structures with their own institutions and organizations. Cubans and other Latinos will tell you that they are the ones who set the cultural pace for restaurants, music, clothing styles, even politics. In order to survive in Miami, the non-Latino English-speakers are the ones who have to learn how to read different cultural codes and how to perform in different cultural and business spaces.

The first wave of Cuban immigrants or the "historic exile," as it is well known, was comprised of a relatively homogeneous group.[8] Sociologists called them "golden exiles" because most of the immigrants were part of the economic, political, and intellectual elites in Cuba. They had the economic and intellectual potential to build the core of an economic base that eventually expanded with the growth of the Cuban immigrant population first, and then immigration from other Latin American and Caribbean countries.

Ideologically, the "golden exiles" shared the US view of the Cold War prevalent at the time. For them, Castro's Marxist revolution was in sharp conflict with Jeffersonian capitalism.

These "golden exiles" were generally strong anti-communists and stout conservatives. Most importantly, they also shared a work ethic similar to that in the United States, and were used to participating actively in a capitalist system. In other words, for these "golden exiles," the "American way of life" was not at all foreign. Louis A. Perez Jr. demonstrates in his groundbreaking study *On Becoming Cuban*, that the "American way of life" had a strong influence in the forging of Cuban identity. Through complex processes of adaptation and transformation, daily life in Cuba had been changing throughout the twentieth century as a result of modernization, that is, Americanization. As Perez Jr. states, "[Cuban] postcolonial environment was dominated by an array of agencies that transmitted North American cultural forms, with which a vast number of people were obliged to come to terms daily in ordinary ways. This process of negotiation, often irrespective of outcome, was arguably the single most decisive determinant of an emerging national identity."[9] This could explain Tennessee Williams' popularity in Cuba's modern theatrical circles, as I will explain later in this chapter.

Usonians' popular response to early Cuban immigration and Cubans' belief in the myth of the "American Dream" began to change with the immigration from the Mariel Boatlift in 1980.[10] This is one of the most traumatic events of Cuban exile history. The 125,000 Cubans who migrated to the United States through the port of El Mariel were endangered by numerous acts of repudiation and physical aggression in Cuba. Once they arrived in the United States, many were subjected to incarceration and to a negative and unwelcoming response by the Cuban exile community. Until this moment, the United States and the media had welcomed Cubans (as well as others leaving a communist country, following the anti-communist zeal characteristic of the United States during the Cold War). The *Marielitos'* immigration, however, signalled a change in both the official and popular discourse around Cuban immigrants. The change from political refugees to bullets penetrating Miami's social fabric was echoed in the popular press who changed its previous rhetoric of the "hard working resilient Cuban" to emphasize that the *Marielitos* were single men, criminal dregs, and homosexuals.[11] Whereas not all of the 125, 000 fell into the above categories, in reality the slice of the Cuban population comprising the majority of the *Marielitos* brought the statistics of Cubans in the United States closer to that of Cubans on the island with respect to race, class, and education. As a matter of fact, it could be argued that this is precisely the moment in which the economic inequality and ethnoracial fragmentation of Miami come to the fore.

Un mundo de cristal: A Multilayered Memory Play

Sarraín's production of *Un mundo de cristal* underscored, as in Tennessee Williams' antecedent, that this was a memory play. It was staged, as such, in relation to the events within the play (*Marielitos'* experience of Miami in the 1980s). Most importantly, I argue that it functions as a community's memory play as it looks back upon itself and its own

theatrical and socio-cultural history. While *The Glass Menagerie* is usually translated into Spanish as *Zoológico de cristal* (literally, "Glass Zoo"), in Cuba the title that is used most commonly is *Mundo de cristal* (literally, "World of Glass"). Since its Havana premiere in 1947, only two years after its Broadway debut, the play has been a favourite of the Cuban theatrical community both in Havana and in Miami.[12] As a matter of fact, fifteen different Williams plays were presented in Havana between 1947 and 1960, as documented by the 2015 exhibit "Tennessee Williams: *Dramaturgo y pintor*" ("Tennessee Williams: *Playwright and Painter*"), at the Antonio Rodríguez Morey Information Centre of Havana's National Museum of Fine Arts. Williams' ability to expose the innermost turmoil of his characters through cinematic techniques, and his use of poetic language to present human beings' bitterness and despair, were well-received by Havana theatre-goers. Most importantly, Williams' plays were a conduit for director Modesto Centeno to modernize Cuban theatre-making. The director was able to transpose Broadway's modern stagings through the craft of avant garde scenographer Luis Márquez and lighting technician Armando Soler. As a matter of fact, critic Manuel Casal compared Centeno and Márquez to Elia Kazan and Jo Mielziner, Broadway's first director and scenographer of Williams' plays.[13] In other words, Centeno's productions of Williams' plays were proof that Cuba's modern theatre had come of age: Havana had its own Broadway.[14]

The early Cuban exiles in Miami also turned to *Mundo de cristal* and incorporated it as part of their repertoire. Indeed, the first artistic theatre company to produce plays in Spanish in Miami, Teatro 66, chose *Mundo de cristal* as their inaugural play. Likewise, when New York's Repertorio Español decided to present an American play to their Spanish-speaking audience in July–August 1980, they selected *Mundo de cristal*. (An uncanny coincidence is that it was staged right in the middle of the Mariel Boatlift). And when the Coconut Grove Playhouse in Florida finally decided to engage their Spanish-speaking community, they also chose *Mundo de cristal* for an experiment in which they would present the same production with two different casts, one speaking Spanish and one speaking English. It became the theatre's first main-stage production in Spanish. This archival history surrounding *The Glass Menagerie*'s productions in Greater Cuba came to the fore as soon as Sarraín's 2015 production of *Un mundo de cristal* was announced on social media. Cuban theatre critic Rosa Ileana Boudet wrote two entries on her blog titled "Tennessee en La Habana," and the editors of the Cuban Theater Digital Archive, of which I am founding director, updated the productions staged in Spanish in Miami and New York.[15]

All of these productions maintained the dramatic world created by Tennessee Williams. The main characters–Laura, Tom, and Amanda Wingfield–were presented as belonging to a lower-middle class, provincial US family. The play's "dramatic intensity, fluid dialogues, psychological depth, and profound lyricism," the basis for Tennessee Williams' analysis of the "primitive violence subjacent in North American culture,"[16] must have struck a special chord in Cuban and US Cuban audiences. The theatrical repertoire of Greater Cuba, from Virgilio Piñera's *Electra Garrigó* (the first Modern Cuban drama) to Iván Acosta's *El Súper*

(one of the earliest dramas about Cuban exiles in the US), has often placed a special emphasis on the Cuban family as violent, patriarchal, and repressive.

Sarraín and Cabrera's version of *The Glass Menagerie*, however, makes these connections explicit. It constructs Tomás Padilla as a young Cuban exile from the Mariel Exodus, in 1980s Miami. Williams' suffocating South becomes a small apartment in Miami's Little Havana neighbourhood, where the three characters inhabit a frustrating society that does not allow them to live to their fullest potential. Tomás wants to escape from his mother and his shoe factory job in search of a world reigned by poetry and imagination. Laura evades her reality by retreating into her "*mundo de cristal*" ("glass menagerie") and the music she listened to in Cuba. Amanda Wingman's "*neiges d'antan*" ("snows of yesteryear") of her Southern youth, along with her seventeen gentleman callers, inform Amanda Imbert's Santo Suárez youth and her seventeen suitors. However, Amanda's nameless "nigger" is personalized in Sarraín's version becoming "Lazarito, *el negrito;*" the endearing but paternalist diminutive which captures the racial differences in the unconscious racist usage of language in Cuban society.

In rehearsals, the actors read Williams' notes to the staging of *The Glass Menagerie* and I, as literary and cultural advisor, led the discussions of the history of Cuban exiles in Miami, focusing on the impact of the Mariel Exodus on the Miami communities. The older and more experienced actors (Larry Villanueva who played Tomás Padilla, and Yvonne López Arenal who played Amanda Imbert) brought their own personal histories of El Mariel to the discussions and rehearsals. Villanueva actually is a *Marielito* himself, while López Arenal arrived to the United States in 1994, and she lived through Mariel's acts of repudiation in Havana.[17] The youngest actors, on the other hand, barely had any personal memory of the events surrounding Mariel. Diago Fernández (Jaime) is a recent arrival to Miami, but was well-known in Cuba and Spain as a television actor. Vienna Sicard (Laura Padilla), a student of Villanueva, recently graduated from the Academy of Arts and Minds, one of Miami's magnet high schools with a unique course of studies focusing on the Performing Arts. This was her first professional theatrical appearance.

The Mariel Boatlift brought many Cuban artists to Miami who had lived most of their lives during the Revolution. Countless numbers of them were actually in favour of the revolutionary social changes in spite of the fact that they had been excluded by the government, many because of their homosexuality. These recent arrivals had grown up listening to the music of Silvio Rodríguez, Pablo Milanés, and Miriam Ramos, and, as Sarraín has explained, "they didn't even suffer the same nostalgias" as the earlier exiles.[18] It was very difficult for them to adapt personally and culturally to a city that they found conservative, and to artists they did not consider to be risk-takers. Sarraín and Cabrera's Tomás Padilla shares the frustration of the artists of this generation. The production compels the community to remember the conflicts the Mariel artists had to face and the brutal ways in which many of them had to renounce their artistic vocation in order to survive. As the director corroborates in an interview: "The exile's anguish for the land they left behind for reasons beyond their control underlies this play."[19]

Figure 1: Larry Villanueva (Tomás) in *Un mundo de cristal*, by Alberto Sarraín and José Cabrera, directed by Alberto Sarraín, Akuara Teatro, Miami, Florida, USA, September, 2015. Photo credit: Julio de la Nuez.

Un mundo de cristal, adaptation and performance, like Williams' antecedent, is constructed based upon "a reality that exists only in the remembrances and point of view" of Tomás.[20] He wants to be a playwright, and his friend Jaime mockingly nicknames him Cervantes. In developing Tomás' mannerisms and characterization, both actor and director played upon his homosexuality. Although Tomás does not completely partake of the culture of visibility the homosexual *Marielitos* imposed in Miami, the play openly suggests a bond between Tomás and Jaime that if not homosexual is, at least, homosocial.

Furthermore, some of Tomás' evening escapades to the movies could also be read as evening outings to cruising areas and gay bars. In the crucial conflict scene with his mother (Scene III), Tomás yells at her:

You are absolutely right. I don't go to the movies. I'm going to marijuana pubs! Yes, mom, to marijuana pubs, dens of vice and criminals' hang-outs [...]. In reality, I'm leading a double life, a simple, honest shoe factory worker by day, by night a dynamic czar of the underworld... Girl, I could tell you things that would make you sleepless![21]

Not only is Tomás' secretive nightlife connected to homosexuality, other elements in the adaptation also refer us to homosexual culture. In *The Glass Menagerie*, Tennessee Williams uses references to Spain, Franco, and Guernica to enter "the social and political discourse of his time. His postwar plays are dominated by thematic concerns traceable to the damaging effects of the Second World War and the ensuing fear of Communism."[22] *Un mundo de cristal* keeps the references specific to Spain, but they are now referring to the Spain of the 1980s transition, characterized by a loosening of sexual mores and "*la movida*," a countercultural movement of which film-maker Pedro Almodóvar became a well-known representative. As an openly gay director, he was instrumental in changing Spain's perceptions towards homosexuals. It should come as no surprise, then, that Tomás, the narrator, poetically evokes Almodóvar and sexuality when talking about 1980s Miami: "In Spain, Almodovar was becoming famous! But here there was only hot *ranchera* music and liquor, dance halls, bars, and movies, and sex that hung in the gloom like a chandelier and flooded the world with brief, deceptive rainbows."[23] Cast as an outsider because of his artistic and homosexual tendencies, the audience commiserates with Tomás and exiles like him who suffered harassment by their families and community because they were "different."

Although Tomás is not exactly like the "flamboyant gender-transgressive male homosexuals," or "*locas*" studied by Susana Peña,[24] members of the community/audience undoubtedly had to face the role the exile community played in marginalizing *Marielitos* as *maricones* ("faggots"). Indeed, "The men who crowded into small apartments together so they could afford the rent, who bleached their hair with hydrogen peroxide, and wore house dresses in the street because that was the drag they could afford, who endured the insults hurled at them because they were both *Marielitos* and *maricones*, presented a challenge to the homogeneous images of Cubans in the United States."[25] It is precisely the conflation and denigration of *Marielitos* as *maricones* and the memory of that doubly traumatic past that *Un mundo de cristal* forces us to revisit.

Tennessee Williams explained in his notes to the play that his ideas "have to do with a conception of a new, plastic theatre which must take the place of the exhausted theatre of realistic conventions if the theatre is to resume vitality as a part of our culture."[26] *Un mundo de cristal*'s director, Alberto Sarraín, shares many of Williams' anti-realist conventions.[27] Thus, the play was staged following Williams' notions of a "plastic" theatre and Sarraín's own expressionistic style, which also takes advantage of the nonverbal elements that make a play theatrical more than dramatic.[28] The choice of music, as well as the scenic and lighting designs, were planned carefully in order to evoke, on the one hand, that personal world of memory and, on the other, the socio-cultural milieu of 1980s middle-class Cuban Miami. Sarraín chose jazz music as background to Tomás the narrator's incursions into personal memories. This selection was reminiscent of Sarraín's previous use of jazz as evocative of Havana's underground artistic scene in his production of *Chamaco: Boy at a Vanishing Point* (2009).[29]

The most suggestive and controversial musical choice was Silvio Rodríguez' "*Unicornio Azul*" ("Blue Unicorn") as the song that Laura "played" on "the old record player" over and

over again.[30] Laura's favourite piece in her glass collection is the one with a single horn on his forehead: "This is one of the oldest. It's been with me for nearly thirteen years; I brought it from Cuba."[31] The director took advantage of Williams' unicorn and Rodríguez' famous song to evoke Laura's retreat into her Cuban past. Although the song has had multiple interpretations, for Laura and theatre-goers of her generation who grew up in Cuba, for whom this song was practically an anthem, it conjured memories of youth, happiness, and deceptions, and, most importantly, lost but still possible dreams. Rodríguez' songs were banned from Miami-Cuba's airwaves because he was and still is considered a spokesperson of the Cuban government.[32] Official exile culture does not recognize the rebellious and anti-government or anti-establishment nature of his music. Ironically, Miami-Cuba repeats the very acts of censorship that Rodríguez suffered in Havana.[33]

When the first notes and words of "*Unicornio azul*" were heard at Akuara, "My blue unicorn / I lost it yesterday: I left it grazing / and it disappeared,"[34] they struck a special note of nostalgia and, I argue, reconciliation. Habey Echevarría's review aptly captured the impact of the music on this complex community that has to reinvent itself:

> The ruins of the Washington-Havana differendum […], and the imminent disappearance of the "historic exile" […] shape the context of this play […]. The musical atmosphere of the period, including appropriate songs by the troubadour Silvio Rodríguez – cultural representative of the Castro brothers' government – presented implicitly a confrontation between worlds that are crumbling.[35]

Finally, a theatrical production in Miami had dared to include one of Silvio Rodríguez' songs and to recognize the value his music has had for many members of this complex and heterogeneous exile community.

The scenic design was also a key component in this memory play. Visual artist Angela Valella worked with Sarraín to create an atmosphere of transparency or translucency through the use of glass, Lucite, and plastic in stark contrast to the suggested enclosure by the use of straight lines demarcating the alley stage left. Valella is a visual and performance artist who has been living in Miami since the mid-1970s. She works in a variety of media including, painting, collage, installation, and video informed by architecture, and art-historical references.[36] "The Narcissist," one of her abstract paintings reminiscent of Leger, was used to suggest the photograph of the absent father and "What comes Real to Us," a moving installation piece, stands in place of Laura's old record player.

This expressionistic use of art pieces imbued the staging with a striking retro beauty, but it was her use of plastic to wrap the sofa in the living room area and the transparent plastic tablecloth, napkins, and eating utensils that immediately caught the audience's attention.

It is well known that Jo Mielziner, designer of the Broadway staging of *The Glass Menagerie*, used transparent interior walls in the set. As he explains, "If he [Williams] had written plays in the days before the technical development of translucent and transparent scenery, I believe he would have invented it […]. My use of translucent and transparent

Theatre, Reconciliation, and the American Dream in Greater Cuba

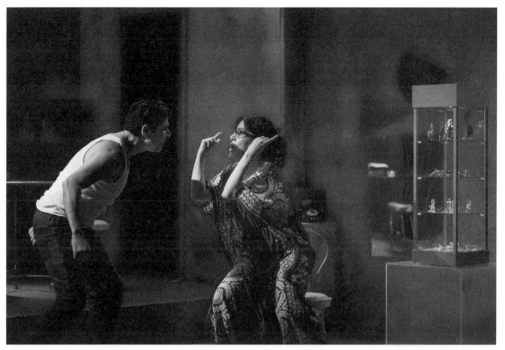

Figure 2: (L-R) Larry Villanueva (Tomás), Yvonne López Arenal (Amanda) in *Un mundo de cristal*, by Alberto Sarraín and José Cabrera, directed by Alberto Sarraín, Akuara Teatro, Miami, Florida, USA, September, 2015. Photo credit: Julio de la Nuez.

scenic interior walls was not just another trick. It was a true reflection of the contemporary playwright's interest in and at times obsession with the exploration of the inner man."[37] Sarraín and Valella's use of plastic in *Un mundo de cristal* aptly served a double function. On the one hand, like in Mielziner's design, it suggested the fragility of the inner spirit and the malleability of time. However, many theatre-goers reminisced about the sofa wrapped in plastic in the living room (to avoid soiling "the formal living room") and the use of plastic instead of linen or glass in the dining room found in many Cuban exiles' homes in the 1960s and 1970s. Indeed, the use of plastic in *Un mundo de cristal* is a comment on the contradictory ways in which an exile community adapted to and adopted the "plastic" North American culture typical of this time period. The recently-arrived Amanda needs to partake of this aspiring middle-class custom in spite of the lack of income in her household. A post on social media by a theatre-goer underscored the audience's ability to read this and other not so subtle cultural winks: "I am not sure what I enjoyed the most, if the play itself, or the complicity it propitiates all the time."[38]

In the end, Tomás found a way to escape his mother's and Miami's repressive environment: to travel constantly and to "plunge compulsively into a world of strangers,"[39] like Tennessee

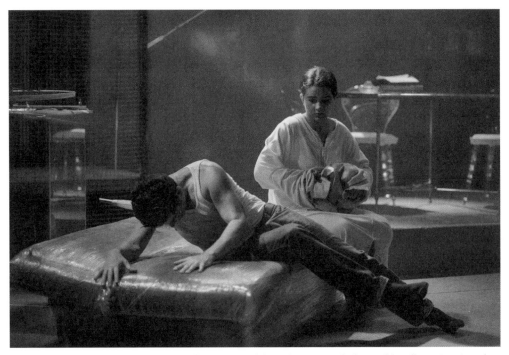

Figure 3: (L-R) Larry Villanueva (Tomás) and Vienna Sicard (Laura) in *Un mundo de cristal*, by Alberto Sarraín and José Cabrera, directed by Alberto Sarraín, Akuara Teatro, Miami, Florida, USA, September, 2015. Photo credit: Julio de la Nuez.

Williams did during his life. As John Lahr, Williams' biographer, has suggested, "torn between facing his problems and fleeing them, he chose flight."[40] Accordingly, Tomás almost ends the play reminiscing precisely about his constant flight always haunted by the memory of his sister, Laura:

> I travelled around a great deal. The cities swept about me like dead leaves, leaves that were brightly colored but torn away from the branches. I don't know […] I would have stopped in Madrid, in Caracas, in Prague, or in Santiago de Chile, but I was pursued by something. […] I cross the street, I run into the movies or a bar, I buy a drink, I speak to the nearest stranger. Anything that can blow your candles out![41]

In this revisiting the past, home is an elusive and unstable category that never existed to begin with. Many of Williams' critics have noted that *The Glass Menagerie* is an allegory of failed patriarchy precisely when "the Great Depression brought with it the shattering of the American Dream and the dissolution of image of America as a land of opportunities."[42] Indeed, Tom's good-bye and Laura's final act of blowing out the candles at the end of

Williams' play offer the perfect connection between that dissolution and "the scene dissolves" as the audience is left in the dark.

I have argued that *Un mundo de cristal* revisits the present of an exile community through an examination of its past. Tomás', Laura's, and Amanda's failed dreams underscore that for the *Marielitos*, the "American Dream" was and is nothing but the daily nightmare of work. Their shattered dreams can be read not only as the shattering of the exile dream but, most importantly, the shattering of the Cuban "golden exile" myth of exemplarity. Sarraín's production, though, has a slightly different ending than Williams' play. After Laura blows out the candles, Tomás tells the audience: "There my memory ends and imagination is born. Good bye! (*One continues to hear the music until the end*)."[43] If it is through poetry and the imagination that each character can survive in a society that has marginalized them for being different, the very production of *Un mundo de cristal* is exemplary of the power theatre has to imagine different conceptions of home, to claim and maintain a small performing art space in a world city such as Miami, where the arts, whether in Spanish, English, or Kreyòl, are underfunded and undervalued. Theatre, the imagination, and music survive Tomás' good-bye.

Towards a New Miami–Cuba

On March 22, 2016, US President Barack Obama addressed the Cuban people at Havana's Grand Theatre. In one of the sections of his speech, he stated:

> So the reconciliation of the Cuban people – the children and grandchildren of revolution, and the children and grandchildren of exile – that is fundamental to Cuba's future…
>
> You see it in Melinda Lopez, who came to her family's old home. And as she was walking the streets, an elderly woman recognized her as her mother's daughter, and began to cry. She took her into her home and showed her a pile of photos that included Melinda's baby picture, which her mother had sent fifty years ago. Melinda later said, "So many of us are now getting so much back."[44]

The Melinda López mentioned in President Obama's speech is a Boston-based US Cuban playwright, and is the inaugural Mellon playwright-in-residence at the Huntington Theatre Company. President Obama might not have known that López is a playwright, or the role that theatre has played in the reconciliation process of Cuba and its exile/diasporic communities. Alberto Sarraín has been at the forefront of this process since 1993 when with me, and the International School for Latin American and Caribbean Theatre, he co-organized a "Meeting in Havana," the official title for an event meant to bring together Cuban theatre artists from the United States and Cuba. The meeting was cancelled at the last minute because, apparently, the Ministry of Culture considered it was not the appropriate moment

for such a meeting. Unbeknownst to us, this event, organized from the ground up, would have come ahead of other official dialogues and conferences organized by the Ministry of Culture that took place the following year: "Nation and Emigration" in Havana, and "Cuban and Diaspora Writers" in Sweden in April and June of 1994, respectively. In spite of its cancellation, several of us were able to travel to Cuba, and laid the groundwork for future collaborations.

In 1995, Sarraín founded La Má Teodora Cuban Cultural Group in Miami, a project meant to introduce contemporary Cuban plays in the Miami theatrical scene in spite of the rejections by some members of the exile community. He received the PEN/Newman Freedom of Expression award for his fight against Miami-Dade County's Prohibition to use public funding to stage plays by artists who lived in Cuba. That same year, we co-organized the First International Monologue/Performance Festival in Miami. It was described by the press as "the ten days of Spring that changed the cultural landscape of the city,"[45] because we brought twenty-nine Cuban artists to the US, along with the Vice-President for the National Council of the Performing Arts (supposedly the largest delegation of Cubans ever to travel to the US), and the "Miami Cuban Mafia" (a term used by the Cuban press to describe members of the Miami exile community) behaved itself: there were no protests or acts of repudiation.

The experience of the festival and the communication that was established moved all participants to act and think differently, to open themselves to the others in our midst: it was an experience that forced the Cubans to change their views of Miami, Miami-Cubans to change their views of the theatre produced in Havana, and both groups to act accordingly as agents of that change. Personal impact was best stated by Marta Barber, in an opinion piece published in *The Miami Herald*:

> I realized how far we have come, and how, right under the eyes of both governments, the invisible barrier that has separated our communities for four decades is crumbling. Leave it to the arts to be the hammer that deals that fatal blow to this political conundrum [...]. After 10 days of kisses, embraces and emotional tears what struck me most about this theater event is the banality of trying to keep our communities split.[46]

The festival "whose beginning initiated a groundbreaking cultural and artistic journey and whose ending undeniably opened doors long shut"[47] was proof that transformative politics can take place in the realm of theatre. Indeed, as one of the festival directors observed: "Much more than a display of theatre, the festival has been a door that has opened a lesson in civil tolerance and peaceful coexistence."[48]

All of these small theatrical projects helped establish an artistic dialogue that aimed to rethink Cuba as Greater Cuba and theatre as a space for identity in process beyond national or political borders.[49] Although these undertakings were first and foremost theatrical undertakings, they proved to be effective in fostering a dialogue between two communities that are often politically separated. Theatre has allowed us to develop projects in which

cooperation, mutual understanding, and common artistic goals brought us together outside of the Cold War rhetoric that guided US-Cuba relations on both sides of the Florida straits until December 17, 2014. At this time of changing attitudes in US-Cuban relations, *Un mundo de cristal* brought that reconciliation process to the city of Miami itself. The production, as I have argued, opened up a space for the audience to recognize the many Cubas that coexist in the city and the role all of us Cubans – exiles, migrants, and transnationals – have in imagining, performing, and constructing a new Miami for the twenty-first century.

Notes

1 Alberto Sarraín and José Cabrera, "Un mundo de cristal," (unpublished playscript, 2015), pdf. To access a full copy of the unpublished script, go to http://ctda.library.miami.edu/media/publications/Un_mundo_de_cristal_1.pdf, accessed April 12, 2016.
2 *Un mundo de cristal*, by Alberto Sarraín and José Cabrera, directed by Alberto Sarraín, Akuara Teatro, Miami, Florida, September 2015.
3 Mary Louise Pratt, *Imperial Eyes: Travel Writing and Transculturation* (New York: Routledge, 1992), 6.
4 As a matter of fact, sociological studies corroborate that of all Latinos, "Cubans are by far the group least likely to report discrimination." Lisandro Pérez, "Growing Up in Cuban Miami," in *Ethnicities: Children of Immigrants in America*, ed. Rubén G. Rumbaut and Alejandro Portes (Berkeley: University of California Press, 2001), 108–09.
5 Elspeth Probyn, *Sexing the Self: Gendered Positions in Cultural Studies* (New York: Routledge, 2003), 18.
6 Alejandro Portes and Alex Stepick, *City on the Edge: The Transformation of Miami* (Berkeley: University of California Press, 1993), 8.
7 These contacts underscore the existing ethnoracial inequality in the city in terms of "occupation, income, and poverty as well as related spatial inequalities." Laura P. Kohn-Wood, Frank Samson, and Jomills Braddock, "Race, Social Identity, and Generative Spaces: Miami as a Microcosm of Categorical Complexity in a 21st-Century Global City," *American Behavioral Scientist* 59, no. 3 (2015): 387.
8 US literature on Cuban immigration talks about four waves of Cuban immigrants. The first wave covers the years 1959–62. These dates coincide with the rise of the Cuban revolution in January 1959 until the Cuban missile crisis in October 1962, which resulted in the cancellation of legal emigration from Cuba as well as termination of all flights from Cuba to the United States. About 280,000 Cubans migrated legally and illegally to the United States during this first wave. Between 1962 and 1965, there was no direct legal transportation between the United States and Cuba. Nevertheless, it has been estimated that about 56,000 Cubans still came to the United States during this period, most of them via a third country.

The second wave of Cuban immigrants began in 1965 when the US and Cuban governments negotiated *el puente aéreo*, an airlift between Varadero, Cuba, and Miami, Florida. These flights are also known as "freedom flights" and brought about 325,000 Cubans.

In April 1980, an economy in recession as well as government austerity programs resulted in the takeover of the Peruvian embassy in Havana by over 10,000 Cubans. This precipitated the opening up of the port of Mariel, which initiated the third wave of immigration. Between April and September 1980, over 125,000 Cubans arrived in Miami.

The fourth wave of immigration is comprised of over 15,000 people who arrived in Florida daily during 1994 in makeshift rafts, the *balseros*, as well as almost 400,000 legal and illegal immigrants from all walks of life, including a large number of important and well-known intellectuals and artists who have come to the United States in rafts or via Mexico, Spain, and other third countries. This last wave of immigration was prompted by Cuba's economic crisis during the Special Period and changes in US immigration policies towards Cuba.

9. Louis Pérez Jr., *On Becoming Cuban: Identity, Nationality, and Culture* (Chapel Hill: University of North Carolina Press, 1999), 157.
10. For the use of Usonian instead of American, see Lillian Manzor-Coats, "Who are you Anyways? Gender, Racial and Linguistic Politics in US Cuban Theater," *Gestos* 6, no. 11 (1991): 163–74.
11. See Flavio Risech, "Political and Cultural Cross-dressing: Negotiating a Second Generation Cuban-American Identity," *Michigan Quarterley Review* (Special Issue) 33, no. 3 (Summer 1994): 526–40. Ruth Behar and Felix Masud Piloto, eds., *From Welcomed Exiles to Illegal Immigrants: Cuban Migration to the U.S., 1959–1995* (Lanham: Rowman & Littlefield, 1996).
12. See Lillian Manzor, "Mundo de cristal," *Cuban Theater Digital Archive*, http://cubantheater.org/production/4638, accessed April 12, 2016.
13. Manuel Casal, "Un tranvía llamado deseo. Crítica," *Prometeo* 1, no. 8 (August 1948): 22, 24.
14. Early Cuban exiles also brought that interest in Broadway to 1970s Miami. See Lillian Manzor and Beatriz Rizk, "Broadway is Around the Corner," in *Cuban Theater in Miami: 1960–1980*. To view full page, go to http://scholar.library.miami.edu/miamitheater/section3.html, accessed April 12, 2016.
15. Rosa Ileana Boudet, "Tennessee en La Habana," *Lanzar la flecha bien lejos* (blog), September 1, 2015, http://rosaile.blogspot.com/2015/09/tennessee-desemboca-en-la-habana-2.html, accessed April 12, 2016.
16. "*La intensidad dramática, el dinamismo de la acción, los diálogos fluidos, la hondura psicológica de los personajes (sobre todo los femeninos) y su profundo lirismo, que son los puntales en los que se apoya el autor para analizar la violencia primitiva que subyace en la civilización norteamericana.*" José Cabrera, "Notas al programa," *Un mundo de cristal program* (Miami: Akuara Teatro, September 2015). This and all other translations into English are mine.
17. As artistic director of Akuara Teatro, she participated in Akaura's production of *Huevos* ("Eggs"), a documentary play written by Ulises Rodríguez Febles and directed by Alberto Sarraín about the impact of the Mariel Boatlift on those who left and those who stayed behind.
18. Alberto Sarraín, "Presagio de un encuentro," in *Teatro: Memoria e Historia. VII Encuentro Internacional de Dramaturgia de La Valldigna*, ed. José Monleón and Nel Diago (Valencia: Universitat De València, 2007), 227.
19. "*En la obra original subyace la angustia del desterrado por la tierra que dejó atrás por razones ajenas a su voluntad.*" Arturo Arias Polo, "Un mundo de cristal," *El Nuevo*

Herald, September 16, 2015. To view full article, go to http://www.elnuevoherald.com/entretenimiento/teatro/article35502171.html, accessed April 12, 2016.

20 "Una realidad existente solo en el recuerdo y el punto de vista," Ibid.

21 "¿No? Pues tienes toda la razón. Por una vez en tu vida, tienes toda la razón. No voy al cine. ¡Me voy a los fumaderos de mariguana! Sí, mamá, a los fumaderos de mariguana, guaridas del vicio y refugio de criminales… En realidad, llevo una doble vida. De día, soy un sencillo y honrado trabajador de una factoría de zapatos, pero por la noche soy el zar del hampa… ¡Muchacha, podría decirte cosas que no te dejarían pegar un ojo por las noches!" Sarraín and Cabrera, "Un mundo de cristal," 17. All translations of *Un mundo de cristal* to English are mine, using Williams' text.

22 Lisa M. Siefker Long, "Tennessee Williams in Cultural Context: The Glass Menagerie to Cat on a Hot Tin Roof" (PhD diss., Vanderbilt University, 1996), 2.

23 "¡En España empezaba a triunfar Almodóvar! En este pueblo, sólo había música frenética de rancheras y alcohol, bares y películas. Y el sexo suspendido en la sombra como un candelabro que anegaba al mundo con breves y engañosos arco iris…" Sarraín and Cabrera, "Un mundo de cristal," 28.

24 Susana Peña, *Oye Loca: From the Mariel Boatlift to Gay Cuban Miami* (Minneapolis: University of Minnesota Press, 2013), x.

25 Ibid., xii.

26 Tennessee Williams, "Production Notes," in *The Glass Menagerie* (Oxford: Heinemann Educational Publishers, 1996), xvii.

27 See Lillian Manzor, "El promotor del intercambio: Alberto Sarraín," *Theater der Zeit - Spezial: Theater in Kuba* (September 2010): 44–45.

28 Tennessee Williams uses the concept of "plastic theatre" to highlight the importance of nonverbal elements in the creations of plays. This is underscored in his letter to Eric Bentley where Williams highlights

> […] the extra-verbal or non-literary elements of the theatre, the various plastic elements, the purely visual things such as light and movement and color and design, which play, for example, such a tremendously important part in theatre such as Lorca's and which are as much a native part of drama as words and ideas are […]. Actually all of these plastic things are as valid instruments of expression in the theatre as words.

Tennessee Williams, Albert J. Devlin, and Nancy M. Tischler, *The Selected Letters of Tennessee Williams. Volume II: 1945-1957*, ed. Albert J. Devlin and Nancy M. Tischler (New York: New Directions Books, 2000), 203.

29 *Chamaco: Boy at a Vanishing Point*, by Abel González Melo, directed by Alberto Sarraín, Trail Theater, Miami, Florida, October 2009.

30 I use quotation marks because the song, as I will analyze later, was heard through a music soundtrack since there was no real record player on stage.

31 "Este es uno de los más viejos, tiene casi trece años conmigo, lo traje de Cuba." Sarraín and Cabrera, "Un mundo de cristal," 56.

32 Actually, one of Silvio Rodriguez' most revolutionary songs "welcomed" President Barack Obama at Havana's Grand Theatre during his groundbreaking March 22, 2016 visit to Cuba.

Not only is Obama the first sitting US President to visit Cuba in 88 years, his visit served to consolidate the change of course in US–Cuba relations that he started December 17, 2014. He travelled to Cuba first and then to Argentina. This sent an important message to the hemisphere and the world that for the United States, Cuba is finally returning to the hemispheric family of nations. Most importantly, US isolationist policies towards Cuba were the vestiges of the Cold War. Although the embargo is technically still in place, the establishment of diplomatic relations first, and now Obama's visit to Cuba signals that the Cold War is finally over.

33 See, for example, "Silvio Rodriguez: Folk Music, Revolutionary Style," in *Culture and the Cuban Revolution: Conversations in Havana*, ed. John M. Kirk and Leonardo Padura Fuentes (Gainesville: University Press of Florida, 2001), 1–16.

34 "*Mi unicornio azul / ayer se me perdió: / pastando lo dejé / y desapareció.*" Silvio Rodríguez, "Unicornio Azul." To see full song lyrics, go to http://www.musica.com/letras.asp?letra=68815, accessed April 12, 2016.

35 "*las ruinas humeantes del diferendo Washington- La Habana… y la inminente desaparición de 'los históricos'…, conforman el contexto que envuelve esta obra… El ambiente musical de la época, incluyendo canciones apropiadas del trovador Silvio Rodríguez –representante cultural del gobierno de los hermanos Castro plantearon implícitamente un enfrentamiento de mundos que se deshacen.*" Habey Hechavarría Prado, "Observación de Miami como 'Un mundo de cristal,'" *Teatro en Miami* (blog), November 21, 2015, http://www.teatroenmiami.net/index.php/habey-hechavarria-prado/7949-observacion-de-miami-como-un-mundo-de-cristal, accessed April 12, 2016.

36 Information taken from artist's website, http://angelavalella.com/, accessed April 12, 2016.

37 Jo Mielziner, *Designing for the Theatre* (New York: Bramhall House, 1965), 124.

38 "*No se que disfruté más, si la obra en sí misma, o la complicidad que propicia todo el tiempo.*" De Cazuela, post on *Un mundo de cristal* Facebook event page, October 3, 2015. To view post, go to https://www.facebook.com/events/1489563014672154/permalink/1496603297301459/, accessed April 12, 2016.

39 Eric P. Levy, "'Through Soundproof Glass': The Prison of Self-Consciousness in *The Glass Menagerie*," *Modern Drama* 36, no. 4 (December 1993): 533.

40 As a matter of fact, one of these trips included a short trip to Havana during the early years of the revolution, as he tells director Kazan: "My favorite city in the Americas…. The swimming and the fucking are wonderful here… The revolution is very inconspicuous, and not all scary to me." John Lahr, *Tennessee Williams: Mad Pilgrimage of the Flesh* (New York: W.W. Norton & Company, 2014), 194.

41 "*Vi mucho mundo. Las ciudades pasaban vertiginosamente ante mí como hojas secas, de brillantes colores, pero arrancadas de la rama. Qué sé yo… Me hubiera detenido en Madrid, en Caracas, en Praga o en Santiago de Chile; pero, algo me perseguía, me acechaba. cruzo la calle, entro corriendo en un cine o un bar… Pido un trago, hablo con el extraño que tengo al lado. ¡Cualquier cosa que te sirva para apagar tus velas!*" Sarraín and Cabrera, "Un mundo de cristal," 63.

42 Humaira Tariq, "American Dream and Its Fallibility in Tennessee Williams' 'The Glass Menagerie,'" *International Journal of Arts and Humanities* 38 (December 31, 2010): n.p.

43 "*Y ahí termina mi memoria y nace la imaginación. ¡Adiós!... (Sale por la callejuela de la derecha. Se sigue oyendo música hasta el final)*." Sarraín and Cabrera, "Un mundo de cristal," 63.
44 Barack Obama, "Remarks by President Obama to the People of Cuba," *whitehouse.gov*, March 22, 2016. To view full speech, go to https://www.whitehouse.gov/the-press-office/2016/03/22/remarks-president-obama-people-cuba, accessed May 1, 2016.
45 Mia Leonin, "From Ports to Puertas: Looking Back on Ten Days in Spring that Changed the Landscape," *Miami New Times*, May 17, 2001, 31.
46 Marta Barber, "A Bridge Over the Sorrows of Cubans in Miami," *The Miami Herald*, May 6, 2001, 6B.
47 Leonin, "From Ports to Puertas: Looking Back on Ten Days in Spring that Changed the Landscape," 31.
48 Sarraín quoted by Leonin, Ibid.
49 I borrow the term "Greater Cuba" from Ana M. Lopez, "Film and Video in Greater Cuba," in *The Ethnic Eye: Latino Media Arts*, ed. Chon A. Noriega and Ana M. Lopez (Minneapolis: University of Minnesota, 1994), 38–58.

Chapter 2

Three Angry Australians: A Reflexive Approach

Tania Cañas

Subordinate people do not have the privilege of explicitness, the luxury of transparency, the presumptive norm of clear and direct communication, free and open debate on a level playing field that the privileged take for granted.
 –Dwight Conquergood, *Cultural Struggles: Performance, Ethnography, Praxis*[1]

I am not writing for the scum who want to have the cockles of their hearts warmed.
 –Bertolt Brecht, *Brecht on Theatre: The Development of an Aesthetic*[2]

I am an Australian. I am a refugee. I am angry. Certain bodies are afforded the privilege of anger. As refugees, our communities are expected to be grateful, not angry.

A few years ago I was invited to perform a piece as part of an interdisciplinary community health conference. Prior to the performance, I sent through my biography and Curriculum Vitae, outlining my theatrical training and performance experience. I also sent through a synopsis of the solo performance piece, titled *Untouchable* (2013), which dealt with the issues of identity politics and the politics of representation within Australia. Nervous and excited, I rehearsed extensively, read my script on the tram journey to the conference, and showed up in my neutral black clothes, as I was trained to do as an undergraduate theatre student. As the conference progressed, however, ominous, problematic signs began to appear. Next to my name, frustratingly, in the published conference program were the words, "traditional performance," despite the documents that I had sent through weeks in advance identifying the content and style of my performance. Furthermore, projected on the giant wall behind the performance area was the go-to image of a generic African child staring up at the camera with eyes wide open. No context, no reason. Just an interesting humanitarian backdrop for seemingly altruistic consumption. The Master of Ceremonies frantically offered to introduce me, but couldn't pronounce my surname despite several half-energized attempts to do so. Ironically, this echoed one of the lines in the semi-autobiographical performance I was about to present, which tracks the protagonist returning to (my native) El Salvador, twenty-three years after leaving the chaos of the civil war:

> I step off the plane to be greeted by the air hostess who takes one look at my Australian passport and says:
> "*Bienvenida, Señorita Cañas.*"
> She pronounces my name right; that never happens in Australia.
> It's Cañas not can-ass.[3]

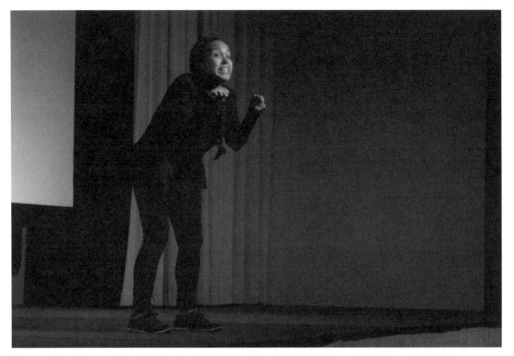

Figure 1: Tania Cañas in *Untouchable* at the Critical Mixed Race Studies Conference in Chicago, USA, 2014. Photo credit: Ken Tanabe.

"I'll introduce myself," I told the Master of Ceremonies. In that moment it became painfully clear that the stage and the terms of enunciation[4] were set: I was to perform a certain character in a certain way. Such demands were consistent rather than isolated incidents at the event, in both advocacy as well as theatrical terms. Refugees are assumed to be bearers of traditional culture not contemporary voices; posters for humanitarianism, but not angry, self-organized, or politicized; subjects, but not citizen-subjects. My body was expected to possess a voice that could only speak in the past tense, as if I was an archaic, unchanging relic of culture, with the inherent assumption that I was unaware or unable to contribute to contemporary socio-political Australian discourse. Refugee narratives, on stage, often sit within unchallenged binaries of old and new country, despite our very existence as refugees being disruptive to statehood ideas of borders, order, and identity.[5] I continuously encountered these predefined expectations of me as, "refugee performer," and thus what constituted a refugee performance. Therefore, as an act of resistance, I am angry. I am an angry refugee, as equally as I am an angry Australian.

I wrote *Three Angry Australians* as part of Apocalypse Theatre Company's quick-response ASYLUM season at the Old 505 Theatre in Sydney in February of 2015. The rapid-response format invited playwrights from across the country to create new, one-scene plays, written in

less than ten days, rehearsed in less than two days, and performed over twelve nights across two weeks. Selected plays were matched to directors and actors before being performed as staged readings to a sold-out season. The call for proposals asked playwrights to explore what it means to seek asylum, particularly as a response to the Australian Coalition government's Operation Sovereign Borders policy, a military-led response claiming to combat people-smuggling and protect Australia's borders. All twenty-five playwrights participating waived their fees, so that the proceeds of ticket sales could be donated in full to the Asylum Seekers Centre in Newtown, and the Asylum Seeker Resource Centre (ASRC) in Melbourne.

As a playwright, I wanted to use the opportunity to stage a different type of narrative, one that challenged the expectations I had directly encountered regarding the idea of a definitive, universal refugee narrative. Therefore, I began by asking: "what does it mean to seek asylum?" I approached the concept of asylum not in the legal or descriptive sense, but rather as an ontological consideration: what does it mean to seek asylum as a naturalized Australian of refugee and asylum seeker background? How does my community create safe spaces? How do we behave and speak within these spaces as opposed to out of these spaces? I desired to see characters on stage grappling with the nuanced ethical dilemmas, the mundane and the administrative minutiae, the contradictions and confusion of refugeeness,[6] in ways that reflected who I was. This chapter will explore how refugee narratives are expected to sit within a restrictive, highly problematic, predetermined discursive framework[7] that limits possibilities for staging a multiplicity of ontologies, and how *Three Angry Australians*, as intervention, sought to challenge these. To illustrate my assertions, I will include relevant excerpts from *Three Angry Australians*.

The Setting: Beyond the Border Scenario

Three Angry Australians was not set at sea, in the middle of the Australian desert, or in a detention centre. Thus, the most obvious thing the play did was to actively take the scene out of what Guterman refers to as border scenarios.[8] Instead, it is set in a refugee aid and advocacy organization, during a typical day's work, exploring how pockets of sanctuary are created, not *for* refugees and asylum seekers but rather how these spaces are created *by*, and embodied *as*, refugees and asylum seekers.

The performance began with this action:

> (*In blackout. The sound of a protest taking place outside is heard: "Free, free the refugees! Free, free the refugees!" The sound builds to a roar, then suddenly stops. Lights up. An office. Three people are working at their computers.*)

TRIANGLE: "Name of organization." "How many refugees does your organization support?" "Please tick the ethnicity of your clients below."

CIRCLE: "I am writing to seek referral for our member, not client."

SQUARE:	"See attached, kind regards."
TRIANGLE:	"Tick, tick, tick, tick."
SQUARE:	"Level 3, Williams Landing Street."
TRIANGLE:	"Please tick the suburbs your organization covers." "Tick, tick."
CIRCLE:	"See attached details and respond to me as soon as you can, as a matter of urgency."
TRIANGLE:	"Tick, tick." " Australian business number 85 89 …"
CIRCLE:	Send.
TRIANGLE:	Save.
SQUARE:	Send.

(*Beat. The sound of the protest begins again, quietly at first, but grows increasingly louder.*)[9]

This beginning alone, contrasting the sounds of the ongoing protest in the streets while the three main characters worked away at their office computers, was in stark contrast to the narratives of other plays on the bill that particular evening. One of the plays depicted an encounter between a character who had escaped from one of Australia's mainland detention centres and an outback farmer. Another looked at the moment one gets a knock at the door and has five minutes to grab one's belongings and flee from home and homeland. *Three Angry Australians* presented a different tone and rhythm that night. The style was verbally dense, drawing inspiration from the style of the text of Reginald Rose's play *Twelve Angry Men* (1954), the imagery of Eugene Ionesco's *The Chairs* (1952), and the absurdity in Samuel Beckett's dramatic writing. There was no fleeing, hyperventilating, or having to convince another character on stage about their pain, suffering, and legitimacy as an asylum seeker. Instead, by depicting characters who were all refugees, in a narrative written by a refugee writer that was set outside of border scenarios of immediate exile, the play attempted to shift the discourse away from border crosser versus border monitor scenarios.

A considerable amount of refugee theatre is set within this type of border scenario as "flourishing phenomenon"[10] revolving around two representational figures: border crosser and border monitor. In this scenario, the border crosser "must convince his or her audience (and monitor), even for just one moment, of a particular truth."[11] Further, in this narrative, "[…] one of the characters must argue their credibility."[12] The dramatic conflict is realized in the moment of opposing views, where a figure is seeking entry and a figure is exercising denial. Such scenes are often centred on the rhetoric of humanitarianism and citizenship. This type of refugee theatre allocates a gaze, a social positionality, and thus specific subject characteristics, based on imperial power dynamics. The refugee is relegated to a passive role in this dynamic reduced to "helpless objects one is encouraged to protect and to whom one should be charitable."[13] This was demonstrated by the other performances that night which reproduced a narrative that I myself had, in many other instances, also been expected to perform; expectations that anticipate portrayal of refugees as easily consumable,

non-threatening, and vulnerable subjects, "caged within a depoliticized humanitarian space"[14] as a passive, self-apologetic voice in the national space, rather than a force that can galvanize social commentary and political engagement. This positioning and identifying of refugees, I argue, also disrupts the staging of the complex, multiplicity of refugee narratives that exist within Australia, but are not seen on its stages.

Asylum seekers and refugees have travelled to Australia through various modes and temporalities, from maritime to air arrivals, and in modern times, from the 1970s to present day, 2016. We speak a multitude of languages, our roots stem from wide-ranging and geographically distant parts of the globe. We have experienced, directly or generationally, the ramifications of ongoing colonialism, implicated in the expansion of the imperial global order and forced into exile through war. Some of us, as arriving refugees, have been locked up in one of Australia's onshore or offshore detention centres, while others have been held under community detention. Others have arrived through humanitarian programs. Some identify as humanitarian exiles, others as political exiles. We are not all located in the same area of the political spectrum, nor do we often agree with one another in response to political or social issues.

I locate myself, primarily, as a theatre-maker, who does facilitation work within the large and diverse refugee and asylum seeker community in Melbourne,[15] and the absolute minimum required for this type of work is to listen in order to understand the specific needs of each component of the community. Despite the resonances and subsequent understanding of components of refugee journeys and refugee narratives, my lived experience from the late 1980s Central America is very different from the narratives of exiles from the Horn of Africa, South East Asia, or the Middle East. The diversity within refugee and asylum seeker communities is something I have experienced and observed through my community practice, but not necessarily seen on stage, which is why I wanted to bring *Three Angry Australians* to the ASYLUM season. This multiplicity of experiences and perspectives is why the characters in the play are not assigned names, but rather are identified by a geometric shape. I did not want to refer to a particular ethnicity, temporal exile, or narrative. I also hoped that not naming my characters was in itself a critical interrogation of the very premise of what constitutes an "Australian" versus being a person with a "foreign" name. Furthermore, unlike the other plays presented, the characters in *Three Angry Australians* spoke in an Australian accent rather than an arbitrary "foreign" accent.

Border scenarios have the tendency to frame "new immigrants as outsiders until shown otherwise,"[16] until they perform their credibility to other characters and/or the audience itself. Thus performances become a way to frame narratives in such a manner as to convince rather than challenge dominant discourse. *Three Angry Australians*, despite making the audience privy to usually hidden discourses, never conveys to the audience how or why the characters came to be refugees. Actively refusing to do so through the writing process, I sought to avoid a performance of credibility. I wanted to convey instead the fact that as refugee and asylum seekers, we are subject to constant interrogation.

SQUARE:	(*Reading off e-mail*) "So what I need from you is to get in contact and find multiple, different refugees. Ta."
CIRCLE:	(*Sarcastically*) What an innovative idea.
TRIANGLE:	Come and exhibit our individual faces and names. So that you can really understand that we are human. How sickening.
SQUARE:	The more painful the story the better. It's like *Australian Idol*.[17]
TRIANGLE:	It's a selfish, masochist intent to want to hear our story for the sake of hearing it.
CIRCLE:	Portrayals between the victim and survivor.[18]

Three Angry Australians was not about convincing, but rather about offering an insight into characters behaving in a space that they considered safe. As SQUARE says, "So grateful to have this space. I can't talk like this out there."[19] The character is referring to the exhaustion and continued performance of credibility in daily life, in which one has to argue and justify one's existence on a constant basis if one doesn't fit the mould of what an Australian is supposed to look like. I have experienced this phenomenon on countless occasions. As Jeffers mentions, a majority of refugee theatre is created and performed with the purpose of raising awareness as well as changing the attitudes of the community in which refugees settle.[20] *Three Angry Australians* attempted to stage this struggle, focusing on voices from the community, rather than voiced through think tanks and academics. It was not about speaking to notions of host community, but playing with these social categories. This play wanted to centre the voices of refugee and asylum seekers and stage a different type of conversation and refugee dramaturgy, one in which characters didn't have to demonstrate credibility.

With the good intention of highlighting a particular cause, non-refugee theatre-makers impose characters and power dynamics that manage refugee and asylum seeker voices, a ventriloquism of theatre professionals who don't identify with the nuanced struggles of that particular community. This is something the three characters are acutely aware of:

(*Beat. The sound of the protest begins again, quietly at first, but grows increasingly louder.*)

SQUARE:	"Please see below, a three-part photography workshop that has reserved a number of FREE places for refugees/asylum seekers in detention (particularly youth). If you could kindly share widely that would be much appreciated, and feel free to contact me with any queries."
CIRCLE:	"To whom it may concern, just following up on our member," (*To others*) not client, "you referred…"
TRIANGLE:	"Does your organization have endorsement as deductible gift recipient under subdivision 30-BA of the Income Tax Assessment Act, provide details below."
CIRCLE:	From whom?

SQUARE: International Solidarity Network, Melbourne.

CIRCLE: I'd be careful with the Solidarity Network doing this. I suspect they will use it to promote themselves.

SQUARE: What do I respond?

TRIANGLE: Nothing.

CIRCLE: Argh, what time did this thing start? You think it would be over by now?

TRIANGLE: Fortunately we don't have to reply.

SQUARE: 1 pm, I think. You going later?

TRIANGLE: No. Applying for the three-year organizational grant from Moss & Meg.

CIRCLE: Who organized it? The socialists?

SQUARE: Not sure.

CIRCLE: Let me see. (*Looks up the information on the computer. Moment of silence.*) Yep.

ALL: Arghhh.

TRIANGLE: The worst. I guess I'll just spend more time on this grant and get it done by today. This is my protest.

CIRCLE: If there was a refugee organization associated with it maybe, but not if it's just them. "Free, free the refugees," sounds so condescending when they say it like that.

TRIANGLE: Either way, I don't have the luxury of going out to the streets with a bunch of hipsters looking for a temporary cause.

CIRCLE: Write grants, upskill our community, deliver a foodbank, keep up to date with developments on the issue. We go and study, work with community. Even getting a PhD is part of our political struggle. This is the unglamorous side of political activism. Noodles anyone? (*Holds up a packet of two-minute noodles.*)

.....

CIRCLE: (*Continues to talk from kitchen.*) People like to demonstrate to demonstrate support, but care is useless and in some cases even counterproductive. Care can mean anything and nothing. Like sympathy: what am I supposed to do with your sympathy? I'd prefer resonance.

TRIANGLE: Keyboard warriors.

CIRCLE: Well, the hardest working people I know working in this industry are not at this protest.

TRIANGLE: Nor do they win "multicultural awards" or ambassadorships. Congratulations for being brown. Here is an award. Look what an accepting nation we are. Our protest is in the work we do.

SQUARE: What if these people have good intentions but don't work in the field and have no way to show it?

TRIANGLE:	Pppft. Anyone can have good intentions. Some people really need to stop having good intentions.
SQUARE:	So to protest, you have to completely dedicate your life to that particular issue? Work or be part of community? Is that humanly possible? There are so many issues out there.
TRIANGLE:	Better to choose one and do it well than to just hold a megaphone.
SQUARE:	All social issues are connected though.
CIRCLE:	Doesn't mean one needs to feel they have to always say something for each. Knowing privilege is knowing how much space you already take up. I'd be interested in seeing how many members of our community are at that protest though.
TRIANGLE:	Our existence is a protest. To go to a protest like that (*Points outside to the ongoing protest*) is to exhibit oneself and to go to a parade.
SQUARE:	That's a bit harsh.
CIRCLE:	"There are men who struggle for a day and they are good. There are men who struggle for a year and they are better."

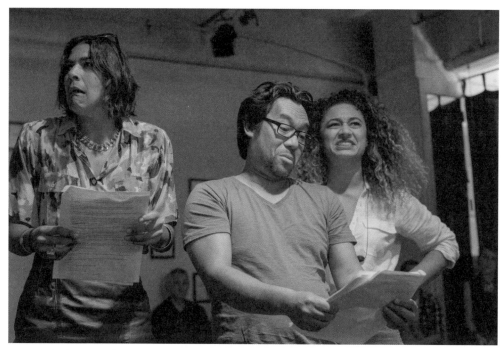

Figure 2: (L-R) Rani Gardner, Felino Dolloso, Emily Havea in *Three Angry Australians* in Sydney, Australia, 2015. Photo credit: Robert Catto.

TRIANGLE:	For some it's an afternoon, for others it's a lifestyle.
CIRCLE:	"There are men who struggle many years, and they are better still. But there are those who struggle all their lives: These are the indispensable ones." Bertolt Brecht.
TRIANGLE:	We should tweet that.
SQUARE:	"There are men..." (*Writing a tweet.*)[21]

The Characters: Refugee Versus Refugeeness

Three Angry Australians was staged simply, with the three actors facing the audience, standing in a line, wearing high-heeled shoes or sneakers, large gold necklaces, chunky rings, and brightly coloured clothing.

TRIANGLE:	If I join that protest; they'll probably look at my sneakers and flat cap and assume I've sold out. It's ok for them in ripped shirts and dreads. Just cause I dress up doesn't mean I'm not struggling or working for the cause. As people of colour and refugees we navigate differently. White people just don't know how to read it. They think it looks like that. (*Points to an audience member in the front row.*)[22]

This assertion highlights a performativity that these characters working in an NGO aid and advocacy organization are aware of, particularly with the protest happening outside. All three characters are aware that their dress is in direct contrast to what the refugee pain narrative demands. As SQUARE states, "the more painful the story, the better. It's like *Australian Idol*." Performing the personal plays into a performance of credibility, in that it attempts to capitalize on authenticity, the truthful story, in order to demonstrate the individual's inclusion in state-sanctioned citizenship through stage-sanctioned performances. The dramaturgy of performances of credibility requires the inclusion of innocent and traumatized characters in order to garner sympathy from the audience,[23] stuck in a binary that romanticizes exile, through individual notions of victimhood and heroism. This perpetuates a dynamic in which we remain a passive, self-apologetic voice in the national place rather than a galvanizing force utilizing social commentary, and involved in acts of political engagement. In *Three Angry Australians*, however, the three characters are passionate yet realistic, dedicated yet overworked, optimistic yet angry, and they are further identified as people of colour, refugee-Australians, directly challenging the notion that such identities are mutually exclusive. Each character has a voice that speaks fiercely, angrily, and politically in the present tense. As the scene progresses the audience becomes increasingly privy to the raw discourse that happens after the phone is put down and that e-mail is sent, in all its rage, political incorrectness, and resistance.

CIRCLE:	Another e-mail looking for arts project participants. Everyone wants to do a refugee project now.
TRIANGLE:	Like how everyone used to want a gay friend. Now everyone wants a brown friend. Now what's in vogue is a refugee friend to take around to parties. A refugee project! Wow!
SQUARE:	"Some of my best friends are …"
TRIANGLE:	Congratulations, you organized one refugee-themed event and have x number of refugee friends. Now you can never be called a racist, ignorant person again.
CIRCLE:	Funny how these projects are always *for* and not *with*.
SQUARE:	I don't think people get that minor detail.
TRIANGLE:	Artists are the worst.
SQUARE:	Even worse than the socialists?
TRIANGLE:	That's a hard one. Yes. At least the socialists know they are being political. Artists think that by waving a paintbrush or pen they'll get away with anything because in the end there is a nice, beautiful, artistic outcome. Regardless of critiques of process.
CIRCLE:	The pen is mightier than the sword, but only if you know how to use it.
TRIANGLE:	The pen can lead to the sword, as our refugee laws demonstrate.

Performances of credibility call upon the entitled membership of those within the dominant Australian narrative to "save" or acknowledge through their self-appeasing consciousness – under the guise of a neutral humanitarianism frame – while essentially reproducing the same power dynamics that systematically silence the multiplicity of voices. The purpose of the performance thus becomes about how to prove and express one's humanity under the paradoxical assumption that if one argues enough they will be given the same privilege within the system that has created the structural violence to begin with. Refugee characters and actors on stage are reduced to arguing our humanity, credibility, and thus our very existence to the politically privileged, under the gaze of, and to the satisfaction and approval of the dominant societal members. The humanity argument can thus become a guise to dismiss politicized ontology and social inequality. *Three Angry Australians* was a way to unpack this behaviour, through characters receiving various e-mails about applying for grants for arts proposals:

CIRCLE:	Oh no. (*Reading off computer. The others move closer.*) "I'm currently working on a photographic series. I'm looking for refugees living in Melbourne as their stories are an incredibly important point of view to portray within the series. I won the $10,000 National Photographic Prize earlier this year. I will give the sitter a copy of the portrait to keep. Cheers." (*All wince.*)

SQUARE:	And she called it "a photo project to change Australia." (*All wince again.*)
SQUARE:	What do we respond?
TRIANGLE:	Nothing. We shouldn't have to waste our time.
CIRCLE:	We have to respond; otherwise they'll never understand why.
TRIANGLE:	If they don't know now, we shouldn't have to waste our time explaining the frameworks of self-determination, capacity building, and how her project to "change Australia" is just reinforcing power dynamics.
CIRCLE:	They need to understand why though. That's part of our job.
TRIANGLE:	We are overstretched as it is and don't need such stupid e-mails to waste our time. My responsibility is to the community we are working with, not responding to every hero wannabe, loud mouth occupier of power as it is. I'm not going to contribute to their CV and humanitarian cause-for-the-month.
SQUARE:	We have to respond something.
TRIANGLE:	How about this (*Typing.*) "We are sorry, we do not supply models for art projects. You may like to approach a modelling agency or advertise in the papers?" (*All laugh.*)
CIRCLE:	Send. We should have a policy for responding to e-mails.
TRIANGLE:	We should.
SQUARE:	I could write one?
TRIANGLE:	Put it on the agenda for the next meeting.
CIRCLE:	Junk mail, junk mail, theatre project, junk mail.

Conclusion

> Instead characters here carve new space for existing, one which was not there before.
> –Gad Guterman, *Performance, Identity, and Immigration Law*[24]

Though important and part of a larger discourse, border scenarios do not always go as far as challenging dominant discourse as they remain in the same discursive frame that allocates character subject positions within an imperial dynamic of power relations. This dynamic places dramaturgical demands and determines what stories are refugee enough, struggle enough, and thus worthy of presentation on the theatrical stage. When restricted to border scenarios, refugee and asylum seeker voices become answerable to predetermined frames that leave us as instrumentalized objects, stuck within performances of credibility. This dynamic, in including, actually excludes as the inclusion only occurs under the terms already created. This systematically silences the autonomy, agency, strength, and multiplicity of refugee and asylum seeker voices. In staging the scene outside of border scenarios and dynamics, *Three Angry Australians* sought to prioritize issues of community-driven

self-actualization, outside of colonial, Western, citizenship frameworks. It attempted to challenge border scenarios as a nationalist practice, as an assertion of spatial power from the group with the imperial power to monitor. Performing beyond the border highlights the complexities, power dynamics, and contractions of nationhood. Theatre beyond border scenario dynamics moves beyond dramatizing opposing stances of the immigration debate[25] and focuses more on the navigation of daily life in holding these oppositions. Theatre from this perspective highlights how our identities, as communities in diaspora, shift, change, resist, and reframe. The attention is on demonstrating not how we perform credibility, but refugeeness as navigation: we must tell stories created *due* to exile but not *about* exile. When we challenge the terms of enunciation, we challenge expected ontologies and suddenly have the ability to explore a multiplicity of navigations that confront consumable representations. As refugees, we can be angry, politicized, sarcastic, critical, and we can exist and perform in the present tense. In so doing we explore the potential to seek new dialogic relationships[26] and dramaturgies that "become[s] a site of resistance offering an opportunity for transformations for both speaker and respondent."[27] In so doing we remind ourselves that it is not our responsibility to change our narratives in order to fit into theatre, but rather that theatre must change to accommodate our narratives.

TRIANGLE: They always think that they are doing the discourse a favour with their "new asylum project."
CIRCLE: Sometimes we don't want their help. They don't get that. They even get mad at that. Indignant almost.
SQUARE: Self-determination: autonomy, self-reliance, home rule, self-rule, sovereignty, self-sufficient.
TRIANGLE: We should tweet that.
(*All go back to typing at their computers, silently.*)[28]

Notes

1 Dwight Conquergood, *Cultural Struggles: Performance, Ethnography, Praxis*, ed. E. Patrick Johnson (Ann Arbor: University of Michigan Press, 2013), 34.
2 Bertolt Brecht, *Brecht on Theatre: The Development of an Aesthetic*, ed. and trans. John Willett (London: Methuen, 1964), 14.
3 Tania Cañas, "Untouchable," in *The Voices Project 2013: Out of Place*, ed. Australian Theatre for Young People (Strawberry Hills, N.S.W.: Currency Press Australia, 2013), 17.
4 Walter Mignolo, "Epistemic Disobedience, Independent Thought and De-Colonial Freedom," *Theory, Culture & Society* 26, no. 7–8 (2009): 4.
5 Alison Jeffers, *Refugees, Theatre and Crisis: Performing Global Identities* (Basingstoke: Palgrave Macmillan, 2012), 9.

6 Peter Nyers, *Rethinking Refugees: Beyond States of Emergency* (New York: Routledge, 2006), xv.
7 Mignolo, "Epistemic Disobedience, Independent Thought and De-Colonial Freedom," 4.
8 Gad Guterman, *Performance, Identity, and Immigration Law: A Theatre of Undocumentedness* (New York: Palgrave Macmillan, 2014), 34.
9 Tania Cañas, "Three Angry Australians" (unpublished manuscript, February 2015), 1. Performed as part of Apocalypse Theatre Company's ASYLUM quick response series, Sydney, Australia, February, 2015.
10 Guterman, *Performance, Identity, and Immigration Law*, 13.
11 Ibid., 36.
12 Ibid., 37.
13 Ghassan Hage, *White Nation: Fantasies of White Supremacy in a Multicultural Society* (Annandale: Routledge, 2000), 95.
14 Nyers, *Rethinking Refugees*, xii.
15 I refer primarily to my work at RISE Refugee, Australia's first refugee aid and advocacy organization to be entirely run and governed by refugee, asylum seekers, and ex-detainees. For further information, view the organization website at http://riserefugee.org/, accessed April 11, 2016.
16 Guterman, *Performance, Identity, and Immigration Law*, 44.
17 *Australian Idol* is a competitive reality television show that is part of the international phenomenon of singing talent shows that began with *Pop Idol* in the United Kingdom, and quickly spread to many countries around the world.
18 Cañas, "Three Angry Australians," 5.
19 Ibid., 1.
20 Jeffers, *Rethinking Refugees*, 50.
21 Cañas, "Three Angry Australians," 2.
22 Ibid., 6.
23 Guterman, *Performance, Identity, and Immigration Law*, 36.
24 Ibid., 59.
25 Ibid., 3.
26 Alex Rotas, "Is 'Refugee Art' Possible?" *Third Text* 18, no. 51 (2004): 60.
27 Ibid., 60.
28 Cañas, "Three Angry Australians," 3.

Chapter 3

Exilic Solo Performances: Staging Body in a Movement/Logos Continuum

Yana Meerzon

Exile is strangely compelling to think about but terrible to experience. It is the unhealable rift forced between a human being and a native place, between the self and its true home: its essential sadness can never be surmounted.
 –Edward Said, *Reflections of Exile and Other Essays*[1]

To those who have never been forced to cross the ocean on a boat, or run from occupied territories under airstrikes, the trauma of exile is unimaginable. Paradoxically, one might still seek works of art capable of transmitting the trauma of exile as associated with banishment, loss, physical threat, and life danger, across the borders of a theatrical performance. In this chapter, I analyze four solo performances created by exilic artists that convey this pain of the exilic condition and the aftermath of living in a new world. I argue that the shock of exile has a lasting psychological effect, so much so that often the testimonial word needs to be replaced with silence, and, much like in documentary theatre, the materiality of an actor's body turns into a device for making truth. Actors in an exilic solo performance often "perform both as themselves and as the actual personages they represent. The absent, unavailable, dead, and disappeared make an appearance by means of surrogation."[2] Here, the body of an exilic actor (or "the exilic body" as subsequently called in this chapter) functions as a container of memory and as a canvas to write upon, so one's personal story is revealed through the (in)visible gap between the performer's own body and that of a character.

A container of memory, the exilic body accentuates the performance's fleeting sense of present. Functioning as a kind of time machine, this body reflects the performer's own past, the fictional time of a story, the time of the narration, and that of reception. An example of Schechner's "twice-behaved behaviour," the exilic body helps to turn a document into a public performance.[3] A canvas onto which a new story, the story of making and performing an exilic Self, is projected, it becomes a performative object displayed for the audience's consumption, so the conflict between the autobiographical and the fictional (which such a body evokes) drives the drama of exile forward. The newly created body/character dependence becomes the subject of an exilic solo performance, and hence the focus of this study.

As my philosophical imperative, I refer to Primo Levi's: "those who experienced imprisonment [...] are divided into two distinct categories [...]: those who remain silent and those who speak."[4] By analogy, I examine the aesthetics of an exilic solo within the movement/logos continuum, which approximates movement-based performance to the work of silence, and logos-based performance to the work of speaking, both being the stratagems of giving a testimony.

MOVEMENT	←------------------	------------------→	LOGOS
↓	↓	↓	↓
Aesthetics of physis: movement-driven solo	*Aesthetics of (con)fusion:* movement/media-driven solo	*Aesthetics of translingualism:* movement/logos-driven solo	*Poliphonie d'écriture:* logos-driven solo
Josef Nadj	Akram Khan	Anita Majumdar	Wajdi Mouawad

Figure 1: The Movement-Logos Continuum as expressed in the work of Nadj, Khan, Majumdar, and Mouawad.

Similarly to Kirby's model of the not-acting/complex-acting phenomenon,[5] the movement/logos continuum places movement-based performance at one end of the spectrum (e.g., dance), and logos-based at the other (e.g., dramatic monologue). The complexity of this movement/logos interdependency is similar to Bakhtin's literary heteroglossia, a conflicted co-existence of distinct narrative voices within a unified literary utterance.[6] On stage, heteroglossia makes the author/character tension visible. It depicts the voice of the author, the voice of the performer, and the voice(s) of the character(s) collapsing into each other, being simultaneously distinct and intertwined. When applied to the movement/logos continuum, Bakhtin's heteroglossia refers to the ontological position of the exilic body on stage, when its materiality is revealed through the intricate matrix of performative codes or interweaving. Such performance, I argue, offers its spectators a chance to better understand – if not intellectually then emotionally – how the social processes of migration, globalization, and cosmopolitanization work. The multiplicity of meanings that the exilic body evokes is rooted both in the performative techniques an exilic artist possesses, and in the stories they tell.

To support this statement, I begin my analysis with Josef Nadj's solo *Last Landscape* (2005), in which this French choreographer of Hungarian origin utilizes his body to evoke the images and the rhythms of his native land.[7] I examine *DESH* (2011) (translated from Bengali as "homeland") created by Akram Khan, a UK-based artist of Bangladeshi descent, as the artist's deeply personal exploration of his family history and two home cultures, British and Bangladeshi.[8] My third example is *Fish Eyes* (2005), created by a Canadian performer, Anita Majumdar,[9] daughter of Hindu Bengali immigrants from India. My final example is the multimedia piece *Seuls* (2008), produced by Lebanese-Québécois artist Wajdi Mouawad, in which he performs himself – the author, Wajdi Mouawad, a Lebanese exile living in Québec – as his character Harwan.[10] This production recognizes linguistic heteroglossia as the defining feature of a second-generation exile's identity and as its major performative principle. When Harwan realizes that he has exhausted the verbal means of communication, he turns to images. Thus, I argue, even in logos-driven performance, at the moments of crisis, when an exilic performer meets their past on stage, it is movement not word that takes over.

Staging Self and Body in the Movement/Logos Continuum

Friedrich Nietzsche suggested that the "I" can begin to account for itself only in the aftermath of trauma. Punishment, Nietzsche proposed, is "the instrument of making memor(ies)."[11] Exilic flight, or the liminal state of in-betweenness, in which second-generation exiles live, functions as Nietzsche's instruments of punishment. These social conditions create punishing or distant gazes that compel an exilic subject to take account of themselves. The primary punishing gaze is the gaze of the exilic subject's own Self, which takes on the role of another, "You," who demands the "I" account for their life journey. The secondary gaze is that of a new society directed at the exilic subject, one that judges whether they can fit into this society or not. The third gaze is the gaze of the performing subject towards themself, now conditioned by the two primary gazes. This third gaze projects the performer's self-doubt and the doubts cast by their audiences. The exile's quest for a new Self is a typical example of the consequences of the third gaze. This quest is a journey of negotiation because, as Nietzsche writes, we become self-reflective "as a consequence of fear and terror."[12] The "I" can acquire a new narrative only because there is the "You" that asks questions. A refusal to provide such an account, the act of silence, becomes a form of resistance.

In the theatre of exilic solo performances, the account of "I" as Self takes place: the performance recognizes Self as relational subject, where the "I" is constructed as not necessary within the "I/You" paradigm, but at the "moments of unknowingness about oneself [which] tend to emerge in the context of relations to others."[13] The complete account of the Self is never possible, unless it takes place in the presence of the sought for and acknowledged addressee; hence, it is always performative. In theatre, this philosophical postulate turns into a dramaturgical challenge, forcing an exilic performer to create new conditions of speaking, necessarily linked to the materiality of the exilic body. This body appears on stage as an empty sign, with the signified and the signifier being equal to each other: the exilic actor's stage presence is revealed through their body, performative techniques, and the gaze of the audience or our own "twice-restored behaviour."[14]

Last Landscape: Josef Nadj's Movement-Driven Exilic Solo Performance

Josef Nadj's dance presents the epitome of exilic theatre. It stages the journey of an exile as the process of introducing and translating the artist's native landscape into a performative metaphor. As homage to his homeland and ancestry, Nadj's works reclaim the terrain, paraphernalia, personalities, and mythology of the artist's childhood. *Last Landscape* presents the dancer's philosophical and practical exploration of the artistic tension between movement and music. Together with composer Vladimir Tarasov, Nadj embarks on making an elaborate portrait of the choreographer "Josef Nadj" within a theatrical landscape of his memories. An empty stage, the space of *Last Landscape* presents a

performative frame for the dancer and the percussionist to explore sounds and sensations reminiscent of Nadj's home. At the back of the performance space, there is a transparent screen, on which the shapes of a bird, a river, and a house are projected. The performance begins with Nadj and Tarasov slowly putting on red clown noses, evocative of birds' beaks, and so the game of sound and movement begins. The sounds of dripping water, dry wind, and birds' singing, summon the world of Nadj's memories. This world is ancient yet fragile; it refers to an abandoned field of clay near Nadj's native village Kanjiža, which used to be a settlement for nomadic tribes. On stage, Nadj evokes the energy of the arid field and turns it into a stream of life, a river of memory; so through his dance and in the spectators' imagination, the neglected clay wasteland of Kanjiža turns into a metaphorical space of rebirth. The dance presents the artist's longing for a past inevitably lost and impossible to reconstruct in the present. As the show proceeds, Nadj takes a position at centre stage, to further explore the artistic potential of dialogue between his dancing body and the soundscape created by Tarasov. Nadj uses sporadic movements and gestures, masks and projections, shadows and changing lights, occasional dialogue and sounds. The images constantly shift; they invite the audience to ponder their childhood places, life and death, loneliness and displacement. In this, *Last Landscape* becomes the choreographer's eulogy to the existential sense of solitude as experienced by a poet, a painter, and an exilic dancer, left alone with his material to create a work of art, to nurture his loneliness through the public display of his dancing Self. *Last Landscape* becomes an illustration of Lehmann's statement that the actor's body acts as a source of potentiality. In an exilic solo, the body does not stand as a physical signifier for a character; it becomes "an *agent provocateur* of an experience without 'meaning,' an experience aimed not at the realization of a reality and meaning but at the experience of potentiality."[15] Here, the previously unknown or hidden energies are released through the body. The body becomes its own message, "exposed as the most profound *stranger of the self*: what is one's 'own' is *terra incognita*." The intensity, vibrancy, and imagistic power of dance helps Nadj express the artistic and historical angst triggered by his exilic voyage. The dancing body transmits the exile's sacred knowledge; it "articulates not meaning but energy, it represents not illustrations but actions."[16] In *Last Landscape*, the body becomes the narrating vehicle itself, with the image of Kanjiža projected by the choreographer onto his body.

The solo ends with a gesture that is somewhat enigmatic, but iconic to Nadj's work: the dancer draws a line across his chest with black paint. The image suggests the act of mapping and commemoration. With this gesture, Nadj imprints the memory of his homeland onto his body. At this moment, Nadj's theatre stresses the ambivalence of "a lived life and its representation."[17] It presents the audience with the subject "Josef Nadj," and the object of his own narration, an exilic dancer and former resident of Kanjiža. Nadj remains forever imprinted within his native landscape, whereas his body becomes this landscape's archive; so the dancer's body, presented as the body of the character, identical to the artist himself, takes on a similar function to the everyday-speech-turned-theatrical-dialogue. It acts as the instance of Schechner's twice-restored behaviour.

DESH: Akram Khan's Aesthetics of (Con)fusion: Movement/Media-Driven Solo Performance

The work of Akram Khan presents a second example of exilic solo performance to be placed on the movement/logos continuum. By shifting the dramaturgy of movement into that of image and space, *DESH* redefines the movement/logos order. Thematically, it builds on the second-generation exile's need to revisit their roots, to rethink them theatrically, specifically if the artist is confused by and ashamed of them.[18]

Born in Wimbledon, London, to Bangladeshi immigrants, Akram Khan presents the very incarnation of the Eastern–Western cultural hybridity, which he expresses through the medium of dance. In *DESH*, this tension becomes the artist's special subject of investigation, with Khan "transforming the landscape of British and global contemporary dance through his own embodied approach to new interculturalism."[19] This interculturalism is as much political as it is embodied. Conditioned by Khan's personal position of "insider–outsider," or diasporic subject deeply seated within the cultural life of the host country, *DESH* rests within the "multiple movement vocabularies from the South Asian dance form of Kathak to the eclecticism of Western contemporary dance with a special emphasis on the genre of physical theatre." This positioning enables Khan "to negotiate within his own body the tensions and potentials of working with and through a body that is fundamentally intercultural."[20] In *DESH*, Khan focuses on deeply personal subject matter: his ongoing attempts to reconcile his father's cultural traditions and beliefs with his own worldviews, a process that Khan sees as universally appealing. Created in collaboration with visual artist Tim Yip, Indian poet Karthika Nair, and British composer Jocelyn Pook, *DESH* presents Khan's journey back to the country of his family origins, and explores his impressions and memories.

At the same time, Khan expects us to believe that *DESH* is "a much more universal story than Bangladesh. At its centre is a child in crisis."[21] An acknowledgement of one's story as simultaneously deeply personal and universal, i.e., applicable to many if not all intergenerational conflicts marking the workings of the exilic families, positions Khan's worldview as unmistakably intercultural and cosmopolitan at the same time. It dictates the artist's search for a performative language that includes and reflects some "microcosmic, personal and embodied starting points," to make his works "more accessible and less threatening to the source cultures."[22] Such orientation to "universal themes" prompts Khan to employ communication devices of "an open-ended corporeal aesthetic that is ambivalent and ephemeral and therefore impossible to fix in its significations."[23] In his referential palette, Khan employs the multilingual landscapes of English and Bengali, mixing the dramaturgical devices of Western and South Asian storytelling.

Much like in Nadj's work, the beginning of *DESH* is driven by movement. Gradually, however, as the performer introduces bits of dialogue, the narration begins to drive the story. It never takes on the leading role, always remaining secondary to movement. On the barely lit stage, the figure of a middle-aged man dressed in *dhoti* trousers and a

white shirt, holding an old-fashioned lamp, appears. He kneels over a small mound, ready to perform what seems to be a ritual of mourning. The first sounds the audience hears are the rhythmical strikes of the sledgehammer: the man bashes the ground as the lighting changes, gradually expanding the action space from a tiny square of the dancer's personal place to the vast area of the empty stage. Suddenly the sounds of the busy city with honking taxis and buses, hurrying bikes, and shuffling feet fill the stage, as Khan begins dancing out the story of his physical and metaphorical returns. The language of Khan's mesmerizing movements is polyvalent. His body is framed through many technologically advanced theatrical lenses that convey the sense of hip, urban culture, in which there is no space for sentiment, personal memories, or feelings. Here a human body, the dancing body of Khan, functions as the retainer of pollution and noises, something into which the ethos of the city centre – be it that of Dhaka, in Bangladesh, or London, UK – immerses its inhabitants. The city hunts the man, pulling and pushing him around; it strips him of any will or identity, turning his body into one more mechanism for making a metropolitan phantasmagoria. On stage, however, there is just the one performer; the images are only suggested for the audience to encourage them to envisage a symphony of urban lifestyle.

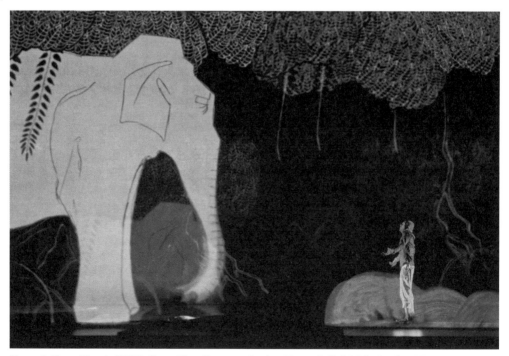

Figure 2: Akram Khan in *DESH*, Akram Khan Company, October, 2011 at Sadler's Wells, London, UK. Photo credit: Richard Haugton.

Through constant oscillations between East and West, *DESH* tells a story of exilic liminality, in which many second-generation immigrants reside. It is an attempt to give the "I" a chance to account for itself, if not in words then in movement; something that prompts Mitra to approximate Khan's restored behaviour to Homi Bhabha's sociological concept of the third space. Khan's version of interculturalism, Mitra explains, "is bound up in questions of the self. Through it he negotiates the tricky terrain between his inherited relationships with Bangladesh and his own embodied Britishness."[24] In *DESH*, in other words, "Khan's body does not just occupy the third space," but becomes it. Khan "rewrites the third space as an embodied and lived condition, and collapses the conceptual segregation of space and body as distinct entities."[25] Unlike in *Last Landscape*, in which the past/present experiences are centred on the dancer's body, in *DESH* the gap between Khan's knowledge of the past, his experience of the present, and his fantasy about the old country is staged in the space of the performance. Khan prefers to keep the gap between his own Self and other characters visible, and insists on them being only masks, which he can freely put on and take off. This mask-like nature of the characters Khan evokes suggests the uncanny promise of the object into which the dancer's body turns; whereas the clear separation between the body of the dancer and the body of the character creates the sense of distancing – the alienation effect – which alerts, not enthrals Khan's audiences.

Moreover, the projections function as extensions of the character's psyche, the stage becomes a special venue for Khan to perform his inner world. At these moments, his body acts as only one possible holder of the actor's Self. In its high degree of intermediality, *DESH* can be regarded as Kirby's "non-matrixed representation," a "condition in which the performer does not act and yet his costume represents something or someone. […] In 'non-matrixed representation' the referential elements are applied to the performer and are not acted by him."[26] As the man enters the fantasy world, he meets a little boy who might stand for Khan's own younger self; then a tank enters the space and sends the fantasy away. In this sequence, Khan's body becomes more than a container of memories: it turns into one of fantastic images, emanating from his imagination. The new bodies invade the stage; they turn into protesting crowds, suggesting the troubled history of Bangladesh. Everything – what took place in the actual past of Bangladesh's history, Khan's father's personal experiences and memories, Akram's knowledge of it – is intertwined in the space of this performance. History, memory, fantasy, and experience become one: collapsing within the dancer's body, the images and the bodies of the others originate in Khan's imagination and return back into it. But it is in movement not word that Khan "finds solace, comfort, and escapism. And ultimately by being immersed in movement he desires to be left alone in order to discover his own sense of self, by navigating his own embodied third space on his own terms."[27]

This sense of being on the move characterizes the new diasporic subjects, who often see themselves as citizens of the world, freely moving between countries, borders, languages, and artistic practices. They create and define the new interculturalism. Similarly to *DESH*, they often feature a story of a child in crisis, continuously negotiating multiple cultures. The new interculturalism comes to manifest itself both as "a life-condition," "an aesthetic and political intervention,"[28] and the exilic performer's twice-restored behaviour.

Anita Majumdar's *Fish Eyes*: Aesthetics of Translingualism: On Movement/Logos-Driven Solo Performance

Anita Majumdar's solo *Fish Eyes* reflects the performer's personal history of cultural imbalances, experienced as she was growing up between her Indian heritage and English Canadian culture. Similarly to *DESH*, *Fish Eyes* evokes a story of the seventeen-year-old Meena (short for Meenakshi, or "fish eyes" in Bengali) from Port Moody, British Columbia, in the Canadian West, expressed through Majumdar's daring performative stylistics, in which the highly codified language of Bharatnatyam classical Indian dance, including costume, music, hand gestures (*mudras*), and movements of the feet, functions as the dramaturgical syntax and performative punctuation to the logos-driven story. *Fish Eyes* imagines its target audience both as the South Asian community of Canada, and as the multilingual and multicultural urbanite spectatorship. Positioned at the middle point of the movement/logos continuum, *Fish Eyes* presents an organic mix of movement/word-driven dramaturgy. Majumdar's acting can be defined as Kirby's "simple acting," when the performer remains themself, not necessarily becoming one with the characters.[29] In *Fish Eyes*, Majumdar's body is more of a canvas: her impeccable technique of switching between characters, using just a single *mudra* or an elaborate sequence of foot-movements, invites a comparison with Cubist painting. In this style, distorted fragments of geometrical shapes come together in an artist's unifying gesture, creating an illusion of the three-dimensionality of a depicted object, while at the same time referencing the two-dimensionality of the canvas itself. Majumdar's body and speech create a feeling similar to this technique: they help the performer compose a story recognizable to any Westerner, while utilizing the conventions of classical Indian dance. Here, the language of dance and the language of words create a complex system of significations – the aesthetics of fusion – related to the autobiographical and embodied interculturalism, from which Majumdar's dramatic universe originates. Although the story of Meena is not strictly autobiographical, it remains tightly connected to the experiences of cultural liminality, through which Majumdar, as a diasporic child, has lived.

Fish Eyes is specifically interesting in that it portrays the journey of an artist, a theatre performer, who through her professional theatre schooling has been forced to rethink the values and the traditions of making performance as she learned them in her childhood. As a student of acting at the National Theatre School of Canada (Montréal), Majumdar recollects that her teachers continuously desired to exploit her skills as an Indian dancer. They openly suggested that Majumdar's creative talents could only shine through dance, and often felt the need to justify casting the young performer in classical repertoire through the lens of ethnicity. For instance, they asked Majumdar to perform and interpret the Shakespearean role of Cleopatra using the techniques of her "exotic" dance.[30] This pigeonholing exemplifies Butler's point that "I" begins an account of itself only under the pressure of a punishing gaze. This reflects the story of Majumdar forced to become a "professional immigrant," performing the story of humiliation and pride, encouraged to fashion the Self as Other.

In this aspect, Majumdar's artistic journey is not very different from that of Nadj, who brought to France the sensibilities of his home culture, and who found himself constantly negotiating between his past artistic preferences and the expectations of his new audiences. In this sense, Majumdar's body, much like Nadj's, functions as the container of her past experiences and a tool to fight prejudice. Through her artistic choices, Majumdar's performance acquires the ability to empower diasporic subjects, whose looks, tastes, and lifestyles, despite their Canadian birthplace, make them marked, vulnerable to the gaze of the Other. This embodied knowledge of one's difference informs Majumdar's artistic choices in *Fish Eyes*. In this, her work is unique: it exemplifies how a theatre artist who is a second-generation Canadian copes with the trauma of displacement, by creating a new theatre language to depict those social encounters and experiences of everyday interculturalism. Majumdar insists on depicting the exclusivity of the South Asian Canadian experience, something that makes the body of a female South Asian Canadian both object of fetish and subject of objectification.

Although very different from Nadj or Khan's language, Majumdar's work also springs from distrust of realistic narratives and the desire to find her own performative vocabulary. Self-distancing through exploration of formal performative elements marks the exilic solo work: in Nadj's case it may be his search for a new partner with whom to dialogue on stage; in Khan's, it may be the artist's exploration of body, space, and image tensions; and in Majumdar's, it is the use of the language of dance that helps her create new metatheatrical narratives. With the focus on the "how" of storytelling, these artists negotiate their and our differences. In *Fish Eyes*, English words are in constant dialogue with Majumdar's hand gestures and footwork. Neither of these media takes over, however, with words being the vertebra of the story, and the movement serving as its performative syntax. The rhythm of dance determines the rhythm of storytelling, which is situated within the collage of spoken text and movement, and also within the performer's body. Majumdar's breathing (a bit faster when she finishes the dance sequence), her switching between Hindi, Hindi-accented English, and standard Canadian English, her balanced postures (from quick and precise moves in dance sequences to slower and less defined choreography in the speaking parts): all these signifiers of the embodied experience simultaneously become the strokes, the touches, and the nuances of this multidimensional and densely populated genre painting, coming alive through the exilic performer's refinement of the techniques of Indian dance.

Furthermore, such on-stage behaviour mimics the mixed language codes immigrants routinely use to communicate within their ethnic communities, freely mixing the lexicon of their second language with the syntax of their first. *Fish Eyes* picks on this linguistic idiosyncrasy and makes it its performative and dramatic point of departure. In its on-stage heteroglossia of movements and words, *Fish Eyes* reflects the translingual practices of immigration, based not necessarily, as Canagarajah argues, on the interlocutors' grammatical (in)ability, but rather on their "performative competence, that is, what helps achieve meaning and success in communication."[31] The translingual practice occurs in what Canagarajah calls contact zones of communication, which appear in those spaces of contact

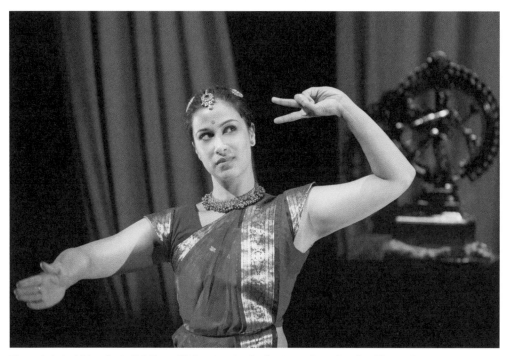

Figure 3: Anita Majumdar in *Fish Eyes*, a Nightswimming Production at Great Canadian Theatre Company, October, 2014, Ottawa, Canada. Photo credit: Andrew Alexander.

where "diverse social groups interact."[32] Such contact zones can be found both on the streets of multicultural Canada and on stage, when the languages that make up an exilic artist's lingo meet and interact in the performative gesture of communication. In its communicative practices, translingualism, Canagarajah further explains, "transcends individual languages" and "involves diverse semiotic resources and ecological affordances."[33] The first condition of translingualism implies that languages are never at war with each other but in a productive dialogue, so "the meaning does not arise from a common grammatical system or norm, but through negotiation practices in local situations."[34] The second condition relies on our mutual agreement that "communication involves diverse semiotic resources; language is only one semiotic system among many, such as symbols, icons, and images."[35] All these systems work to create meaning; they are deeply embedded in "a social and physical environment" from which they come and to which they refer.[36] Majumdar often substitutes her dialogue with hand gestures, which often work as her characters' "native language," whereas the English words they speak function as their second one. Accordingly, the hybridization of Majumdar's theatrical language takes place first within the space of her performing body, then in the space of the show itself, and finally on the page. In the published version of the script, this is demonstrated with stage directions like "*kalyani aunty dances a short phrase to emphasize*

her point," and "*Meena's foot work moves her into a fantasy dreamscape*,"[37] serving not only as evocation of the authorial voice through the stage directions, but also as indication of changes in the story line, which itself often jumps in time and space, from the realities of Meena's day life and dance practice to her fantasy world, inspired by Bollywood films.

To summarize, in the hybrid aesthetics of post-exilic performance, Majumdar's case is not that different from Khan's, both of whom demonstrate how the new generation of twenty-first-century artists, the artists/nomads, and the artists/cosmopolitan citizens, is created. Recognition and appreciation of her roots, the sense of inner dignity and pride come to Meena through dance itself. Accordingly, it is not by chance that the statue of Natraj, a representation of the Hindu God Shiva, a powerful cosmic dancer, occupies centre stage in this performance, and is its only symbolic object; for it is into this image that Meena will transform at the end of her spiritual and artistic journey.

Seuls: Wajdi Mouawad's *poliphonie d'écriture*, or Logos-Driven Solo Performance

A logos-driven solo, Wajdi Mouawad's *Seuls* explores the polyphonic possibilities of stage-writing, emphasizing the experience of the real. It equates its author with its fictional character not only because it was conceived, directed, and performed by Mouawad himself, but because it discloses the imaginary signposts of this artist's creative homeland and references.

Much like with Nadj, Khan, and Majumdar, exploring the condition of non-belonging is Mouawad's artistic signature. Focusing on exilic children's creolization of Self, pursuit of family narratives, and discovery of linguistic and cultural heritage, Mouawad dramatizes exile as a longing for return. When searching for origins, it is the path not the discovery that becomes more important.[38] *Seuls* illustrates this gesture of seeking; it investigates the protagonist Harwan's routes of return to self by stripping him of linguistic proficiency. Silence becomes his refuge, whereas painting turns into a major device of self-expression. The show ends with a 30-minute "monologue of silence," with Mouawad frantically covering his body and the stage with paint. The symbolism of this finale comes from the complex plot, based on the dramaturgical principles of the mirroring effect. As Preston explains,

> The work's title provides a key to the performance. *Seul*, without an "s" translates into English as the singular adjective "alone," but Mouawad makes the word into an uncommon plural ("Alones"). The performance's uncanny encounter between theatre and painting celebrates theatricality as a medium and sensation as a conduit for self-knowledge.[39]

The play opens with Harwan desperately trying to finish his doctoral thesis on the topic of the sociology of the imaginary. We see him procrastinating in his isolated bachelor apartment, with an old-fashioned telephone serving as his personal connecting device to the world of his family and today's Montréal. The thesis is dedicated to the analysis of the functions of the imaginary in the theatre of Robert Lepage.[40] Harwan's thesis is the core

reference within the play: if he figures out the conclusion of this work, he will understand something profound about his own existence. To finish his research, Harwan must travel to St. Petersburg, Russia, where he intends to meet Lepage for an interview. However, prior to his departure he learns that his father has fallen into a coma. His visit to his father's hospital room results in a series of revelations. Preston writes,

> In his father's hospital room, Harwan unleashes a one-sided confession of private resentments in the family drama. He recalls their flight from Lebanon during the civil war and his father's changed behavior in Montréal. He wishes aloud that when the family left, his father had thought to pack a small suitcase with childhood things, paintings, colors, and brushes. Attempting to address his father in his first language, Arabic, Harwan stumbles and fails to make complete sentences.[41]

In *Seuls*, however, this intergenerational conflict typical to immigrant theatre results in an unexpected twist, with Harwan (and after him the audience) suddenly realizing that in this play's world of distorted reflections, it is not Harwan's father but Harwan himself who is lying in coma, due to a stroke he suffered during his journey to St. Petersburg.

Here, much like in *DESH*, the metamorphosis is complete, but takes on an ironic twist: Harwan, much like Akram, is pushed to step into the psyche of his own father. In *Seuls*, as in *DESH*, this dramatic gesture signifies that the exilic circle is bound to repetitions, so the exile's past will haunt their children's present. Harwan's earlier inability to communicate in his native language functions in this narrative as a foreshadowing of his ultimate tragedy, his loss of vision. Harwan's blindness traps him within the childhood trauma, so his post-exilic body not only becomes the physical container of his memories, but also turns into the mausoleum of his Self. In the play, however, Mouawad transforms Harwan's frailty into an engine of creativity. Silence is Harwan's only option as a means of completing his research into the imaginary. Painting is the device he must utilize to transmit testimony. This metaphor can be read further as Mouawad's fear of and reflection on the state of exile in general, traditionally accompanied by the exilic subject's loss of their ability to freely and adequately express themself through language. Physical gestures and facial expressions become this subject's linguistic idioms; with an exile looking into the mirror of the Self, unable to construct and complete the account of the "I" in the language that the "You" follows. The return home, to the Self, can be sought actively, but never fulfiled, with the exilic subject being lost within the multiple mirrors of broken promises, failures, and qualms. Here, the mirror metaphor is further explored through the dramaturgical and visual references to the famous painting, *Prodigal Son* by Rembrandt. Mouawad complicates this reference further, positioning this image next to another biblical story and another painting by Rembrandt, *Sacrifice of Isaac*. Preston writes:

> Performing a kind of patricide, the son in Mouawad's performance reaches up and cuts into the father's projected body, climbing into the painting. Harwan, already a kind of effigy, climbs into his likeness within the work of art, and he freezes, as though partially born.[42]

These reflections continue to multiply. Visually, Mouawad uses the backdrop frame of his stage, a screen, as his prop, and as a conceptual metaphor. Shaped as a rectangular three-part frame, the screen serves as the place of projection to evoke references to Rembrandt, the images of an apartment window, a movie shot, a photo booth, an Internet page, and, finally, Harwan's stage-painting. Most importantly, it exhibits multiple projections of the author-performer himself, questioning the idea of the real and of the twice-restored behaviour. This sometimes nauseating structure of mirroring reflections identifies not only the effect of postmodern simulacra, but also some major tendencies in the aesthetics of exilic solo performances, which tend to focus on the recurring patterns of meaning. In *Seuls*, this search for mirror structures turns into Mouawad's device for reaching the unconscious, the dream state. This state, in turn, provides his character with an escape from the irresolvable dilemmas of reality, from the fact that the exilic identity is forever split, and that there is no possibility to reach beyond it: ignorance of one's native tongue and an absence of memories lead to an excessive imaginary.

Positioned within the movement/logos continuum, *Seuls* makes extensive use of Mouawad's poetic language. At the same time, it reveals deep interdependence between the exilic body and the exilic word. It appears, if somewhat paradoxically, that in order to tell the story of spiritual blindness and loss, Mouawad must rely on the intricacy of the plot and the complexity of the verbal expression, despite the fact that at the end, the word fails the character. In *Seuls*, Harwan is on a personal quest for a language of expression that can adequately articulate his psychological dilemma. The action here takes place in the complex dialogue between a writer and his fictional world, as well as between the performer and his audience. The play ends rather prophetically: the act of stage-painting allows Mouawad to enter the space of metaphor, literally, the space of Rembrandt's masterpiece. Deprived of an opportunity to "speak back," Harwan makes a visual testimony, thus going from the highly idiosyncratic ways of self-expression in logos to something more universal: speaking in images. This leaning towards the visual as the aesthetic dominant in a theatrical performance illustrates the tendency for exilic performative deeply embedded in Mouawad's work. Mouawad attributes the healing power of communication to a performative speech act. In *Seuls*, he assigns to painting the power of the bystander's testimony when a written memoir gives in to visual utterance.

Conclusion

As the chosen examples demonstrate, often exilic solo performances present instances of a new theatrical interculturalism, in which the artist's personal trauma of displacement, imbalance, and confusion is presented as both problematic and pleasurable. Here, the work of on-stage heteroglossia and interweaving creates "the state of in-betweenness into which the performance transfers its participants," and it "allows them to anticipate and experience a future."[43] The movement/logos continuum reveals the designs of performative interweaving; it allows testimony to take place. An exilic solo provides the power of movement to act as

silence, and offers the power of logos as a chance for an encounter, so that an exilic artist can accept the state of difference as norm, and their spectators can experience a moment of stillness, a moment of reflection, inviting us to confront the stranger, the exile, within us.

Notes

1. Edward Said, *Reflections of Exile and Other Essays* (Cambridge: Harvard University Press, 2000), 137.
2. Carol Martin, "Bodies of Evidence," in *The Drama Review* 50, no. 3 (2006): 10.
3. Ibid.
4. Primo Levi, *The Drowned and The Saved*, trans. Raymond Rosenthal (New York: Vintage International, 1989), 121.
5. Michael Kirby, "On Acting and Not-Acting," *The Drama Review* 16, no. 1 (1972): 3–15.
6. Mikhail Bakhtin, "Discourse in the Novel," in *The Dialogic Imagination: Four Essays*, ed. Michael Holquist (Austin: Texas University Press, 1981), 252.
7. *Last Landscape* was commissioned by D'jazz à Nevers. Co-produced by Centre Chorégraphique National d'Orléans, Festival d'Avignon, and Emilia Romagna Teatro Fondazione (Modène). It was performed on July 11, 2005 at Festival d'Avignon.
8. Directed, choreographed, and performed by Akram Khan, *DESH* opened in September 2011, at the Curve Theatre in Leicester, UK, with a following presentation in London, UK, at the Sadler's Wells.
9. *Fish Eyes* was presented at the André Pagé Studio at the National Theatre School of Canada in 2004. Directed by Kate Schlemmer and choreographed by Anita Majumdar. It was further developed by Brian Quirt under the Nightswimming Theatre development program, and toured to the Great Canadian Theatre Company, Ottawa, 2014.
10. *Seuls* was created by Le Carré de l'Hypoténuse, and co-produced by l'Espace Malraux Scène Nationale de Chambéry et de la Savoie, Grand T Scène Conventionnée Loire-Atlantique, Théâtre 71 Scène Nationale de Malakoff, Comédie de Clermont-Ferrand Scène Nationale, Théâtre National de Toulouse Midi-Pyrénées, and Théâtre d'Aujourd'hui, Montréal. It premiered on March 4, 2008 in France.
11. Judith Butler, "An Account of Oneself," in *Judith Butler in Conversation: Analyzing the Text and the Talk of Everyday Life*, ed. Bronwyn Davies (New York: Routledge, 2007), 21.
12. Ibid., 22.
13. Ibid., 29.
14. Richard Schechner, "Restoration of Behavior," *Between Theater and Anthropology* (Philadelphia: University of Pennsylvania Press, 1985), 35–116.
15. Hans-Thies Lehmann, *Postdramatic Theatre*, trans. Karen Jürs-Munby (London: Routledge, 2006), 162–63.
16. Ibid.
17. Deirdre Heddon, *Autobiography and Performance* (Basingstoke: Palgrave, 2008), 4.
18. Akram Khan, "COLLABORATION," Keynote Address for ISPA Congress at The Times Center, New York, January 11, 2011.

19 Royona Mitra and Akram Khan, *Dancing New Interculturalism* (Basingstoke: Palgrave Macmillan, 2015), 10.
20 Ibid., 23.
21 Michael Crabb, "Akram Khan Searches for Himself in Desh," *thestar.com*, October 28, 2013. To view full article, go to http://www.thestar.com/entertainment/stage/2013/10/28/akram_khan_searches_for_himself_in_desh.html, accessed March 22, 2016.
22 Mitra and Khan, *Dancing New Interculturalism*, 23.
23 Ibid.
24 Ibid., 92.
25 Ibid., 101.
26 Kirby, "On Acting and Not-Acting," 4–5.
27 Mitra and Khan, *Dancing New Interculturalism*, 105.
28 Ibid., 11.
29 Kirby, "On Acting and Not-Acting," 6–7.
30 Anita Majumdar, personal interview with Yana Meerzon, Toronto, December 27, 2015.
31 Suresh Canagarajah, *Translingual Practice: Global Englishes and Cosmopolitan Relations* (London: Routledge, 2013), 32.
32 Ibid., 26.
33 Ibid., 6.
34 Ibid., 7.
35 Ibid.
36 Ibid.
37 Anita Majumdar, *The Fish Eyes Trilogy* (Toronto: Playwrights Canada Press, 2016), 12, 14.
38 Wajdi Mouawad, *Seuls: Chemin, texte et peintures* (Montréal: Leméac, 2008), 17.
39 V.K. Preston, "Imag/ing Theatre in Wajdi Mouawad's *Seuls*," *TheatreForum* 35 (2009): 18.
40 Robert Lepage (1957–) is an internationally known theatre actor, director, and writer from Québec.
41 Preston, "Imag/ing Theatre," 18.
42 Ibid., 19–20.
43 Erika Fischer-Lichte, "Interweaving Cultures in Performance: Different States of Being In-Between," *NTQ* 25, no. 4 (2009): 401.

Chapter 4

Foreign Bodies in the Performance Art of Jorge Rojas: Cultural Encounters from Ritual to Satire

Elena García-Martín

Much of the attraction of Jorge Rojas's performance art resides in its multifaceted, complex, and, one might argue, contradictory approaches both to Mexican culture and culture in general. Since the age of six, when his family left his native Mexico for the United States, he has moved frequently and taken every opportunity to return to his homeland. Rojas was born in Morelos, Mexico, educated in Fine Arts in San Miguel de Allende, and transplanted to his current residence in Salt Lake City, Utah via New York City, where he lived, curated, and created for many years. His life and work have undergone a constant movement that informs his sense of home, foreignness, and exile: "My exile was my family's exile; […] moving back-and-forth between Mexico and the US happened every four or five years until I began doing it on my own; until it became who I am."[1] Each change in location, culture, and space has been embraced by the artist as part of a fluid sense of identity, an in-betweenness[2] that has led him to make virtue of necessity:

> I am a "Foreign Body" in every sense of the word. I am a foreigner in the US and a foreigner in my own country of Mexico […]. Somewhere along the way, I realized that moving was an opportunity to observe each country and its cultures more objectively, from an outsider perspective. This is a valuable thing for an artist. Being an outsider has offered me a critical and creative freedom that I wouldn't have otherwise.[3]

His work reflects precisely this position of oscillation between homelands as it shifts incessantly in focus and style, often within a single work, in ways that complicate his position of enunciation.[4] Rojas's foreignness and his awareness of both cultures allow him to adopt a processual attitude towards subjectivity, communication, and artistic creation. As he observes in one of his artist's statements, cultural taboos, social interaction, and communication systems are important topics in his work

> […] as he relies on the exchange between himself and others. He constructs environments where communicative and social encounters can occur. By examining the relationships between artist, viewer, and art work, Rojas explores how we communicate, how we perceive one another, and why we adopt and play out certain roles within our societies.[5]

In effect, the discourse of the artist in exile, understood as living between two homelands and feeling foreign in both, has the virtue of producing a communicative bridge with audiences in all settings and contexts, a dynamic exchange between spatial transition and

cultural transaction that, at the same time, contributes to the construction of the artistic subject as a subject in-between.

Rojas's experience as artist, curator, and educator has broadened his conception of the artistic space, leading him to perform in art galleries, universities, public schools, streamed media, the wrestling ring, and museums on both sides of the US/Mexican border. Parallel to Rojas's fluid conception of space, runs his notion of the performance process, which for him entails questioning familiar distinctions: tradition and innovation, intimacy and exhibitionism, cultural-specificity and universality. In sum, his performance art derives strength from the fluidity and indeterminacy of the foreign body, from the playful interplay between presence and embodiment, and from the dynamics of knowledge production and exchange. Rojas describes his creative process as a kind of cognitive investigation: "My motivation is learning, experimenting, and letting myself feel; we should allow ourselves to feel, cry, laugh […]."[6]

His performance pieces often combine Mexican cultural themes that range from cosmopolitan to pre-Hispanic topics, and that question notions of nation, tradition, and identity. Rojas's performance style effectively transforms space as it produces shifting cultural identities, allowing him to exist as both a citizen and an exile simultaneously. I will focus here on the nature of the socio-cultural exchange that takes place in two specific performances: *Tortilla Oracle* (2009), and *Lucha Libre* (2008). In both pieces, Rojas manages to challenge audiences' expectations on both sides of the border as he lures them into sharing the artist's own empowering experience of an exilic culture situated between the home and the homeland. The varying challenges presented by each individual audience, whether Mexican or North American, condition Rojas's approach and point of entrance into each performance without altering his position as a fluid artistic subject, conscious of his position in-between. As a performing body, far from impersonating a "foreign" Other, Rojas moves fluidly between cultural grounds – from the space of Mayan divination to that of Westernized meditation, and from Mexican *lucha libre*[7] to Western puppetry and international wrestling – he positions himself dialectically and strategically between cultures. Both, *Tortilla Oracle* and *Lucha Libre* underscore the cultural aspect of Rojas's upbringing and his awareness of the artistic process: "I am very much aware of where I come from, my cultural background plays a great part in what I do and who I am. It empowers my art."[8]

Through his performative style, Rojas achieves a unique brand of interculturalism that is made possible thanks to his dynamic sense of embodiment, presentness, and receptivity in exchange with the audience. What at first sight may appear as an ambiguous or contradictory attitude towards culture may be better termed, using Lo and Gilbert's description of theatrical intercultural encounters, as a "two-way flow:"

> In our model […] both partners are considered cultural sources while the target culture is positioned along the continuum between them. The location of the target culture is not fixed: its position remains fluid and, depending on where and how the exchange takes place, shifts along the continuum.[9]

Foreign Bodies in the Performance Art of Jorge Rojas

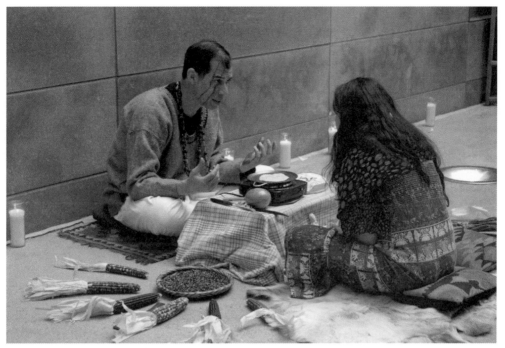

Figure 1: Jorge Rojas in *Tortilla Oracle* with unidentified participant, The Hemispheric Institute's 9th Encuentro, Concordia University, Montréal, Canada, 2014. Photo credit: Amélie Brindamour.

In this model, which closely relates to the "double-swing model" of interculturalism introduced by Muneo Yoshikawa, communication is understood as an infinite process where both parties change in the course of the communicative interchange. The dialogic nature of the exchange, which assumes a respectful and transformational transaction in which both interlocutors participate, is foregrounded by the shifts in performance spaces, but also and more importantly, by the performance scripts, which are built upon audience participation and by Rojas's identification with and embodying of both the culture of origin and the new homeland culture.

Tortilla Oracle, as an individualized divination act, hinges upon the issue the "questioner" (an audience member) wishes to pose to begin the performance. The process and the forms of meaning production and interpretation of the performance are inspired by the symbolic importance of corn in Mexican culture, emphasizing the exchange and intimacy of the individualized encounters:

> I invite the questioner to do a brief meditation and focus on a particular question that he/ she wishes to ask of the oracle. They then pick a tortilla and place it on a hot pan[10] [...] I have devised a system for interpreting the marks on the tortilla. The center of the

tortilla represents the material world, and the circumference represents cosmic forces at play. The first side of the tortilla deals with the past as it enters into the present. The second side deals with the present as it enters into the future. At the end of the reading, participants eat their tortilla as a way of internalizing the experience. The most important things for me are sticking to my methodology, being present, staying open to the process and trusting my intuition.[11]

Clearly, the direction of the performance depends in great part on the degree of complicity of the participant, who may view the reading either as a theatrical, rehearsed act in which Rojas's body functions as a semiotic entity (as a represented, theatrical character), or else as an epistemological event in which Rojas's shamanic body is understood phenomenologically (as a physical, mediating body).

Though the performance lays no claims to authenticity and takes place in environments that tend to foreground the *constructed* rather than the *real* character of the oracle – performance festivals, museums, art galleries – there is no question that audiences have fluctuated in their responses, ranging from reluctance to utter abandonment. Rojas mentions, for instance, that he has been surprised by participants giggling unexpectedly, or sobbing uncontrollably. He seems to encourage ambiguity and to welcome any attitude as an ideal point of departure. It is evident also from the artist's language that the performance evokes a number of different aesthetic frameworks: the idea of the performer as interpreter, as creator, as shaman, and as perceiver. *Tortilla Oracle* involves ritual and originality, sacred spaces and flowing energies, construction and intuition. Rojas describes the ritual process of the performance:

It begins with creating a sacred space. […] The flow of energies (corn, water, fire, metal, air, intent) is indicated by the marks made on the tortillas. I use corn because I feel a strong connection to it. It carries an ancient history that I can learn and draw from. Being from Mexico gives meaning to that connection. I do a ritual and a prayer to invoke the Corn Goddess/*Madre Maiz* and ask for her blessing.[12]

While his performance methodology clearly evokes Mexican culture and ancient Mayan practices, it also engages with yoga and contemporary uses of meditation; it resonates with existing performance narratives, creating a rich blending of new and familiar elements from which to engage the participants, which facilitates a diversification of points of entry into each piece. Rojas's style offers a constant oscillation of perspectives that afford access to both skeptic and complicit audiences. By allowing a flow between the body as medium of presentation and of representation, and by presenting the potential of humour both as a distancing and satirical element, the artist satisfies the expectations of audiences seeking a ritualized performance as well as those who, looking for entertainment, might be made uncomfortable by its ceremonial dimensions.

The flow of energies in connection with self and transcendence dialogues with performing traditions such as that of Eugenio Barba, who similarly recognizes the role of energy, tradition, and presentness in his own acting style:

> It is the search for a personal technique which is a refusal of all techniques which specialize: a personal technique which is capable of modelling our energies without letting us become frozen in this modelling. It is the search for one's own temperature. [...] The only territory into which I sink my roots is the "country of speed," that tangible and inscrutable dimension which is myself as presence, as a unity of soul – body – spirit, perceptible to others through their five senses. For me, the theatre is the ephemeral bridge which in 'elected' contexts links me to another: to the actor, to the spectator. It is the interweaving of one solitude with another by means of an activity which obliges a total concentration of my entire physical and mental nature. The theatre is the fortress on the mountain, visible and impregnable, which permits me to be sociable while following the way of refusal.[13]

While the juxtaposition of shamanism and Third Theatre[14] reflects more my interest in establishing intercultural associations than any interdependence between Rojas and Barba, the points of divergence between their styles may prove revealing: while Barba conceives of performance as a bridge between isolated bodies unaffiliated with territories, Rojas's performance establishes a bridge between cultures, a flow of exchange, an embodied self that sheds its foreignness, to embrace the interplay of interculturalism. As Rojas invokes the power of *Madre Maiz* to communicate, and prompts the participant to aid in opening the collective third eye, visualize love, embrace presence, presentness, and lightness, and to "become dancers in the dance of life,"[15] in bringing all these elements together – shamanism, Mayan divination, meditation, Third Theatre – Rojas cannot but create his own form of embodied knowledge, his own performance of "unknowing" or decentring dominant conceptual paradigms that run across cultures: rationalism, materialism, heaviness.

Tortilla Oracle evokes an enactive approach both to acting and to the dynamics of ancient ritual, of shamanism, and energetic theatre, but with a difference. As an actor aware of possibilities of presentness and embodiment, his approach is akin to enactive acting, which conceives acting as phenomenon rather than representation. Phillip Zarrilli describes the approach, which borrows from phenomenology, cognitive science, and anthropology as follows:

> In contrast to representational and/or mimetic meta-theories of acting that construct their views of action from a position as an outside observer to the process/phenomenon of acting, an enactive view provides an account of acting from the perspective of the actor as enactor/doer from "inside."[16]

Given the transformative nature of *Tortilla Oracle* for Rojas, his performance cannot be viewed as mere role-playing, but rather, to cite Zarrilli again, "as a dynamic, lived experience in which the actor is responsive to the demands of the particular moment within a specific [theatrical] environment."[17] In this, Rojas's performance and his position on foreignness could also be perceived as performance of his own sense of home much in line with Barba's, whose statement below poses interesting parallelisms:

> My body is my country. The only place where I always am. No matter where I go, to Montréal or to Tokyo, to Holstebro, Bogota, or New York, I am always at home, always in my country. I am never a foreigner, never in exile, if I am not separated from my body. [...] He [the actor] wants to be an actor in order to rediscover his country, not to possess a technique, but to possess himself.[18]

In fact, when I asked Rojas to react to the statement above, he confirmed that he found Barba's position to complement and resonate with his own:

> I've never felt that sense of belonging in Mexico or in the US (except for maybe in New York City), or any other country I've visited. So if it is not the country or place where I am that makes me feel at home, it must be my body and my mind, where I'm at home. Maybe that's why I perform, to come home.[19]

But, despite the parallelisms between these artists, there are also significant differences. In Rojas's view, the transformative potential of the encounter with the audience is two-directional. While he hopes the encounter will "long resonate" with the participants, he also admits to his personal involvement in it:

> I started performing *Tortilla Oracle* in 2009, and it wasn't until this year [2013] that I began donning the ritual (face and hand) paint. I had considered it for a long time but it didn't feel right before. The paint is low key, I don't want to scare or alienate anyone, but it is part of my transformation.[20]

Rojas's strong connection with the piece is partially motivated by his identification with a ritual image that aids him to situate the performance between past and present:

> A few years ago I was walking through the Metropolitan Museum of Art and came across a ceramic funerary urn from Monte Alban, Mexico, 4th-5th Century. I immediately connected with the piece and noticed how the cobs of corn were so prominent on the figure's lap. I felt that I had come across a figure that represented the ancient version of the work I'm performing through *Tortilla Oracle*. The figure's palms were red and he had two dark lines, very likely tattoos that went down each side of the figure's face. Ever since then, painting my face and palms has become part of my ritual as I prepare to do

the readings. I can't explain why, only that it feels right to me and that it has become part of my ritual. In addition to it being part of how I become the Tortilla Oracle for every performance, I think it also helps the sitter enter into a space of ritual and the unknown. I think of the paint very much in the same way I think of my mask for *Lucha Libre*. They are both part of the ritual in helping me become/channel who I'm performing. Before I saw that figure at the Met, I didn't have any sense of what my paint would be, or that I would find something that would connect me so deeply to what an ancient Maiz Oracle might have looked like.[21]

As a performer, Rojas admits also to the effects of his transformation and to the potential benefits of the exchange:

There have been times when I hardly need to say anything, some people immediately open up and tell me about what's going on in their lives. People need someone who they can trust, who won't judge them, so that they can get something off their chest or just share what they're going through. It can be very healing.[22]

As the stated main object is to achieve spiritual fulfilment and enlightenment by recovering interconnectivity with the elements and with each other, the performance has a two-way impact on the participant and on the artist himself.[23] Venues use similar language in describing his performance as "channeling ancient shamanistic practices and rituals,"[24] and observe the transcendent or metaphysical aspects of its aesthetics: "The ritualistic tempo, rhythm and concentration on repetition provide a connection with the higher orders of the cosmos."[25]

But, Rojas does not require the participant to commit to the dynamics of a sacred ritual in order to enjoy the performance. In fact, other descriptions of *Tortilla Oracle* focus on the constructedness of the event, and at times even admit to its foreignness, as this interviewer candidly admits:

When I first heard of your project, the *Tortilla Oracle*, it immediately captured my imagination. I thought it was funny – that an ordinary tortilla could reveal some kind of truth about the self. [...] You started interpreting the marks on cooked tortillas with friends at a dinner party as a game, but have since developed the persona of Tortilla Oracle that is closer to a shaman than a party goer.[26]

Far from eschewing any interpretation as reductive, or denying the constructedness of the event, Rojas welcomes its ludic aspects:

I think it's great that most people chuckle or laugh when they first hear about it. Humor can provide a safe place to enter into the piece. Another thing that usually comes to people's mind is a sense of disbelief; they wonder "Is he for real?" "Is this a real thing?"

But once people enter into the work and they sit with me, they realize that I take this very seriously and am committed to what I'm doing. Not only to my performance, but also to the exchange we're about to have.[27]

Far from assimilating the ludic in ritual as Victor Turner would, that is, as a possible place of transgression and liminality, Rojas conceives of playfulness and humour as a bridge or gateway enabling intercultural communication by offering a "safe place" as alternative to the "sacred place" of the performance.[28] Once the participant chooses and becomes at ease with the tenor of the encounter, the exchange may happen unfettered. By allowing for the free oscillation between theatrical performance and shamanistic ritual, Rojas has created a unique participatory formula that involves a personal transformation, investigation, and experiment. He recognizes the implications and importance of the project: "What started as an experiment in social participation and communication has evolved into a profound historical and anthropological research project […]."[29]

From its general success, it is evident that *Tortilla Oracle* manages to communicate to audiences across the continent of North America despite remaining at the crossroads of cultural traditions and artistic models. The same may be said of *Lucha Libre*, another of his performance acts. Significantly, both pieces engage multiple cultural traditions and blend new and established performance practices. *Tortilla Oracle* combines popular contemporary uses of Tarot reading and the traditional ritual of the oracle, while *Lucha Libre* presents the structure of the medieval morality play and the popular conventions of puppetry (reminiscent of the Punch and Judy style) and the wrestling match. Both pieces are deeply entwined with Mexican culture: the corn resonates with myths of origin and claims of cultural and economic heritage; the wrestler remains even today a cultural symbol at the heart of Mexican identity that combines political theatre, morality, and spectacle, allowing Rojas to tackle a different set of religious myths. The parodic performance of the *lucha libre* evokes a number of different aesthetic frameworks: the wrestler as entertainer-superhero (US) and the wrestler as a masked super-agent of socio-political change (Mexico), but also, in a surprising turn, it combines the structure of morality play and puppetry. The artist explains it as follows:

Lucha Libre is a performance about a time in my youth when I was simultaneously indoctrinated into the concepts of religion and superheroes. Growing up in Mexico my superheroes were *lucha libre* wrestlers, or *luchadores*. *Lucha Libre* deals with the myths and mythical creatures that we as humans have created around religions, faith, and fear. It's about the age-old battle between good and evil. I ask the question "If Jesus and the Devil had a wrestling match, who would win?"[30]

The premise of *Lucha Libre* establishes a religious conflict (Jesus versus Devil) parallel to the conflict presented by the conventions of the genre, *rudos* (bad, or rule-breaking guys, also known as heels) versus *técnicos* (good, clean, or rule-abiding guys). Both conflicts are staged

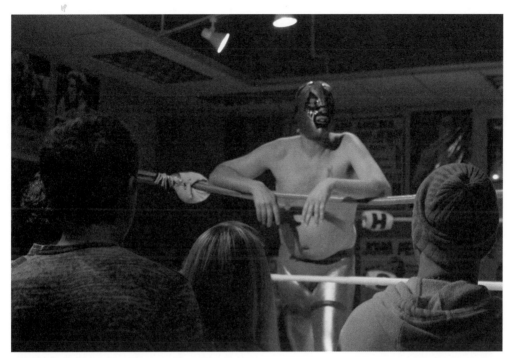

Figure 2: Jorge Rojas in *Lucha Libre*, Vertigo 15 Performing Art Series, National Wrestling Hall of Fame Dan Gable Museum, Waterloo, Iowa, 2015. Photo credit: Justin Allen.

as constructed mythologies to be observed and scrutinized. As Rojas impersonates *Mil Máscaras* – the *luchador* who was his childhood hero – a new process of self-representation is established that reproduces personal memory and redefines his conception of embodiment, presentness, and exchange.

Here Rojas has moved from the controlled, paused, rhythmical, ceremonial body of the shaman of *Tortilla Oracle* to the screaming antics and bravado of the masked wrestler. Yet, both performances stage a constant oscillation between theatrical representation and the presentation of self, between the semiotic and the phenomenological body. Both prompt the spectator to wonder about the status of the real as Rojas inhabits, comfortably, the in-betweenness of self and staged persona, of Mexican and American, of here and there, of then and now.

The terms of *Lucha Libre*, he admits, demand a "heightened theatricality," partially imposed by the hyperbolic gesturality of the genre and intensified by the character of *Mil Máscaras*, whose super-power hinges upon his mysterious and protean identity. Rojas explains the attraction of the character and his significance: "The whole idea is that when you take off one of his masks, there's always another mask. So you can't really quite get to his identity […] and because of that you can't take away his power."[31] Given the importance of masks in *lucha libre*,

Mil Máscaras' super-power makes virtue of the fluidity of a continually shifting identity. This challenge poses an interesting parallel to the performer's in-betweenness. Yet, becoming *Mil Máscaras* clearly implies a transformation. As Rojas swaggers into the room rhythmically in tune with Queen's anthemic song "We Will Rock You" blasting from the speakers, he exudes the energy of the *luchador*, which he transmits as he bounces, roars, and high-fives members of the audience on his way to the ring. Yet, after a brief ring-choreography in which he farcically, and to the delight of the public, reproduces the taunting moves of the *luchador* before a fight, he approaches the ropes, sizes up the audience as he would an opponent and, suddenly, relaxes his body. Then he begins a long, intimate monologue in which he relates his personal connection with the spectacle of *lucha libre*:

> As a child I spent my time watching these powerful athletes on the screen; in the movies they fought all the bad guys: mummies, werewolves…they were incredible! And at night they would enter the ring and fight other wrestlers. […] Around the same time (I was 5 or 6) I started to be told about religion; it made no sense: if God is the father of Jesus; who's the father of God? The Holy Ghost, can anyone tell me? Who are the bad guys? God is supposed to like some people but not others?… People of color, not so much; they've been stained throughout history. *And* the music *you* love is evil! ACDC? Really? I don't mean any disrespect, I'm just telling you what happened to me!… And you guys are going to help me decide, right?[32]

The extravagant antics clearly imply a break in the normal, automatized energy flow of the body and highlight the somatic body, the donning of a persona, thus providing a communication bridge with the audience, a humorous point of entry into the performance, and into Rojas's interrogation of identity and in-betweenness. To again use Barba's imagery, if acting requires a process by which the artist must first, "deculture" himself or break with the automatisms imposed by the kinetic culture of one's particular society; second, transition to codified theatrical movements; and, lastly, after enough training and repetition, find a "new muscular tonicity" in its new "dilated body," Rojas may be seen whimsically fluctuating between the first two phases: alternating de-culturizing or de-automatizing his body and adopting the theatrical kinetics of *lucha libre*, back and forth, at will.[33] However, the sudden shift in the performer, as his muscles relax and his body loses its "dilated" state, implies a consciousness of the body's own energy and of its capacity to control meaning production by establishing a dialectical relationship between his somatic and phenomenological selves – between his acting persona and his own self as a social actor – that exposes the latter.

Rojas has fashioned an acting formula within which to experiment with logic and meaning creation. After this, the artist shifts spaces, exits the wrestling ring to American musician Tom Waits' "Jesus Gonna Be Here," and sets up a stage on a small table to introduce a second childhood memory: a puppet show that will help the audience reflect upon and process a new cultural myth: Christianity, with its heroes and villains. While the theatrical conflict in the ring was presented, oscillating between the diegetic narration of the artist's

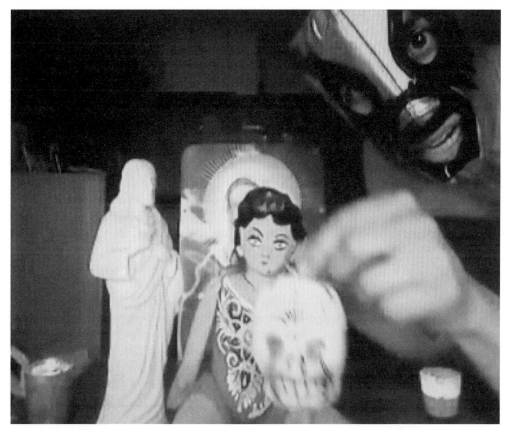

Figure 3: Jorge Rojas, Video still from My Space: Live – *Lucha Libre* performance, live streaming video, Brooklyn, New York, 2008. Photo credit: Jorge Rojas.

childhood dilemma, and segments of fights in which the author throws himself around as if flung by an invisible force, the second part of the performance presents the mimetic struggle between the figures of Jesus and the Devil – observed by a wooden skeleton and a doll representing Mary Magdalene, to be awarded to vanquished and victor, respectively. The fight representing a decentred, constructed, downsized mythology is to be refereed by the audience who is now positioned above the sitting artist. And, as Rojas opens the moral dilemma to indeterminacy, satire, and debate, he resignifies professional wrestling, contradicting the values assigned to it by Western scholarship.

Roland Barthes, who turned scholarly attention on wrestling by associating the spectacle with existing mythologies, defined the spectacle precisely by its portrayal of certainty:

What is portrayed by wrestling is therefore an ideal understanding of things; it is the euphoria of men raised for a while above the constitutive ambiguity of everyday

situations and placed before the panoramic view of a univocal Nature, in which signs at last correspond to causes, without obstacle, without evasion, without contradiction.[34]

This lack of ambiguity, however, seems to oversimplify the perception of *lucha libre* that prevails in Mexican culture. As Heather Levi observes,

> Professional wrestling has been deemed worthy of scholarly attention because and insofar as it can be defined as a ritual confrontation between social categories and/or between representations of good and evil. In other words, academics have found it interesting insofar as it could be analyzed as a form of theater. But, while Mexican wrestlers are aware of this aspect of *lucha libre*, it is not one to which they themselves draw attention. Nearly all of the wrestlers I knew insisted that *lucha libre* had to be understood as a sport. Whenever I asked them to define it or describe it, they would emphasize the rigor of their training regimen, the years of physical preparation, and the hours spent in the gym.[35]

Rojas situates his performance ambiguously between both cultural approaches to wrestling: emphasizing the ritual aspect of Western struggles between good and evil, rather than the Mexican vision of the sport, yet establishing an intercultural encounter that forces a "two-way flow" with spectators as it allows audience participation, and destabilizes the moralizing conflict with an undetermined outcome. The performance in Iowa I refer to here[36] serves as an example of one of the possible conclusions to the match. As Rojas sets the rules of the game as they were explained to him in childhood, and presents the audience with the contenders and referees, i.e., with the ever-vigilant God who, unlike his fantasy-world *luchadores* is "real" and "all-knowing" and who "might or might not be judging me, might not love me depending on the color of my skin or my sexual preference or things like that?"[37] After that, he confronts the audience with the final deliberation: "So, who won the match between the Devil and Jesus? Tell me!"[38] In Iowa, the audience cheerfully crowned the Devil. "While it's always up in the air who will emerge the victor, Rojas said, the Devil does typically come out on top, perhaps because people who like performance art are more irreverent."[39]

As can be seen from the description above, far from portraying a normative and "ideal understanding of things,"[40] as Barthes would have it, *Lucha Libre* places itself in an in-between space that allows for reflection and transaction between cultural models: between *lucha libre* and professional wrestling, between performance art and puppetry, between spectacle and sport, between religion and ethics. Rojas's performance embodies a productive model of interculturalism where the dialogic nature of the exchange is foregrounded by shifts in embodiment and performance spaces (in or out of the ring, above or below the audience), and where the performer's position "remains fluid and, depending on where and how the exchange takes place, shifts along the continuum."[41] Rojas displaces familiar dominant values, rechannels cultural icons, and opens both to new paradigms of knowledge construction.

In sum, in *Lucha Libre,* as well as in *Tortilla Oracle,* Rojas draws power from fluidity and indeterminacy, from the lively interplay between presence and embodiment, and from the

dynamics of knowledge production and exchange. Rojas engages with the expectations of audiences across North America about spirituality in *Tortilla Oracle*, about what is contrived or real in *Lucha Libre,* and manages to communicate while remaining at the crossroads of cultural traditions and artistic models. Both *Tortilla Oracle* and *Lucha Libre* are cultural forms of empowerment that invite spectators to encounter new epistemologies and forms of meaning production. Through his staging of the "foreign bodies" of the shaman and the *luchador*, Rojas's performances manage to function, in Diana Taylor's terms, "as vital acts of transfer, transmitting social knowledge, memory, and a sense of identity."[42] But also, and more importantly, these performances are opportunities to play with the rhythmic oscillation between acting and being and to establish two-way transfers with audiences that allow the artist to "learn, experiment and laugh [...]."[43]

Notes

1 Jorge Rojas, e-mail message to Elena García-Martín, March 7, 2016.
2 Though in-betweenness is an often used term in feminist as well as communication theories, among others, I find that the model that relates closest to the mode in Rojas's performance is the "dynamic in-betweenness" that Muneo Yoshikawa introduced in 1978 in connection to the double-swing model of intercultural communication. He describes dynamic in-betweenness as the way in which the individual is able to approach intercultural encounters by producing an enlightened and dynamic sense of self that implies interconnectedness: "This model indicates that one is neither this side nor that side nor beyond both sides, but one is the between. This position of between is, however, not a neutral middle position or a transcendent position 'beyond' or a mere dialectical (melting) synthesis which lacks a dynamic process, but rather, is a dynamic, tension-laden 'between' in which there is a constant pull from both sides," M.J. Yoshikawa, "The Double Swing Model of Intercultural Communication Between the East and the West," *Communication Theory: Eastern and Western Perspectives*, ed. D.L. Kincaid (San Diego: Academic Press, 1987), 327. Rojas's mode of intercultural communication works similarly, yet with a difference, as he describes how, despite feeling the pull from both cultures, he does not feel at home in either, and remains foreign to both. Yet, his interactive performances yield similar results in offering a transformative environment where individuals, cultures, and intercultural notions can meet in constructive ways.
3 Jorge Rojas, e-mail message to Elena García-Martín, November 28, 2015.
4 I borrow here from the Lacanian distinction between the subject of the statement and the subject of enunciation in order to draw attention to the fluidity of the subject position. Lacan defines the subject of the statement as the grammatical I, "the person who is actually speaking at the moment I say." In contrast with the subject of the statement, the subject of enunciation is "the subject not insofar as it produces discourse but insofar as it is produced [*fait*], cornered even [*fait comme un rat*], by discourse," Jacques Lacan, *My Teaching*, trans. David Macey (New York: Verso, 2009), 36. He poses this distinction in order to highlight the extent to which the subject is constructed by his own speech and the way it is interpreted

by others. When dealing with Rojas as performance artist, the subject of enunciation shifts along with the positions (spatial as well as psychological) from which he speaks.
5 Jorge Rojas, e-mail preface to *PERFORMEANDO 2013,* Grace Exhibition Space, Brooklyn, NY, June 4, 2013.
6 "KUED Specials: Verve 'Jorge Rojas,'" *KUED,* December 23, 2015.
7 *Lucha libre* is the Spanish name of Mexican Professional Wrestling, a liminal genre where the contenders wear symbolic masks, an element traditional in Mexico since the Aztecs. The sport is highly codified and, as Heather Levi observes, ridden with contradictions:

> [E]mbodied performance that communicates apparently conflicting statements about the social world. During its seventy-five-year history in Mexico, it has stood for modernity and tradition, urbanism and indigenismo, honesty and corruption, machismo and feminism. Why should *lucha libre* be the vehicle of such a complex and contradictory set of associations? I would suggest that its capacity to signify comes from the very fact that it occupies a space somewhere between sport, ritual, and theater and is thus capable of drawing its power from all of those genres.

Heather Levi, *The World of Lucha Libre: Secrets, Revelations and Mexican National Identity* (Durham: Duke University Press, 2008), 6.
8 "KUED Specials: Verve 'Jorge Rojas.'"
9 Jacqueline Lo and Helen Gilbert, "Toward a Topography of Cross-Cultural Theatre Praxis," *The Drama Review* 46, no. 3 (2002): 44.
10 In the context of Mexican culture, a tortilla has been a staple food since pre-Columbian times consisting of a thin, unleavened flat bread, made from finely ground corn.
11 Jorge Rojas, e-mail preface to *PERFORMEANDO 2013.*
12 Ibid.
13 Eugenio Barba, "The Way of Refusal: The Theatre's Body-in-Life," *New Theatre Quarterly* 4, no. 16 (1988): 298.
14 Eugenio Barba describes Third Theatre as a theatre excluded both from institutionalized and avant garde theatres, a theatre that lives on the fringes. "It is the sum of all those theatres which are, each in its own way, constructors of meaning. Each of them defines in an autonomous way the personal meaning of their doing theatre" ("Third Theatre," 7). He further clarifies its import and the difficulty of defining the term:

> When I began to talk about the Third Theatre in 1976 I felt that it was not an aesthetic category, nor simply a sociological category of non-aligned theatre. Today, it is clear to me that the essential character of the Third Theatre is the autonomous construction of a meaning which does not recognize the boundaries assigned to our craft by the surrounding culture.

Eugenio Barba, "The Third Theatre: The Legacy from Us to Ourselves," *New Theatre Quarterly* 8, no. 29 (1992): 8.
15 "KUED Specials: Verve 'Jorge Rojas.'"
16 Phillip B. Zarrilli, "An Enactive Approach to Understanding Acting," *Theatre Journal* 59, no. 4 (2007): 638.

17 Ibid.
18 Barba, "The Way of Refusal," 293.
19 Jorge Rojas, e-mail message to Elena García-Martín, March 7, 2016.
20 Susan O'Malley, "Someone Who Inspires: Jorge Rojas," September 25, 2013. To view full article, go to http://susanomalley.org/someone-who-inspires-jorge-Rojas/, accessed March 25, 2016.
21 Jorge Rojas, e-mail message to Elena García-Martín, March 7, 2016.
22 O'Malley, "Someone Who Inspires: Jorge Rojas."
23 "KUED Specials: Verve 'Jorge Rojas.'"
24 Movimiento de Arte y Cultura Latino Americana, *Maize y Más: From Mother to Monster?* (San José: Cultural Center, 2013). Print Catalogue.
25 Ibid.
26 O'Malley, "Someone Who Inspires: Jorge Rojas."
27 Ibid.
28 Victor Turner, *From Ritual to Theatre: the Human Seriousness of Play* (New York: PAJ, 1982).
29 O'Malley, "Someone Who Inspires: Jorge Rojas."
30 Jorge Rojas, e-mail message to Elena García-Martín, January 18, 2016.
31 Kari Williams, "Performance Artist Channels Mil Mascaras: Jorge Rojas Depicts His Childhood Hero in Event at National Wrestling Hall of Fame Dan Gable Museum," *SLAM! Sports Wrestling*, April 21, 2015. To view full article, go to http://slam.canoe.com/Slam/Wrestling/2015/10/13/22561977.html, accessed March 25, 2016.
32 Jorge Rojas, *Lucha Libre* Performance, National Wrestling Hall of Fame Dan Gable Museum, University of Northern Iowa, November 5, 2015; original emphasis.
33 Barba, "The Way of Refusal," 297.
34 Roland Barthes, "The World of Wrestling," in *Mythologies*, trans. Annette Lavers (New York: Hill and Wang, 1972), 24.
35 Heather Levi, *The World of Lucha Libre: Secrets, Revelations and Mexican National Identity* (Durham: Duke University Press, 2008), 8.
36 Rojas, *Lucha Libre* performance.
37 Ibid.
38 Ibid.
39 Williams, "Performance Artist Channels."
40 Barthes, "The World of Wrestling," 24.
41 Lo and Gilbert, "Toward a Topography," 44.
42 Diana Taylor, *The Archive and the Repertoire: Performing Cultural Memory in the Americas* (Durham: Duke University Press, 2003), 2.
43 "KUED Specials: Verve 'Jorge Rojas.'"

Chapter 5

Lingering Cultural Memory and Hyphenated Exile

Seunghyun Hwang

Emigration from a homeland, no matter the cause, results in social changes that can lead to agitation and a disturbance in matters relating to identity and hyphenated existence, as well as psychological distress and cultural depletion. Many definitions of exile denote an enforced or involuntary physical removal. To distinguish between an immigrant and an exile, Salman Akhtar lists five points of differentiation: voluntary or involuntary, planning time or none, degree of the traumatic event causing emigration, possibility or no possibility of returning, and degree of acceptance "by the host population."[1] Akhtar's differentiations are reliant mostly on a physical danger perception and define the exile in a traumatic and negative voice. The immigrant, when compelled to leave the homeland by a psychological danger factor such as the hardship of stifling poverty, is also like an exile "who lives away from their native country, either from choice or compulsion"[2] for the sake of future generations. This challenging situation implies a psychological status of regret and sorrow, because there is little possibility of returning to the native land, despite the fact that leaving the homeland is a conscious choice made by the first generation of immigrant.

Connecting this idea to the Asian diaspora and immigration to North America, in particular to the United States, I propose that the term "exile" better connects to the 1.5 and second generations of immigrants who did not make the conscious choice to leave their homeland. 1.5-generation immigrants are those who came as children to North America and grew up with an Asian culture at home, and American culture in public.[3] Second-generation immigrants are those born in the new country after the immigration of the parents. 1.5-generation and second-generation immigrants often experience cultural identity issues because their parents tend to adhere to the original culture, while they tend to feel closer to the new culture. These are the children who did not make a conscious decision to immigrate and who are exiles from their family's native land. They are caught between their parents' lingering memory of homeland and their own perception of acceptance by the mainstream culture of their country of residence. The first generation, the one that makes the decision to emigrate, keeps a sense of the homeland as a retrospective nostalgic memory (or hovering trauma) while they struggle with adjustment to such changes as foreign language, law, and culture. Conversely, the younger generations, who were either born or grew up in the new land, establish their lives in line with the host country's culture. They identify their parents' adopted country as their home country. Their cultural memory is heavily grounded in Americanness. However, at home they must also deal with the lingering cultural memory of the older generation.

Akhtar's fifth differentiation involves the reception "by the host population."[4] Despite the younger generation's education or birth in the United States, they are all too often faced with discrimination based on stereotypes constructed by mainstream American culture. The use of hyphenated categories, like Asian-American, reinforces the formulistic racist stereotypes, such as "model minority,"[5] and marginalizes the 1.5 and second generations to the periphery of American society.[6] In this line of thinking, the children of immigration are exiled to a hyphenated space. It was not their choice to leave the homeland of their elders, and it is not their choice to be labelled as semi-American/semi-foreigner. The hyphenated individual, more in line with Akhtar's designation of exile, is doubly banished.

The identity struggle that takes place within the hyphen is fueled by "experiences of cultural difference, alienation, and marginality."[7] This struggle is addressed in Young Jean Lee's play *Songs of the Dragons Flying to Heaven* (2006).[8] I propose that Young Jean Lee is a 1.5-generation immigrant, as she was born in Korea and came to the United States at the age of two with her family. Living in Pullman, Washington, Lee did not fit the model minority stereotype of an overachieving Asian student; "Not engaging in school was, perhaps, her way of not dealing with the casual and not so casual racism that was directed her way by the predominantly white students there: if she didn't excel, she wouldn't risk standing out, being

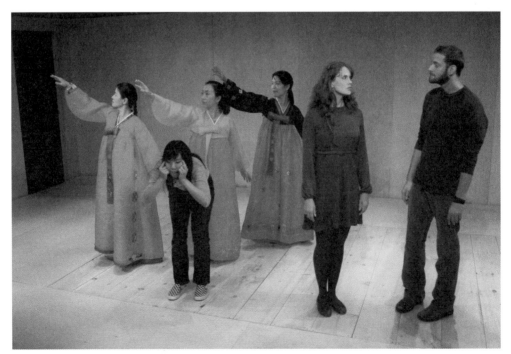

Figure 1: (L-R) Jennifer Lim, Becky Yamamoto, Haerry Kim, Jun Sky Kim, Juliana Francis Kelly, and Brian Bickerstaff in *Songs of the Dragons Flying to Heaven* at HERE Arts Center, New York, 2006. Photo credit: Carl Skutsch.

seen."[9] This chapter analyzes Lee's narratives of hyphenated betweenness as a byproduct of immigration that causes an identity crisis felt by the 1.5 and second generations. The emphasis, in particular, is on how Lee stages the frustration and rage that accompany a hyphenated existence. For example, Lee's autobiographical main character clearly expresses rage, saying, "[M]inorities are discriminated against because there is a thing in the world that is bad, and that thing is racism."[10]

Lee's *Songs of the Dragons Flying to Heaven* is organized into a series of unconnected scenes (or sections) that are populated by two distinct groups of characters: one comprised of four Asian women, and another of a white couple.

The Asian group includes characters named Korean 1, Korean 2, Korean 3, and Korean-American. Lee expands the identities of the characters in the first group to include other Asian ethnicities, explaining in a casting note in the published playscript:

Korean-American and Korean 1, 2, and 3 should be played by actresses who are one-hundred percent Korean, Chinese or Japanese (or any mix of the three, for example half Chinese/half Japanese). When speaking English, Korea 1, 2, and 3 speak with authentic Asian accents and Korean-American speaks with a perfect American accent.[11]

The white group is described as "a straight couple called White Person 1 and White Person 2."[12]

As Lee does not delineate separate scenes in the playscript, I have designated separate sections and provided brief descriptions in the table that follows to assist the reader in understanding the specific references that inform my discussion of the play.

Section	Description
1	Video clip of Young Jean Lee's face being slapped repeatedly. She faces the camera as she weeps audibly. Her facial expression shows suffering. "*Sarangga*" – a traditional Korean opera song.
2	Character "Korean-American" (dressed in jeans and t-shirt) speaks about racism and minority issues in the United States in a stand-up comic manner.
3	Characters Korean 1, 2, and 3 enter dressed in traditional *hanbok*. They dance and play like children. When Korean-American tries to join in, they punch and kick her. "I Was Born a Unicorn" – a Canadian alternative pop song.
4	The three Koreans present memories of female exploitation and abuse. "*Santokki*" – an adapted Korean folk song. Then they dance a courtly traditional dance as Korean-American reappears. She tries to join them, but then makes fun of them, miming Asian stereotypes. "Small Waiting" – a pop love song sung in Korean. After Korean-American exits, Korean 3 acts out the story of a school girl being raped by her teacher, with her father's permission.

115

5	Korean-American interrupts the story by crawling through Korean 3's legs. She is dressed in traditional male clothing. In the persona of an Asian male, she delivers another monologue about minority rage and racism. As she verbally attacks white people, the three Koreans interrupt with simplistic memories of the homeland.
6	A white man and white woman enter. The woman explains why they need to break up.
7	Korean-American sits with her grandmother. Grandmother comments on Korean-American's life choices. Grandmother's dying wish is that her granddaughter be humble and obedient. She uses her belief in Jesus to inspire her granddaughter to be a "good girl." Grandmother then dies.
8	The white man and white woman express their desires. He wants his life to join totally with hers. She wants to travel to Africa.
9	The two groups merge temporarily, when the Koreans invite the white couple to sing a Korean church song. "*Ye-su mi-du-se-yo*" – a religious song sung in Korean. After the white couple leaves, Korean-American (dressed in jeans and t-shirt) and the three Koreans discuss their points of view on Christianity and life.
10	The white couple makes accusations against each other about intimacy and power. They are suddenly interrupted as the Korean characters chase them off the stage.
11	The three Koreans and Korean-American (now dressed in female traditional clothing) dance to an upbeat Christmas song. Their comical dance changes into individual miming of suicide techniques. "All I Want for Christmas Is You" – a pop love song sung in English. The white couple enters and shoos them away, using chairs.
12	The white couple role-plays a job interview where he has the power and she refuses to accept his dominance. They are interrupted by the entrance of the four Asian characters. The four speak in unison about racism, rage, and power.
13	The white couple has a nonsensical argument that is repeatedly restarted as if the author is trying out various directions for the scene. Disjointed comments by each character expose the effect of an unrealistic view of life based on imagined memory. Eventually the woman makes an "I had a dream" speech (echoing Martin Luther King's famous speech in format) about a strong relationship. They agree to make the dream into a reality by getting counseling. "Held" – an American alternative pop song.

Table 1: Scene descriptions of *Songs of the Dragons Flying to Heaven*.

Among Lee's six characters, Korean-American is the character that struggles with the feelings of exile initiated by the nostalgic lingering cultural memory of her elders, and a sense of hyphenated alienation from the mainstream culture. Her agitation and "minority rage"[13] mix with a disturbance in matters relating to identity. In Section 5 Korean-American declares, "There is a minority rage burning inside of me."[14]

Lingering Cultural Memory

First-generation immigrants from Asia make a conscious choice to leave their homeland for various reasons. Some seek economic or educational opportunities,[15] where others flee oppression or poverty. Identifying as Korean, or Chinese, or one of the many other Asian nationalities, they bring the cultural values of their part of Asia with them to their new homeland. The process of acculturation, however, "can lead to a loss of these cultural values and their protective factors."[16] As the first generation develops a new life in America, they presume "the culture of origin to be static."[17] Their memory of that culture becomes stylized. Some parts are forgotten and others adjusted by reminiscence. It is this cultural memory that they expect their children to embrace, even if the memory differs vastly from the current reality. Jade Wong confirmed this thought in the introduction to the 1989 edition of her autobiographical novel, *Fifth Chinese Daughter*, stating, "I was aware that my upbringing by the nineteenth-century standards of Imperial China, which my parents deemed correct, was quite different from that enjoyed by twentieth-century Americans in San Francisco, where I had to find my identity and vocation."[18] In the same manner, the Korean culture of Young Jean Lee's parents did not match with the American culture of Pullman, Washington in the 1970s, or the reality of Korea, when Lee wrote her play in 2008.[19] The diasporic memory involves "the simultaneous experience of alienation and the maintenance of affiliation to both the country of residence and the homeland."[20] According to Marita Sturken, cultural memory "is shared outside the avenues of formal historical discourse yet is entangled with cultural products and imbued with cultural meaning."[21] Sturken distinguishes cultural memory from the official recorded history. What the younger generation of Asian-Americans learn from the culture of the public school in some respects conflicts with the cultural memory of their elders. When "American values and traditional values" do not align, a generation gap develops, and the older generation can "feel alienated from their children's lives and struggle to maintain parental authority as their children surpass them in navigating a new language, culture, and value systems."[22] This generational conflict is a prime dynamic in the behaviour of the character Korean-American in *Songs of the Dragons Flying to Heaven*.

For example, Young Jean Lee expresses the frustration generated by the generational conflict in Korean-American's monologue in Section 2. First, Korean-American grumbles about her life with Asian parents:

> Have you ever noticed how most Asian-Americans are slightly brain-damaged from having grown up with Asian parents? It's like being raised by monkeys – these retarded monkeys who can barely speak English and are too evil to understand anything besides conformity and status. Most of us hate these monkeys from an early age and try to learn how to be human from school or television, but the result is always tainted by this subtle or not-so-subtle retardation.[23]

Performing Exile

This frustration of being a child of immigrant parents, however, is tempered with a "sense of guilt and obligation" caused by "witnessing their parents' immeasurable sacrifices."[24] Korean-American implies this saying, "we come to this country and want to forget about our ancestry, but this is bad, and we have to remember that our grandfathers and grandmothers were people too, with interesting stories to tell."[25]

In Section 3, Korean-American, dressed as a typical young American in jeans and a t-shirt, attempts to connect with cultural memory, represented by the three Korean female characters dressed in traditional *hanbok*. The three women (Korean 1, 2, and 3) dance to the alternative pop song "I Was Born a Unicorn" (2003). At first, the dancing characters interact gently with Korean-American; however, the gentleness quickly turns to violence with hair-pulling, face-punching, biting, and kicking.[26] As Korean-American crawls away, the song lyrics declare, "We're the Unicorns. We're more than horses. We're the Unicorns and we're people too!"[27] This section clearly depicts Korean-American as not being the same as Korean 1, 2, or 3, who cling to their lingering cultural memories and practices. They reject her American hyphenated identity.

In Section 4, Korean-American again tries to interact with the three Korean women as they dance to the Korean pop song "Small Waiting" (1994). The song, much like Simon

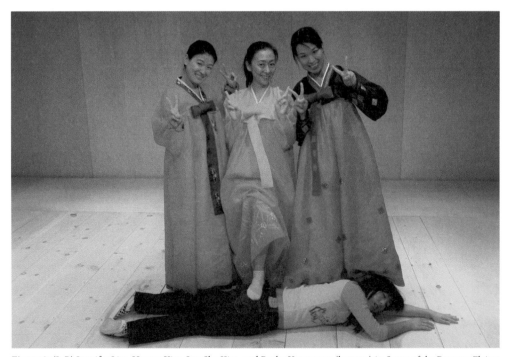

Figure 2: (L-R) Jennifer Lim, Haerry Kim, Jun Sky Kim, and Becky Yamamoto (bottom) in *Songs of the Dragons Flying to Heaven* at HERE Arts Center, New York, 2006. Photo credit: Carl Skutsch.

and Garfunkel's "Bridge Over Troubled Waters," indicates that if you need to rest or are tired in your life, think about someone special and that person will always be there for you. However, the memory does not comfort Korean-American. Lee's stage directions indicate a sense of rejection and retaliation with caricature Korean gestures.

> Korean-American imitates their movements clumsily, beaming with happiness. Korean 3 eyes Korean-American's dancing critically and makes a disgusted face, shoving her away. Korean-American feels humiliated and stops. She glares at the Koreans through the rest of their dance. When the dance ends, Korean-American makes racist faces at the Koreans. She makes "Chinese eyes" at Korean 2, mimes eating rice at Korean 1, does a karate chop for the audience and bows to Korean 3 – all while making big buck teeth. The Koreans are offended.[28]

The stereotypical exaggerated movements of Korean-American match the "alienation and isolation" felt by Young Jean Lee during her youth in Pullman, Washington.[29] In fact, "many minority youths experience rejection and prejudice both from school and society, contributing not only to dismay, but also long term insecurity and low self-esteem."[30]

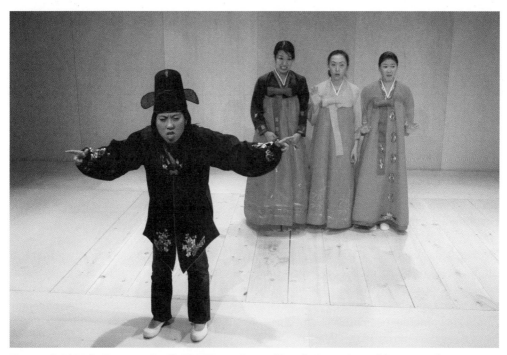

Figure 3: (L-R) Becky Yamamoto, Jun Sky Kim, Haerry Kim, and Jennifer Lim in *Songs of the Dragons Flying to Heaven* at HERE Arts Center, New York, 2006. Photo credit: Carl Skutsch.

In Section 5, Korean-American takes a different route to interaction. When she joins the three Koreans, this time she is dressed in traditional Korean apparel. However, instead of the traditional clothing for Korean women, the stage direction describes the clothing as "a traditional Korean male jacket, white rubber Korean gardening clogs, and a traditional Korean groom's hat with flaps on the sides, which look like Mickey Mouse ears to Westerners."[31] Korean-American, as a result of the influence of her American culture, identifies more with the power held by Korean men than with the submissive role of Korean women in her lingering cultural memory. She behaves very aggressively towards the women and calls them monkeys, then goes on a rant against white people. To defuse Korean-American's aggression, the three Korean women push her out of the way and attempt to smooth over the rant with simple, innocuous stories.

Lee addresses religion in Sections 7 and 9. The Korean church in America is often perceived as taking the place of "the home, hometown or country of origin."[32] It provides the social functions of offering fellowship with other immigrants, sustaining cultural tradition, delivering social services, and enabling "social status and social positions for adult immigrants."[33] It also strengthens "the immigrants' psychological defense against the dominant institutions of the larger society."[34] Young Jean Lee's parents "ensured she spent every Sunday in church."[35] Nevertheless, her rebellious attitude to church, when she became an adult, was, "you can't force this on me anymore."[36]

In Section 7, Korean-American sits with her grandmother, who expresses her dying wish that her Americanized granddaughter should be humble and obedient and believe in Jesus, and thus remain under the influence of traditional culture. Rather than a comment about Christianity, Grandmother's reference to Jesus refers to how "many Korean American families view the church as the ideal place to foster their children's development."[37] Like Lee's rejection of the religion of her parents, in Section 9 Korean-American discusses religion with the three Koreans using "[R]everse Bible study! We are studying the Bible, but what it leads us to is my own personal teachings."[38] The influence of individualism over collectivism clashes with the church traditions of the first-generation immigrants, resulting in the detachment from tradition and even familial separation.

Hyphenated Existence

Hyphenated categories separate the minority group from the mainstream society group and can be a basis for discrimination. This separation can also be a catalyst for the rage caused by being discriminated against. The minority rage in *Songs of the Dragons Flying to Heaven* is not veiled but directly accuses white society of racial and gender discrimination. Korean-American's monologue in Section 2 begins as an angry outburst, "I am so mad about all the racist things against me in this country, which is America."[39] Her rage climaxes with a threat: "The wiliness of the Korean is beyond anything that you could ever hope to imagine. I can promise you one thing, which is that we will crush you. You may laugh now, but remember

my words when you and your offspring are writhing under our yoke."[40] She ends her monologue with a raised, clenched fist, indicating Asian power.[41]

In Section 5, Korean-American, dressed in male Korean traditional clothing, is much more aggressive through a balance of humour and anger. The hyphenated nature of her identity brands her as a minority:

> There is a minority rage burning inside of me. And this minority rage comes from the fact that I am a minority, and because minorities are discriminated against. And minorities are discriminated against because there is a thing in the world that is bad, and that thing is racism.[42]

Her words point a finger directly at white America; "I hate white people because all minorities secretly hate them."[43] Insultingly, Korean-American yells, "Your face is like a white slab of white English pudding!"[44] The venom in her accusations scares the three Koreans. This tirade might make them visible and targets of discrimination; yet Korean-American's rage will only be temporarily silenced.

In Section 12, the three Korean characters join Korean-American, who is now dressed in a women's *hanbok*, in declaring the evils of minority discrimination. Now speaking for all Asian ethnicities, the four Korean characters stand centre stage between the audience and the white couple. The stage lights are dimmed. They speak directly to the audience in emotionless tones. Their voices express, in unison, their frustration and rage at racism and lack of power.

> I come up here with all this racist shit, and when minorities get mad I'm like, 'Go to hell, you unfashionably angry minorities, this is my sophisticated critique of racism that you are too stupid to understand.' But the truth is, if you're a minority and you do super-racist stuff against yourself, then the white people are like, "Oh, you're a 'cool' minority," and they treat you like one of them.[45]

Their response highlights that even when rage surfaces, the white majority can defuse their power. Asian Americans are saddled with the model minority image that marks them as "cool," meaning something interesting to the white majority, but it also strongly delineates them as a minority, as the Other, and therefore less powerful.

Mudfish and Tofu

The influence of "a racist legal and intuitional history"[46] on contemporary American culture has made it difficult for certain ethnic immigrant groups to assimilate. Americans of Asian heritage are often marginalized or perceived as invisible. An Asian American highlighted in a news story is often treated as a phenomenon, like the case of professional basketball player Jeremy Shu-How Lin. Lin's impressive winning streak in 2012 while playing for the New

York Knicks led to the coinage of the word "Linsanity." When the winning streak faltered, one commentator assigned the blame to a "Chink in the Armor" of the Knicks. It is this type of derogatory marginalization that feeds the rage that Korean-American represents in *Songs of the Dragons Flying to Heaven*.

In Section 2, Korean-American talks about a Korean dish that her grandmother made once each year. Before cooking the tiny fish (called mudfish), Grandmother would soak them in salt water to make certain that they "puke out all their mud until they were shiny clean."[47] Then she "would put pieces of tofu on a skillet, heat it up, and throw the live mud fish onto the skillet. The mud fish would frantically burrow inside the pieces of tofu to escape the heat and, voila, stuffed tofu!"[48] Like the mudfish, the children of the generation that crossed the Pacific Ocean begin to purge their Asian culture as they acculturate through school and work. They burrow into white mainstream culture as a "path of severing ethnic ties, unlearning 'old world' values, norms and behavioural patterns, and adapting to the culture of the Anglo-Saxon core associated with the white middle class."[49] No matter how deep they burrow into the "tofu" their physical appearance elicits insensitive comments like "What are you?"[50] In *Songs of the Dragons Flying to Heaven*, Young Jean Lee unleashes the frustration and rage caused by the uncomfortable imbalance of cultural identity that is a byproduct of immigration, a lingering cultural memory, and a hyphenated exile existence.

Notes

1 Salman Akhtar, *Immigration and Identity: Turmoil, Treatment, and Transformation* (New York: Rowman & Littlefield Publishers, Inc., 1999), 124.
2 "exile," *Oxford English Dictionary* (Oxford University Press, 2016). To view full entry, go to http://www.oxforddictionaries.com/definition/english/exile, accessed March 22, 2016.
3 Anthropologist Kyeyoung Park addresses the term, "1.5 generation": "More than three-quarters of Korean immigrants are post-1965, many immigrating on family reunification provisions. The Korean immigrant community includes many child immigrants who are often called the 1.5ers, or what is called *ilchom ose* within the Korean American community" (140). Kyeyoung Park, "'I Really Do Feel I'm 1.5!': The Construction of Self and Community by Young Korean Americans," *Amerasia Journal* 25, no. 1 (1999): 139–63.
4 Akhtar, *Immigration and Identity*, 124.
5 The term "model minority" is based on a proclivity for hard work and a strong desire for education among Asian Americans. The use of this term, though positive in nature, contains a less than positive implication, and has been and continues to be used to identify Asian Americans as a defined minority that is separate and distinguishable from mainstream society and from other minorities.
6 Josephine Lee, "Between Immigration and Hyphenation: The Problems of Theorizing Asian American Theater," *Journal of Dramatic Theory and Criticism* 13, no.1 (1998): 49.
7 Ibid., 46.

8 *Songs of the Dragons Flying to Heaven* was commissioned by the HERE Arts Center in New York. The world premiere in 2006 was followed by national and international tours in 2007 and 2008.
9 Hilton Als, "Real Gone Girl: Young Jean Lee's Identity Plays," *New Yorker*, November 3, 2014. To view full article, go to http://www.newyorker.com/magazine/2014/11/03/real-gone-girl, accessed April 12, 2016.
10 Young Jean Lee, "Songs of the Dragons Flying to Heaven," *American Theatre* 24, no. 7 (2007): 79.
11 Ibid., 76.
12 Als, "Real Gone Girl."
13 Anita Gates, "Laugh Now: You May Not When These Women Rule the World," *New York Times*, September 27, 2006. To view this article, go to http://www.nytimes.com/2006/09/27/theater/reviews/27drag.html?_r=0, accessed March 23, 2016.
14 Lee, "Songs of the Dragons Flying to Heaven," 79. Anita Gates explains that "the show is actually about minority rage." Gates, "Laugh Now."
15 Lee's family came to the United States so her father could pursue "a doctorate in chemical engineering." Als, "Real Gone Girl."
16 "Children Living In Stressful Environments Resource Kit: Children of Immigrants or in Bicultural Families," *Vermont Department of Health* (n.d.): 5. To view full article, go to http://healthvermont.gov/adap/clearinghouse/documents/N-Summary-Immigrants.pdf, accessed February 2, 2016.
17 Tracy Floreani, *Fifties Ethnicities: The Ethnic Novel and Mass Culture at Mid Century* (Albany: State University of New York Press, 2013), 26.
18 Jade Snow Wong, *Fifth Chinese Daughter* (Seattle: University of Washington Press, 1989), vii.
19 Lee portrays her experience of growing up in Pullman, Washington through her play, *Pullman, WA*, which premiered in 2005 at Performance Space 122, New York, and in the revival of the production, in 2010 at the SACRED Festival of Contemporary Performance at the Chelsea Theatre in London.
20 Rachel S. Parreñas and Lok C.D. Siu, introduction to *Asian Diasporas: New Formations, New Conceptions*, ed. Rhacel S. Parreñas and Lok C.D. Siu (Stanford: Stanford University Press, 2007), 1.
21 Marita Sturken, *Tangled Memories: The Vietnam War, the AIDS Epidemic, and the Politics of Remembering* (Berkeley: University of California Press, 1997), 3.
22 "Children," 5–6.
23 Lee, "Songs of the Dragons Flying to Heaven," 77.
24 Joann J. Hong and Steve Hong, "The Korean American Family: Assimilation and Its Toll on the First and Second Generation Relationship," *ERIC* (Institute of Education Sciences, 1996), 10. To view this article, go to http://eric.ed.gov/?id=ED401348, accessed March 23, 2016.
25 Lee, "Songs of the Dragons Flying to Heaven," 77.
26 Ibid., 77–78.
27 The Unicorns, *I Was Born a Unicorn* (Montréal: Caterpillars of the Community, 2003), CD.
28 Lee, "Songs of the Dragons Flying to Heaven," 78.

29 Laura Collins-Hughes, "Upending Racial Assumptions Korean-American Playwright Explores Black Identity," *The Boston Globe*, September 24, 2010. To view full article, go to http://www.boston.com/ae/theater_arts/articles/2010/09/24/korean_american_playwright_upends_racial_assumptions/, accessed March 23, 2016.
30 Hong and Hong, "The Korean American Family," 11.
31 Lee, "Songs of the Dragons Flying to Heaven," 79.
32 Inn Sook Lee, *Development of Self Integration for Asian American Women* (Lanham: University Press of America, 2009), 71.
33 Pyong Gap Min, "The Structure and Social Functions of Korean Immigrant Churches in the United States," *International Migration Review* 34, no. 4 (1992): 1371–72.
34 Hong and Hong, "The Korean American Family," 7.
35 Alexis Soloski, "Hell Is for Bohos," *Village Voice*, April 24, 2007. To view full article, go to http://www.villagevoice.com/arts/hell-is-for-bohos-7157349, accessed March 23, 2016.
36 Ibid.
37 Lee, *Development*, 71.
38 Lee, "Songs of the Dragons Flying to Heaven," 81.
39 Ibid., 77.
40 Ibid. Lee uses a combination of humour and shocking statements to make her audience actively think about the subjects addressed in her plays.
41 In the late 1960s, the raised clenched fist salute became a symbol of Black Power movement's silent protest.
42 Lee, "Songs of the Dragons Flying to Heaven," 79.
43 Ibid.
44 Ibid.
45 Ibid., 82.
46 Lee, "Between Immigration and Hyphenation," 49.
47 Lee, "Songs of the Dragons Flying to Heaven," 77.
48 Ibid.
49 Min Zhou and Yang So Xiong, "The Multifaceted American Experiences of the Children of Asian Immigrants: Lessons for Segmented Assimilation," *Ethnic and Racial Studies* 28, no. 6 (2005): 1123.
50 Stephanie Wong, "This Hyphenated Life," *Reflections: A Magazine of Theological and Ethical Inquiry from Yale Divinity School*, 2013. To view full article, go to http://reflections.yale.edu/article/future-race/unfinished-business-race, "The Unfinished Business of Race," scroll down to third article, accessed March 23, 2016.

Chapter 6

Carrying My Grandmother's Drum: Dancing the Home Within

Sashar Zarif

> I am in exile
> For when I am not in here
> I will never be out there
>
> –Sashar Zarif, excerpt from an untitled poem

In the summer of 2015, during a creative residency in Kyrgyzstan working with young artists, I encountered a Kyrgyz proverb that translates into English as: "There is no impurity in running water." This resonated with my long-held belief that a moving memory, in constant flow, is healthy. By "moving memory" I mean that remembering is amended by time, place, and a variety of other influences and variables.

Born to an Azerbaijani immigrant family living in exile in Iran, I am a child of revolution, war, prison, torture, and refugee camps. I have experienced involuntary displacement and placement. For me, home is like running water, where memory is fluid, and identity is a navigator.

As a child, I kept all my books, toys, pictures, and clothing in my room in my home, and I carried all my dances, songs, and stories in my body, emotions, and mind. Throughout my nomadic life, while the only physical part of my room and home that stayed intact was my grandmother's hand drum, the dances, songs, and stories that I carried internally never left me. These might have been reimagined or reformatted but they are always inside me. That is the reason for my quest to investigate home within the ever-changing body, especially in times of external exile.

Years of international touring, teaching traditional dance and music of my culture to Europeans, travels and research in Central Asia, Caucasus, Iran, and North Africa, my dance creations, and my many collaborations with any artist who would present a chance to review and renew my inherited longing for home have all contributed to my contemporary practice. It is that artistic practice which provides me with a way to explore and express my discoveries about how I perceive and, sometimes, inhabit home.

There are times that I am not at home when I speak in any of the many native and learned languages in which I am fluent, because I have an accent in all of them.

Grandmotherland

Moving/flowing memories were introduced to me by my grandmother. Every time she revisited memories of her father's home in Azerbaijan, she remembered something different. This gave her a perspective that allowed for creativity and enquiry.

As a child, when I was with my grandmother, her detailed stories, the emotional memory in her songs, and the body memory in her dance and physical movement, taught me about my history and my ancestral homeland. My moving/flowing memories creative practice stems from this stage of my life.

What I am writing here and now reflects my recollections in this time and place, and I know that these memories and my understanding of them will change by the time I am done, and will keep changing. This is the constant flow of moving memory.

The experience of living in a place other than home is part of my heritage. I was born into an Azerbaijani immigrant family living in Tehran, Iran. My grandmother arrived in Iran with her young family some years before World War II, but emotionally and psychologically, she never left her father's home. She engaged with her birth place, Baku, through stories, songs, and dances, increasingly during her last decade when her life was less hectic. During her final years, I, the youngest grandchild of her very late-born son, had the opportunity to spend many hours with her in her room, as her companion, her audience, and even her performance partner. In her room was an old hand-woven carpet that she refused to get rid of because it was one of the only things that she had brought with her from Soviet Azerbaijan. She was a singer and a dancer, which may explain why three of my aunts and my father were all singers and very good movers. For years, she inspired the whole family to dance, to play traditional Azerbaijani instruments, and to sing the popular songs of her era over and over again. With stories, rituals, songs, and dances, she invoked memories of a home we had never experienced. She transformed the rooms of our houses into her homeland.

Every day after my parents would leave to work, we would sit on the hand-woven carpet on the floor, as her tradition required. Many of her stories would start with this carpet. I can remember her saying,

> My dear child, this carpet has layers of stories from so many lives: human lives, animal life, and nature. We are not sitting on a carpet, we are sitting on history. This blood red carpet carries the destiny of the sheep in its wool, the intensity of the beet in colour, the soul of each hand that wove it in its every knot. One day you also will have your own carpet woven for you. Just make sure there are many flowers in it.

She would further explain to me how the weavers would sit in front of the loom for long hours and weave the melody of their hearts, and the rhythms of their life into every pattern.

The carpet was our stage: not a place to perform but a place to transform. We transformed her room in Tehran to her father's mansion in Baku, with the rose garden, the cypress trees, the arched gateways all around the balcony, and the golden fish in the sky blue pond that reflected the whole house and made the place seem twice as big. There we were on that carpet, telling stories, singing, dancing, and drumming ourselves to a somatic heaven, a place where all was joy, where even remembering the sad story of the loss of her mother was joyous to live through, an inner reality experienced through our body, mind, and emotions, in a place that I can now look back at and call home.

When I was eleven, my grandmother passed away at the age of ninety-nine, before the Iranian revolution of 1979. After her death, I visited her room, and realized that the place where we used to dance together and remember was just a small room in the crowded city of Tehran, with an old carpet, an ordinary door, and no balconies. I realized that what transformed the room was her hand drum accompanying her folk songs, her bamboo fan, and her body with her long neck and arms. It was the pair of dangling gold earrings, called *kashkooli*, that accompanied the animated stories with details that transported us to Baku. I came into the world finding my displaced grandmother trying to survive by relating to an imaginary place of her own, reimagining her home by transforming her exile.

Since her death, I have carried her hand drum with me: from Iran, to Turkey, to Canada, and throughout my nomadic dance career that has taken me across the globe, singing and dancing the same remembered stories, hers blended with my own, in every room I have inhabited. I have carried the drum with me in an attempt to create a place where I might belong, and to reimagine my home in my exile.

Years of Turmoil

I finished the last years of my childhood during the revolution, and at the start of the war between Iran and Iraq. Amidst political, social, and economic turmoil, I experienced war, sirens, bombings and bomb shelters, public and silent funerals of young and old people.[1] During the first half of my teenage years, I was one of many youth in Iran who followed the different politics of right and left and centre, in and out of school. My parents were not concerned with politics; they were just riding a wave of uncertainty, hoping it would take them towards survival. I continued to preserve my grandmother's legacy through performing with her hand drum, singing, dancing, and retelling her stories in the privacy of my own room.

At the same time, I joined my friends in exploring foreign music trends such as Supertramp, Kiss, and Scorpio. I started bringing all these new influences into my room, including music cassettes, posters, and books. My room became a museum of the East and West. I would adopt a new trend monthly, if not weekly, hoping to find a world to complement that of my grandmother. I was searching for a way to move my past into the present. This was my first attempt to find another way, to interpret past in the present, accessing and activating memories in a new context.

During this period, my room was invaded by one of several post-revolution militia organizations (called *Komeeteh*), and while all my belongings (including my 300 music cassettes, musical instruments, books, posters, and costumes) were confiscated, my grandmother's drum was, surprisingly, left behind in the living room. With my belongings, I was detained, all because of my involvement with dance and music. I was kept in solitary confinement, and every morning I was taken in for questioning sessions that ended with beatings. It took my parents a couple of months to extricate me from that situation. Before my arrest, in times of fear, sadness, or desperation, I would transport myself to the safety

and familiarity of my grandmother's lap by singing, dancing, or revisiting all her stories. But in that solitary cell I did not (or I don't recall) doing this. Maybe I did not dare, as my private world was full of forbidden elements for which I had already been arrested for practicing.

After my release I was terrified of further repercussions. It was as if my tormentors had succeeded in detaching me from my connection to music, dance, and stories. I had to disconnect from all that connected me to any of the experiences of my captivity. I suppressed all that had to do with dance and music for years, until I arrived in Canada, until I had my own room again.

I was hospitalized for internal infections that were a result of the beatings I had received while in custody. When I was released I began a long and challenging journey that took me from the hospital near Tehran, to a harrowing escape through my own version of the film *Midnight Express*, to refugee camps in Turkey.[2] Three-and-a-half tumultuous and trying years passed before my immigration to Canada. This was to be my new home, a haven from all of the struggles. But for me, Canada was just another land an ocean away, a new foster home in what I expected to be one of many.

I arrived at Pearson International Airport in Toronto, Canada carrying my UNHCR stateless status[3] and my Canadian Landed Immigrant document, and was taken in a black limousine to a Reception Centre at Yonge Street and Sheppard Avenue, behind a Miracle Mart Supermarket. I found a payphone and called my mother in Iran to let her know that I had arrived safely. Though I tried not to cry, I could not help myself when I heard my mother's voice. She reminded me that life is like a river, and that I needed to swim with the flow. She warned me not to give in to the current of the river, for if I did so, surely I would drown.[4]

Visiting My Grandmother's Father's Home

In 1993, during my second year of Systems Design Engineering at University of Waterloo, I had my first opportunity to visit Baku, the capital city of the ex-soviet Republic of Azerbaijan. After the de-unification of the Soviet Union, my parents had moved to Baku, and so I had a chance to reunite with them, and also visit the place of my grandmother's birth. My visit was during the period of post-independence political and economic instability, and the war in Azerbaijan. I found it impossible to find the reality of the world my grandmother had remembered and embellished so beautifully in her stories. My inner world crashed. If not for the extraordinary people I met, and the intensive dance and music training that I undertook over my nine months in Baku, I would have left right away. With the help of my father's best friend, famous singer Aghadadash Aghayev, I studied dance, music, and language with some of the country's foremost masters, including dance master Aslanov, who became my guide, for the time being. The combination of my longing for connection with my ancestral homeland and a desperation to recover the lost world my grandmother had introduced me to led me to study traditional art forms day and night until I reached a level

that was equivalent to three years of study. However, by the end of this period my private rituals of story, songs, and dance, including my grandmother's hand drum were all overshadowed by my new professional dance training. This happened, I came to understand, as a reaction to not being able to establish a connection with the past world of Azerbaijan through my grandmother's memories. I was learning through my own conscious mind, thought, and experiences, rather than through the combination of tacit knowledge and transferred knowledge I was so accustomed to.

Formation of My First Ethnographic Dance Ensemble: Joshgun

When I returned to Toronto, I started my own Azerbaijani dance classes for a group of exiled Iranian-Azerbaijanis. We created and performed *Azerbaijani Wedding* in two months, working from original choreography by my late dance master, Alikram Aslanov. The 25-minute performance took place on a large hand-woven carpet, and included more than twenty participants depicting folkloric characters, games, dances, and songs in a traditional wedding ritual. Following the success of this performance, within two years I had established a professional dance company, and was able to tour the province of Ontario with a dance repertoire consisting of remounts or new creations inspired by the traditional repertoire I had learned in Baku. I named the group after my late master's dance ensemble in Baku: Joshgun. The work we created was part of my intention to transfer my inner world to the public stage, and turn the dancers into characters from that world.

Though this group dissolved in a few years as the result of group members leaving to attend university and following their own paths, it holds an important place in my developing understanding of exilic performance and my relationship to home. Through my work with Joshgun, I realized that since my visit to Baku and the shock of not finding my grandmother's promised world there, I had preserved our imagined world and its practice internally.

The Post-Joshgun Era

During these periods of transition, I left the study of Engineering and enrolled in York University's Cultural Studies Program in Toronto, where I could work, learn, and collaborate with other artists, and be exposed to the world of arts, identity, and displacement, particularly in a first-year course titled "Performance and Identity." In this course, I began to consciously explore both personal and collective memory and history, and its impact on exilic being.

After this period of exploration and investigation, I created a dance performance that was significant to my development as an artist. In 2000, I was to perform at the fFIDA (Toronto's fringe Festival of Independent Dance Artists). Initially, I created a loosely choreographed traditional piece. Unsatisfied, I struggled to find inspiration. One day, as I was waiting for students from an adult dance class that I was teaching to arrive, I listened to a new CD

by Azerbaijani *Mugham* Music Master Alim Qasimov and his daughter, which presented *Mugham* in an accessible and contemporary composition, yet had not lost its traditionalism. I wondered how Master Qasimov could blend traditions with contemporary and personal elements. I listened to my favourite song on the CD repeatedly. It evoked a running river, fresh, flowing, coming from somewhere and going somewhere while simultaneously being present. I opened my arms and stood in the middle of the studio with my eyes closed, and just listened. I ignored all that came to my mind: thoughts, movements, and emotions, and just listened. And listened very carefully. I remembered my grandmother's advice to me whenever I lost my toys in her room. She would say, "Do not look for it, you are scaring it away. You need to stop, sit, close your eyes and listen. Then you will hear it calling you."

So I did the same thing: I listened, and waited for the creative inspiration to call to me. When the music ended I found myself spinning. The music took me on a "turning journey." I had discovered my piece for the festival: Master Qasimov's music and my whirling.

I called this dance creation *Kimlik* (2000) ("identity" in Azeri/Turkish). I associated this word with my experience in Turkey, where a stateless refugee with no documentation would be issued an official Turkish document with their picture on it that was called *kimlik*. In this dance work, for the first time, I let go of all of my dance, performance, and theatrical skills, immersed myself in the moment, and embraced the world in Master Qasimov's music. I found his world similar to my grandmother's not because of its Azerbaijanness but because of its transformative quality. I surrendered my body, mind, and emotions, and I just whirled. The choreographic structure was simple and confined to a few minutes at each of the four corners of the stage, after which I ended up at centre stage. My spinning in the first corner was homage to my ancestors and my grandmother, who I represented by placing my hand on my shoulders. Next I travelled, whirling, to the second corner, as I dropped my hand down from my shoulders to my arms. This second corner represented homage to my family and to the friends I had left behind in Iran and Turkey. Then I travelled, still whirling, to the third corner, as I brought my crossed arms to my chest, homage to me, here and now. The fourth whirling sequence brought me across the stage to the fourth corner, while I dropped my arms in front of me, clasping them. The fourth corner was homage to the future: potential, hopes, and dreams. Finally, an accelerated whirling sequence danced me to centre stage, as I expanded my arms and opened my palms towards the sky to receive what the universe would offer.[5]

As I was performing this piece, I remember my body revolving around my inner core, both making me feel taller, closer to the sky, and shorter as I spun, grounding myself deep into the earth. In between the height and the depth of this experience there was a place of uncertainty that allowed me to connect my inner and outer exiled being with the world in which I was living, a connection that I had not experienced for a very long time.

This profound experience, along with the recognition I received from the audience and my peers, encouraged me to tap into all my past knowledge and undertake further in-depth research of related inspirational Sufi poetry, dance, and music. In a year's time, I created *Beloved* (2001), another dance piece based on a much more complex piece of mystical music by Master Qasimov.

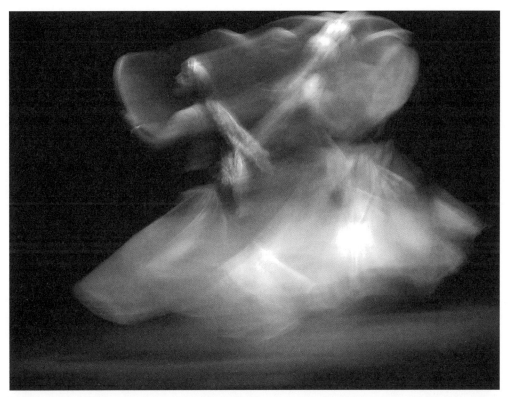

Figure 1: Sashar Zarif in *Beloved*, Centre Civic Can Felipa, Barcelona, Spain, May 19, 2005. Photo credit: Adam Colyer.

In 2000 I started touring in Europe, teaching and performing traditional dances and rituals from Azerbaijan, Iran, and Central Asia, along with my own new dance creations inspired by the experience of *Kimlik*. I taught students not only through my grandmother's stories, using her hand drum, but now also through my own remembered stories of longing and belonging. I played the drum, sang, and I became my grandmother, taking my students to another world. Wherever I travelled, I was carrying her drum in my hand and her room in my body. I was taking my home with me. Throughout this period, I experienced voluntary displacement. My nomadic practice, that river filled with flowing memories that defines my work even today, began in these years.

Reconnecting to the Idea of Home

In 2003, after nearly two decades, I was finally able to return to Iran, my birth place. My visit to Iran was a turning point. As with my earlier visit to Baku, I had expectations of what I would find. As an exile, I still carried within an idea of home that remained static, an archival

memory. I went to Iran expecting to see everything intact as I last remembered it. The reality was that I was changed as much if not more than my remembered home.

On the flight back to Toronto, I wrote on the back of a book I was reading, "I arrived to Canada too late and left Iran too early." Either way, I felt that part of my life had been stolen.

Later on that same flight, I had a dream (or maybe a vision) of my grandmother sitting by a river, washing her rug. I was further down the river, sitting on my own rug that I had purchased in Canada at a garage sale. I was waiting, anticipating something. She sang to me, telling me that everyone needed to wash their own rug in this river.

Back in Toronto, I recognized the need to further develop my dance practice in order to better tell my own stories that would reflect a complex reality that included my past and my present, as well as all the aspects of my identity, both the inherited and the experienced. I decided to return to *Mugham* music and the Sufi poetry that inspires it. I also decided to work directly with Master Qasimov on my next creations.[6]

On the other hand, my experience of being my grandmother through my teaching and performing in Europe led me to start weaving my own rug, and telling my own stories: those that emanated from my father's house in Iran, my new home Canada, and my itinerant home – my body. This artistic choice also brought my private world closer to my contemporary world.

Dancing *Mugham*

In January of 2004, I sent Master Qasimov the video of *Beloved* and invited him to assist me in reconstructing the traditional dance elements that historically accompany this style of music. In mid-spring of 2004, I went to Baku to undertake a four-month, in-studio experimentation with the Master himself, which I called *Dance of Mugham*.

Returning to Baku for the second time after eleven years, I did not intend to enter my grandmother's world, but rather I went to find my own world within hers. Pleased with the creative work and its potential, Master Qasimov helped to arrange a performance, a 50-minute work, titled *Mugham-Rast*,[7] in August of 2004 at the Gence Tamashachilar Theatre of Baku for an invited audience of local Azerbaijani artists and scholars. The piece was received with great enthusiasm.

I could return to Toronto with a clearer understanding of how moving/flowing memory was shaping my creative process, blending my understanding of Master Qasimov's *Mugham* music with inspiration from the moving/flowing memories instilled by my grandmother. The next stage in the evolution of my performance of exile was the construction of a movement vocabulary and syntax that would not contradict my need to maintain the flow of moving memory in relation to my current context.

In the fall of 2004, I started teaching at York University's Dance Department in Toronto, where I also concurrently began my Master of Arts degree in Dance Ethnology. This period gave me the chance to share my experiences with my students, and reflect on how I was

continuing to integrate my inner identity with my external practice in relation to a place and time.

At this point, I realized that I wanted to find a way to articulate how the influences of the home I carry within, and the knowledge transferred to me by my grandmother, could blend with what I was learning and practicing in my current environment. A breakthrough came when I was teaching a course, called "Introduction to World Dance Practices." I had to find a way to transfer my observations to students from a variety of cultural backgrounds. I also wanted to find resources to provide me with methods for developing, delineating, and disseminating my own dance style. This investigation became the subject of my Master of Arts Major Research Topic, the reimagination of a dance form called *Saghi*.[8]

This research project entailed creating a dance style employing vocabulary and syntax based on the music, poetry, culturally specific movement references, and Islamic calligraphy. For the next three years I worked intensively with Pirouz Yousefian,[9] a master of the Iranian *Dastgah* music, which is closely related to Azerbaijani *Mugham* music. His mastery in music composition, performance, and rhythmical pattern, along with his extensive knowledge of Sufi poetry and literature, made him a fundamental contributor to my project. The project gave birth to a new dance creation called *Meeting with Saghi* (2007). This full evening dance theatre work was meant to share not only my research findings, but also the process I had shaped.[10]

With this performance, I started a tradition of including a public gallery that would exhibit elements from the creation process for the audience that would be accessible before the show. This gallery, located in the theatre lobby, exhibited materials used in making the performance, including the symbolic materials that were removed from the choreography during the development process. The gallery was a display of my "room": the personal, internal home that had inspired the project. Books, instruments, notes, old costumes, audio, and visual material from my fieldwork were displayed. With this performance, and the exhibition of personal artifacts, my stories were going beyond the small carpet I used to sit on with my grandmother in her room. I was not sitting anymore, I was on the move, exploring the environment around me. My stories were not only about where I came from, but also an exploration of the possibilities my present life held.

In this production, an ensemble of three females joined me, portraying my *Saghi* characters. They began the dance dressed in heavily adorned, traditional Persian costumes, only to shed them within the first five minutes of the work to reveal simple, generic white pants and longs shirts, in which they performed for the rest of the show. The shedding of the elaborate costumes represented my willingness to go beyond the cultural and ethnic symbols that differentiate people, and focus on commonality. For most of the show, I stayed within a confined area, my back to the carpet, framed by a square shape created by stage lighting down stage right. This shape could be perceived as either a cage or a carpet (or both), depending on the interpretation of the audience. This design element referred to my initial point of connection to *Saghi*/this project. Gradually, through the choreography, I left my carpet/cage to meet the world. Eventually, by the end of the piece,

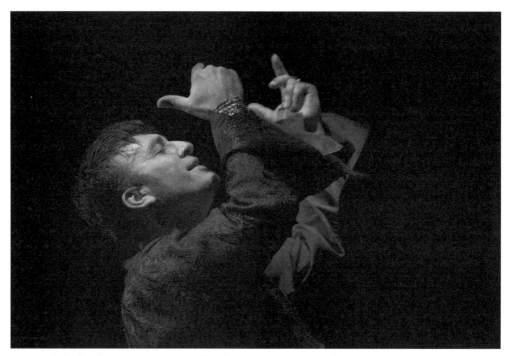

Figure 2: Sashar Zarif in *Sama-e Rast, Dance of Mugham*, Toronto Centre for the Arts, Toronto, Canada, December 21, 2012. Photo credit: Shahrokh Saeedi.

the carpet, or the lighting effect representing it, along with myself, expanded to embrace the whole stage. The lighting that created the frame in which I performed changed into projected writings in Islamic calligraphy that were intended to call forth the image of storytelling. The shapes of the letters were reflected in the main movement vocabulary of this section of the work.

This project gave me more tools and experience with which to return to Master Qasimov in Baku, and continue my work on *Dance of Mugham*. The culmination of my work with Master Qasimov was a world premiere of *Dance of Mugham* (2012) at the Toronto Centre for the Arts, with the live accompaniment of Master Qasimov and his acclaimed *Mugham* Ensemble. *Mugham* is a dance style that I have continued to reimagine over the past twelve years, and it is a physical language that allows me to access my memories and emotions. Further, this style of dance has given me the means of relating to my body in movement as a percussion instrument. I have come to understand this as carrying my grandmother's drum inside my body.

While I do not have the space to detail my entire repertoire, the following works offer examples of my ongoing commitment to sustaining my ties to my past, while maintaining a connection to my present and flowing towards the future.

Choreographies of Migration

At this point in my life, I was beginning to understand how to blend my internalized home with my life in Canada. My dance works had begun to reflect both aspects of my being in productions such as *Choreographies of Migration* (2008).[11]

In this program, I explored aspects of the migrations and cultural adaptations that ultimately led to my life in Canada. I positioned myself as an exile and a citizen simultaneously, letting the audience experience and consider their own origins and the notion of exile in a new way. This major presentation featured a solo, a trio, a quartet, and a duet, performed by a professional, cross-generational group of contemporary dance and music artists.

Each component of this work represented a different period of awareness and growth in my journey from Iran to Canada; each drew upon different styles, experiences, and cultural influences.

In the Letters of My Name[12] was initially inspired by the thirty-eight letters that spell my full name in three languages (Arabic, Persian, Azerbaijani), as tools to explore moments of my early life in Iran and my time in the Turkish refugee camps. The first in-studio creation rehearsal with my collaborator, Canadian choreographer, dancer, and dance professor Holly Small, triggered an intense series of memories of my forgotten past: the troubled period of revolution, war, and refugee camps. As I have explained, this type of remembering different or new pieces of the past is an important aspect of my moving/flowing memories process. This dance work started with me catching a drum, as it was rolled on stage, playing and singing with it, and then rolling it off stage. The drum was rolled on and off the stage several times as I interpreted different chapters of that particular period of my life. The creative process and the performance experience of this work was a type of coming out, or autobiographical ritual for me, as it was the first time I explored deeply personal experiences publically through artistic creation.[13]

Wait[14] again remembered my grandmother and her teachings. Female dancers performed in angelic white dresses I designed for them, drawing from the images of my grandmother's sister.[15] The choreography was drawn from the cultural body language and dances of my grandmother, depicting her stories of longing for home, whispering, as they always do, in my ears.

Created in honour of my sixteen-year-old cousin who was executed in Iran, *Anar* ("pomegranate") was a quartet.[16] The piece was performed primarily in four confined cubicles created by black stage drapes hung in sections across the entire stage. Each dancer was confined in a cubicle that resembled a solitary prison cell, like the one in which my cousin and I had been held. At moments, the cubicles also resembled my grandmother's room. This setting isolated the performers, placing them in exile. I designed an elaborate head piece with four braids, and added costumes resembling Turkmen Shamans. The costumes displaced my four seasoned, professional dance artists, four white Canadian bodies. With this work, I was exploring the idea of introducing a parallel experience to my

own displacement experience in the host society by subverting comfort and familiarity for both the performers, and the audiences.

Life is the Feeling of a Migrating Bird[17] was an autobiographical solo that I performed to live music, performed by musician Anne Bourne on cello with her vocals. This work interpreted my exilic experience in Canada. Bourne represented the host society, and the performance was an expression of my interaction and negotiation with my new environment.

For this production, there was a pre-show gallery exhibition in the lobby featuring some of my letters,[18] writings, and drawings from my time in the Turkish refugee camp, a video installation, and other cherished items that assisted in telling my story of exile.

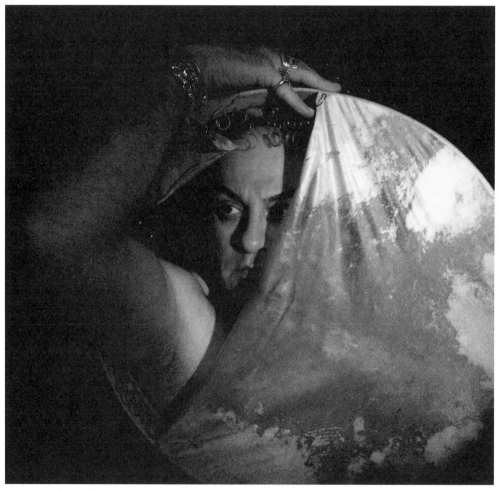

Figure 3: Sashar Zarif in improvisational development work during the creation of *Moving Memories: My Grandmother's Drum*, Toronto, Canada, May 1, 2015. Photo credit: Mahla Ghasempour.

The focal point of the gallery exhibition was an installation of my grandmother's drum, a symbol of both home and exile. It hung in the middle of the hallway, suspended from a dome-like skeleton (made from my grandmother's skirt) by invisible thread, turning continuously. To transform the drum's exile, I added the audio playback of a 1979 recording of my great aunt singing my grandmother's songs, accompanied by the same drum. As a further way of performing exile and involving the audience in the experience, at the entrance to the performance venue I positioned a student of mine, in full authentic Turkmen costume, who I trained to sit by a carpet loom and weave. The weaving started before the show, and continued until the performance ended and everyone had left the theatre. I also placed artifacts of my personal history including letters, post cards, and photos, between the upper strings of the loom as part of the weaving pattern.

Solos of My Life (2011)[19] revisited the stories and memories of my life from a different perspective. At this point in my life and in my career, I had merged my own stories with my grandmother's stories in my work to discover a hybrid that could blend past and present, there and here, flowing between the two.

This work is a collection of personal stories that I have carried with me for miles and years. These stories are the very foundation of who I was, who I am, and who I want to be. It is with these stories that I remember the past, relate to the present, and dream of the future through my moving/flowing memories. Bringing these stories into my current life has long been a goal of my artistic work, so that as I revisit these stories, I can move on, I can be on the move constantly; for when I don't move, I am in exile.

The work is based on four different solos that were created individually for four dancers, based on my memories of influential characters of my past: my grandmother, my mother, my playmate cousin, and I as a child. As the four solos are brought together side by side in different combinations on stage, the work uncovers the parallel sentiments experienced in each story by each character as I remember them.

There is a simple unadorned loom on stage that, through the piece, is dressed in strings to represent the weaving of the carpet. This loom represented another incarnation of my carpet that is being woven not only by me, but also the four other performers, and the characters and stories that they carry within. This was a performative expansion of the concept of home and exile that included not only me, but the world around me that I weave and am woven into.

Conclusion

My ongoing exploration into my relationship to exile, home, dance, memory, and process do not really lead to a conclusion, but rather to some concluding thoughts.

My struggle in life has shaped me, and brought me to a state of statelessness.

Memories are the traces of experiences, and our experiences are the process of and/or inquiry into evolution, development, and growth.

Much in the way one physically carries the genes of their ancestors, one carries their memories as well.

As much as I might consciously or unconsciously resist the concept of a nomadic existence, life itself is a nomadic process.

I like to move these flowing memories of mine, so first I need to identify them, inquire into them, wake them up, talk to them, work with them, and move them.

At this point of my life I question the meaning of exile, as home for me is becoming more of a process of longing than a place of belonging. Home is more about my inner reality surpassing the idea of geographical, cultural, sexual, economical, racial, and any other type of identity or external concepts.

Throughout my life, the only consistent thing close to the idea of a physical home that I have had is my body, with the dances, songs, and stories carried within. Besides this, all my belongings have come and gone except my grandmother's hand drum.

From the time that I embodied my aged, largely immobilized grandmother's legs in her dances, to the time that I left the study of Engineering to visit Baku in search of her dances, songs, and stories, to establishing my own Azerbaijani dance group in Toronto, to collaborating with different dance artists and inquiring into their dance forms, to the time I left all that to recreate my own dance form that contains all of me, I have been dancing. And that is what I do not know what to call: being in exile or being at home.

Notes

1. In some cases, funerals were forbidden. Sometimes families did not know of the deaths of their loved ones, or where their burial sites were located.
2. In the Turkish refugee camps, my experiences were bittersweet. Despite the terrible conditions, I found friends who helped me greatly, but I also shared a fear for my life with many fellow detainees.
3. This refers to the status conferred on stateless refugees by the Office of the United Nations High Commissioner for Refugees.
4. During my second semester at Eastern High School of Commerce (my first home in Canada, because I felt like I belonged when I was there), I became a member of the school's Race Relations Club, and by the third semester, I had started a new club called the Multicultural Art Society. Through the next two years I organized three multicultural shows, which were embraced by the faculty and students. Furthermore, I was acknowledged and I subsequently received several awards of merit, including East York Board of Education's Trustee's Award that reads "in recognition of your contributions to the priorities and initiatives of the Toronto School Board of Education." I began to feel at home, in an environment that allowed me to be creative. I was already finding my way to swim with the flow.
5. Before performing this work, I had also received the support of a Toronto Sufi master whose opinion I sought prior to performing the work. He validated my work as being a true dance of the heart, so I took *Kimlik* on stage.

6 *Kimlik* was presented in a revised version, *Beloved*, in which I brought in my grandmother's hand drum and singing, as well as dancing. In this iteration of the piece, the corners are not physically visited but rather invoked through different sections in the content, and vocabulary of the choreography. Set in part to another song by Master Alim Qasimov, this piece was performed in Germany, Czech Republic, Hungary, Slovakia, Spain, and Morocco (2000–2004). This was the piece that initiated my collaboration with Master Qasimov, and afforded me the opportunity to work with him live rather than by incorporating his recorded music.

7 *Rast* is the first of the seven main musical modes of *Mugham*, also referred to as the mother of the *Mugham*'s modes. This is because it has preserved its originality and functionality throughout history.

8 *Saghi,* meaning wine-bearer of the taverns of ruins, is a mystical character in Sufi poetry.

9 The full biography of Pirouz can be viewed on the Harbourfront Centre website at http://www.harbourfrontcentre.com/whatson/today.cfm?id=445, accessed March 18, 2016.

10 This work was my second attempt, after my experience with Master Qasimov, to create movement before the music, and have the music accommodate and be inspired by the choreography. It was also a turning point for me, as I realized that as I delved deeper into this project and built integrity and substance for this style of dance, I tended to organically simplify or remove the symbolic elements and materials, so that I could get closer to the core of the work.

11 Premiered on March 6–8, 2008, at the Enwave Theatre, Harbourfront Centre in Toronto.

12 Originally commissioned by Dance Ontario, this solo was performed by me, and was co-choreographed with Holly Small featuring music by John Oswald. It was the winner of the 2006 Paula Citron Award at the Toronto International Dance Festival (formerly fFIDA).

13 I would like to acknowledge the immense contribution to this work by Holly Small, who functioned as dramaturg, and by John Oswald, who created music from my singing and storytelling.

14 Choreographed by me, *Wait* was performed by dance artists Jennifer Bolt, Keiko Kitano, and Robyn Alfonso.

15 She was one of the heroic characters in my grandmother's stories.

16 Performed by professional dancers and York University dance professors Holly Small, Carol Anderson, Susan Cash, and Terrill Maguire.

17 The title of this work was inspired by a line in the poetry of an Iranian poet, Sohrabe Sepehri, which translates as: "Life is the estranged feeling of a migrating bird," which I simplified.

18 These were letters that I had written to my mother from Turkey and Canada after I left Iran. She kept all of them, and when we reunited in Canada, after thirteen years apart, she brought them with her for me in a big box.

19 Premiered on May 12–14, 2011, at Enwave Theatre, Harbourfront Centre with Sylvie Bouchard, Marie-Josée Chartier, Katherine Duncanson, Viv Moore, and Sashar Zarif. Dramaturgy by Soheil Parsa. The music was a blend of archival recorded music of Azerbaijan, and compositions by Sashar Zarif and Eric Cadesky.

Chapter 7

Blood Red: Rebecca Belmore's Vigil of Exile

Tara Atluri

To be an exile from one's native land in white settler colonial Canada is most violently and acutely experienced by those who are native to the land, particularly Indigenous women and Two-Spirited people. The everyday debasement of Indigenous people is part of an ongoing history of colonial violence in Canada. David Sanlal argues, "[…] sexual violence against Aboriginal women is legitimized by colonial attitudes that have created systematic racialized hatred and systemic discrimination […]."[1] The author further states that stories regarding violence against Indigenous women in the Canadian press, "[…] received six times less coverage; their articles were shorter and less likely to appear on the front page. Media constructs the image of Aboriginal women as bad or beyond redemption, which render the invisibility of the violence perpetrated against them."[2] Aboriginal artist Rebecca Belmore's artistic praxis and theatrical performance embody the incalculable losses and the survival endemic to those who are exiled within their "home and native land."[3] In this chapter, I discuss Belmore's performance art installation *Vigil* as a form of public art that offers insight into the body of the Indigenous woman as an exile within a white settler colony, whose alienation provides a position from which to perform inspirational and creative enactments of politics. Belmore's art should be contextualized in relation to what Julia Emberley terms the epistemic forms of "representational violence" that form the discursive background in which material, economic, physical, and sexual violence against Indigenous peoples occurs.[4] Belmore's public, street-based performances also exist in opposition to a mainstream culture of consumer branding in which images of Aboriginality and "the wild" are used in commercial branding campaigns. Belmore's artistic works provide an example of the embodied resistance of Indigenous feminist artists whose work offers a poignant commentary on colonial exile. In the context of contemporary Canada, where Indigenous women go "missing" and are murdered in routine acts of white settler violence, the appearance of Belmore's body and her body of poignant political artistic work functions as an aesthetic affront to the invisibility and debasement of Aboriginal people. The cruelty of racism and its aesthetic privileging of whiteness are challenged by Belmore's embodied and emotive artistic works. Despite platitudes of peace and multicultural harmony, Belmore's fierce performances and deft creative skills expose the racism of a nation that has exiled Indigenous people, and produces abhorrent forms of physical and sexual violence against Indigenous women.

Belmore's art is a creative enactment of political resistance. Shannon Bell discusses Belmore's performance art as a form of militant activism, arguing that Belmore's artistic performances are a "[…] knife to the heart of homogeneous society […]" exposing "[…] the other

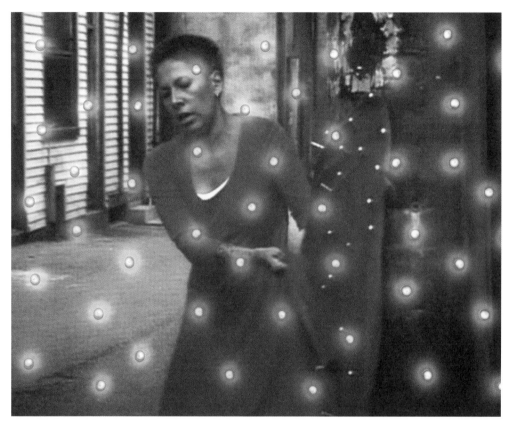

Figure 1: Rebecca Belmore. *The Named and the Unnamed* (2002). Video Installation. Collection of the Morris and Helen Belkin Art Gallery, The University of British Columbia. Purchased with the support of the Canada Council for the Arts Acquisition Assistance program and the Morris and Helen Belkin Foundation, 2005. Photo: Howard Ursuliak.

side, the history not known […]" and offering a "[…] political aesthetic of relentless, militant critique."[5] Rebecca Belmore's artistic work offers an anti-racist feminist critique that elucidates how white settler colonies such as Canada produce political exiles to support colonial occupation and genocide. Belmore uses her position as an exile within a colonial country as a point from which to produce creative forms of resistance and alternative discourses that challenge dominant nationalism.

Belmore's *Vigil* (2002) was performed in Vancouver, British Columbia as part of the Talking Stick Aboriginal Arts Festival.[6] A video installation that included a recording of *Vigil* titled *The Named and the Unnamed* was also exhibited at the Art Gallery of Ontario in Toronto, Ontario (2003).[7]

Vigil pays tribute to missing and murdered women from Vancouver's Downtown East Side (DTES), many of whom are Aboriginal. The original live performance of *Vigil* is documented on the artist's website:

Performing on a street corner in the Downtown East Side, Belmore commemorates the lives of missing and murdered aboriginal women who have disappeared from the streets of Vancouver. She scrubs the street on hands and knees, lights votive candles, and nails the long red dress she is wearing to a telephone pole. As she struggles to free herself, the dress is torn from her body and hangs in tatters from the nails, reminiscent of the tattered lives of women forced onto the streets for their survival in an alien urban environment. Once freed, Belmore, vulnerable and exposed in her underwear, silently reads the names of missing women that she has written on her arms and then yells them out one by one. After drawing a flower between her teeth, stripping it of blossom and leaf, just as the lives of these forgotten and dispossessed women were shredded in the teeth of indifference. Belmore lets each woman know that she is not forgotten: her spirit is evoked and she is given life by the power of naming.[8]

As part of *Vigil*, Belmore wrote the names on her arms of women whose lives have been lost to unspeakable violence, and she subsequently screamed out their names on the streets of Vancouver. Bell writes that as an artist Rebecca Belmore "[…] contextualized *Vigil* not as a work of mourning, but rather as a celebration of life, of lives that had ended traumatically and too soon."[9] Maggie Tate also discusses *Vigil* and *The Named and the Unnamed* stating that,

> Belmore's performance brings into consciousness the social problem of spaces and people being treated by Canadian officials as degenerate, unworthy and outside of the public imaginary of Canada.[10]

The construction of Indigenous women as "degenerate" and pushed to the margins of the nation state is structured by colonial history and expressive of contemporary racism in white settler Canada. Discussing the many cases of murdered and missing Indigenous women, Tate states,

> Between 1980 and 2002, more than 65 women were disappeared from the Downtown East Side area of Vancouver, British Columbia. As the poorest neighbourhood in Canada, this inner city space has been conceptualized within Vancouver as an unproductive space. A majority of the women who were disappeared were First Nations women and thus were historically marginalized from the imaginary of Canadian citizenship.[11]

The racism that exiles Aboriginal people from Canadian citizenship and mainstream culture is informed by class politics and the moral pathologizing of the colonized. Tate argues that the inordinate violence done to Aboriginal women is often ignored by the state and Canadian public, owing to the assumption that Indigenous people are morally and criminally deviant. Tate further argues that while the DTES of Vancouver has received a great deal of media attention, sexual and physical violence against Aboriginal women is not endemic to this neighbourhood and exists throughout Canada.

Vigil and *The Named and the Unnamed* are examples of uses of art to comment on the violence of exile in Canada, and to centre the resilience of Indigenous feminists. Discussing *Vigil*, Belmore states, "Those women lost their lives and I am alive still, I am calling their names out to the air, the breath of life, with my breath. I am alive, they are not alive. In that sense it is personal. I have this ability and opportunity to make performances."[12] The red dress Belmore wears in *Vigil* signifies female sexuality, and in wearing this symbol, she draws attention to the violent sexualization of Aboriginal women. At the end of Belmore's performance, pieces of a torn red dress remain on the streets, remnants of national genocide written in the blood of Native women, spilled on the streets of ostensibly good and clean countries, spaces of denial occupied by those who feel entitled through histories of colonial settler violence to call Aboriginal land home.

In addition to *Vigil*, Belmore has produced other work, including *Tent City* (2003), which was produced as part of anti-poverty demonstrations in Vancouver. The tent city protests in Vancouver were demonstrations against homelessness, displacement, and colonialism that took place in 2014 when participants occupied Oppenheimer Park in Vancouver's DTES. Those involved slept in tents erected in public spaces in an effort to challenge homelessness and the disillusion of the commons. Activist Harsha Walia suggests that the protests were tied to anti-colonial struggles. Walia states,

> Herein lies the greatest power of this tent city: the refusal to continuously be displaced and dispersed out of sight, the assertion of collective power including the power to defy unjust evictions, the beautiful daily practices of strengthening community relationships including sharing of meals and talking over a sacred fire which is impossible in one hundred square feet rooms, and the undeniable affirmation by Indigenous people of their title over unceded lands.[13]

Belmore's artistic work alluded to the relationship between the exile of Indigenous peoples and poverty in Canada through a filmed performance of her. In the filmed installation of Belmore's *Tent City*, the audience cannot see Belmore's body as she arranges objects that are used to signify poverty. The video installation depicts various materials found in the streets that signify homelessness such as street debris, cheap food, and other remnants of the lives and livelihoods of homeless exiles that the artist assembled. This video plays in conjunction with live footage from the tent city protests. Belmore's video installation was broadcast throughout Canada and globally, screening (in addition to Vancouver) in locations including Newfoundland, Australia, China, and Italy.

Another remarkable installation that critics throughout the world have commented on is Belmore's *Fountain* (2005), which was performed as part of the Venice Biennale. *Fountain* is a filmed performance of Belmore struggling in a body of water that turns to blood. The short film of this performance finishes with Belmore throwing a bucket of blood onto the camera screen, leaving a chilling final image for the viewer. Belmore states that the piece was filmed at "Iona Beach, between the Vancouver airport and West Vancouver First Nations. Iona Beach

is where we have the big sewer pipe going out into the ocean."[14] Commenting on the use of blood, Belmore states, "The blood between us becomes water. We war over oil. What is going to happen when it comes to water?"[15] Belmore's multidisciplinary and globally acclaimed artwork involves a utilization of artistic techniques to comment on forms of environmental and political destruction that continue to produce exiles of war and occupation.

Installations such as *Worth* (2010), which I discuss later in this chapter, offer an example of how Belmore uses public performance to question the relationship between commodification, art, and Indigenous land. Belmore's critique of capitalism and the inhospitable landscape of Canada exist in a genealogy of white settler violence and Indigenous resistance. Finally, I will discuss Belmore's installation *Freeze* (2006) that documents the chilling indifference to Aboriginal lives, artistically reflecting upon cases of Indigenous people who were left to freeze to death in contemporary Canada.

Haunted Houses

Images of White Domesticity and Wild Women

Julia Emberley writes of "representation violence" in colonial Canada as a form of epistemic brutality that supports material and economic forms of imperialism against Indigenous peoples. Technologies of representation such as photography and film were used in early colonial discourses in Canada to depict Aboriginal people as degenerate and morally reprehensible in order to justify colonial domination. The image of the wild woman, the ostensible paternal failings of the Aboriginal man as father, and the visual depiction of Indigenous children as those who were uncared for by parents appeared within mainstream media and historical writings to justify the forcible seizure of Native children from parents. The documented histories of abhorrent abuse of Indigenous people within the residential schooling system were hidden behind lies of white bourgeois innocence. The phantasm of the good white, Christian, and Catholic colonial family became a model of the political governance of the nation. The depiction of Indigenous peoples as those who could not govern their families was metaphoric for the derogatory invocation of Aboriginal people as unsuitable for political authority.[16] Such techniques of epistemic violence continue to haunt contemporary Canada and the derogatory images of Indigenous people that often appear within mainstream public culture. Emberley also argues that in colonial Canada, racist representations erased the diversity of Indigenous lives, causing the archetypal Aboriginal to appear as a familiar caricature of the complexity of Indigeneity. As she writes,

> [...] aboriginality signifies both a semiotics of subjugation and a mode of colonial representational violence in which the subject is made to vanish from historical veracity and reappear as a simulacrum. What images propose as the truth of "aboriginal peoples" is, ironically, a substitute for something that may have never existed to begin with.[17]

The spectral violence of colonial discourse did not simply misrepresent the Indigenous, but constructed them as a uniform group of people, obliterating traces of specificity between band, tribe, and nation. Within the lingering colonial imagery of white settler Canada, Cree, Ojibway, Anishinaabe, and several other tribes and nations are known simply as Aboriginal or Native, terms that efface the complexity of Indigenous lives. *Vigil* personalizes the lives and deaths of Indigenous women whose humanity and specificity of identity are collapsed into colonial categories that construct their bodies as targets of racist violence. Tate discusses violence against women in the DTES of Vancouver,

> [...] a majority of the women who were disappeared were First Nations women, a term that encompasses the numerous Aboriginal groups that are formally recognised by the Canadian government following the Indian Act of 1876. Because many were also allegedly sex workers and drug addicts, their disappearances garnered little attention from the police or from media outlets. They had already become invisible from the respectable Canadian social body by being situated in this area.[18]

Postcolonial theorists argue that colonial discourse revolves around succinct binaries of morality and identity. Within racist discourse, all Aboriginal people are reduced to a singular and vilified position. Belmore challenges the cruelty of this racism, in the streets. She also offers a critique of forms of identity politics that assume an Anishinaabe artist can and should represent all Aboriginal people. She discusses the burden of representation that racialized artists often face, to speak for all of "their people." Belmore states,

> I do a lot of "visiting artist" work for university programs and people cannot see beyond the "Indian-ness." I was recently asked during a visit if I ever got tired of always having to represent my people? I joked that I have never run for the position of "chief." Seriously, how do non-aboriginal people view themselves? That is my question.[19]

Albert Memmi writes of the "mark of the plural," a form of racism in which colonized people are asked to represent all those who are scripted as being like them through reductive colonial categories.[20] White male artists are not assumed to or expected to represent all white men, while racialized artists are judged in relation to a reductive categorization of Otherness. Belmore further argues that Anishinaabe identity cannot be equated with all forms of Aboriginality. Discussing her positionality as an Anishinaabe artist from Vancouver, she states, "I spent eleven years in Vancouver, on Coast Salish land, before moving to Winnipeg in 2012. We are culturally different people and have our own way of doing things, as First Nations we understand this."[21] Colonized bodies are constructed as uniformly Other in relation to dominant whiteness, ghostly apparitions of buried Indigenous histories that haunt the reductive ways in which the specificity of Aboriginal lives are made invisible in white settler Canada.

Burial Grounds and Camping Grounds

Space, Sexual Violence, and Public Art

While Belmore could perform installations such as *Vigil* in gallery space, the artist pointedly occupies public space. In interviews about *Vigil*, Belmore points to the importance of occupying the spaces of streets that have displaced so many Indigenous people, often to the point of death. Belmore also describes her installation for *Tent City*. She states,

> I performed in a studio space where we focused the camera on a square metre and on my hands – you didn't see me. I used materials of the poor that you find on the street: McDonald's food, clothing from the Salvation Army, I used bread, milk, I used objects, I washed cans. People collect cans to make a living through recycling. My performance was mixed live with tent city footage and the cityscape footage to blend into a live painting juxtaposing the wealth and poverty of the city.[22]

The figures of the homeless person and sex worker are not necessarily Native, as Indigenous persons occupy a range of diverse positions within the class strata of Canada. And yet, the relationship between urban poverty and Indigeneity is one that is deeply imbricated in colonial history and unfolds in city streets. Belanger, Awosoga, and Weasel Head state,

> The issues confronting all homeless populations are dire, but those facing the urban Aboriginal homeless population in particular are of mounting concern: growing numbers of urban émigrés lead to new residents integrating themselves into populations experiencing high birth and fertility rates. This quickly escalating population now represents more than 60 percent of the country's Aboriginal population, and 73.4 percent of the national Aboriginal households.[23]

Indigenous women, missing and murdered in Canadian cities, are a haunting presence in Belmore's *Vigil*. Their very right to life is threatened through a spatialization of fear. Vancouver's DTES is marked as a "bad" neighbourhood in ways that mark women on the streets as "bad" and deserving of violence. Belmore's installation offers a gripping and poignant challenge to the pathologization of both people and places through her defiant occupation of the city streets. Belmore states, "I prefer working outside in real space with my performance work. It has to do with autonomy. I am going to occupy this space for the time being. If you want to watch me you can. And if you don't, I don't give a shit."[24] Belmore refuses to remain silent, living in the midst of and in spite of Canada's ongoing colonial exile. Michel Foucault suggests that,

> [...] the anxiety of our era has to do fundamentally with space, no doubt a great deal more than with time. Time probably appears to us only as one of the various distributive operations that are possible for the elements that are spread out in space [...].[25]

The lives and deaths of Indigenous women on city streets are definitive of what Kannabiran terms, "[…] the violence of normal times […]."[26] In *Vigil*, *The Named and the Unnamed*, *Tent City*, and *The Fountain*, Belmore creates artistic worlds to reveal ongoing forms of colonial violence that haunt the landscape. Belmore discusses the significance of using her body to occupy public spaces artistically,

> Public space as a material is a good way of seeing my approach to making work, especially performance works. I take off my shoes, stand, and momentarily imagine how it must have been before Europeans made it theirs. My physical being becomes conceptually grounded, my female Indian-ness unquestionable. From this place I can address what is immediate and know that I am one in a long line of Indigenous artists.[27]

Rebecca Belmore's art of exile provides an eviscerating public critique of Canadian racism and the absence of justice in a nation of "missing" Indigenous women.

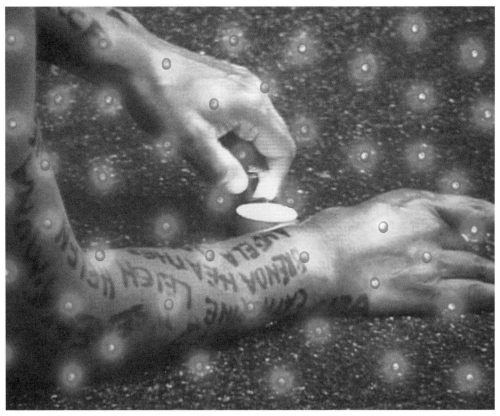

Figure 2: Rebecca Belmore. *The Named and the Unnamed* (2002). Video Installation. Collection of the Morris and Helen Belkin Art Gallery, The University of British Columbia. Purchased with the support of the Canada Council for the Arts Acquisition Assistance program and the Morris and Helen Belkin Foundation, 2005. Photo: Howard Ursuliak.

Seeing Red in the Streets

Empathy, Racism, and Invisible Pain

Commenting on recent governmental reports regarding "missing" and murdered Indigenous women in Canada, Belmore states that "[…] numbers can be numbing."[28] Belmore uses art to articulate traumas that cannot be expressed in cold, hard, numbers. She discusses her evocation of emotive responses from spectators, "In *Vigil*, I want them to feel. I am standing there, they are standing there, I am hollering the names of the women who are missing, we are aware that their names disappear. I think it creates a reckoning between the viewer and myself."[29] To empathize often involves being able to place one in the position of another, to imagine the circumstances that beset their lives. Silverstein writes of what some researchers term the "racial empathy gap" to discuss how skin colour can effect one's ability to empathize with others. Writing about the shooting of Treyvon Martin, an African American shot by a white police officer, Silverstein argues that race and racism inform different perceptions of the pain of others. As Silverstein writes,

> […] researchers at the University of Milano-Bicocca showed participants (all of whom were white) video clips of a needle or an eraser touching someone's skin. They measured participants' reactions through skin conductance tests – basically whether their hands got sweaty – which reflect activity in the pain matrix of the brain. If we see someone in pain, it triggers the same network in our brains that's activated when we are hurt. But people do not respond to the pain of others equally. In this experiment, when viewers saw white people receiving a painful stimulus, they responded more dramatically than they did for black people.[30]

Silverstein states that the "racial empathy gap" can be used to explain the racism of the criminal justice system, but also extends beyond institutional and judicial power to how the general public perceives pain through a racist gaze. He states,

> The racial empathy gap helps explain disparities in everything from pain management to the criminal justice system. But the problem isn't just that people disregard the pain of black people. It's somehow even worse. The problem is that the pain isn't even felt.[31]

In several studies regarding race, racism, and empathy, researchers found that if one appears to be more privileged, they garner more empathy regarding their perceived pain. As Silverstein states, making reference to research studies that attempt to gauge the relationship between racism and empathy within a cross section of the North American public,

> The more privilege assumed of the target, the more pain the participants perceived. Conversely, the more hardship assumed, the less pain perceived. The researchers

concluded that "the present work finds that people assume that, relative to whites, blacks feel less pain because they have faced more hardship."[32]

Racist representations of "strong Black women" and "warrior women," which may be used to celebrate the resilience of colonized people, produce emotionless images of Otherness. Simultaneously, derogatory images of deviant Indigenous people are normalized. Drawing on research regarding mainstream representations of Aboriginal women in Canadian media, Sanlal concludes that "[…] the discursive construction of Aboriginal women as social waste simultaneously organizes the narratives of Canadian media."[33] These representations, much like other caricatures of racialized lives, are used to enforce the imagined innocence and superiority of colonial whiteness. Sanlal states,

> […] the colonial manipulation of public perceptions of Aboriginal women rationalize their subjugation by constructing the idea of Indigenous women as the "Squaw Drudge" who is dirty, degraded, and a slave to men.[34]

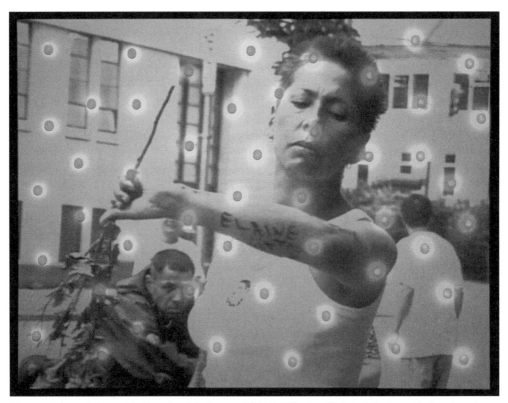

Figure 3: Rebecca Belmore. *The Named and the Unnamed* (2002). Video Installation. Collection of the Morris and Helen Belkin Art Gallery, The University of British Columbia. Purchased with the support of the Canada Council for the Arts Acquisition Assistance program and the Morris and Helen Belkin Foundation, 2005. Photo: Howard Ursuliak.

Sanlal further compares the construction of Native and non-Native women within Canadian media, discussing how the representational violence that defines Canadian colonial history continues to haunt images that are seamlessly woven into the mainstream media. He writes, "The media treatment of Aboriginal women victimizes the women again as they perpetuate the colonial views that Aboriginal women are inferior and insignificant."[35] Belmore challenges the rhetoric of Indigenous inferiority, using artistic tactics to counter mainstream representations of Aboriginal women. Installations such as *Vigil* also counter the mythic image of the "warrior woman" who can withstand the violence of colonialism, by publicly addressing the brutality that Indigenous women face.

Rebecca Belmore's artistic work also exposes the disturbing lack of empathy afforded to Indigenous people. Belmore makes specific reference to cases of extreme indifference to Aboriginal lives that inform her artistic praxis. She discusses the Robert William Pickton murders that took place between 1983 and 2002, horrific, documented cases in which a pig farmer kidnapped women from Vancouver's DTES, many of them Indigenous, subjecting them to sexual and physical torture, and subsequently murdering them. It is reported that Pickton fed the pigs on his farm with the bodies of Indigenous women he murdered, and was harvesting their bones.[36] Pickton was sentenced to life in prison in 2007.[37] Such cases of wretched violence inform Belmore's artistic praxis and her tenacity as an outspoken artist and critic.

Another reason that Belmore performs *Vigil* publicly is to generate emotion from spectators. She states, "Performance is calling attention, making people aware. I take a moment through performance to create a space to acknowledge that what is going on is important."[38] Other installations such as *Freeze* (2006) also comment on the chilling brutality of white settler colonial violence. Lee Ann Martin states that this installation,

> [...] brought attention to the fate of 17-year-old Neil Stonechild in Saskatoon, who in 1990 was taken outside of the city by police and was later found frozen to death, partially clothed and wearing only one shoe on a -28°C night. Authorities turned a blind eye to the case of the frozen boy in the snow for 10 years, until three more Aboriginal men were found frozen to death within two weeks in late January and early February 2000 [...].[39]

Freeze was part of Toronto's 2006 *Nuit Blanche* exhibition. This installation commented specifically on the death of Neil Stonechild. Belmore utilized artistry to offer a moment of collective catharsis for spectators in which they could enact forms of empathy that are often denied to Aboriginal people. She describes the staging of *Freeze* at *Nuit Blanche*,

> The letters of Stonechild's surname were etched deep into separate blocks of ice that were bonded together by water, then left to slowly melt. According to the audience count, 7,000 visitors passed through our space. Their warm hands touched and caressed the ice-cold surface that held his name, their heat conceptually and physically easing the harsh edge of reality.[40]

Rebecca Belmore further discusses how the deaths of Indigenous people that *Freeze* commemorated and exposed are endemic of state-led colonial violence. She states,

> Two of the freezing deaths in 2000 happened near the Queen Elizabeth Power Station. Darrell Night, a survivor of one of these deadly police excursions, was also abandoned here. He pounded on the door of the power station and was able to get help. A few days later, he would tell his story and burst this racist practice wide open [...].[41]

The shocking insignificance of Indigenous people's lives and deaths reflects a lack of empathy that haunts colonial Canada. Belmore's artistic work offers an intense and visceral spectacle that challenges the numbing racism of white settler ideologies.

Hipster Headdresses and Wild Women

The Gentrification of the Sacred

The ironies of Canada are felt in the exile of those who are Indigenous to the nation. Increasingly, urban displacement produces class-stratified urban spaces in which the colonizing ethos of affluent white settlers entitled to plant flags across world maps is expressed in the subtle racism that defines urban gentrification. One can consider clothing companies such as the American chain *Urban Outfitters* as a banal example of how contemporary corporate culture profits from ongoing histories of colonial violence. Paradis writes of the "Smudge Kit" in which the spiritual traditions of Aboriginal people were turned into hipster branding. As the author states,

> Urban Outfitters came under scrutiny for its sale of a "Local Branch Smudge Kit" ($39.99 on sale from $52.00), a sort of pseudo-ceremonial kit marketed towards hipsters as "energy balancing" that contains a wild turkey smudging feather, stoneware smudging dish, candle and instructions [...].[42]

Paradis discusses the reactions from Indigenous peoples in the Americas regarding the appropriation of sacred signifiers, often synonymous with urban hipster lifestyles of fashionable consumerist excess. The author states,

> Many indigenous people feel this is cultural appropriation. What is the big deal? To start with, there is not just one Native American culture; there are hundreds across the U.S. and Canada. Secondly, repeated missteps by retailers and non-indigenous fashion designers could be avoided if they took the opportunity to engage with indigenous communities in an authentic way, instead of commodifying and misappropriating sacred symbols.

Simply put: If Urban Outfitters loves the aboriginal aesthetic, maybe they should hire some aboriginal fashion designers and artists.[43]

Major corporations commodify both subaltern identities and avant garde aesthetics. Conversely, Indigenous female artists such as Belmore use creative mediums to offer a political commentary regarding enduring sacred Indigenous traditions. In *Vigil*, as with many of Belmore's performances, she smudges the ground before performing her installations, gesturing to her use of sacred Indigenous traditions as a form of postcolonial feminist politics. Without irony, Belmore invokes sacred religious and cultural traditions of Aboriginality as a testament to the use of the sacred as a means of postcolonial survival for the Indigenous.

Following a legal dispute with a gallery owner regarding finances and monetary compensation, Belmore created an installation titled *Worth*. In *Worth*, Belmore smudges the ground of Vancouver and proclaims loudly "I quit!" She then sits on the ground with a sign, which states, "I am worth more than a million dollars to my people."[44] The commodification of earth, of art, of sacred Indigenous traditions such as smudging are challenged in Belmore's use of the sacred as a form of political art. Belmore offers a confrontational performance in opposition to the commodification of Indigenous artists as exotic and undervalued tokens. Belmore invokes sacred signifiers as a political commentary in a time in which Indigenous symbols are sold en mass to consumers while Indigenous people face high levels of poverty, and Aboriginal artists struggle to survive in a mainstream art world dominated by affluent white men.

Body Language

Creative Grammars to Express the Untranslatable

Slavoj Zizek suggests that trauma cannot be fully expressed in rational ways.[45] It is arguably only through nontraditional mediums, where truth is not authorized as financial transactions are, that trauma can be expressed. Belmore's *Vigil* offers a stark performance in which trite platitudes of home are interrupted by the stuttering refrains of colonial history, tongues forever caught on English and French lies of civility. While feminism within mainstream middle-class life worlds is often an academic and institutional project that centres on the mastery of the Queen's English, postcolonial feminist artists like Belmore defy these scripts and stage their own walking revolutions. In contemporary Canada, Aboriginal languages are increasingly disappearing. One journalist states that "[…] of the more than 60 across the country that were registered in the 2011 census, only a relative handful – such as Cree, Ojibway, Oji-Cree and Dene – remain strong and viable, the latest numbers from Statistics Canada suggest."[46] In British Columbia, where more than half of Aboriginal languages were once spoken, all Indigenous dialects face extinction. Only one in twenty Aboriginal people remain fluent, and most of them are elders.[47]

The importance of Belmore's performance-based art lies in her use of the body as a tool that exhibits and challenges colonial violence. In a lecture given as part of the *Global Feminisms* exhibition (2010), Belmore discussed an impromptu performance that she enacted. Belmore narrated an event that took place as part of this exhibition where a fellow artist asked her to sing a song in her native language, to represent Canada. Belmore stated that unlike her mother and grandmother she had been alienated from her Indigenous language and was "[…] born to speak English."[48] To express the painful politics of being an exile in Canada, Belmore gave a performance for her fellow artists. She sang the national anthem in both English and French, while strangling herself with a scarf. This impromptu performance expressed Belmore's enduring embodied defiance.

The violence of colonialism is expressed in the very articulation of postcolonial critique in a colonizing language. The exiled body is one whose homelessness is clearly expressed in its inability to express this ontological trauma.[49] Gayatri Spivak states "[…] the task of the feminist translator is to see language as a clue to the workings of gendered agency."[50] Rebecca Belmore's body language enacts a feminist protest that utters the wretched sickness of colonial exile, and the remarkable tenacity of Indigenous feminist art praxis. Her prolific creativity demonstrates how the life of a subaltern artist can be one of exemplary integrity and philosophical significance. As Belmore states, "Whether it is about Aboriginal issues or women's issues, I try to make the work open enough so that it is bigger than the issue at hand. All of my work is basically trying to understand what it is to be alive."[51]

Notes

1. David Sanlal, "Stolen Sisters: Colonial Roots of Sexual Violence Against Aboriginal Women and Unsympathetic Media Representations toward Their Stories in Contemporary Canada," *Capstone Seminar Series* 5, no. 1 (2015): 13. To view full article, go to https://capstoneseminarseries.files.wordpress.com/2015/04/david-sanlal.pdf, accessed August 25, 2015.
2. Ibid., 3.
3. The phrase "home and native land" comes from the Canadian national anthem that is written and sung in Canada's two colonizing languages, English and French. There have been several debates regarding the lyrics of the national anthem, including critiques of the sexism of the phrase, "O Canada… in all our sons command." For more information, see John Ivison, "Margaret Atwood joins Prominent Canadian Women in Call for Gender-neutral Anthem 'Restoration,'" *National Post*, October 1, 2013, http://news.nationalpost.com/news/canada/margaret-atwood-joins-prominent-canadian-women-in-call-for-gender-neutral-anthem-restoration, accessed February 21, 2016.
4. Julia Emberley, *Defamiliarizing the Aboriginal: Cultural Practices and Decolonization in Canada* (Toronto: University of Toronto Press, 2007), 6.
5. Shannon Bell, "Rebecca Belmore: Fiercely Political, Politically Fierce," *Canadian Dimension* 43, no. 1 (Jan/Feb 2009): 36.

6 Rebecca Belmore, *Vigil* part of the Talking Stick Festival, Full Circle First Nations Performance, Firehall Theatre, Vancouver, BC, 2002.
7 Rebecca Belmore, *The Named and the Unnamed*, Art Gallery of Ontario, Toronto, 2003.
8 To view this page on Belmore's website, go to http://www.rebeccabelmore.com/video/Vigil.html, accessed August 25, 2015.
9 Bell, "Rebecca Belmore: Fiercely Political, Politically Fierce," 38.
10 Maggie Tate, "Representing Invisibility: Ghostly Aesthetics in Rebecca Belmore's Named and Unnamed," *Visual Studies* 30, no. 1 (2015): 24.
11 Ibid., 20.
12 Belmore cited in Bell, "Rebecca Belmore: Fiercely Political, Politically Fierce," 38.
13 Harsha Walia, "Tent City Occupants Have Law on Their Side," *The Vancouver Sun*, July 29, 2014. To view full article, go to http://www.vancouversun.com/travel/Opinion+Tent+city+occupants+have+their+side/10076172/story.html, accessed March 31, 2016.
14 Belmore cited in Bell, "Rebecca Belmore: Fiercely Political, Politically Fierce," 38.
15 Ibid.
16 Emberley, *Defamiliarizing the Aboriginal*, 45–47.
17 Ibid., 12.
18 Tate, "Representing Invisibility," 21.
19 Rebecca Belmore, "An Interview with Rebecca Belmore," by Wanda Nanibush, *Decolonization: Indigeneity, Education & Society* 3, no. 1 (2014): 215.
20 Albert Memmi, *The Colonizer and the Colonized* (London: Earthscan Publications, 2003), 129.
21 Belmore, "An Interview with Rebecca Belmore," 215.
22 Bell, "Rebecca Belmore: Fiercely Political, Politically Fierce," 38.
23 Yale Balenger, Olu Awosoga, and Gabrielle Weasel Head, "Homelessness, Urban Aboriginal People, and the Need for a National Enumeration," *Aboriginal Policy Studies* 2, no. 2 (2013): 5.
24 Belmore cited in Bell, "Rebecca Belmore: Fiercely Political, Politically Fierce," 37.
25 Michel Foucault and Jay Miskowiec, "Of Other Spaces," *Diacritics* 16, no. 1 (Spring 1986): 23.
26 Kalpana Kannabiran, *The Violence of Normal Times: Essays on Women's Lived Realities* (Delhi: Women Unlimited, 2006), 3.
27 Belmore, "An Interview with Rebecca Belmore," 216–17.
28 Rebecca Belmore, "Anishinaabe Artist Rebecca Belmore on Beauty and Horror," interview by Jian Ghomeshi, *Q Studio*, CBC Canada, 2014.
29 Belmore cited in Bell, "Rebecca Belmore: Fiercely Political, Politically Fierce," 38.
30 Jason Silverstein, "I Don't Feel Your Pain: A Failure of Empathy Perpetuates Racial Disparities," *Slate magazine*, June 27, 2013. To view full article, go to http://www.slate.com/articles/health_and_science/science/2013/06/racial_empathy_gap_people_don_t_perceive_pain_in_other_races.html, accessed August 25, 2015.
31 Ibid.
32 Ibid.
33 Sanlal, "Stolen Sisters," 3.
34 Ibid.
35 Ibid.

36 Rebecca Belmore, "Rebecca Belmore: Global Feminisms," YouTube video, from talks for the exhibition Global Feminisms March 23–24, 2007, posted by "Brooklyn Museum," April 28, 2010. To view full video, go to https://www.youtube.com/watch?v=YhWkrHDZue4, accessed February 2, 2016.
37 Megan O'Toole, "Seeking Justice for Canada's Murdered Women," *Aljazeera*, March 7, 2014. To view full article, go to http://www.aljazeera.com/indepth/features/2014/03/seeking-justice-canada-murdered-women-2014338655968569.html, accessed March 31, 2016.
38 Belmore cited in Bell, "Rebecca Belmore: Fiercely Political, Politically Fierce," 36.
39 Lee Ann Martin, "Out in the Cold: An Interview with Rebecca Belmore," *Canadian Art*, March 6, 2012. To view full article, go to http://canadianart.ca/features/rebecca-belmore-out-in-the-cold/, accessed March 17, 2016.
40 Ibid.
41 Ibid.
42 Danielle Paradis, "Urban Outfitters' Smudge Kit Is Insensitive Cultural Appropriation for the Low Price of $39.99," *Toronto Metro News*, April 8, 2015. To view full article, go to http://www.metronews.ca/views/2015/04/08/urban-outfitters-smudge-kit-is-insensitive-cultural-appropriation-for-the-low-price-39-99.html, accessed August 25, 2015.
43 Ibid.
44 Marsha Lederman, "The Story behind Rebecca Belmore's 'I Quit' Performance," *The Globe and Mail*, September 22, 2010. To view full article, go to http://www.theglobeandmail.com/arts/the-story-behind-rebecca-belmores-i-quit-performance/article4326740/, accessed March 13, 2016.
45 Slavoj Zizek, *Violence: Six Sideways Reflections* (London: Picador, 2008), 63.
46 "Once-Vibrant Languages Struggle for Survival," *CBC News*, October 24, 2012. To view full article, go to http://www.cbc.ca/news/canada/once-vibrant-aboriginal-languages-struggle-for-survival-1.1173659, accessed February 17, 2016.
47 Ibid.
48 Belmore, "Rebecca Belmore: Global Feminisms."
49 Suzanne Yang, "A Question of Accent: Ethnicity and Transference," in *The Psychoanalysis of Race*, ed. Christopher Lane (New York: Columbia University Press, 1998), 159–63.
50 Gayatri Spivak, "The Politics of Translation," in *Outside the Teaching Machine* (New York: Routledge, 1993), 179.
51 Belmore cited in Bell, "Rebecca Belmore: Fiercely Political, Politically Fierce," 37.

Chapter 8

Yaffa Mish Yaffa (Yaffa Is No Longer Yaffa)
From Diaspora to Homeland: Returning to Yaffa by Boat

Yamit Shimon

Displaced, refugee, homeland, homelessness, exile, outsider, out of place, stranger, and diaspora are a few of the words that are part of the discourse of the exilic experience. These words, whether describing a personal or collective condition, reveal the inherent connection between exilic experience and space.

In this chapter, I will discuss this connection by analyzing the performative event *From Diaspora to Homeland: Returning to Yaffa by Boat* that took place May 14 to May 16, 2015 in the city's old harbour.[1] The event, a sailing tour, invited the public to participate as passengers in a symbolic return home of the Palestinian refugees and the exiles of Jaffa/Yaffa/Yafo's Arab community, who had to leave during Israel's War of Independence in 1948. Many of those who left did so by boats and ships, and arrived as refugees to Alexandria, Egypt, and to diverse refugee camps in Lebanon and Gaza. *From Diaspora to Homeland: Returning to Yaffa by Boat* was intended to "illustrate an act of returning to Yaffa in the opposite direction, an act which seeks to turn the journey of refugeehood into one of return."[2]

In this chapter I will refer to the city of Jaffa by all three of its names:

JAFFA: The name commonly used in the English language to identify the city.
YAFFA: The Arabic name by which Arabs commonly refer to the city.
YAFO: The Hebrew name by which Jews and Israelis commonly refer to the city.[3]

The choice to use all three of these names in this chapter reflects my attempt to reveal, represent, and understand the complexity of this city with its different ethnic groups of inhabitants in a dialectical way. Further, by using all three names, I am resisting the hegemonic structure that using only one of the names would imply. Occasionally, when meaning dictates that I do so, I use one of the three names on its own.

From Diaspora to Homeland: Returning to Yaffa by Boat was one of the tours in the "Houses beyond the Hyphen"[4] project that was formed by *Zochrot* ("זוכרות" is the plural feminine formation of the verb "remembering" in present tense in Hebrew), a non-governmental organization, working within the Israeli community to promote acknowledgement of, accountability, and responsibility for the *Nakba*,[5] the Palestinian catastrophe of 1948. The organization, which was founded in 2002, acts in various creative modes in the fields of research, education, arts, publishing, memory strategy, and organized tours, focusing on the Palestinian/Israeli future, and creating the conditions for the return of Palestinian refugees.[6] The other tours that took place as part of the 2015 "Houses beyond the Hyphen" project were: *Echoing Yaffa: Vocal Tour of Manshiye*; *Fishing for Clues: Artistic action*; *Empty Façade – On*

Erasure and Reconstruction: Tour of Yaffa; and a tour to the Ajami neighbourhood, which occurred immediately after the sailing event.

"Houses beyond the Hyphen" took place over three days, and included exhibitions, open houses, and tours in the city. It was initiated by *Zochrot* to offer an alternative "bottom-up (re)reading"[7] of Jaffa/Yaffa/Yafo's urban space as a Palestinian city. The project aimed to enable an understanding of the space from the perspective of the streets and the people, independently from hegemonic forms of knowledge. On the event's Facebook page, the city is described as a space that "for the past 67 years has seen constant attempts to dim its visibility, cover its tracks, and above all control it."[8] This was the first year that "Houses beyond the Hyphen" was staged. After this first successful event, *Zochrot* embraced the project as part of its program for the following year.

Zochrot views the urban space of the city of Jaffa/Yaffa/Yafo, as a product of the hegemony of the Israeli state as a Jewish state. This identifies Jaffa/Yaffa/Yafo as a "(social) space is a (social) product," which, as Henri Lefebvre suggested also, "serves as a tool of thought and action; that in addition to being a means of production it is also a means of control, and hence of domination of power [...]."[9] This point of view, which refers to space as an embodiment of social relations,[10] offers to interpret the project and the event as an experience that reveals the various forces active in space, those that influence as well as construct its narrative, its mentality, and its design. Hence, in this chapter I propose interpreting the sailing event, *From Diaspora to Homeland: Returning to Yaffa by Boat*, as a performative political activist action in the hegemonic public space of the city of Jaffa/Yaffa/Yafo.

From Diaspora to Homeland

On a sunny Saturday on May 16, 2015, at 11:00 a.m., eighty people gathered in the harbour of Old Jaffa/Yaffa/Yafo to participate in the tour *From Diaspora to Homeland: Returning to Yaffa by Boat*. While other regularly scheduled tourist sailings depart from the port on a daily basis, this was a unique event, marking the sixty-seventh anniversary of the *Nakba*.

The meeting point for the event was the centre of the harbour's tourist area, where the tourist and leisure boats, and ships were anchored, waiting for people and groups to join tours. From this point, the people who came to participate in *From Diaspora to Homeland: Returning to Yaffa by Boat* were led to the *Sababa*,[11] the boat on which the event was to take place. Alongside the *Sababa*, there were a few fishing boats, pleasure crafts, and boats intended for youth-oriented sports activities. At the same time, there were crowds of people including families with children who came to enjoy a relaxing weekend in the Old Jaffa/Yaffa/Yafo Port, with its panoramic view, popular cafes and restaurants, and its cultural and entertainment programming.

The event was open to the public (with prior registration) and was publicized in different media, including promotional newspaper articles and press releases, in print and online,

a Facebook event page, *Zochrot*'s website, and a mailing list. On the day of the event, the audience participating in the sailing tour represented a diversity of constituencies: Israelis, Jews, Palestinians, Arabs, tourists, media professionals, an Arab member of the *Knesset* (the Israeli parliament), and even some children.

At the meeting point, *Zochrot* members wearing t-shirts printed with the word *Awda* ("عودة" or "return" in Arabic) welcomed the tour participants. Alongside the activist members of *Zochrot*, the crew of the ship *Sababa* also welcomed the passengers, and collected the sailing fee, as they would do for any regular sailing tour.

The participants boarded and settled on the ship's deck, sitting around tables, spending time together, mostly with the other passengers, the majority of whom had never met. The event's main activity during the sailing was a lecture containing historical information that was augmented by documentary photographs, music, and a personal testimony.

Umar Al-Ghubar, *Zochrot*'s Head of Landscape and Space Department, opened the sailing tour by announcing, in Hebrew and Arabic, that the event was dedicated to the sixty-seventh anniversary of the Palestinian *Nakba*. He referred to *Zochrot*'s choice to dedicate this journey to Jaffa/Yaffa/Yafo as an economic, cultural, and political centre of Palestine that had been demolished during the independence battles of the State of Israel (November 1947 to July 1949).[12] During the voyage, with both a view of the sea from the bow and a view of the city from the stern, Al-Ghubar gave historical background and spoke about life in Jaffa/Yaffa/Yafo when it was a Palestinian urban centre during the nineteenth century, during the Ottoman period, and throughout the British Mandate (1917–48). He spoke about the life of the Palestinians in the city during those years, including its lively market economy, thriving merchant trade, coffee house culture, sports activities, and the vibrant cultural and community life, all of which were disrupted by the war, and ultimately destroyed.

Al-Ghubar also spoke of more recent historical events and life in Jaffa/Yaffa/Yafo, before, during, and after the Israeli War of Independence. As part of his presentation during the event, he presented photographs that depicted Jaffa/Yaffa/Yafo, as a cultural and economic Palestinian centre, interspersed with photographs that documented the Palestinian refugees fleeing their homes on boats. The use of the photographs visually substantiated the information in his lecture, and helped the participants imagine the other life of Jaffa in its incarnation as Yaffa. The audience sat and listened to the lecture with rapt attention. Not everyone could see the photographs clearly during the tour, but after it was over, some of the participants were interested and asked to scrutinize the images more closely.

Al-Ghubar's intention, as he told me in our informal conversations after the event, was to "fill the historical voids, to eradicate the ignorance of Yaffa's history and to bring spirit into the story of the city of Yaffa as a Palestinian city before 1948."[13] During his lecture on the boat, Al-Ghubar spoke about the Palestinian Arabs' fear and insecurity during the battles that led the Palestinian people (or at least those of them who could afford it) to leave their homes in Jaffa/Yaffa/Yafo on refugee boats that took them by sea to Lebanon, Gaza, or Egypt.

Along with sharing the historical information and the photographs with the participants, the Palestinian song "Once Upon A Time I was in Yaffa" by the Rahbani Brothers was played

over the ship's sound system as a reminder of the desire to return to Jaffa/Yaffa/Yafo. The lyrics include a poignant expression of longing for home:

> As the wind blew we said: we shall return to Yaffa
> Today, the wind blows and roars […] but we will return to Yaffa
> And we shall return, O Yaffa […][14]

During the event, not only Al-Ghubar spoke. A significant part of the tour was dedicated to the personal story and testimony of Mr. Sha'ban Balaha, who fled Jaffa/Yaffa/Yafo as a teenager for Port Said, Egypt, by boat. During his testimony, Balaha sat at the head table, beside Al-Ghubar, and told his personal story in Arabic to the passengers, using the sound system to amplify his voice, while Al-Ghubar translated his words into Hebrew. The participants heard the testimony and its translation, but most of them could not see Balaha because of the way the tables were arranged, so only his head and white hair were visible to them. These moments on the boat provided access for participants to an evocative, deeply personal experience alongside the general historical information. Balaha's testimony gave visibility to stories that are not seen or heard often in the public sphere. It provided the

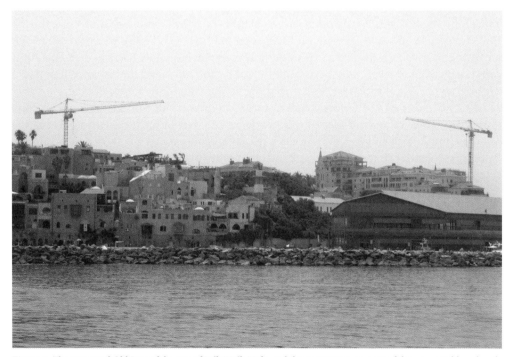

Figure 1: The renovated Old Port of the city of Jaffa/Yaffa/Yafo, and the contrasting scenery of the new neighbourhood of Andromeda as seen from on board the tourist boat, *Sababa*. Photo credit: Yamit Shimon.

framework for being exposed to the experience of exile through a bodily experience that existed "between the visible and the invisible, the material and the immaterial, palpable and the impalpable, the voice and the phenomenon."[15]

While he was telling his personal story, Balaha pointed in the direction of the visible cityscape of Jaffa/Yaffa/Yafo, to his family house, and to places he used to spend time with friends, all of which could be seen from the ship, merging his personal history with the history of the city. He also spoke about the war of 1948, and its specific battles, chronicling how he heard bombs exploding, and saw the wounded, which all became a common part of his daily life in Jaffa/Yaffa/Yafo.

Balaha's exile narrative continued, as he recounted his flight, as a teenager, without his family, on a refugee boat. He stayed in a military camp in Port Said, Egypt for a year, until he was transferred to a refugee camp in Gaza. Meanwhile, the battles ended and the State of Israel was established. Balaha's father obtained a certificate for family unification from the Israeli authorities, and Balaha returned by bus from Gaza to Gabaliya Beach in Jaffa/Yaffa/Yafo, where he reunited with his father after almost two years. Balaha recounted to the audience that when he arrived, his father ordered a taxi to take them to their home. He remembered that his father spoke in Hebrew to the taxi driver. Balaha was surprised and asked his father why he was speaking in Hebrew. His father explained that now the majority of the people in Jaffa/Yaffa/Yafo were Jews and that Hebrew was the new primary language of the city. This was Balaha's first encounter with his home city after the long period he had lived in exile. Balaha had succeeded in returning to Jaffa/Yaffa/Yafo, but "*Yaffa mish Yaffa*," he said in Arabic. "Yaffa was no longer Yaffa." The fabric of the city life and the people had changed, and Balaha didn't recognize his home.

Yaffa mish Yaffa

Yaffa mish Yaffa: Yaffa is no longer Yaffa. This statement resonated within me throughout the entire event of *From Diaspora to Homeland: Returning to Yaffa by Boat*, from the moment that it was uttered by Balaha during his testimony. In the Israeli-Palestinian political discourse, the designation of Palestinian refugees cited most frequently are those from 1948 who left their homes, and continue to live in physical and geographical exile. Balaha's personal testimony illuminated another aspect of the Palestinian refugee condition and exile that receives less attention in the general discourse. This is the exile of Jaffa/Yaffa/Yafo's people who returned to their city, but lost their homes, their familiar living space, and their homeland: home did not feel like home anymore.

The phrase *Yaffa mish Yaffa*, which is frequently spoken by the adult Arab residents of Jaffa/Yaffa/Yafo, points to internal exile and the paradoxical living situation that exists among those who returned to their homeland and now feel like strangers in their own home. If the purpose of the sailing event was to point out the possibility of Palestinian refugees returning to Jaffa/Yaffa/Yafo, and to highlight the Palestinian history of the city of Jaffa/Yaffa/Yafo,

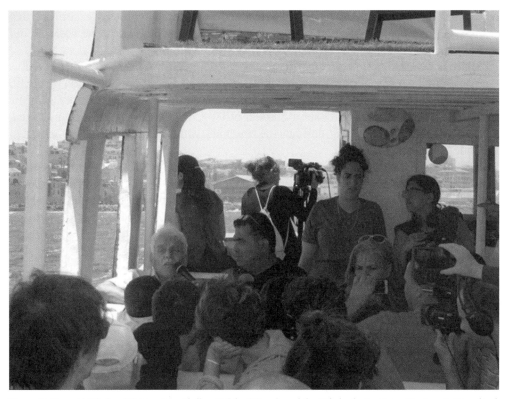

Figure 2: Umar Al-Ghubar (R) interviews Sha'ban Balaha (L) on board the *Sababa* during *From Diaspora to Homeland: Returning to Yaffa by Boat*, May 16, 2016. Photo credit: Khalil abu Shhada.

the live testimony offered by exiles such as Balaha highlighted the complexity of returning to a place that has been changed, the complexity of the existential experience of being in exile, and that the exilic experience does not necessarily depend on physical or geographical distance. In this way, Balaha's personal testimony gave presence to the potential of the internal and existential exile of the returners.

Rebecca Schneider suggests approaching performance "[…] as both the *act* of remaining and a means of re-appearance and 'reparticipation.'"[16] Regarding the live testimony, Balaha appeared in front of the participants in the event as a subject, while he embodied his memories and his pain at the loss of his home and his city. In this sense, in the living testimony the body became a kind of archive and host to a collective memory,[17] while the audience's participation in the sailing tour can be seen as a reparticipation in the collective memory and trauma of the experience of the Palestinian refugees who had to leave Jaffa/Yaffa/Yafo by boats from the same harbour in which the sailing event occurred. I suggest that the bodily aspects of the experience of sailing in the framework of the event, as well as its name, enabled an ephemeral participation in an exilic voyage.

The crowd that participated in the event experienced it in an active way: a bodily experience of the ship rolling on the waves, the feeling of the blowing wind, the view of the seashore and the buildings of the municipality of Tel Aviv-Yafo, and the encounter with the living testimony, linking the past and the present. All these made *From Diaspora to Homeland: Returning to Yaffa by Boat* a performance (of Balaha, the participants, and the tour itself) that challenged the loss[18] of the city of Yaffa, the Palestinian refugees in exile, and those who returned to Jaffa as Yafo, and, at the same time, live the loss of the homeland they came back to on a daily basis.

During the sailing event, most of the people sat around the tables and listened with interest to the lecture and testimony without any interruptions. Some of them took photos of the event, of their friends, and of the scenery they saw from the boat. There were no particular behaviours that could have characterized people as belonging to one ethnic group or another: Israeli Jews or Palestinian Arabs.

Besides the event's content, one thing that differentiated this sailing from other "regular" sailing tours was the presence of the journalists' cameras and the Arab Palestinian member of the Israeli parliament, Hanin Zoabi,[19] who is considered to be a radical and controversial figure within Israeli public opinion.

When the sailing was over, the passengers disembarked and exited onto the pier. These participants included Zoabi, who proceeded to give an interview in Hebrew to the media, where she said: "We are not talking about nostalgia, but about a national project for the return of the Palestinian refugees."[20]

While one could not notice a difference in the reactions of the diversity of people who were on board during the tour, when it was over, the situation was different. People in the harbour area who had not been passengers reacted to the big group disembarking, especially to the parliament member giving the interview. This presence in the public arena of the port, off the boat and outside the parameters of the event, created a provocation. Some people interrupted the interview, and a loud argument arose regarding Zoabi's presence at the event, and contesting her position as a member of the Israeli parliament, considering her calls for active violent resistance against the Israeli State and her alleged connection with Palestinian terrorists.

Meanwhile, participants from the tour who had backed away from the altercation re-assembled while Al-Ghubar gave them more information and explanations about Jaffa/Yaffa/Yafo, and allowed a closer look at the collection of photographs he had exhibited during the tour. The participants were invited to join a second part of the tour, on land, in the Arab Palestinian neighbourhood of Ajami. Most of the participants chose to continue to this part of the tour.[21]

As an activist event, *Zochrot*'s sailing tour resisted the constructed, the designed, and the production of Jaffa/Yaffa/Yafo's current urban site as an oriental space that was depleted of its Palestinian signs as part of an ongoing "Jewish transformation," neoliberal gentrification process, and the branding of Jaffa/Yaffa/Yafo as a leisure and culture tourist site.

During the tour, *Zochrot* suggested an alternative narrative for the city of Jaffa/Yaffa/Yafo and offered the Palestinian narrative of the city based on Balaha's testimony and the historical lecture. Balaha's personal story combined with the photographs of the city streets and city's central locations, before they were ruined and disappeared as a result of the current modern urban planning, enabled *Zochrot* to give place to the city of Yaffa in the current space of Jaffa/Yafo. This tour created the potential to imagine Yaffa and gave it visibility, even if temporarily, in the hegemonic space of Yafo.

Hence, I suggest interpreting *Zochrot*'s sailing tour as a tactical action that subverted the hegemonic spatial and political order by using the hegemonic space as part of the event itself.[22] *Zochrot* used the renovated tourist harbour, which is part of the results of the modern urban planning, its public visibility, as well as the *Sababa*, to construct the event's basic foundation.

In this sense, *From Diaspora to Homeland: Returning to Yaffa by Boat* can be understood as a creative tactic in the dominant urban net and a way to "compose the network of antidiscipline," as Michel de Certeau offered.[23] As such, the tour also had the potential to produce and to "lend a political dimension to everyday life practices."[24] After participating in *Zochrot*'s alternative tour, the pleasurable, unengaged, simple experience of walking and enjoying the old port of Jaffa/Yaffa/Yafo will not be the same as before for any of the participants.

Performance as Re:Location

Richard Schechner argues that "a performance [...] takes place only in action, interaction, and relation. Performance isn't 'in' anything, but 'between.'"[25] For him to analyze something *as* performance means "to investigate what the object does, how it interacts with other objects or beings, and how it relates to other objects or beings."[26] In the spirit of Schechner's approach, Sharon Aronson-Lehavi offers an understanding of performance as an ongoing process of relocation. By investigating artistic performances in the public sphere, she sees the process of relocation as "an aesthetic and social experience that is in constant state of motion between creators, performance and environment."[27] In addition, she defines the concept of "re:location" as "the social, aesthetic and the experimental meanings of the actual location of the performance [...] and its impacts as both artistic creativity and the spectators' experience."[28]

Following these two scholars, I suggest interpreting *From Diaspora to Homeland: Returning to Yaffa by Boat* as performance, and as an ongoing process of relocation and movement between the space, the living testimony, the monumental architecture of the city, the performativity of everyday life, and the event itself, in the present as well as in the past. This perspective, offering an understanding of the event according to the motion and the new relationships that were created between the space and the event's components, included: the sailing experience; the current urban space of Jaffa/Yaffa/Yafo harbour as a leisure and consumer tourist centre; the scenery of the city, and the view from the *Sababa* during the

sailing; the historical information, the photographs, the living testimony, the Palestinian song, and the participants' experiences as individuals or as a group audience.

Michel de Certeau made a distinction between "place" and "space." He identified "place" as the order, the law of "proper," stability, and the denying of a few things being at the same location. He defined "space" as such that "exists when one takes into consideration vectors of direction, velocities and time variables."[29]

I suggest that the sailing event, characterized by its performative, participatory, and ephemeral elements, constructed the city of Jaffa/Yaffa/Yafo as a "space" that "composed of intersections of mobile elements [...] functions in polyvalent unity of conflictual programs or contractual proximities," and as a practiced place.[30] The performances of the event created encounters between different elements, and in this way revealed Jaffa/Yaffa/Yafo's social space, not just as a social product that reflects power and hegemony, but also as simultaneity, as an encounter or assembly; social space as an assembly that includes "Everything: living beings, things, objects, works, signs and symbols."[31]

In this way, I suggest that the varied elements and the encounters between them (including the event itself, the historical information alongside the photographs of Jaffa/Yaffa/Yafo, and the refugee boats, Balaha's personal story and testimony, and the current urban space of Jaffa as part of the municipality of Tel Aviv-Yafo) acted as an evocative factor in the spatial and political system. According to the psychoanalyst Christopher Bollas, "Each person needs to feed on evocative objects, so-called 'food for thought,' which stimulate the self's psychic interests and elaborate the self's desire through engagement with the world objects."[32] *From Diaspora to Homeland: Returning to Yaffa by Boat* acted as an evocative performance in the public space that activated different elements as "food for thought," which enabled participants to rethink the social-political-spatial-historical relations in a way that encouraged them to be involved in the world.

Following this, I suggest that the participation in the alternative tour enabled participants to think and examine spatial relationships, and in this way to reconstruct the city of Jaffa as the city of Yaffa. This construction of Yaffa was enabled by introducing the Palestinian exilic dimension into the landscape of contemporary Jaffa/Yaffo. *From Diaspora to Homeland: Returning to Yaffa by Boat* did not just point to the special situation of the refugees that returned to Jaffa/Yaffa/Yafo, it also constructed the city as an exilic city. By that I mean a city that exists in its same location, but that has also been changed; a city in which people who lived there feel in exile despite their return to their homeland; a city that is torn between its identity as Yaffa and Yafo. In this respect, I propose that Jaffa reflects the ambivalence and the split identity, common to exiles, refugees, and immigrants, and sees exile as an existential experience of being in the world.

Analyzing the event as a performance and as a relocation process of political, social, and aesthetic meanings among the space, the participants, and the event itself, enabled me to think about the event as an element within the civic spatial system in which it took place. I perceived the event as an active element that, while active in the system, also activated other elements in it. Therefore, I would ask, what does this event reveal on a civic level? What

is the character of the exile that was revealed in the performance, and how do all of these connect to the political civic reality and the life within the Israeli/Palestinian sphere?

The Performative Archive of Exile

After considering the analysis of *From Diaspora to Homeland: Returning to Yaffa by Boat*, I suggest interpreting the event as a performative archive of exile. The etymology of the word archive comes from Greek, and refers to "public building" and as "a place where records are kept."[33] Rebecca Schneider adds that the Greek root of the word archive also "refers to the archon's *house* and, by extension, to the architecture of a social memory linked to the law."[34] In addition, she writes "The demand for a visible remains [...] would eventually become the architecture of a particular social power *over* memory."[35]

Diana Taylor, in her book *The Archive and the Repertoire*, defines the archive memory as that which "exists as documents, maps, literary texts," and "all those items supposedly resistant to change."[36] This kind of memory, she argues, "works across distance, over time and space [...] separating the source of 'knowledge' from the knower," and "leads to comments such as de Certeau's, that it is 'expansionist' and 'immunized against alterity.'"[37] On the other hand, she constructs the "repertoire" as performance gestures that enact the embodied memory and require the presence of the people "participating in the production and reproduction of knowledge by 'being there,' being part of the transmission."[38]

On the basis of these distinctions, I suggest that the sailing event created a collage composed of diverse materials that can be identified as archive materials (photographs, the song, architecture) alongside repertoire elements (the living testimony, the performance of everyday life). All these components existed together in a dynamic and performative system that created the conditions in which participants could think about their relations with each other and their meanings. The platform of the sailing event allowed the presentation of a variety of materials of Jaffa/Yaffa/Yafo's history and of the exilic Palestinian experience, while these issues were and still are being ignored in the Israeli state archive.[39] In addition, the participatory characteristic of the event enabled the creation of a kind of "performative archive" that was based on the encounter between the subject of knowledge and the knowers.

In this sense, *From Diaspora to Homeland: Returning to Yaffa by Boat* can be seen as an example of a performance that functioned as a vital act of transfer, transmitting social knowledge, memory, and identity,[40] and even as a system of knowledge that extended the concept of knowledge. In the spirit of Schneider's premises, I suggest that the event's participatory and performative characteristics challenged some of what had disappeared and was repressed from the urban space and the traditional archive. Mr. Balaha's testimony, alongside the photographs, the historical information, the actions of the people using the space, as well as the crowd of the participants comprised of Israelis and Palestinians, created multiple layers of the past and the present.[41] The event highlighted the possibility

and the potential of performance to treat the past "not as a timeline – accessed as a leap of backwards, and forward to the present again – but also as a multilayered sedimentation," while "the bearers of performance, those who engage in it, are also bearers of history who link the layers past-present-future."[42]

The performative archive of exile was neither limited to the hegemonic forms of knowledge, nor to the architecture of the modern archive that values the document over the event.[43] It enabled participants to construct, to present, and to participate in an active way with different modes and ways of knowledge. In this aspect, *From Diaspora to Homeland: Returning to Yaffa by Boat* resisted the construction of the "archive as a deposit of a time that is past, completed, one that poses no real threat to the power and to the law, and at most can serve for writing history."[44]

Considering this issue, Ariella Azulay suggests that instead of asking "What is the archive?" in a manner that keeps the archive external to our world, we have to ask: "What do we look for in an archive?"[45] Azulay's answer is: "[…] that which we have deposited there. Not necessarily you or I personally, but you and I as those sharing a world with others […] 'we' who ought to have been regarded as the reason and sense of the archive, but were instead replaced by 'history.'"[46] From this, we can extrapolate that *From Diaspora to Homeland: Returning to Yaffa by Boat* is a performative political activist action in the hegemonic public space that is very relevant to present life.

The conceptualization of the event as a performative archive of exile was driven not just by the event's content, but also by the dynamic form in which the content was enacted. If we think about the exile aspect of this performative archive, we can notice the symbolism of its lack of "place," that it is not a "public building" as part of the archon *house*, but rather, exists in a temporary site on a tourist ship.[47] From here, perhaps from this performative archive of exile, we can continue to think and conceptualize the civic potential within the form and the concept of the performative archive as an exilic and nomadic archive.

Notes

1. I am an Israeli researcher living in the conflicted and tangled society that is comprised of Israelis and Palestinians.
2. "Zochrot / ذاكرات / זוכרות", Facebook page, May 10, 2015. To view full post, go to https://www.facebook.com/Zochrot/photos/a.503319706349031.131021.487569804590688/1066727173341612/?type=3&theater, accessed February 3, 2016.
3. The name *Yafo* originally appeared in the Bible. Today, it refers specifically to the city that is part of the Israeli state.
4. In this context, a remark regarding the city's names is needed because of the use of the two different names of the city of Jaffa: the Arabic name *Yaffa*, and the Israeli name *Yafo*, which is connected to the city of *Tel Aviv* by a hyphen to its current formation as the municipality of *Tel Aviv-Yafo*. The project's name "Houses beyond the Hyphen" refers to this hyphen "as a sign designed to connect – but which in actual fact separates Yaffa from the Jewish city

Performing Exile

which has swallowed it ever since their forced unification as Tel Aviv-Jaffa in 1949." To view full site, go to http://zochrot.org/he/event/56224, accessed February 3, 2016.

5 The *Nakba* (النكبة "catastrophe" in Arabic) is the name the Palestinian people gave to the 1948 Palestinian exodus from Palestine/Israel. The common use of the term refers to the Palestinian Arabs who fled or were expelled from their homes, and the ruin of the Palestinian settlements during the Israeli War of Independence, between December 1947 and the beginning of 1949.

6 This information can be found in both following sources: Umar al-Ghubar (*Zochrot*'s Head of Landscape and Space Activity), in conversation with the author, January 18, 2016, Tel Aviv, Israel, and "Who We Are," *Zochrot Organization*, http://zochrot.org/en/content/17, accessed February 3, 2016.

7 "Zochrot / ذاكرات / זוכרות", Facebook page. To view full post, go to https://www.facebook.com/events/809480652439525/, accessed February 3, 2016.

8 Ibid.

9 Henri Lefebvre, *The Production of Space*, trans. Donald Nicholson-Smith (Oxford: Blackwell, 1991), 26.

10 Ibid., 27.

11 Sababa ("صَبَابَة" in Arabic; "סבבה" in Hebrew).
The meaning of the boat's name in the Hebrew slang is: great, cool, everything is just fine. The word is derived from the Arabic word "*sababa*," which means longing and ardent love. In spoken Arabic, the use of the word refers to something excellent and great.

12 While until the declaration of Israel's independence, the conflict took the shape of a civil war during the British mandate in Israel/Palestine, after May 29, 1948 it became an outright war between the newly formed state of Israel, and Jordan, Syria, Lebanon, Egypt, and Iraq, also involving volunteers from Saudi Arabia.

13 Umar al-Ghubar, in conversation with the author.

14 This video of the song was played during the tour, https://www.youtube.com/watch?v=dx895jr5JC0, accessed April 13, 2016.

15 Nicholas Mirzoeff, "Ghostwriting: Working Out Visual Culture," *Journal of Visual Culture* 1, no. 2 (2002): 239. To view full article, go to http://www.nicholasmirzoeff.com/Images/Mirzoeff_ghoswriting.pdf, accessed April 27, 2016.

16 Rebecca Schneider, *Performing Remains: Art and War in Times of Theatrical Reenactment* (London and New York: Routledge, 2011), 101; original emphasis.

17 Ibid.

18 Ibid., 103.

19 Hanin Zoabi, Arab Muslim Palestinian member of the *Knesset* – the Israeli parliament – from 2009 as a representative of the Arab party *Balad* (*National Democratic Assembly*; in Arabic الديمقراطي التجمع الوطني). Zoabi is perceived within the Israeli public as one who supports and identifies with Islamic Palestinian terrorist activity in Israel. Her statements and activities are controversial. For example, in May 2010, Zoabi participated in the *Gaza flotilla* that aimed to break the Israeli-Egyptian restrictions on the Gaza Strip. The flotilla resulted in the Israeli Defense Forces (IDF) taking over the flotilla in a violent confrontation between

the two sides. In addition, in June 2014, Zoabi was criticized and attacked after she met with the families of terrorists who kidnapped and murdered three Israeli teenagers. In response, there were loud voices in the Jewish Israeli public calling for the revoking of Zoabi's privileges as a parliament member.

20 YouTube video, 3:55, "שיבה משט," filmed May 2015, posted by "SocialTV," May 19, 2015. https://www.youtube.com/watch?v=Mvw59dV4Th0, accessed February 3, 2016.
21 The Ajami neighbourhood tour was guided by Umar al-Ghubar. On the tour the participants walked through Ajami's streets and alleys, and were given information about its history before and after the *Nakba* of the Palestinian people. During the walk, Umar identified houses of Palestinian refugees whom the Israeli State prevented from returning, and discussed the gentrification process that he characterized as part of the Judaization process of transformation of the area.
22 Michel de Certeau, *The Practice of Everyday Life*, trans. Steven Rendall (Berkeley: University of California Press, 1984), xiii–xiv.
23 Ibid., xv.
24 Ibid., xvii.
25 Richard Schechner, *Performance Studies: An Introduction* (Oxon: Routledge, 2006), 24.
26 Ibid.
27 Sharon Aronson-Lehavi, "Relocation," in *Performance Studies in Motion*, ed. Atay Citron, Sharon Aronson-Lehavi, and David Zerbib (New York: Bloomsbury Methuen Drama, 2014), 105–06.
28 Ibid.
29 de Certeau, *The Practice of Everyday Life*, 117.
30 Ibid.
31 Lefebvre, *The Production of Space*, 101.
32 Christopher Bollas, "Architecture and the Unconscious," in *The Christopher Bollas Reader*, ed. Christopher Bollas (New York: Routledge, 2011), 218.
33 Diana Taylor, *The Archive and the Repertoire: Performing Cultural Memory in the Americas* (Durham and London: Duke University, 2003), 16.
34 Schneider, *Performing Remains*, 99.
35 Ibid; original emphasis.
36 Taylor, *The Archive and the Repertoire*, 16.
37 Ibid., 19.
38 Ibid., 20.
39 Ariella Azulay, "Archive," *Political Concepts: A Critical Lexicon* 1 (Winter 2011). To view full article, go to http://www.politicalconcepts.org/issue1/archive/, accessed January 27, 2016.
40 Taylor, *The Archive and the Repertoire*, 2–3.
41 Diana Taylor, "Performance and/as History," *TDR Drama Review* 50, no. 1 (2006): 83.
42 Ibid.
43 Schneider, *Performing Remains*, 100.
44 Azulay, "Archive."

45 Ibid.
46 Ibid.
47 In this aspect, temporary sites can exist in diverse places, whether as walks evoking or re-creating alternative spaces, artistic performances, everyday life practices, or as activist actions in the public sphere.

Chapter 9

Belonging and Absence: Resisting the Division

Elena Marchevska

> Joe Mulroy: Why do you think he'll leave?
> Frank Dixon: Because he slipped through and fell in a crack. Nobody likes staying in a crack because they're nothing. Nobody likes to be stuck in a crack.
>
> – Steven Spielberg, *The Terminal*[1]

Borders have traditionally been seen as lines of division,[2] as the final line of resistance between a mythical "us" and an equally mythical "them": either a method of containment or a final barrier leading to ultimate liberation and freedom. At the time of writing (2015–16), an immense refugee crisis is unfolding in Europe. This creates a challenging context within which to examine the nature of borders, but one within which I considered it both urgent and valuable to explore trauma and the female body. These days I often evoke Michel de Certeau's aphorism: "What the map cuts up, the story cuts across."[3] I further advocate taking account of local context and transnational narratives while travelling between two types of knowledge: the official abstract maps and the personal embodied stories.

In the face of the current refugee crisis, it is important to contemplate forms of political art practice that address exile and immigration. This chapter will look at two feminist performances: Tanja Ostojić's *Looking for a husband with EU passport* (2001–05) and Lena Šimić's *Blood & Soil: we were always meant to meet...* (2011–14). Both projects are an aesthetic exploration of women's experiences of belonging and Otherness in borderland after the Yugoslavian war. Their works cluster around the exploration of personal, social, and political exile and displacement from country of origin. Notably, both artists have chosen to relocate from East to West Europe by (ab)using the institution of marriage. Their projects use performativity as a powerful lens through which to perceive the Other as unseen, to imagine a place outside the strictly defined border categories.[4]

The first part of this chapter will focus on differences between the concepts of border and borderland. This section will also introduce feminist performance strategies for dealing with the topic of borders and borderlands. The second part of the chapter will analyze the artists' approach to the body, and the history it inevitably carries. A very specific history, of bodies that have been trapped in liminal spaces for a very long period (both in a

geographical/historical sense and in a metaphorical and metonymical sense); bodies that have been captured in "a world of multiple crises and continuous fragmentations."[5] Both Šimić's and Ostojić's projects are multimedial; they combine performative elements, objects, photographs, originals or copies of official documents and private letters, self-produced artists' books, and online documentation.[6] This chapter will also explore how the particular choices of medium and autobiographical reflection made by Ostojić and Šimić contribute to the meaning produced in their work.

Finally, I must briefly mention that there are multiple layers of writing styles and voices in this chapter. There is the academic voice: analytical and critical, paying attention to detail. However, the reader will also encounter the autobiographical voice, present in my diary entries, printed in italics.[7] Though deeply involved in the personal landscape, my diary entries are not just autobiographical. I do not write solely about remembered moments perceived to have significantly impacted on the trajectory of my life. Rather I retrospectively and selectively write about events that stem from, or are made possible by, being part of a culture and/or by possessing a particular cultural identity – being an Eastern European woman who has immigrated to the West.

Exile Diary, Day 4

I do not have many close relatives who have emigrated or lived in different countries during their lifetime. My entire family have always been happy where they were, proud of their origins and struggling with the demanding economical and political conditions of the Balkan region. However, that struggle was constantly emphasized by my grandmother's story about her father, the only one who left the country – to go to Chicago in the USA. At that time, the beginning of the 20th century, it was an arduous journey, and one you would undertake if you wanted to disappear. Apparently he came back to get married and stayed in Macedonia, though the conditions of his return were always puzzling and nobody wanted to discuss them.

When I received my scholarship to attend the School of the Art Institute of Chicago, I went to see my grandmother. Having suffered a couple of strokes one after the other, she was struggling with dementia. When the news of my scholarship was shared at the table with our family, her eyes opened wide and for a moment she seemed to be quite her old self. She then took me by the hand and said that it was my job to fulfil the dreams of my great-grandfather. She showed me a box of old photographs, letters, and a passport with an American visa – memories that had not been shared with anyone before. The box was now mine, I deserved it. There were many reasons why Todor, my great-grandfather, was a silent man and never talked about his life in the USA. Mostly because every day he silently questioned his decision to return to Macedonia. It was a painful gift, a Pandora's box in a way, a gateway to someone's life story: so well kept.

Even now it puzzles me that these mediated memories, an aged window into a lost life, are such a strong burden for me. I am still struggling to understand why my grandmother thought that it was my job to fulfil his dreams and why until the day she died (just a couple of months after I left for the USA) the only things she remembered clearly were my name and my location. What was the process that linked all of us to this painful story of migration, borders and invisible liminality?

I never returned to live in Macedonia.

Border as Divisions: Encountering the Personal Crossing

In the face of the 2016 refugee crises in Europe, anxieties about national identities have surfaced with a vengeance. Despite the prolific "Refugees welcome" rhetoric, racial and ethnic profiling in train stations, airports, and on European cities' streets has escalated, revealing the "we" to be both contestatory and exclusionary. Few texts confront these issues more profoundly than Gloria Anzaldúa's *Borderland/La Frontera: The New Mestiza* (1987).[8] Anzaldúa interrogates dominant conceptions of nation and identity, exploring through the text's experimental format the challenging narratives of national identity, revealing the histories of exile, Otherness, and sexuality. Anzaldúa wrote this book as semi-autobiographical encounter with the historical oppression of the imposed border between the United States and Mexico. The most engaging aspect of this book is the encounter between the historical, rational language of high theory and the poetic language of myths and collective self-expression.

I suggest that it is particularly potent to think of Gloria Anzaldúa here, and the distinction that she makes between a border and the borderland. While borders are set up to define the places that are safe and unsafe, to distinguish us from them, a borderland is a vague and undetermined place created by the emotional residue of an unnatural boundary. The borderlands are loaded with meaning. Anzaldúa's borderland is in a constant state of transition. As described by Cixous, the borderland marked the zone of not belonging for her as a child. She poetically describes:

> I went toward France, without having had the idea of arriving there. Once in France I was not there. I saw that I would never arrive in France. I had not thought about it. At the beginning I was disturbed, surprised, I had so wanted to leave that I must have vaguely thought that leaving would lead to arriving. In the first naïve period it is very strange and difficult to not arrive where one is. For a year I felt the ground tremble, the streets repel me, I was sick. Until the day I understood there is no harm, only difficulties, in living in the zone without belonging.[9]

Female artists and theorists have explored the borderland and how it has been constructed through the body on many occasions throughout recent history. The practical explorations

have focused on what it means to be a woman and an artist in this borderland space. For Bracha Ettinger, both a philosopher and painter, the borderspace is not a boundary, a limit, an edge, or a division. It is, instead, a space shared between different subjects who, while they can never know each other, can, nonetheless, affect each other and share, each in different ways, a single event. Ettinger's borderspace relates back to Anzaldúa's borderland and the multidimensionality of this concept:

> The actual physical borderland that I am dealing with [...] is the US/Mexican border. The psychological borderlands, the sexual borderlands and the spiritual borderlands are not particular to the Southwest. In fact, the Borderlands are physically present wherever two or more cultures edge each other, where people of different races occupy the same territory, where under, lower, middle and upper classes touch, where the space between two individuals shrinks with intimacy.[10]

She is eloquent in her analysis of the psychological, the sexual, and the spiritual borderland, and argues that living in a state of constant division is similar to living in the shadows.[11] As Anzaldúa performs her own dislocations, her text poignantly reveals gaps in the current dominant national narrative, both in the United States and in Europe. Anzaldúa describes the ambivalence of the terms home and homeland in her poetry: "I stand at the edge where earth touches ocean/ where the two overlap/ a gentle coming together/ at other times violent crash."[12] There is only a momentary comfort found in the homeland, and these moments call for a flexible reading of what constitutes national identities and belonging. As argued by Berila, borderland links this border stasis to a political agenda of resisting and reinventing national identity; Anzaldúa calls for a new consciousness, allowing her to exist on both sides of the border without a violent division.[13]

Coco Fusco has suggested that art is a particularly valuable site for border disruption because "culture is a [...] critical, if not the most crucial, area of political struggle over identity."[14] The artwork analyzed in this chapter questions the form that a border takes, trying to challenge its accessibility, permeability, and potential as a contact and communication zone. This derives from the artists' experience of an actual border as the boundary line between two states; one which has a concrete location and a set of geographic attributes. In reality, however, it is a far more complex and nebulous entity, traversed in both directions, with a constant leakage of hostile bodies, never able to sustain the separations and protect the inhabitants in the way that its political authors intended.[15] Rosi Braidotti, a feminist theorist who deals with the issues of migration and displacement, states that being nomadic, homeless, an exile, a refugee, an itinerant migrant, or an illegal immigrant is not a metaphor. Being an immigrant has highly specific geopolitical and historical features and is history tattooed on the human body.[16] Francis Alÿs contemplates the need to spread stories and to generate situations that can provoke a sudden unexpected distancing from the immediate situation. He further questions assumptions about the way things are, and opens up a different vision of the situation, as if from the inside. He adds:

I think the artist can intervene by provoking a situation in which you suddenly step out of everyday life and start looking at things again from a different perspective – even if it is just for an instant. That may be the artist's privilege, and that's where his field of intervention differs from that of a NGO or a local journalist. Society allows (and maybe expects) the artist, unlike the journalist, the scientist, the scholar or the activist, to issue a statement without any demonstration: this is what we call poetic license.[17]

Exile Diary, Day 25

Living between two worlds can be demanding. Like an illness, you can't escape from it. It is so deep in your body. It covers every border that protects you from outside. You can articulate yourself through citizenship, but deep inside you know that the citizenship never articulates, it only imposes form.

Delivery at gate.
There are two gates. One in. One out. And me in between.
A: "We miss you so much." Her eyes get tearful.
I can't deliver the news.
B: "Maybe we will stay."
A: "Stay where?"
B: "I am not quite sure…."
I am thinking of my great grandfather. How do you deliver a loss?

Resisting the Division: Questioning Belonging

The first time I saw the work of Tanja Ostojić, *Looking for a husband with EU Passport*, as part of the project *Capital and Gender*[18] in Macedonia, I was in my early twenties, and felt stuck in a country[19] that had suffered years of political turmoil and economical struggle, and was literally shut down due to embargos and strict visa regimes. It was very easy for me to relate to her work and recognize multiple narratives entangled in the provocative posters plastered on billboards, shop windows, and alleys around the city of Skopje.

I still vividly remember her distributing flyers to unsuspecting shoppers in the City Shopping Mall as part of the group public art project *Perfect Match*. Ostojić started this project in August 2000. After publishing an advertisement with the title *Looking for a husband with EU passport* she exchanged more than five hundred letters with numerous applicants from around the world. After a correspondence of six months with a German man, K.G., Ostojić arranged a first meeting as a public performance, in a field in front of the Museum of Contemporary Art in Belgrade, in 2001. One month later, she was officially married to him in New Belgrade. With the international marriage certificate and other

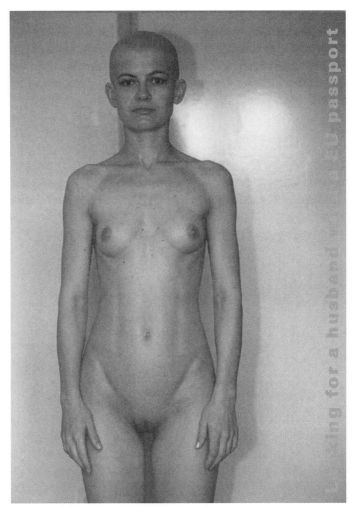

Figure 1: "The Ad," *Looking for a Husband with EU Passport* (2000–2005), Participatory web project/combined media installation, Belgrade, Serbia. Courtesy: Tanja Ostojić. Photo: Borut Krajnc.

required documents, she applied for a visa. After a further two months, she obtained a family unification visa and moved to Dusseldorf.[20] Initially manifesting as a simple homepage on the Internet featuring a personal advertisement, the project blurs the boundaries between artist and artwork, biography and artistic practice. As argued by Gade, Ostojić has, in several ways, given her actions the shape of performance.[21] The meeting with her future husband, waiting in a line for a visa, the German lessons, are all staged and real at the same time, a performance of the process of becoming an EU citizen. All these performances were

Figure 2: "Under EU Flag," from *Looking for a Husband with EU Passport*, 2000–2005, Participatory web project/combined media installation. Düsseldorf, Germany. Courtesy: Tanja Ostojić.

carefully filmed and documented and were exhibited in galleries and museums afterwards, along with the e-mail correspondence with suitors, her passport, and images of her life-changing journey. As further asserted by Gade, this instrumentalization of the work in part involves instrumentalizing of the artist's body and personality, because the stake of the work is Ostojić herself.[22]

After fifteen years, what still resonates strongly with me is the complexity of her performative expression and the self-irony that allows the viewer to travel with her beyond national borders. Ostojić is making the private act public and is consequently empowered by this transposition. The documentation allows a performative entry into an imagined, but also very real threshold identity created by Ostojić. Victor Turner argues that there are "threshold people" (liminal personae) who "elude or slip through the network of classification that normally locates states and positions in cultural space."[23] Threshold people exist in in-between spaces where new beginnings and unexpected combinations can occur. Neither entirely inside nor fully outside any single community, they adopt ambivalent insider/outsider positions in relation to a variety of cultural, professional, gender, and sexual groups. But threshold positions can be dangerous, uncomfortable locations. Thresholds mark crisis points, spaces where conflicting values, ideas, and beliefs converge, unsettling

fixed categories of meaning. As argued by Ostojić herself: "In order to claim my own rights, which I have been deprived of under current EU laws, I explicitly applied the strategy of tricking the law to gain the right to move freely, and live and work in diverse locations."[24] She consciously inhabits this threshold where normal limits to thought, self-understanding, and behaviour are undone. In such situations, according to Turner, the very structure of society is temporarily suspended and allows the possibility of new perspectives. Threshold locations are performative. By performatively translating her life into an artwork, Ostojić reinvents herself and enacts new forms of identity. This challenges the viewer to rethink the dominant culture's socio-political inscriptions.

Ostojić's work can be classified under what Trinh Minh-Ha describes as "boundary events." For Minh-Ha, boundaries signal endings and beginnings at the same time; "There where one stops to exit is also there where one stops to enter anew."[25] Boundary events are situated at the edge of many binaries, where thinking is acting on both sides. What comes out also comes in, what reaches great depths also travels great distances. However, creating artwork about the border is challenging; Lucy Lippard highlights the difficulty of this approach:

> Among the pitfalls of writing about art made by those with different cultural backgrounds is the temptation to fix our gaze solely on the familiarities and the unfamiliarity, on the neutral and the exotic, rather than on the area in between – the fertile, liminal ground where new meanings germinate and where common experiences in different contexts can provoke new bonds. The location of meaning too specifically on solid ground risks the loss of those elements most likely to carry us across borders.[26]

Ostojić is firmly focused on the fragility of the border, on the story of coming up against the same thing over and over again. Ahmed argues that what stops movement moves: "If you witness only the movement […] you are not witnessing what (or who) is being stopped."[27] This also links back to Anzaldúa, who states that "Living on borders and in margins, keeping intact one's shifting and multiple identity and integrity, is like trying to swim in a new element, an 'alien' element. It is living in the shadows, living being constantly divided."[28]

Exile Diary, Day 26

> *Chicago, winter 2003. At a friend's baby shower party. It is the first winter day, snow and wind, it is absolutely freezing outside. Standing next to a woman that I just met, waiting for our guest of honour to come. I hardly know anyone at this party; moreover, it is my first experience of a baby shower. She tries to understand where Macedonia is, I try to explain what I am doing here. And there she is, covered in snow, in a long greyish, old coat probably borrowed from her husband, her hair is soaking wet, and her face is pale from the cold. She enters shivering with a hesitant smile, her belly popping the buttons of the coat. A man from the far end of the room, half drunkenly yells at her.*

"Oh, there she is! Ann, with that bump you look like an Eastern European woman. Like a female version of Tom Hanks in that movie… What was the name…"
And bursts out in loud laughter.
She smiles back at him, puzzled by the comment, and then her gaze is frozen on my face. Her lips move in a whisper:
"Sorry."
I just wave my hand…
The woman next to me asks:
"So Macedonia was in Eastern Europe?"
I nod with my head, starring at my shadow, thinking to myself,
"Can you tell that I am Eastern European?"

Economics of Belonging: Becoming Legal

Nina Power has openly questioned, in the book *One Dimensional Woman*, the purpose and economics of feminism today, and how we have done little to address the real questions of emancipation in the last decade. And that is:

That personal is no longer just political, it's economic through and through. The blurring of work, social, personal and physical life is almost total. If feminism is to have a future, it has to recognize the new ways in which life and existence are colonized by new forms of domination that go far beyond objectification as it used to be understood.[29]

In the performance event *Blood & Soil: we were always meant to meet…* Lena Šimić seeks to problematize notions and economies of citizenship and belonging. By exposing the application process for becoming British in the United Kingdom, Šimić encroaches on territories of legality, personal decisions, and intergenerational responsibility. The border alters the way that bodies carry and perform themselves, not only in the moment of encounter but for years (and even generations) afterwards. Entire cultures have been defined by the proximity to a border or by the border crossing of ancestors.

Šimić frames her performative investigatory journey through *Blood and Soil*, by asking British friends and colleagues to give her a task to accomplish that will help her to "become British." This was followed by a performance that was conceived as a "community exam" where the audience members took the "Life in the UK" test – an obligatory test for all immigrants applying for British citizenship and for Indefinite Leave to Remain. Throughout the performance/test, two performers (Lena Šimić and Jennifer Verson) map their stories of multiple belongings to the British isle. The performance event addresses the question of how texts regulate, map, and shape real living bodies. This performance reveals the complexity of citizenship acquired through birth and naturalized citizenship. Nyers argues that

[c]itizenship is a concept that is derived from a specifically European lineage and so represents a kind of conceptual imperialism that effaces other ways of being political [...] for all the innovations in how we conceive of citizenship, the concept remains deeply embedded with practices that divide humanity according to race, ethnicity, gender and geography.³⁰

Citizenship is being employed to both "secure the borders" and "secure the future" according to Tyler, through an "active citizenship agenda" in school and communities, which aims to transform unruly migrants into productive citizens, through education and tests.³¹

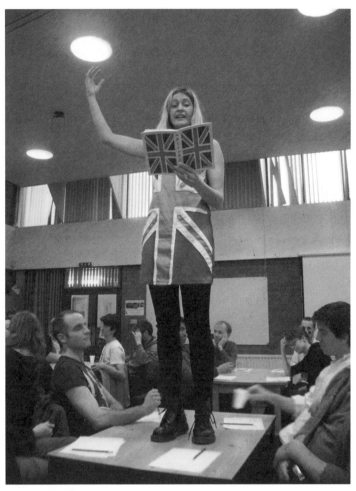

Figure 3: Lena Šimić in *Blood & Soil: we were always meant to meet...* at West Everton Community Council, Liverpool, UK, April 1, 2011. Courtesy of Lena Šimić (permission of the artist). Photo credit: Dejan Karadaglić.

Šimić, in her collaborative project, foregrounds Avtar Brah's argument that the emerging hybrid identities challenge the assumption of monoculturalism in Europe.[32] It is evident from her "Endnotes on How to become British" that at times home is nowhere, that she belongs in the margin, that she lives on the edge. Her home life consists of the following: there are three kids, her performance practice, Institute for the Art and Practice of Dissent at home, PhD, and marriage with Gary (although they married just for papers). This itemization works with hooks' argument that "home is that place which enables and promotes varied and ever-changing perspectives, a place where one discovers new ways of seeing reality, frontiers of difference."[33] hooks identifies marginality as the site of radical possibility, a space of resistance. Marginality offers the possibility to imagine alternatives, new worlds. This brings us back once more to Anzaldúa's borderland and to her assertion that

> [b]orders are set up to define places that are safe and unsafe, to distinguish us from them. A border is a dividing line, a narrow strip along a steep edge. A borderland is a vague and undetermined place created by the emotional residue of an unnatural boundary. It is a constant state of transition.[34]

Absent Belonging: The Levels of Europeanness

"Fortress Europe"[35] has acquired a whole new meaning since 2014. But in order to explain the levels of Europeanness and belonging/being European that are emerging from current crises, I need to resort to nominal symbology, derived from the continent-designated Greek name. The myth of Europe brings to attention human union with the bull as the symbolic representation of strength and fertility. Thus, Europe still strongly signifies fecundity, wealth, and abundance. And, as such, it is perceived as a desired location for immigrants and refugees.

The phenomenon of the border, its constitution, shifts, and apparent dissolution, has increasingly become the subject of negotiations and rethinking in EU politics. Both Ostojić and Šimić are European, but their place of birth prevents them from claiming a legitimate European identity that will allow them to work or travel to what is currently defined as the European Union (2008). Braidotti elaborates on this and argues that people from the Balkans, and some parts of the South-Eastern regions of Europe, are not yet perceived as "good Europeans."[36] For non-EU Europeans, the passage through a passport office requires many forms of identification, proof, and guarantees of identity. Alexandrova and Lyon highlight the process of justification requested particularly from migrant women from Eastern Europe, who are required to outline the reasons and explain their decisions to cross the national border. Ostojić claims that women move across borders to gain agency and to improve their lives. By drawing attention to the autobiographical, she questions the levels of belonging and Europeanness in EU. When asked to elucidate on her choice to produce highly political work about Fortress Europe, Ostojić draws on the personal as political:

As artists, the way I see it, we don't have that nine to five job where we can keep a distance. That's the point with this project, it asks all of you in a way. There are explicit consequences in your daily life. I ended up communicating with people I didn't know […]. I wanted to address the so-called Fortress Europe biopolitics, violence of the borders existence, restrictions of the access to the citizens' rights and in particular fragility of gender in the context of migration. The frame of this project was emancipatory for me regarding the segregation of my passport, that didn't allow me to move without a visa. Instead, *I* chose the husband, *I* chose the method, *I* chose the rules, and *I* financed the project.[37]

Lena Šimić acknowledges the centrality of the passport in a very pragmatic way. Similarly to Ostojić, she is employing the strategy of massaging the law by not taking the regulations for granted. She writes:

See, I am after the passport, the British passport. When I was little I used to say I want to marry someone from England because England is blue. Blue is my favourite colour. So, I married someone from England. England is more grey than blue. Passport is kind of dark red. I need the passport. At airport arrivals and departures I am all the other nationalities. I want to go directly through. I want the passport.[38]

Alexandrova and Lyon argue that women without identity documents acutely feel the precarious nature of not belonging. They state that women with dual citizenship or two identification documents are comforted by having them, and are fully aware of the flexibility they permit: the possibility of changing one's formal identity and belonging.[39] Bauman suggests that the world is now characterized by two classes of people: tourist-consumers (those with agency who are free to consume and move), and vagabonds (disposable populations who get stuck, and whose lives are often wasted). What distinguishes these two classes is mobility; the relative freedom to move across borders. The tourists' distances are easily bridged, but when vagabonds attempt to cross borders,

[t]hey travel surreptitiously, often illegally, sometimes paying more for the crowded steerage of a stinking unseaworthy boat than others pay for business-class gilded luxuries and are frowned upon, and if unlucky, arrested and promptly deported, when they arrive.[40]

Ostojić and Šimić use strategic first-person voices to acknowledge the precarious second category to which they both belong. My thinking on voice here bears an affinity with that of feminist law professor and writer Drucilla Cornell: voice in contrast to muteness that not only implies the silencing of women, but indicates the dumbness before what cannot be heard or read because it cannot be articulated.[41] Both Ostojić and Šimić are challenging the division of population by resolutely refusing to belong completely to either side. They open up the complexity of in-between transitional states, which remain untouched by strict border policies and passport classifications.

Happily Ever After: Self-chosen Exile as Resistance

Migration often entails the physical disruption of intimate relationships, and it always involves distance from one's own familiar territory. Mobility can be motivated by relationships, as they make geography and the personal intersect. Ostojić and Šimić employ marriage as legal relationship and use the autobiographical mode to address wider political and economic issues. Heddon has noted that many performers who activate the power of the autobiographical mode "simultaneously place the referent into a situation of instability prompting us to question the status of what we see."[42] She maintains "that the challenge for all autobiographical performance is to harness the dialogic potential afforded by the medium, using it in the service of difference rather than sameness."[43]

By adopting and playing the game of love and marriage, Ostojić and Šimić embody the personal within a potent economical discourse. On every level they challenge the notion of belonging and entitlement that only comes with an EU passport. For Arendt, belonging can never be something that an individual performs. It has to be an action performed with others, and it has to be public. Indeed, in her terms, belonging has to enter into the sphere of appearance. For Arendt, the efficacy and the true exercise of our freedom does not follow from our individual personhood, but rather from social conditions such as place and political belonging. And it is not that we first need a place or a mode of belonging, but that the rights we exercise are grounded in pre-legal rights to belonging and to place: "the right to have rights, or the right of every individual to belong to humanity, should be guaranteed by humanity itself."[44]

In light of this, it is incredibly important to keep resisting the monolithic culture of what constitutes Europeanness today. By employing humour, intimacy, and self-reflection, Ostojić and Šimić use the state of self-exile as a point of resistance. We need more examples of personal dissidence like this: examples of unruliness, disobedience, and of a general indisposition to follow the path determined by the state and the European Union. This may help us create a more conceptualized and creative reading of what constitutes a migrant in a contemporary European context. In these moments of desperation and grief,[45] we must find ways to empathize with the Other, and to care for ourselves and others. The visual, conceptual, and artistic exploration of borders and states of exile are necessary to renounce patriarchal, sexist, and racist attitudes that separate the body from the mind, the intimate from the political, and human beings from each other.

Notes

1 *The Terminal*, directed by Steven Spielberg (Universal City, CA: DreamWorks Pictures, 2004), DVD, quoted at 3 min.
2 This traditional conception of borders can be found in several works on the topic, including: Klaus J. Bade, ed., *Population, Labour, and Migration in 19th- and 20th-Century Germany*

(Leamington Spa: Berg Publishers, 1987); Aihwa Ong, *Flexible Citizenship: The Cultural Logics of Transnationality* (Durham: Duke University Press, 1999); C. A. Corrin, *Democratization, Women's Movements and Social and Political Change in East-Central Europe* (Economic and Social Research Council, 1992); Irit Rogoff, *Terra Infirma: Geography's Visual Culture* (London: Routledge, 2000).

3 de Certeau in Dwight Conquergood, "Performance Studies: Interventions and Radical Research," *The Drama Review* 46, no. 2 (2002): 145.
4 Peggy Phelan, *Unmarked: The Politics of Performance* (London: Routledge, 1993), 104.
5 Guillermo Gomez-Peña, "From Art-mageddon to Gringostroika: A Manifesto Against Censorship," in *Mapping the Terrain: New Genre Public Art*, ed. Suzanne Lacy (Seattle: Bay Press, 1995), 103.
6 To view the online documentation of the project *Blood & Soil: we were always meant to meet...* go to http://lenasimic.org/performance-collaborations/becoming-british/, accessed April 17, 2016.
7 The borderspace may be experienced and imagined in many different ways, so that means that the personal narrative of the border crossing can be considered as a key moment in the construction of the meanings in this study. The border-place is a threshold in my life and the levels of narration of this experience bring into evidence my self-reflexivity, and forms of belonging, both achieved and imagined. The series of autobiographical writing/diary entries that I used as part of this essay were made during a period of 140 days in 2011. The period was symbolic, equal to 140 questions that I had to answer about myself, my children, and my family in the visa application. This is a challenge that repeatedly occurs in my life. Coming from South-East Europe (the ex-Yugoslavia region), my validity and legal status is constantly reevaluated and subject to the scrutiny of the Western European authorities. The period of 140 days was a period of confirming the validity of my legal status in the United Kingdom.
8 Gloria Anzaldúa, *Borderlands: The New Mestiza = La frontera* (San Francisco: Spinsters/Aunt Lute, 1987).
9 Hélène Cixous, *Stigmata Escaping Texts* (London: Routledge, 1998), 169.
10 Gloria Anzaldúa, preface to *Borderlands*, iii.
11 Anzaldúa, *Borderlands*, 19.
12 Ibid., 23.
13 Beth Berila, "Reading National Identities: The Radical Disruptions of *Borderlands/La frontera*," in *EntreMundos/AmongWorlds: New Perspectives on Gloria Anzaldua*, ed. AnaLouise Keating (New York: Palgrave Macmillan, 2008), 24.
14 Coco Fusco, "Passionate Irreverence: The Cultural Politics of Identity," in *Art Matters: How the Culture Wars Changed America*, ed. Julie Ault, Brian Wallis, Marianne Weems, and Philip Yenawine (New York: New York University Press, 1999), 26.
15 Rogoff, *Terra Infirma*, 136.
16 Rosi Braidotti, *Metamorphoses: Towards a Materialist Theory of Becoming* (Cambridge: Polity, 2002), 3.
17 Francis Alÿs et al., *Francis Alÿs: A Story of Deception* (London: Tate, 2010), 39.

18 The international project for theory and art called "Capital & Gender," curated by Suzana Milevska, took place in Skopje, Macedonia. It was a project of complex structure that included theorists, curators, art critics, managers, and artists from Eastern European countries. Participants were invited to discuss how capitalism challenges gender issues in the countries that are experiencing the shift from state to market economy.
19 Macedonia officially celebrates Sept. 8, 1991 as Independence day, with regard to the referendum endorsing independence from Yugoslavia. Robert Badinter, as the head of the Arbitration Commission of the Peace Conference on the former Yugoslavia, recommended EC recognition in January 1992. Macedonia became a member state of the United Nations on April 8, 1993. It is referred to within the UN as "the former Yugoslav Republic of Macedonia," pending a resolution of the long-running dispute with Greece about the country's name. Macedonia remained at peace through the Yugoslav wars of the early 1990s. However, it was seriously destabilized by the Kosovo War in 1999, when an estimated 360,000 ethnic Albanian refugees from Kosovo took refuge in the country. Soon after, Albanian radicals on both sides of the border took up arms in pursuit of autonomy for the Albanian-populated areas of Macedonia. A civil war was fought between government and ethnic Albanian insurgents, mostly in the north and west of the country, between March and June 2001. The war ended with the intervention of a NATO ceasefire monitoring force. Under the terms of the Ohrid Agreement, the government agreed to devolve greater political power and cultural recognition to the Albanian minority.
20 Tanja Ostojić and Marina Gržinić, *Integration Impossible? The Politics of Migration in the Artwork of Tanja Ostojić* (Berlin: Argobooks, 2009), 163.
21 Rune Gade, "Making Real: Strategies of Performing Performativity in Tanja Ostojić's 'Looking for a Husband with EU Passport,'" in *Performing Archives/Archives of Performance*, ed. Gunhild Borggreen and Rune Gade (Copenhagen: Museum Tusculanum Press, 2013), 181–207.
22 Ibid.
23 Victor Turner, *The Ritual Process: Structure and Anti-Structure* (Chicago: Aldine Pub. Co., 1969), 95.
24 Ostojic, *Integration Impossible?*, 163.
25 Trinh T. Minh-Ha, *The Digital Film Event* (London and New York: Routledge, 2005), 207.
26 Lucy Lippard, *The Lure of the Local: Senses of Place in a Multicentered Society* (New York: New Press, 1997), 86.
27 Sara Ahmed, "Feminism and Fragility," *Feministkilljoys* (blog), January 26, 2016. To view this website, go to http://feministkilljoys.com/2016/01/26/feminism-and-fragility/, accessed February 1, 2016.
28 Anzaldúa, *Borderlands*, 19.
29 Nina Power, *One Dimensional Woman* (Winchester: O Books, 2009), 26.
30 Peter Nyers, "Introduction: Why Citizenship Studies?" *Citizenship Studies* 11, no. 1 (2007): 2.
31 Imogen Tyler, "Designed to Fail: A Biopolitics of British Citizenship," *Citizenship Studies* 14, no. 1 (2010): 64.
32 Brah cited in Rosi Braidotti, "On Becoming Europeans," in *Women Migrants From East to West: Gender, Mobility and Belonging in Contemporary Europe*, ed. Luisa Passerini, Dawn Lyon, Enrica Capussoti, and Loanna Laliotou (New York: Berghahn Books, 2007), 36.

33 bell hooks, "Choosing the Margin as a Space of Radical Openness," in *The Applied Theatre Reader*, ed. Tim Prentki and Sheila Preston (London: Routledge, 2009), 81.
34 Anzaldúa, *Borderlands*, 3.
35 Currently, within Europe, the most common use of the term "Fortress Europe" is as a pejorative description of the state of immigration into the European Union. This can be in reference either to attitudes towards immigration, or to the system of border patrols and detention centres that are used to help prevent illegal immigration into the European Union.
36 Gustav Seibt, "Please Don't Be So Sensitive: Jurgen Habermas Continues Arguing for Europe in Berlin," in *Old Europe, New Europe, Core Europe: Transatlantic Relations After the Iraq War*, ed. Daniel Levy, Max Pensky, and John Torpey (London and New York: Verso, 2005), 132.
37 Tanja Ostojić, interview by Laurel McLaughlin, "Marriage and Other Migrations," *Slought* (blog), November 18, 2015. To view this interview, go to https://slought.org/blog_posts/marriage_and_other_migrations, accessed February 1, 2016; original emphasis.
38 Lena Šimić and Jennifer Verson, *Blood and Soil: We were Always Meant to Meet Performance Publication* (Liverpool: The Institute for the Art and Practice of Dissent at Home, 2011), 8.
39 Nadejda Alexandrova and Dawn Lyon, "Imaginary Geographies: Border-places and 'Home' in the Narratives of Migrant Women," in *Women Migrants from East to West: Gender, Mobility and Belonging in Contemporary Europe*, ed. Luisa Passerini, Dawn Lyon, Enrica Capussotti, and Ioan Laliotou (New York: Berghahn Books, 2007), 97.
40 Zygmunt Bauman, *Globalization: The Human Consequences* (New York: Columbia University Press, 1998), 57.
41 Drucilla Cornell, *Beyond Accommodation: Ethical Feminism, Deconstruction and the Law* (London: Routledge, 1991).
42 Deirdre Heddon, "Performing Lesbians: Constructing the Self, Constructing the Community," in *Auto/biography and Identity: Women, Theatre and Performance*, ed. Michael Gale (Manchester: Manchester University Press, 2004), 229.
43 Ibid., 238.
44 Hannah Arendt, *The Origins of Totalitarianism* (New York: Harcourt, Brace & World, 1966), 298.
45 See more about this issue in Judith Butler, "Human Shields," *London Review of International Law* (2015): 1–21. To view full article, go to http://lril.oxfordjournals.org/content/early/2015/08/17/lril.lrv011, accessed April 18, 2016.

Chapter 10

Caryatid Unplugged: A Cabaret on Performing and Negotiating Belonging and Otherness in Exile

Evi Stamatiou

In August 2013, I created and performed a solo cabaret show titled *Caryatid Unplugged*[1] at the Edinburgh Fringe Festival in Scotland.[2] I devised the performance to explore and expose notions of belonging and Otherness in relation to two female bodies in exile: my own and the Caryatid's feminized body. I am a Greek expatriate artist who moved to the United Kingdom in 2010, at the beginning of the so-called Greek crisis.[3] The Caryatid is the ancient Greek marble column that was forcibly removed from Athens during the Ottoman occupation, and now "belongs" to the British Museum. The performance presents a response to UK Prime Minister David Cameron's 2011 refusal to return the Parthenon Marbles,[4] including the Caryatid, to Greece,[5] and to his suggestion to the House of Commons Liaison Committee in 2012 that the government should control Greek citizens' right to enter and remain in the United Kingdom.[6] Cameron's statements caused me to experience an intensified sense of exile, which I explored in *Caryatid Unplugged*. This chapter investigates how this identity was challenged and negotiated through my interaction with the audience.

The Creation of the Exile Identity

Caryatid Unplugged incorporated an autoethnographic journey, so it is necessary in reflecting upon it that I explore my basic assumptions about exile and identity. My sense of belonging and Otherness is affected by my relationship with particular "imagined communities,"[7] a term coined by Benedict Anderson. Of course, Cameron does not know every member of the British nation, but he imagines that they exist and identifies himself as one of them. Similarly, he does not know all Greek nationals, but he conceives of them as another imagined community, and addresses them as such. While Cameron did not address me directly in his remarks, I felt that he did so indirectly, because I identify with the Greek imagined community. I will expand the term "imagined communities" beyond the idea of national identity and interpret it to include other identities and imagined communities that are not merely national.

For example, Stuart Hall describes identity as

> [...] the processes that constitute and continuously re-form the subject who has to act and speak in the social and cultural world. Identity is the meeting point, or the point of future, between, on the one hand, the ideological discourses which attempt to interpolate or speak to us as social subjects, and, on the other, the psychological or psychical processes which produce us as subjects which can be spoken.[8]

Identity is fluid and multiple, and depends on the speaker's linguistic resources and the social context in which they are speaking and acting. Before moving to the United Kingdom, I identified as, among other things, female, Greek, European, and cosmopolitan: these are the imagined communities to which I wished to belong.

The importance of constructing such multiple identities is illustrated by Bourdieu's notion of habitus: "a set of dispositions and orientations that do not simply 'regulate' [our] actions, but define just who and what [we] are."[9] Cameron's statements in 2011 and 2012 made me realize that my European and cosmopolitan identities were no longer available to me. Cameron's statements openly contrasted the Greek identity with the European.[10] By using the words "we" and "our" in phrases such as "we are not going to lose them [the marbles]"[11] and "our country,"[12] he asserted his British identity and set up an adversarial relationship between the British and the Greeks. His remarks challenged my European identity as a Greek, and implied that my Greek identity did not bear the same symbolic capital and power[13] as the national identities of other European countries.[14] His statements not only prevented me from claiming my desired cosmopolitan identity, but further ascribed to me the identity of the unwanted economic immigrant. As Austin writes, "Language is performative because its speaking produces what it claims."[15] Cameron's statements imposed on me the identity of the Other.

After 2012, my Greek identity was altered, which affected my belonging and imposed Otherness in relation to my imagined communities. I reflected on Cameron's 2011 statement that the Ancient Greek Marbles were "our" [British] Marbles. I identified with the feminized marble Caryatid that was held in the British Museum and not allowed to return to her homeland. This connection triggered my exile identity. Cameron's power to challenge and transform my identities caused me to begin to negotiate my belonging and Otherness in exile. I sought to explore this sense of exile in *Caryatid Unplugged*.

The narrative of the performance focuses on two women who meet in an immigration office in London. The first woman is Rita, a Greek economic immigrant who is about to be deported. The second is the Caryatid, who wants to go back to Greece, but is forbidden to do so by Cameron. By creating and performing these two characters (among others), I could perform my intensified dual-exile identity. The piece rehearses a hegemonic approach to modern Greek national identity, which is perceived as inseparable from its Ancient Greek past. Rita represents my nostalgia for the European imagined community, and the Caryatid represents my nostalgia for Ancient Greece. Margherita Laera writes that nostalgia for Ancient Greece is closely linked to myths about the origins of the Western identity.[16] I realized that, although my Greek identity makes me Other, the shared nostalgia evident in Cameron's statements could provide fertile ground for exploring my new identity and enacting it in the cultural field.

The Enacting of Identity in *Caryatid Unplugged*

Caryatid Unplugged was constructed as four sections, with each culminating in a song, which enabled me to explore different dimensions of my identity. The first three songs

parodied pre-existing material, and the last presented a medley of well-known songs. In the creation process, I explored a variety of contemporary theatre performance practices, and my aesthetic and stylistic choices for the performance were greatly influenced by Aristophanic comedy. I also used elements of parody, puppetry, physical comedy, clowning, documentary, and verbatim theatre throughout the performance.

In the role of Narrator, I directly addressed the audience at the start of the play. I portrayed eight other characters during the performance: John (an immigration officer), Rita (a Greek woman), the Caryatid (the feminized, anthropomorphized marble column), Lord Elgin (who brought the Caryatid to Britain in 1801), Salim (a male illegal immigrant from Pakistan who lives in Greece),[17] XX (a female illegal immigrant in Greece, probably Bulgarian or Chinese in origin, who is a victim of human trafficking),[18] a translator (who translates the Caryatid's song from Greek to English), and Melina Mercouri (famous film actress, and the former Greek Minister of Culture). The unseen David Cameron character was performed by a male British actor, as a disembodied voice transmitted through the theatre sound system.

In the first part of the play, Rita, the Greek woman, appeals to John, the immigration officer, to prevent her deportation to Greece. Her negotiation with him climaxes in a performance of a parody of alternative British rock band Pulp's 1995 hit song "Common People." Listening to Britpop in Greece during my teens and early university years played an important role in the construction of my European identity. This music provided more than entertainment to me: it delivered a crucial means of understanding the English language and culture. As a child, I spent many hours in classes learning English, French, and Italian. By the time "Common People" was released, my ability to understand and speak European languages became a primary way of accessing the imagined community of Europe. My fluency in English enabled me to consider myself what Bourdieu calls a "legitimate speaker,"[19] and a member of the imagined European community.

"Common People" depicts a privileged Greek female student who wants to "live like common people."[20] This character did not sound like a Greek stereotype to me: the student seemed real and European. In my parody of the song, Rita is also a privileged Greek female student who moves to the United Kingdom and romanticizes the "poor folk," like the girl in the original song. However, because of the economic crisis, she later becomes one of the "poor folk" herself. My parodic lyrics warn the audience:

Well, be careful what you wish for, my wishes all came true.
My daddy lost the supermarket.
Tax officers had to start somewhere, and they started there.
Then daddy said, "We've got no money,"
I just laughed and said, "Oh, daddy, you're so funny."
He said "No." There is no-one smiling in Greece.
You have to live like common people [...][21]

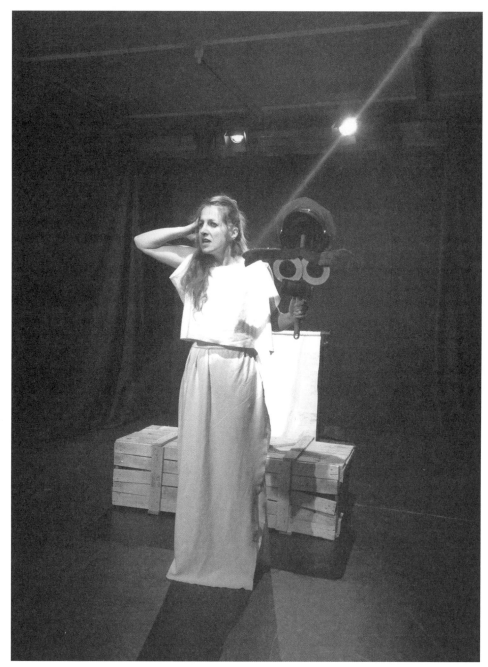

Figure 1: Evi Stamatiou in *Caryatid Unplugged*, Edinburgh Fringe Festival, 2013. The Caryatid asks the border officer John (broom puppet) to let her return to Greece. Photo credit: Katerina Valenti.

After Rita's song, in the next section of the play, the Caryatid goes to the Immigration Office, delighted that all the Greeks residing in the United Kingdom will be sent back to Greece, but John informs her that she cannot return to her homeland because she belongs to the British Museum.

In a parody of the Broadway musical number "Big Spender" from Sweet Charity (1966),[22] the Caryatid explains that she was seduced into going to England. In the original "Big Spender," the dance hall girls seduce their audience/customers to attain a "better life."[23] In the parody of "Big Spender," the Caryatid tries to seduce Lord Elgin and persuade him to take her to the British Museum. The original lyrics of this song "The minute you walked in the joint," and "Hey, big spender! Spend a little time with me!"[24] become, in my parody, "The minute you walked in the Acropolis," and "Hey, Lord Saviour! Take me to the British Museum!"[25] This song enabled me to explore my Greek identity through my Ancient Greek cultural heritage. The parodic song lyrics indicate an exchange of cultural consumption: Lord Elgin wants to consume Ancient Greece, and the Caryatid is willing to be consumed with the hope of acquiring the symbolic capital of the British Museum in return.

The notion of cosmopolitanism is highly problematic, as it is rooted in an elitist, Western concept that "celebrates the commodification of cultural difference."[26] Gilbert and Lo identify three types of "New Cosmopolitanism": moral (rooted in the Kantian idea of a "universal community"); political (rooted in transnational governance and notions of cosmopolitan democracy); and cultural (rooted in an openness to different cultures and a desire to cross cultural boundaries).[27] My cosmopolitan identity is rooted in cultural consumption and the ideal of an imagined universal community. It is related to the ideal of a cosmopolitan democracy, in which each culture has equal symbolic power.

In the performance, my Greek identity reaches for my Ancient Greek heritage in search of more symbolic power, but Elgin claims the Ancient Greek heritage as part of his own Western identity. As my Greek identity moves away from my Ancient Greek heritage, my exile identity is negotiated through the construction of a new Greek identity that feels dislocated from both Europe and Ancient Greece.

In the third part of the performance, Rita and the Caryatid blame each other for the Greek Crisis. Rita blames the Caryatid for treason/xenophilia:

RITA: I thought you loved foreigners.
CARYATID: What do you mean?
RITA: I mean the story with the Persians. You girls from Caryes betrayed Sparta! You took sides with the Persians back then in the 4th century BC. That is why you were doomed to hard labor. But now the barbarians are doomed to hard labor as well. And if they do not work as hard as we want them to, we kill them.[28]

Rita's revelation of how foreigners are treated in Greece allows for the Narrator's intervention to tell the story of Salim, a male immigrant from Pakistan who, when working in the

strawberry fields in Manolada, Greece in 2008, was shot for asking for his wages.[29] The story of Manolada and this example of immigration in modern Greece, allowed me to enact the moral perspective of my cosmopolitan identity:

NARRATOR: So by now, ladies and gentlemen, you must be thinking that there is nothing worse than being an illegal immigrant worker in Greece. Oh, yes, there is. Being a female illegal immigrant worker in Greece.

XX: (*applies red lipstick*) I am XX (*writes XX on her breasts*), I belong to any age group, any ethnic group, any nationality. It is highly likely I am Bulgarian or Chinese. I do not have a name, not even a false name. I am not allowed to speak. I am not beautiful or clean. I am locked in a room with closed windows, somewhere hidden in the strawberry fields. I work day and night. The only way you could find out about my existence is if you read a Greek blog entitled "Where do the 8000 (*writes "8000" on her back*) immigrant workers of the strawberry fields fuck?"[30]

Legal and illegal immigration in Greece has played a major part in the construction of my cosmopolitan identity. Immigration offers a different perspective on my cosmopolitan identity from that of cultural consumption, and is related more to the moral idea of a universal community. There were various numerals that figured prominently in Salim's story and in XX's story: I inscribed them all on my body in red lipstick, depicting the body as entirely reduced to a numeric value, however high or low its consumer value. Referring to this section of the play and its impact, critic Nick Awde, in his review for *The Stage*, wrote: "Under the slapstick, the finger stays firmly on our political pulse, and towards the end the message suddenly becomes shockingly clear when the spotlight turns on the exploitation at the heart of Europe's dark underbelly."[31] This presentation of my exile identity, which is intrinsically linked to my female identity and the character XX, brought focus onto the vulnerability of the female body in exile.

After this section of the play, John telephones David Cameron in despair, and informs him of the Caryatid's desire to return to Greece. In a fantasy sequence, through the non-realistic use of a speaker-phone device, and the comic intervention of a translator, the Caryatid attempts to convince Cameron to let her go home, singing the traditional Greek song "*Gianni Mou to Mantili Sou*" ("My John, Your Handkerchief").[32] In this song, the irreversible state of the stained handkerchief correlates to my irreversible traumatic experience, and reminds me once more of my exile identity.

This traditional song originates in my hometown, Epirus, and it is sung to the rhythm of the traditional Greek *syrtos sta tria* dance (which means "dragging in three steps"). Epirus is in the poorest area of Greece, and many people left there during the 1950s and 1960s to look for a better life abroad. In the song, Giannis (John) is revealed to be an exile, and his handkerchief is shown to have been stained by the dirt and grime of the hardship of his exilic life. He has tried to wash his handkerchief in five rivers, the song further explains, but

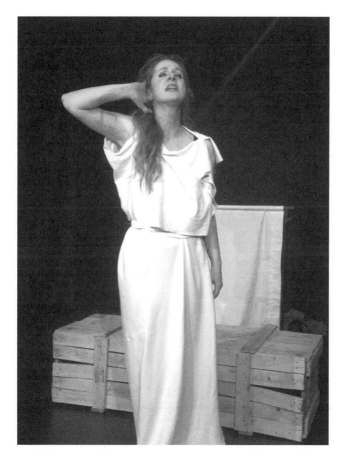

Figure 2: Evi Stamatiou in *Caryatid Unplugged*, Edinburgh Fringe Festival, 2013. The Caryatid sings "My John, Your Handkerchief" to persuade the British PM to permit her to return to Greece. Photo credit: Katerina Valenti.

nothing could cleanse the stain of exile.[33] In my parody of the song, the emotional lyrics of the original verses are interrupted by a clumsy translator, who tries to explain to Cameron that the Caryatid longs to return to Greece. The comic interruption of the emotional song by the awkward translation further highlights the frustration of my exilic identity. This frustration caused by linguistic difference is closely related to my own occasional failures to communicate in a second language, owing to accent, grammar, and syntax mistakes, and the Othering that experience engenders. A particular difficulty demonstrated in the song is the translation of idioms, like the word "*palikaraki*":

CARYATID: Τι το χεις λερωμένο, βρε παληκαράκι μου.
TRANSLATOR: Repeat please …[34]

CARYATID:	Τι το χεις λερωμένο, βρε παληκαράκι μου.
TRANSLATOR:	How did it get that dirty, my (*tries to find the appropriate word*) … Beautiful? (*pauses*) Amazing? Fantastic? One and only? Warrior? This word cannot be translated, really … Huge penis maybe, John.[35]

In the fourth part of the show, Cameron will not change his mind, and will not be moved by the Caryatid's exile song. The former Greek Minister of Culture, Melina Mercouri, intervenes as a deus ex machina, and claims the Caryatid for Greece. She argues with Cameron, but ultimately loses. The Narrator's last words are:

> A female goddess ex machina cannot find the perfect solution as if she were male. There has to be a choice which of the two will be fulfilled with the final verdict. Either they both go back to Greece or both stay in the UK. Please think and share your thoughts with us. If you believe you came up with a good solution, please write it down in the notebook just outside the theatre space. Maybe one day the Greek government will thank you for this.[36]

The performance concludes with a medley of Greek songs representing historic periods that played a major part in the construction of the Greek identity. During these periods, large numbers of Greek people emigrated, or Greek populations that lived in other countries for centuries were sent back to Greece as refugees. The medley included:

- Armand D'Angour's reconstruction of Ancient Greek music (2013);[37]
- the music of the Pontic Greeks[38] (an ethnic group that had to return to Greece as refugees after World War I, early twentieth century);
- Vassilis Tsitsanis' "Cloudy Sunday" (composed during the German occupation in World War II, between 1940–44);
- "My John, Your Handkerchief" (1950, written for the economic immigrants to Germany in the 1950s and 1960s);
- Manos Hatzidakis' and Melina Mercouri's "Never on Sunday" (the only Greek song to have won an Academy Award, it was composed for the film *Never on Sunday* in which a nostalgic American scholar named Homer observes the degradation of Greek culture in the 1960s through his meeting with the Greek prostitute, Ilya);
- Mikis Theodorakis' "Zorba the Greek" (1964, based on Nikos Kazantzakis' novel *Zorba the Greek*, which refers to the Pontic Greeks' persecution at Caucasus, and to the life of Alexis Zorbas, who was a Romanian-born Greek);
- Dionysis Savvopoulos' "May the Dances Last" (1983, Savvopoulos was a politically active singer-songwriter who was briefly imprisoned during the Greek military dictatorship between 1967 and 1974. He wrote the song "May the Dances Last" two years after Greece joined the European Union in 1981).

Through their lyrics and political association, the use of these songs to end the play expressed my Greek identity as a historical accumulation of emigration, immigration, population exchange, and refugee status.

The Notebook as Public Sphere and Its Agonistic/Antagonistic Terms

After the show, some audience members responded to my invitation to write in a notebook, which was situated on a pedestal outside the performance space, in the corridor leading to the venue's foyer.

The notebook functioned as a temporary theatrical public sphere. Jürgen Habermas writes that the bourgeois public sphere of the seventeenth to the twentieth centuries was the discursive, and not the physical, space of theatre, literature, and the arts. The public sphere was primarily apolitical, but offered a place in which non-specialists, or a combination of specialists and non-specialists, were able to discuss public issues. The constituent elements of the public sphere are freedom of access, freedom of speech, autonomy, and the equality of participants. These are the central preconditions of democracy.[39]

After my performance, the audience members were free to choose whether to write in the notebook, what to write, and whether to do so anonymously. The bourgeois public sphere is "the public of private individuals who join in debate of issues bearing on state authority."[40] This requires that social integration be based on rational-critical discourse rather than domination. Such communication opens up space for a potential transformation in which "reason is advanced by debate itself."[41]

The play's question of whether Rita and the Caryatid would return to Greece relates to state authority. However, I undermined the rational-critical discourse by posing a ridiculous dilemma to the audience: either both had to return to Greece, or both had to remain in the United Kingdom. The dilemma is ridiculous not only because it was suggested by neither Greece nor Cameron, but also because it contradicts the explicit desires of both parties. I identified Rita and the Caryatid as inseparable Others and asked the audience whether they thought Britain should allow their Otherness to remain in the United Kingdom. The ridiculousness of this assumption was an enactment reflecting my own ridiculous negotiation of identities according to which the undesired symbolic capital of the Greek female immigrant and the desired symbolic capital of the Caryatid as cultural commodity worked both with and against each other. The antagonistic relationship of my identities was an internalized replication of the antagonism that Cameron's statements triggered.

The dilemma of Rita's and the Caryatid's return to Greece formed a bridge between Cameron's statements and the audience. Cameron's statements were, as I have discussed, antagonistic. His use of the terms "we" and "our country" in discussing Greece implied that Greeks are "them." Chantal Mouffe writes that "democratic logic entails drawing a frontier between 'us' and 'them,' those who belong to the 'demos' and those outside it."[42] When David

Performing Exile

Figure 3: The notebook in which *Caryatid Unplugged*'s audience responded to the question: "Should both Rita and the Caryatid stay in the UK, or should they both return to Greece?" August 3, 2013. Photo credit: Evi Stamatiou.

Cameron was asked in 2012 whether he intended to control the entry and residential status of Greek citizens in the United Kingdom, he replied: "I would be prepared to do whatever it takes to keep our country safe."[43] The use of "our" implied the imagined British community and established an antagonistic us/them relationship with the Greek imagined community. Moreover, because at the time no other European people were targeted as "them," his statement implied that the frontier was solely between the European and the Greek imagined communities. Discussing Derrida, Mouffe writes that "the constitutive outside allows us to tackle the conditions of emergence of an antagonism."[44] Cameron's statement constructed frontiers for the Greek imagined communities, who became "them." In his statement about Greek immigration, it is not clear if Cameron considers the rest of the Europeans as "them" or "us." However, the us/them relation suggests antagonism, which can be perceived as friend/enemy distinction. Mouffe continues:

> If collective identities can only be established on the mode of us/them it is clear that under certain conditions, they can always become transformed into antagonistic relations. A

key task for democratic politics is therefore to create the conditions that would make it less likely for such a possibility to emerge.[45]

The exploration of the multiple identities and the ridiculousness of the utopian dilemma in *Caryatid Unplugged* aimed to challenge the friends/enemies duality that Cameron's statements suggested, and further expose the multiplicity and fluidity of identities based on notions of "us" and "them."

Chantal Mouffe suggests that the aim of democratic politics must be to transform antagonism into agonism without underplaying the antagonistic nature of democratic politics. She proposed the notion of "agonistic pluralism" as an alternative: "For agonistic pluralism the prime task of democratic politics is not to eliminate passions from the sphere of the public, in order to render a rational consensus possible, but to mobilize those passions towards democratic designs."[46] Agonistic pluralism acknowledges the antagonistic nature of politics and emphasizes, rather than ignores, the role of emotions and passions. Cameron made his statements in the political space of the British Parliament, and they carried the emotions and passions of the social group that Cameron, I suggest, thought he represented.

Caryatid Unplugged sought to engage with politics in a theatrical context, and used the public sphere of the notebook to trigger audience responses about Otherness. I hoped that the notebook would allow agonistic pluralism to emerge. The notebook was open to any sort of discourse from the audience, and this endless possibility promised a discursive interaction that would allow agonistic pluralism.

Negotiation of Identities and the Audience

In the process of enacting my multiple and fluid identities, I did not attempt to predict or interpret the audience's reactions. Helen Freshwater, in *Theatre & Audience*, writes that every audience member's interpretation of a performance differs according to their "own cultural reference points, political beliefs, sexual preferences, personal histories, and immediate preoccupations."[47] She suggests that audience members' responses are based not only on their habitus and multiple, fluid identities, but on what they consider to be important at the moment that they are invited to respond. Freshwater's theory suggests that it would be difficult to make any assumptions about audience members' reactions to my invitation to write in the notebook. A question that this theory does not consider is why the majority of audience members decided not to respond at all. In any case, I am going to focus on the documented reaction of the minority of audience members who did leave written comments.

By the end of the run of twenty-three performances at the Edinburgh Fringe Festival between August 2 and 26, 2013, forty-two people had written in the notebook (out of a total audience of 297). Ten of the responses were from personal friends, who focused on the show and how I performed, and referred less to the political dimension. I analyzed the remaining

thirty-two audience responses, focusing on how they commented on, and offered space for, a negotiation of my enacted identities.

Caryatid Unplugged was a political artistic project and as such, my methodological approach has been flexible. As I am neither a sociologist nor a statistician, I did not use the type of rigid methodology that they would apply. I aimed to generate critical responses from the audience, and then critically reflect on these responses from the perspective of the artist exploring their position of belonging and Otherness. I treated the notebook both as evidence of the audience's response to my performance, and as a set of performances in the temporary public sphere that I had created. Analyzing the responses through a personal filter enabled me to explore whether and how I was given permission to adopt specific identities and belong to particular imagined communities. In my analysis, I considered any use of words that would indicate an antagonism – like the duality us/them – and also the symbolic capital attributed to nationalities, judging from the context in which they were mentioned.

I will reflect on the negotiation of my belonging and Otherness through my European, Greek, exile, and cosmopolitan identities.

Two audience responses seemed to ally with my European identity:

A: Perhaps they both go back to Greece. FUCK THE BRITISH! Thank you for the show. THE ITALIAN in the front …
B: EUROPE CAN'T EXIST WITHOUT GREEK! THE SARDINIAN IN THE FRONT.

B explicitly granted me membership in the European imagined community with the phrase "Europe can't exist without Greek!" The words "Greek" and "Europe" are used in the same sentence, which suggests that the two identities are inseparable. In A's response, the words "Greece" and "British" are in two separate sentences, which implies an antagonistic us/them relationship. A seems to attribute more symbolic capital to the Greek than to the British identity. Moreover, A and B show that they are allowing me to adopt a European identity by stating their own national identities, Italian and Sardinian. Their identities are also part of the European imagined community, but had not been challenged or questioned by Cameron. The fact that these two members of the European imagined community attributed more symbolic capital to the Greek identity than to the British reinforced my European identity.

A and B were the only audience members who revealed their national or local identities. The other respondents self-identified by only their names, although they often suggested a national identity. Although the text of *Caryatid Unplugged* implies the various characters' nationalities, I did not often directly use the terms "the Greeks" or "the British." However, I did use the term "the Italians" in the play at the point in the action where the Caryatid suspects that Lord Elgin is an enemy of the Acropolis:

[…] or maybe you are a bloody Italian trying to seduce me. Are you? Because there have been some Italians passing by this place […]. Seducing, looting, making the best out of you, and in the end bombing you and abandoning you […] Romans, Luisieri, Morosini, Mussolini, Pasolini, and others […][48]

Here, the Caryatid refers to historic Italian figures who had bombed the Acropolis. The stereotypical Italian male identity that is represented in the script seems to have been encoded by A and B, and reproduced in their responses in the notebook. This is suggestive of a reciprocal relationship of identity negotiation during and after the performance.

Another example of audience members encoding an enacted identity can be seen in the inscriptions from audience members C, D, and E:

C: Μεγάλα αρχίδια, Μπράβο – huge balls congratulations! Spyros
D: Αν δεν έχεις ιστορία απλά κλέβεις μία. If you don't have history, you steal one.
E: *Efharisto!*[49] Story very well told. Is "hypocrisy" a Greek word?? *Kalispera*,[50] Steve and Sara

Audience members C and D are Greek speakers. They reproduced my use of the Greek language in *Caryatid Unplugged*, and wrote in the Greek alphabet, both of which created a shared temporary linguistic habitus.[51] The only Greek language spoken in the script are the lyrics to the traditional Greek song "My John, Your Handkerchief,"[52] discussed above, in which the song is repeatedly interrupted by the translator, who translates from Greek to English so Cameron can understand the Caryatid's feelings about her exile. The translation of the song in performance indicates that my Greek identity is intrinsically linked to my exile identity. C and D allowed me to claim this Greek/exile identity.

E, who does not seem to be a native Greek speaker, uses English characters for Greek words without providing a translation because they know that I speak Greek. The dual Greek/exile identity is again indicated, but in a different way than in the examples of C and D. On one hand, C and D, who seem to be native Greek speakers, accept me as part of the Greek/exile imagined community. On the other hand, E's question "Is 'hypocrisy' a Greek word??" indicates that they think that I am legitimately a Greek speaker and that they are not. They thereby acknowledge the us/them duality and therefore my Greek identity and Otherness. E seems to try to counter my Otherness with a sense of belonging by reversing the translation device that I used in the song, but the group to which E offers me membership is not clearly defined. Another interesting element of E's response is the use of the double question mark, which invites an interpretation other than the literal: they ask if "hypocrisy" is a Greek word, but they are actually denouncing Cameron (or UK citizens in general) as hypocrites. In this case, I might consider that E is contributing to the rise of the symbolic capital of my Otherness, by undermining Cameron' symbolic capital. The speech enactment of such a rise of my symbolic capital offers me a sense of belonging.

For F, my identity as the Other is clearly an identity of belonging, because I am offered membership to an imagined community of immigrants:

F: A big thank you for an amazing show!!! Difficult to answer your question as I am an immigrant too. You made us proud!!! Anna

G, H, and I use the words "we" and "they," signifying an us/them duality, and reinforcing my Otherness:

G: Wish we could all appreciate how relaxed we are. Great performance! Jude X
H: Thank you for your great performance. They should go back to their homeland! Anne and Craig Wallace
I: We need someone like you in the UK!!! XXX

H separates me from the characters of the Caryatid and Rita. However, there is no invitation for me to belong, but only an indication of Caryatid's and Rita's Otherness. I's response was entered in the notebook straight after H's response. In isolation, H's response could be seen as antagonistic, which perhaps caused I to intervene to contradict or better explain that entry. Although I's response initially seems like an invitation to belong, its we/you duality offers the position of belonging to the British imagined community as the Other. H's appreciation of me as a theatre-maker relates to my "aesthetic and consumer cosmopolitan identity."[53] However, I am not the consumer, but the cultural commodity.

The negotiation of a cosmopolitan identity was evident in the comments in which there was no suggestion of the antagonistic we/them duality relating to national identity. Two examples of that kind are:

J: I SUGGEST ERASING ALL BORDERS + LET THE ARTISTS RULE. BRILLIANT WORK! – MICHAEL
K: Solution? Blow up the Acropolis AND the British Museum?? PAV

The temporary public sphere of the notebook, which included the audience's responses to my performed question about whether Rita and the Caryatid should return to Greece or not, allowed me to negotiate the identities that I embodied in *Caryatid Unplugged* with the audience. The identities were fluidly connected in the performance, and they seemed to be similarly interconnected in the notebook.

Conclusion

The Edinburgh Fringe Festival offered a unique opportunity to try out a hegemonic approach to the construction of the new Greek identity in an international environment. In my interaction with the audience, I created a binary opposition of an exile and a cosmopolitan identity. A cosmopolitan audience would consume me as a cultural commodity, and depending on how the audience identified themselves in relation to this binary, my exile identity would fluidly move.

My initial expectations were that audience responses would reveal dominant assumptions about their recently reconstructed notions of belonging and Otherness of the Greek

imagined community in relation to the European and cosmopolitan one. I expected that this would be primarily negotiated through audience assumptions about identity, determined solely by their habitus, and impervious to any influence from the performance. I unexpectedly found that the negotiation of my identities was determined by how the assumptions about identity that I presented on stage were adopted and reproduced in the audience members' responses in the notebook I provided. This observation calls into question how free audiences are when responding to an invitation to interact with a theatre-maker. The audience's assimilation of my unconscious orientation undermined my aim to create an agonistic pluralism, because the negotiation was framed and determined by the words that I chose and by my hidden presumptions. I recognize that it is difficult for a responder in a theatrical context to transcend a given language and its cultural connotations.

It could be suggested that the audience's reproduction of my presumptions demonstrates opportunities for agency within *Caryatid Unplugged*, given that I was able to frame, navigate, and extend the discourse. However, the audience's actions were not conscious, and unconscious actions are not necessarily performed freely. This indicates not only that I limited the audience's agency in responding, but also that my unconscious bias limited my own agency in negotiating my identity following analysis of the audience response.

Nevertheless, my agency was expanded by the opportunity to explore my own voice. According to Bakhtin, the individual's speech, or writing at the point of utterance, always springs from previous utterances (from others, from previous contexts), and are orientated towards some future response. Bakhtin describes it as "laden with the language of others, from previous contexts." [54] Like Bourdieu's concept of habitus, this indicates that the individual has unconscious bias.

The temporary public sphere of the notebook enabled me to see my unconscious dispositions and to understand the bias that burdens the theatre-maker's voice. *Caryatid Unplugged* aimed to generate an audience response that might resemble a conscious, independent debate: instead, it functioned as a reflective mirror in which I could see myself. I concluded that I was indeed a cultural commodity in exile, enacting the dispositions of my habitus on shifting terrain determined by my own bias. But for the first time since becoming a theatre-maker, I was a cultural commodity that recognized her habitus, and therefore a cultural commodity with agency.

Notes

1 The term "unplugged" was chosen for two reasons. The main reason related to the relevance of the term to acoustic music. The composer Andreas Papapetrou composed special arrangements of the songs "Common People" and "Big Spender." The new arrangements were for acoustic piano. "Unplugged" was further used in its metaphorical sense. It aimed to indicate the dislocation of the marble column Caryatid from the porch of the Ancient temple Erechtheion, which is situated on the Acropolis in Athens. The metaphor aimed to highlight the loss of the Caryatid's functional purpose, which was to support the roof of Erechtheion's porch.

2 As stated on the festival's website (to view full site, go to https://www.edfringe.com/, accessed April 12, 2016), the Edinburgh Festival Fringe is the largest arts festival in the world, counting (in 2015) 50,459 performances of 3,314 shows in 313 venues. The festival attracts both national and international performers and audiences. The Edinburgh Festival Fringe is part of Edinburgh's August Festivals, which is an umbrella term used to describe the three festivals that take place during that time: The Edinburgh International Festival (EIF), Edinburgh Festival Fringe (in which *Caryatid Unplugged* participated), and Edinburgh International Book Festival. EIF was launched after the Second World War with the aim of being an "enactment of a European communion" (The term was created by George Steiner in Jen Harvie, "Cultural effects of the Edinburgh International Festival: Elitism, Identities, Industries," in *Contemporary Theatre Review* 13, no. 4 [2003]: 14). The rise of the Edinburgh Fringe was a response to EIF's exclusivity of both artists and audiences. Jen Harvie in "Cultural Effects of the Edinburgh International Festival" analyzes the aims and objectives of EIF. Harvie observes that "the Festival reproduces this elitism, reinforcing and propagating its imbalances of cultural power and its anti-democratic effects" (Harvie, 13), and she further suggests that this elitism may not have "produced" the Edinburgh Fringe but definitely "provoked" it (Ibid., 14).

3 Manos Matsaganis writes in *The Greek Crisis: Social Impact and Policy Responses* (Berlin: Friedrich-Elbert-Stiftung, Department of Western Europe/North America, 2013), that the Greek debt crisis started in late 2009, and that by the end of 2013 the relative living standards in the country had fallen back by 34.3 percent below average living standards in Western Europe. By November 2013 (the year of performance of *Caryatid Unplugged*) Greece resembled the country as it had been in the 1960s (Matsaganis, 1). Unemployment reached 27.5 percent (Ibid., 6), which was a result of many Greek businesses going bankrupt. By 2012, 41 percent of unemployed workers were in relative poverty, and heavier taxation and salary deflation plunged even more below the poverty line (Ibid., 12). As a result, many Greeks emigrated to Western European countries like Germany and the United Kingdom. To view full article, go to http://library.fes.de/pdf-files/id/10314.pdf, accessed April 12, 2016.

4 On the British Museum's website, it is stated that the Parthenon Marbles were created about 2500 years ago in the Acropolis in Ancient Athens. They are marble panels and sculptures, and were structural elements of the Parthenon, which was an Ancient Temple of the goddess Athena. The Caryatid is a marble column depicting a female figure, which was part of the temple Erechtheion next to the Parthenon. The Parthenon marbles are also known as The Elgin Marbles, named after Lord Elgin, who transferred them from the Acropolis to the United Kingdom 200 years ago, during the Ottoman occupation. To view full page about the Caryatid, go to http://www.britishmuseum.org/research/collection_online/collection_object_details.aspx?objectId=459389&partId=1, accessed April 11, 2016. To view full page about the Parthenon Sculptures, go to http://www.britishmuseum.org/about_us/news_and_press/statements/parthenon_sculptures.aspx, accessed April 11, 2016.

5 Mulholland reports that the Liberal Democrat MP Andrew George said to Cameron: "Whilst of course we should not be making a unilateral contribution to the Greek bailout, does the

prime minister not agree that we have something which would help regenerate the Greek economy and put right a 200-year wrong – and that is to give the marbles back?" Cameron replied that he had no intention of allowing Britain to "lose its marbles." He told MPs: "I'm afraid I don't agree... the short answer is that we're not going to lose them." Hélène Mulholland, "David Cameron Rejects Call to Return Parthenon Marbles to Greece," *The Guardian*, June 22, 2011. To view full article, go to http://www.theguardian.com/politics/2011/jun/22/cameron-rejects-return-parthenon-marbles-greece, accessed February 15, 2016.

6 Watts reports that Cameron said that in the scenario of a Greek exit from the Euro zone, Britain was prepared to take measures to avoid a major influx of Greek citizens: "I would be prepared to do whatever it takes to keep our country safe, to keep our banking system strong, to keep our economy robust. At the end of the day, as prime minister, that is your first and foremost duty." Nicholas Watts, "David Cameron 'Prepared to Halt Immigration of Greeks into UK,'" *The Guardian*, July 3, 2012. To view full article, go to http://www.theguardian.com/uk/2012/jul/03/david-cameron-immigration-greece-uk/, accessed February 15, 2016.

7 Benedict Anderson, *Imagined Communities: Reflections on the Origin and Spread of Nationalism* (London and New York: Verso, 2006), 5. Anderson defines the nation as "an imagined political community – and imagined as both inherently limited and sovereign."

8 Stuart Hall, "Fantasy, Identity, Politics," in *Cultural Remix: Theories of Politics and the Popular*, ed. Erica Carter and James Donald (London: Lawrence & Wishart, 1995), 65.

9 James Bohman, "Practical Reason and Cultural Constraint: Agency in Bourdieu's Theory of Practice," in *Bourdieu: A Critical Reader*, ed. Richard Shusterman (Oxford and Malden: Blackwell Publishers, 1999), 130.

10 Hannes Swoboda addressed the discrimination within a meeting in the European Parliament. To view video, go to https://www.youtube.com/watch?v=9X_HavzuY3o, UK Europe News, "David Cameron Cannot Halt Immigration of Greeks," YouTube video, 1:29, posted by UK Europe News, July 4, 2012, accessed April 9, 2016.

11 Mulholland, "David Cameron Rejects Call to Return Parthenon Marbles to Greece."

12 Watts, "David Cameron, 'Prepared to Halt Immigration of Greeks into UK.'"

13 According to Bourdieu's theory, all human action is driven by the desire to accumulate all forms of capital – economic, cultural, social, and symbolic – which inevitably creates conflict and power dynamics. Those power dynamics are later separated from the interests of capital accumulation and therefore pass unrecognized by other social groups. Such mystified symbolic power is the foundation of the dominant social classes. Zander Navarro, 'In Search of a Cultural Interpretation of Power: The Contribution of Pierre Bourdieu," *IDS Bulletin* 37, no. 6 (2006): 19.

14 Pierre Bourdieu, *Language and Symbolic Power* (Cambridge: Polity Press in association with Blackwell, 1991), 95.

15 John Langshaw Austin, *How to Do Things with Words*, 2nd ed. (Oxford: Clarendon Press, 1975), 5.

16 Margherita Laera, *Reaching Athens: Community, Democracy and Other Mythologies in Adaptations of Greek Tragedy* (London: Peter Lang, 2013), 1.

17 Salim is a historical figure, an immigrant who is profiled in Fragisca Megaloudis' and Stelios Papardelas' article "Life in 'Cretan Manolada': Contemporary Slaves." Salim is the witness

who describes the conditions of his own forced labour in the greenhouses of Crete, which were very similar to the conditions of forced labour in Manolada. The shooting of immigrant workers in Manolada by their employers triggered further interest and investigations around their forced labour. Fragisca Megaloudis and Stelios Papardelas, "Life in 'Cretan Manolada': Contemporary Slaves" (original title in Greek: "Η Ζωή στις 'Μανωλάδες της Κρήτης': Σύγχρονοι Δούλοι"), *TVXS News*, April 25, 2013. To view full article, go to http://tvxs.gr/news/ελλάδα/η-ζωή-στις-«μανωλάδες-της-κρήτης», accessed March 29, 2016.

18 XX is a fictional character who represents a male immigrant's testimony about women forced into sex labour in the area of Manolada. This testimony appeared on the Omnia TV website in an article titled "Where Do the 8000 Refugees of #manolada Fuck?" (original in Greek: "Πού Γαμάνε οι 8000 Πρόσφυγες της #manolada?"). The writer of the article joined a protest following the Manolada shooting and he asked a Bangladeshi immigrant worker: "Hey, friend, where do you fuck around here, are there any women that you pay to get laid?" (original in Greek: "Ρε φίλε, εσείς εδώ, πού γαμάτε, υπάρχουν γυναίκες που τις πληρώνετε και πάτε μαζί τους?"). The immigrant's immediate answer was "There are houses, most of them in the fields, that have women and with £20 we get laid" (original in Greek: "Υπάρχουν σπίτια, τα περισσότερα μέσα στα χωράφια, που έχουν γυναίκες και με 20 ευρώ πάμε"). The immigrant continues to describe the conditions of women's forced sex labour, and states that the women were from around the entire globe. These women were not given any specific names or nationalities in the article, and they are represented in *Caryatid Unplugged* by the fictional character XX. The character is named after the gender chromosome type for females XX. XX speaks about the conditions of her forced sex labour as witnessed by the male illegal immigrant. The fact that the character Salim has a name and nationality, whereas XX has neither, highlights the advanced vulnerability of the female body in Manolada's shooting story. The male immigrants were shot by the landowners. The incident attracted the attention of both the media and the authorities concerning the abuse of the male immigrants. This attention led not only to the pursuit of justice but also to the identification of the men and their nationalities. The female immigrants were abused by both human traffickers and trafficked male workers. Their story has not been further investigated and therefore not only have they been denied justice but also identification. The lack of identity becomes synonymous with the violation of the women's human rights. @MPOUZOUKAKI, "Where Do the 8000 Refugees of #manolada Fuck?" (original in Greek: "Πού Γαμάνε οι 8000 Πρόσφυγες της #manolada?"), *Omnia TV*, May 12, 2013. To view full article, go to https://omniatv.com/blog/3022-πού-γαμάνε-οι-8000-πρόσφυγες-της-manolada, accessed March 29, 2016.

19 Pierre Bourdieu, "The Economics of Linguistic Exchanges," *Social Science Information* 16, no. 6 (1977): 645–68.

20 Pulp, "Common People," on *Different Class* (UK: Island Records, October 30, 1995), CD. To view website with full lyrics, go to http://www.lyricsmode.com/lyrics/p/pulp/common_people.html, accessed February 16, 2016.

21 Evi Stamatiou, "Caryatid Unplugged" (unpublished, 2013), 5.

22 The musical number is from the musical *Sweet Charity*, which was created in 1966 with music by Cy Coleman, lyrics by Dorothy Fields, book by Neil Simon, and direction and choreography by Bob Fosse. In 1969 the stage musical was adapted to a film musical with

screenplay by Peter Stone, direction and choreography by Bob Fosse, and production by Robert Arthur for Universal Pictures.
23 The musical *Sweet Charity* played a major role in the construction of my cosmopolitan identity. The African American and Caribbean movement influences in Bob Fosse's choreography challenged the orderly aesthetics of my classical training in ballet and piano. The influence of Federico Fellini's film *Nights in Cabiria* (1959) on the story of the musical further revealed the merging of multicultural influences in the creation of *Sweet Charity*. My taste in dance was challenged, and I left the ballet classes for modern jazz classes: my attempt to reach out to non-European dance was opening possibilities for my cosmopolitan identity.
24 Dorothy Fields, "Big Spender," in *Sweet Charity*, book by Neil Simon and music by Cy Coleman, New York, 1966. To view the lyrics, go to http://www.stlyrics.com/lyrics/sweetcharity/bigspender.htm, accessed April 11, 2016.
25 Stamatiou, "Caryatid Unplugged," 14.
26 Helen Gilbert and Jacqueline Lo, *Performance and Cosmopolitics: Cross-cultural Transactions in Australasia* (UK: Palgrave Macmillan, 2007), 87.
27 Ibid., 10–12.
28 Stamatiou, "Caryatid Unplugged," 15.
29 Salim's true story is that he was an immigrant worker in greenhouses in Crete, and he described similar working conditions to the ones in Manolada in Frangisca Megaloudis' article "Life in 'Cretan Manolada'" (see n. 17). The only dissimilarity to the conditions in Manolada is that Salim wasn't shot by the landowners. For the purposes of "Caryatid Unplugged," Salim's story has been merged with stories emerging from Manolada. An indicative article can be found in BBC News article "Greece Farm Shooting: 30 Injured in Pay Dispute," *BBC News*, April 18, 2013. To view full article, go to http://www.bbc.co.uk/news/world-europe-22198699, accessed March 29, 2016.
30 Stamatiou, "Caryatid Unplugged," 18. The article's title within the quote is from source *Omnia TV*, 2013 (see n. 18).
31 Nick Awde, "Caryatid Unplugged," review, *Theatre London Guide*, August 14, 2013. To view full review, go to http://www.theatreguidelondon.co.uk/reviews/edinburgh2013-1.htm, and scroll down to "Caryatid Unplugged," accessed April 11, 2016.
32 To view video online of "My John, Your Handkerchief" (1950), go to http://www.greeksongs-greekmusic.com/gianni-mou-to-mantili-sou-glikeria/, accessed April 11, 2016.
33 Ibid.
34 In the original song, the verse is repeated anyway, and one would expect that the translator's inability to understand the first verse would have a comedic effect for Greek audiences, who would be familiar with the song and its repetition of verses.
35 Stamatiou, "Caryatid Unplugged," 22.
36 Ibid., 27.
37 Armand D'Angour, "How Did Ancient Greek Music Sound?" *BBC News*, October 23, 2016. To view full article, go to http://www.bbc.co.uk/news/business-24611454, accessed February 20, 2016.
38 The Pontic Greeks were a population that lived around Caucasus and the Black Sea until 1922. The Greek population of the Pontos before World War I was approximately 700,000

(Valavanis, 15). By 1924, about 353,000 had perished (Ibid., 24). The remainder followed the road of the diaspora, mainly to Greece and the Soviet Union, but also to America, the rest of Europe, and Persia (Ibid.). Georgios Valavanis, *Modern General History of the Pontos*, 2nd ed. (Thessaloniki: Kiriakidis Bros., 1986).

39 Jürgen Habermas, *The Structural Transformation of the Public Sphere: An Inquiry into a Category of Bourgeois Society*, 10th ed., Studies in Contemporary German Social Thought (Cambridge: MIT Press, 1999), 221.
40 Craig Calhoun ed., introduction to *Habermas and the Public Sphere*, Studies in Contemporary German Social Thought (Cambridge: MIT Press, 2011), 6.
41 Ibid.
42 Chantal Mouffe, *The Democratic Paradox* (London and New York: Verso, 2000), 3.
43 Watts, "David Cameron, 'Prepared to Halt Immigration of Greeks into UK,'" 2012.
44 Mouffe, *The Democratic Paradox,* 13.
45 Ibid.
46 Ibid., 16.
47 Helen Freshwater, *Theatre and Audience* (Palgrave Macmillan, 2009), 5.
48 Stamatiou, "Caryatid Unplugged," 14. The reference to the film director Pier Paolo Pasolini serves the comic effect. His relation to Ancient Greek culture is his film *Edipo Re* (1967), which is an adaptation of Sophocles' *Oedipus Tyrannus* (430 BC).
49 Greek phonetic for "thank you."
50 Greek phonetic for "good evening."
51 Bourdieu, *Language and Symbolic Power*, 45.
52 Stamatiou, "Caryatid Unplugged," 22
53 Gilbert and Lo, *Performance and Cosmopolitics*, 87.
54 Mikhail Bakhtin, "The Prehistory of Novelistic Discourse," in *Modern Criticism and Theory: A Reader,* ed. David Lodge (New York: Longman, 1988), 126.

Chapter 11

Exile Builds Performance: A Critical Analysis of Performing Satirical Images across Cultures through Media

Sanjin Muftić

Images resemble nomads. They migrate across the boundaries that separate one culture from another, taking up residence in the media of one historical place and time and then moving onto the next like desert wanderers setting up temporary camps.
–Hans Belting, *An Anthropology of Images: Picture, Medium, Body*[1]

In today's media-saturated age, it is possible to identify oneself through the media objects digested: stories, novels, films, performances, music, and more. As a theatre-maker, any creative work that I have developed has arisen out of a dialogue with the media that I have seen or read, was strongly influenced by, and even through the "borrowing" of certain media and their structures. This artistic self-identification was a result of my exilic journey, which was characterized by displacement from my culture and country of origin. As a child from the ex-Yugoslav republic of Bosnia and Herzegovina, my family had to establish refuge first in Ethiopia and later on in Canada, as the war in the Balkans (1992–95) raged on, making it undesirable to return to the country of our birth. As a result, the media objects to which I was exposed at this time, during my formative years of eight to eighteen, were taken from a wide variety of cultural homes, all of which were far removed from the socialist centre of Yugoslavia. I had begun the process of assimilation into these cultures by searching for patterns that mapped me into the media within these new cultural signifiers, seeking an identity within the cultural centres around me.

My aim in the pursuit of these patterns was to reduce the distance separating my original cultural centre with the new ones, in an attempt to locate myself within a home, or, in this case, a combination of homes, as there was not a straightforward mapping from a singular culture to another singular one. This led to my constant search for the similarities or differences across the cultural media that I encountered. This process encouraged a "planetary" thought process as put forward by Spivak,[2] which sides with the diverse gazes upon the world, and, as Rania Gaafar explains, "attempts to introduce an epistemologically intercultural perspective and approach to otherness that does not exclude the question of experience but rather thoroughly induces it as a part of a possible world within the planetary condition of the whole [...]."[3] This planetary condition validates the experience of the exile in their journey, and encourages the expression of their viewpoint.

This is why one of the main methodologies within my work has been the process of *bricolage*. The process draws particularly from Levi-Strauss' focus on how a *bricoleur* uses found and available objects to find a solution.[4] The version of theatrical *bricolage* that I practice devotes the majority of time in rehearsal to the building of theatrical images through

the embodying (performance) of found media samples. Shaped by the experience of exile, it is through the choice of samples and the particular train of thought in their patterning that I can stage my voice. Through the process of devising and performance, I also aim to construct what I have termed a "planetary landscape," a context for performance that prioritizes in its staging "diverse gazes upon the world," and aims to foster an "intercultural perspective."[5]

A set of media images that I acquired from my birth nation's cultural landscape came from a Yugoslav television comedy sketch show entitled *Top Lista Nadrealista* ("Surrealist Hit Parade"), in which, in the late 1980s and early 1990s, young comedians from Sarajevo presented comedy that poked fun at the various social tensions in the country, with its final episodes aligning with the outbreak of the conflicts in the republic as the country disintegrated. While everybody laughed at their Balkanesque version of Monty Python,[6] nobody expected that the sketches would prove prophetic in the subsequent Balkan Wars of the mid-1990s. Now, as a theatre artist who has resided in South Africa for over ten years and has witnessed the socio-political events taking place in the country in 2015 (including protests over education, racism, service delivery), the political images from *Top Lista Nadrealista* resurfaced for me, superimposed onto this different geographical context.

Top Lista Yugo-ZA-Nista (*Yugo-ZA-Nista, 2015*)[7] was a mixed-genre theatrical performance that I created, which mashed-up *Top Lista Nadrealista* (*TLN*) with the events of the 2015–2016 South African socio-economic climate. Performed by senior acting students of CityVarsity (a tertiary arts college located in Cape Town), the performance was staged as a series of sketches that speculated on the future of South Africa, and combined the use of performance and its interplay with media through the blended use of both a live feed and archival television footage. With my experience of practical research in theatrical *bricolage*, I realized that this production offered an opportunity to explore how the images from one culture might rediscover their relevance in another time and place. At the heart of the production were sketches performed by the South African born-frees,[8] all of which were reinterpretations of those performed by Yugoslavian youth some thirty years ago, 15,000 kilometres away. The South African performers reinterpreted the images of one culture, and commented on them through their own performance and interpretation of the media images.

This chapter will provide a brief analysis of theoretical conceptions of the production *Yugo-ZA-Nista*, establishing links with Buck-Morss's interpretation of Walter Benjamin's *Arcades Project*. Through illustrating two examples in the live re-performance of media images, I will contextualize the production by focusing on the choice of the television images as the intercultural link between the two locations and time frames. Finally, Barucha's concept of the intercultural will be used to critique my devising process and question its alignment with Spivak's notion of the planetary. In so doing, I will justify how this process identifies with a theatre-maker who has experienced exile.

The group of artists responsible for the original sketch shows, *Nadrealisti* ("surrealists" in Serbo-Croatian), came from Sarajevo, and had initially developed a radio sketch show

in the late 1970s that was synonymous with a subcultural artistic movement titled New Primitivism. The intention of this youthful movement, which was primarily focused on music, was to present, in a humorous and irreverent manner, that freedom from established and manufactured modes of expression was possible.[9]

What started as youthful and largely improvised expressions of absurd humour began to develop into extremely clever satirical sketches commenting on the socio-political situation around the country. These comments had as much to say about life under socialism, as they did about the developing ethnic tensions that began to arise in the aftermath of the death of leader Josip Broz Tito in 1980. To the audience of the country, it was the characters presented, both stereotypical and yet true to the individual cultural identities, who were a strong point of connection. Certain sayings, expressions, and sketches infiltrated cultural media and were frequently referenced in daily life across the country. The performance style emphasized the stereotypes of the classes and ethnicities within the country, and placed them in situations that revealed many of the fears in the country that everybody could laugh at before the conflict began.

At the height of the television run of *TLN*, I was only seven years old, and while I couldn't understand most of the elements of the social satire they presented, I connected with their buffoonery. The energy behind the individual performances, the outlandish characters, and the sheer absurdity of certain situations remained in my consciousness as I got older. I had absorbed these elements and translated them into images. Through the initial viewing on television, later on VHS video tapes, and today on YouTube, I acknowledge that the images have left an imprint on me. According to Hans Belting, images have that power, as they are tied to the "the locus of the body" that receives, interprets, and stores them.[10] Twenty-five years later, in the research for the production in South Africa, these images were reawakened within my consciousness, and as I reviewed the shows online, while much time had elapsed, I experienced them with the familiarity of returning to an old friend.

However, watching *TLN* in 2015, I was forced to re-examine the images, with the knowledge of the conflict that took place after the filming of these episodes. The war in Bosnia and Herzegovina had seen, over the course of three years, the destruction of entire towns, the establishment of rape camps, the re-emergence of ethnic cleansing, the death of over a million citizens, and the mass exodus of the population who became refugees and immigrants.[11]

The images that the *Nadrealisti* presented were full of humorous suggestions for a future that explored the growing nationalistic fissures and the fragmentation of the country and, even more specifically, the city of Sarajevo. One of the sketches presented a wall that divided Sarajevo into an East and West,[12] as garbage men on either side tossed garbage over the wall. As it became evident that garbage was just being tossed back and forth, from one side to the other, a man from each side climbed up the wall to take issue, only to discover that their rival was actually an old school friend. Their moment of connection and joy disintegrated when they could not agree on which side, East or West, they should go to for a drink. The debate turned into a violent fight across the wall, with garbage flying. The power of this image being

viewed in 2015 lies in the knowledge of the conflict that would come, and how citizens of different national backgrounds had turned on each other, with consequences more fatal than a choice of a place to socialize and drink.

In an analysis of Deepa Metha's film *Water* (2005), Tutun Mukherjee[13] invokes Walter Benjamin's *Arcades Project*. Benjamin's unfinished work (compiled between 1927 and 1940)[14] was an unfinished encyclopaedic collection of diverse writing fragments whose aim, inspired by the closed-in shopping boulevards of Paris, was to present the "world in miniature."[15] Through the encounters and the jumps between fragments, the *Arcades Project* challenges the reader to construct their own experience as described by Crickenberger:

> We read what we hold in our hands; we pick out constellations – we assemble and arrange the text in various ways as its fragmentary style invites us to do. And just as we are expected to do as scholars, we search out patterns, locate references to locatable schools of thought, note recurrent themes, trailing a long thread of words in our wake lest we lose our way [...].[16]

The readers' experience is composed, according to what Mukherjee cites in Susan Buck-Morss's theorizing on the project, around "the dialectic of seeing." Buck-Morss argues that Benjamin's approach encourages thinking through connections, "urging a move towards the transformation and re-combination of ideas and concepts."[17]

In a similar way, the production of *Yugo-ZA-Nista* was to examine contemporary South African issues in an adjusted, translated, and referenced performance of images from the Yugoslavian satirical show, juxtaposing the two contexts. The objective would be to engage the audience in a similar process as reading the *Arcades Project*: searching for patterns, locating references, and noting themes, thus briefly experiencing the planetary condition through the exposure to theatrical images. Indeed, the choice of using images as the primary bridge depends not only on the power of the theatrical but also on Benjamin's view that their "interpretive power [...] make[s] conceptual points concretely with reference to the world outside the text."[18] Within Buck-Morss's analysis of the *Arcades Project*, Mukherjee identifies how "historical configurations can yield insights about human life and behavior in contemporary contexts."[19] In the case of *Yugo-ZA-Nista*, it is specifically the transposition of the geographical configuration, using an exile's path through the different locations and their understanding of the points of commonality, which are presented to accomplish this.

When outlining the origins of the *Arcades Project*, Buck-Morss identifies the impulse evident in Benjamin's early work, his "desire to make allegory actual [...] to make visibly palpable the experience of a world in fragments [...]."[20] As for his structure of the *Arcades Project* being composed of sections of text and not a coherent narrative, Buck-Morss explains that this was indeed the objective in the experience as "the effect of technology on both work and leisure in the modern metropolis had been to shatter experience into fragments, and journalistic style reflected that fragmentation."[21] Through the use of fragments, it is the material (and message) in between the various pieces of text that reveal to the listener the

intended meaning. *Yugo-ZA-Nista* shares structure with *TLN*, with a seemingly unrelated set of sketches, all aiming to suggest a possible other truth, as much in the gaps between the sketches as within the sketches themselves. Thus, the planetary landscape is not only created by the focus on the creation of its images, sketches, beats, or sequences, but rather through the various associations that the audience has to assemble in the separation of and distance between the various components. The production challenges the audience to take the uncertain journey of the exile through the *bricolage*.

Furthermore, *Yugo-ZA-Nista* is located at the intersection of two different axes. One that runs culturally from ex-Yugoslavia to South Africa, and the perpendicular one that runs performatively from body to media. One reason that the use of functioning television sets is important to the production is because they attempt to define these axes, firstly by geographically placing the different images on separate screens on the stage, and additionally by superimposing the body on top of the media, sometimes directly (through the broadcast use of green screen and live feed) and sometimes alongside the television as live performance.

The conceptual frame of the sketches placed the viewer in the zone between searching for the narrative and abandoning themselves to the abstract, but it also placed the two cultures alongside each other, as it was their respective media images that allowed for the recombining to take place on the stage. The placement of the two televisions on either side of the stage, each playing their own cultural satirical images, challenged the audience to swing between gazes (at stage right was a cathode-ray tube television from the 1980s playing *TLN*, while at stage left was a current-technology liquid-crystal display television playing the contemporary media/live feed). The live performance on stage in between functioned as the active translation.

The selection of material for the live performance on stage was informed by the suitability of the original *TLN* sketch and its potential relevance to current South African contexts. While the process of devising will be discussed later in the chapter, it should be noted that the viewing of archival *TLN* sketches was used as a starting point for the devising of the live sketches. The archive shown to the students was mostly constructed from the sketches that had left an imprint on me. The generated live sketches could be broken up into two categories, either more direct translations (either by word or image), or indirect translations (which shifted the action to capture the local context) of the archival *TLN* sketch. The final choice of what to include within the production rested with me as director and my identification of a particular train of thought linked to an exilic journey.

One of the archival *TLN* sketches, which inspired an indirect translation, took the theme of the fracturing of Yugoslavia to absurd lengths within the context of a single family.[22] The action followed a news reporter with a camera into a flat where a family had been divided into two separate camps that were waging war on each other within their apartment. The husband and the younger son had occupied the kitchen and dining room, while the wife and the older son had access to the living room, guest toilet, bathroom, and the passage to the front door. As ammunition ran out, bullets were replaced by plates which started flying across the flat. The flat was also inhabited by a subletting law student who recited his legal

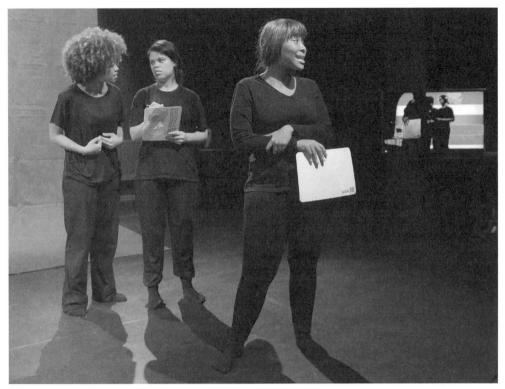

Figure 1: (L-R) Anray Amansure, Robyn Williams, and Lobcke Hein in "The Rainbow Inspection" sketch in the production of *Yugo-ZA-Nista*, Arena Theatre, Cape Town, South Africa, August 25, 2016. Photo credit: Nardus Engelbrecht.

articles aloud as the conflict raged around him. Both the wife and the husband addressed the camera directly, expounding on their military positions within the flat in some detail, before a United Nations peacekeeping delegation arrived by elevator, and refused to believe the family when they tried to convince them that the bullet holes were just dead mosquitoes on the wall. Though the cause of the war is not mentioned, it is implied that the conflict originated with the differing nationalist roots and allegiances of the husband and wife.[23]

In *Yugo-ZA-Nista*, this image was translated into the South African perspective in order to further explore this idea of macro fragmentation within a micro context. "The Rainbow Inspection" sketch presented two government officials and two same-race couples on stage. The green screen behind them was tuned into the rainbow colours, but not those representing South Africa, rather those that were the symbol of the gay pride movement. The two government officials entered the space of the first couple, who were Cape Coloured,[24] in order to complete a mandatory government inspection to verify that each household had the basic facilities/appliances as well as a variety of rainbow colours for those appliances.

Once the inspection of the facilities was completed, the officials announced the next year's requirements, which stipulated that the occupants of the household would also have to be of different colours/races. This scenario was repeated in the second household as well, where the couple was white. However, at the end of their inspection, one of the government officials got the idea to swap the two husbands, going back to the first house to take the Cape Coloured husband to the white woman, and the white husband to the Cape Coloured woman. The sketch ended with the satisfied officials leaving the newly racially mixed couples behind, who now sat on their couches with their hands reaching out longingly towards the wall that separated them from their original homes and partners. The final statement was given to the Cape Coloured husband who voiced his displeasure that the television in his new house was not as good as the set in his previous home.

In the performance, the archival *TLN* sketch about the family played alongside the contemporary South African version. Both sketches investigated the splintering of family as a result of national circumstances. The intention was to comment on the dissolution of the Bosnian family through war due to domestic unions of mixed nationalities, while highlighting the reality that within South Africa, the majority of unions remain within the same race. The performance teased at a possible future where, in order to foster more racial harmony, the government would have to enforce the principles of the Rainbow Nation.

Another compelling re-performance within *Yugo-ZA-Nista* was evidenced in the "*Noot vir Takeaway*" ("Not(e) for Takeaway") sketch. This sketch fell into the category of a direct translation of the *TLN* skit of "*Nagradna Otimanja*" ("Prize Grab") that followed the format of game shows, but inverted, so that prizes were goods that were seized from the audience members, rather than given to them.[25] In this version of the sketch, the items seized from the contestants who sent in the wrong answers were a television, followed by a car, and then the removal of freedom, which meant going to jail. The *TLN* sketch involved cutaways from the studio to the contestants' houses, with a reporter and a pair of policemen on site to take possession of the goods in question. In between each sequence, the host of the show pulled the wrong answer out of the responses sent in by the viewing audience, and explained each "prize." The sketch included a brief advertisement for the prison to which "winners" would be sent, which represented incarceration as a visit to a four-star hotel. Each of the contestants, representatives of various classes within Yugoslav society (all husband and wife couples), protested vociferously about what was being taken away from them. While being mostly absurd, this sketch unpacked the population's paranoia of the socialist state's ability to seize their possessions and curtail their freedom at any time.

My approach for the creation of a contemporary theatrical image inspired by this sketch was to place a separate audio track on top of it, which could narrate the sequence of images while also transporting the context into South Africa, specifically by referencing one of the more well-known television game shows of the South African Afrikaans language media, *Noot vir Noot* ("Note for Note"). This show tests contestants' knowledge of various musical numbers, and includes different formats for questions. Over the years that it has been

Figure 2: Lizelle Bernardo providing the dubbing for the archival *TLN* clip as the host of the "*Noot vir Takeaway*" sketch in the production of *Yugo-ZA-Nista* as the rest of the cast watch, Arena Theatre, Cape Town, South Africa, August 25, 2016. Photo credit: Nardus Engelbrecht.

broadcast, this program has reached iconic status, achieving renown beyond the Afrikaans audience in South Africa. Thus the game show from *TLN* was dubbed into a version of *Noot vir Noot*, with an Afrikaans-speaking host, where questions of a musical nature were used, and the prizes followed the process of taking things away, as presented by the visuals from *TLN*. During this section of the performance, four actors on stage faced the old television that was playing the archival Bosnian program, and provided the dialogue for the various people on screen, with two of them being permanently cast as the game show host and reporter (both speaking in Afrikaans), while the other two voiced the various contestants. The contestants, even though they appeared on the original *TLN* recording as Yugoslav, were portrayed as being from different cultural contexts and classes, depicting a mix of South Africa's population. Within the dubbed version, the students portraying characters chose stereotypical vocal representations of racially homogenous families for each of the contestants: a black family speaking in English whose television is taken away so they can't watch *Generations* (a popular South African soap opera); a Cape Coloured family speaking in Afrikaans whose car is taken; and a white English-speaking family who end up with their freedom taken, incarcerated.

In order to complete the connection, a further layer was added to reference a current instance of seizure. Alongside the television playing the original sketch, the four actors sat on stage, looking towards that television and providing the dubbing, while far stage left the contemporary television was playing *SABC Digital News* footage of the removal of the Cecil John Rhodes statue on University of Cape Town (UCT) campus on April 9, 2015. The footage of the removal was raw and unedited, and it documented the moment that the statue commemorating the colonizer Rhodes was lifted up by the crane and placed on a nearby truck. The clip also displayed the student body reacting to the removal of the statue, from silent witnessing, to rejoicing and defacing of the statue.[26]

Thus, on stage, throughout the dubbing of the *TLN* sketch with an Afrikaans-speaking host and a South African context, the theatrical image was further widened to include the footage of a contemporary event that had captured the attention of the country, and particularly Cape Town. The arrangement and choice of material was purposefully edited within the *bricolage* to provoke the search for a political connection within the images. While the game show performance created a narrative of objects being seized from contestants, the statue object/symbol of Cecil John Rhodes being removed took the references out of a domestic situation and placed them into a historical one through the medium of satire. In both examples, the undermining of agency, citizenship, and identity was connected between two countries, through the exile's play with media, and further established a planetary landscape for the viewer and the participants alike.

As my *bricolage* process used sources from two different locations and even more cultures, it is necessary to address where this creation of what I am terming a planetary landscape sits within intercultural and intracultural theatrical approaches. For Bharucha, the key for any work seeking to identify itself with interculturalism is how it negotiates the "inter": "the space in between polarities, the dynamics between different points and locations."[27] His critique of the more common intercultural approach is the one-way monologue that takes place, with a pillaging of one culture acquiring aspects of the other for its convenience. Furthermore, he goes on to argue that the end result is filtered in order to match the needs of the target culture for whom the piece is staged. Such performances disengage the audience from the historical complexities in order to generate a commodifiable product. This is directly opposed to Bharucha's view of intercultural theatre as something that "lies precisely in working through […] contradictions emerging from our distinct, yet related histories."[28] The ideal intercultural theatre for Bharucha should "evoke a back and forth movement, suggesting the swing of a pendulum […] where reciprocity rather than the separations of relations […] matters."[29]

Bharucha stresses that what is important for respect to be reinstated into intercultural theatre is for the director who is taking the image to "learn what the ritual means within its own culture, and then to reflect on what it could mean in his own."[30] This guides the performance away from a simple copying of action, but rather focuses on dialogue that happens between the places, allowing for the "swing of the pendulum" and the investigation of reciprocity. An exile who is working with combining the cultures is already caught up

Figure 3: (L-R) Video of the removal of the Cecil John Rhodes statue, Sanjin Muftić during the "*Noot vir Takeaway*" sketch in the production of *Yugo-ZA-Nista*, Arena Theatre, Cape Town, South Africa, August 25, 2016. Photo credit: Nardus Engelbrecht.

within the "swing," as they are constructing themselves in the liminal space between their origin and destination, without completely owning either set of cultural perspectives. The exile, through their physical journey, is thus more likely to be aware of their own fragmentation, carrying within themselves not only the socio-political contexts of origin, but also of the context of their journey and destination.

Bharucha's own experience of intercultural theatre led him to discover how "the process of theatrical adaptation [...] extended to a detailed analysis of the social processes determining everyday life in other cultures."[31] Within the adaptation, he suggests how texts (scripts) that are not from the culture of performance may open up different perspectives and conversations on issues within that culture. The text serves the "mediation of an interpreter,"[32] which pushed Bharucha to self-reflect on his own intercultural awareness. In the case of *bricolage*, in particular *Yugo-ZA-Nista*, it is media that became the text, template, and the translator. By relying on television images to be the mediator between cultures, the process and performance provided focus on the contradictions and appreciation of difference. Within the process I undertook of devising, media became a bridge to work across, a tool for working and allowing the "pendulum to swing" back and forth. Each sketch required an investigation into the socio-political and historical characteristics, not

only of the Yugoslavian image, but how that image would fit within the South African context.

The collaborative devising process with the senior acting students included discussions around their concerns for their country (leading into improvisations around particular scenes and living tableaux in the style of Boal's Image Theatre), as well as the viewing of YouTube clips of *TLN* sketches, where I served as curator, translator, and facilitator in discussing the politics of the clip and its potential relevance to South Africa. After viewings and discussions, further improvisations were developed as inspired by characters, situations, or themes from the *TLN* sketch in conjunction with the students' understanding of their contemporary context. Some of the students commented on the similarity of the situations presented in the sketches, and even felt they could identify certain types of characters that were recognizable from their own experience, while others struggled to interpret beyond the language that they did not understand. Initially there was great excitement for the absurd style and a fascination with the comic characters presented. Later this developed into an interest in the country's politics and especially the resulting conflict. The students were encouraged to bring their own South African characters, situations, and contexts to the improvisations, which had been triggered by viewing and discussing the *TLN* sketches. This resulted in frequent moments of group discussion about politics where I served as an audience member, discovering the students' awareness and knowledge of their own context.

The exile has to use the cast with whom they are working as translators into a new culture, as they seek to adapt the media images from the outside culture into theirs. In all of the *bricolage* experiments I have examined and created, there is a key and fundamental aspect of the rehearsal that is geared towards exchange that identifies and empowers all those involved as co-creators. In the rehearsal processes of each of the shows, exchange was made through the performance of the various theatrical or media images. For example, in one of the embodying processes of *Yugo-ZA-Nista*, the performers were asked to bring the media images they remembered from their childhood to the rehearsal process, to be fused within the creation of the piece. These were then combined to generate an alternative view of their country's future, not directly translating an image from the Yugoslavian show, but rather invoking the spirit of the image in a new context. Together with the viewing, discussion, and embodiment, this process of exchange raised awareness of both contexts, and also included the participants as active collaborators in the creation of a planetary landscape.

The *bricolage* process initiated by the exile theatre-maker subscribes to Bharucha's understanding of Barba's dramaturgical desire to "let cultures be seen through cultures."[33] It should be clear how the *Yugo-ZA-Nista* sketches adapted material from *Nadrealisti* into its own version, while commenting on a similar situation within a different context. That space between the sketches was the planetary landscape that challenged the audience to connect the mediatized and live South African and Yugoslavian images, without the intrusion of a linear narrative. *Yugo-ZA-Nista* does not present a clear narrative, but relies instead on the juxtapositions between the images to guide the audience towards constructing their own

story. While this is challenging, it, like the work of Benjamin, does not aim to be arbitrary, as there is a very strong conceptual through-line that suggests the reciprocity of the politics between the two sets of axes.

While it is not possible to quantify how much and what the audience gleaned from the performance, a planetary landscape was established on the stage between the two televisions and between the local performers and the exile director, swinging between Yugoslavia and South Africa. Bharucha argues that "there are no universal values in the theatre. There are only personal needs which get transformed into social and political actions, rooted in the individual histories of theatre."[34] The exile theatre-maker has the personal need that drives them to make the work which within the *bricolage* is the exploration of reciprocity of the cultures through which they have negotiated. In this specific instance of *bricolage*, media and the performance of its images served as the intermediary across the cultures, in an attempt to create the planetary landscape on the stage that allowed for the expression of the diverse viewpoints of the world. To "define our relationship to the cultures in the world for ourselves"[35] is what the exile is negotiating in life, what Bharucha is imploring the intercultural directors of theatre to do, and what the exile theatre-maker must strive for in the construction of their performances.

Notes

1. Hans Belting, *An Anthropology of Images: Picture, Medium, Body*, trans. Thomas Dunlap (Princeton: Princeton University Press, 2011), 21.
2. Gayatri Chakravorty Spivak, *Death of a Discipline* (New York: Columbia University Press, 2003), 72–73.
3. Rania Gaafar, "Planarity/Planetarity: Visual Art Practice as Cultural Technique and the Aesthetics of Xenography in Isaac Julien's Moving-image Art," in *Global Studies: Mapping Contemporary Art and Culture*, ed. Hans Belting, Jacob Birken, Andrea Buddensieg, and Peter Weibel (Ostfildern: Hatje Cantz, 2011), 360.
4. Claude Lévi-Strauss, *The Savage Mind*, trans. George Weidenfeld and Nicolson Ltd. (Chicago: University of Chicago Press, 1966), 16–19.
5. Gaafar, "Planarity/Planetarity," 360.
6. Monty Python was a British comedy group with members John Cleese, Michael Palin, Terry Gilliam, Terry Jones, Eric Idle, and Graham Chapman who were all writers and performers. They began as a television comedy sketch show that was broadcast on the British Broadcasting Corporation from 1969 to 1974. Their particular surreal and absurd approach to comedy achieved worldwide appeal, and influenced many later comedians around the world.
7. To engage with and see photos from the production, go to www.tlyzn.tumblr.com, accessed March 28, 2016.
8. "Born-frees" is a term that refers to South African citizens born after 1994, the year in which Nelson Mandela was elected as the first democratic president. The term refers to the fact that they never experienced life under apartheid in South Africa (a system of racial segregation).

9 As Sarajevo was only the third largest city in Yugoslavia, the youth who started the movement saw it as a way of developing their own original sense of style through their cultural identities, without being constricted by the socialist authorities into a generic profile. These identities were very often hybrid, as Sarajevo itself was a city that contained an equal mix of the three major ethnic groups of Yugoslavia. The mix of the television sketch show and the various musical bands associated with the movement put Sarajevo on the map as an alternative cultural city within the socialist country.
10 Belting, *An Anthropology of Images*, 35.
11 The three sides of the conflict had been drawn up according to nationalist lines: the Muslims, the Croats, and the Serbs. The capital city of Sarajevo, the origin of New Primitivism, was under siege for the duration of the conflict. Serb forces entrenched on its surrounding hills with the aim of not allowing Bosnia and Herzegovina to become independent and to remain within the territory of Yugoslavia. There was not much of Yugoslavia left, with only Serbia as the primary republic, as Slovenia and Croatia had both already exited the federation. At the end of the twentieth century, it had seemed inconceivable that a part of the world could witness such atrocities.
12 To view this sketch, go to www.youtube.com/watch?v=k37ZIbSFIV0, "*Top Lista Nadrealista* Season 2 Episode 17" [video], from 10:59, accessed March 22, 2016.
13 Tutun Mukherjee, "Deepa Mehta's Film *Water*: The Power of the Dialectical Image," *Canadian Journal of Film Studies* 17, no. 2 (2008): 35. To view full article go to http://www.filmstudies.ca/journal/pdf/cj-film-studies172_mukherjee_deepa-mehta_water.pdf, accessed March 28, 2016.
14 With the rise of the Nazi Party in Germany in the 1930s, Benjamin himself became an exile (primarily in Paris before its occupation by the German Army). He was in the process of fleeing to the United States, when he committed suicide in Portbou, Spain in 1940, to avoid being captured by the Nazis.
15 Walter Benjamin, "Paris, the Capital of the Nineteenth Century," in *The Arcades Project*, ed. Rolf Tiedemann, trans. Howard Eiland and Kevin McLaughlin (Cambridge: Belknap Press, 1999), 3.
16 Heather Marcelle Crickenberger, "The Arcades Project (blog)," June 27, 2007. To view this work, go to www.thelemming.com/lemming/dissertation-web/home/arcades.html, accessed March 28, 2016.
17 Mukherjee, "Deepa Mehta's Film *Water*," 41.
18 Susan Buck-Morss, *The Dialectics of Seeing: Walter Benjamin and the Arcades Project* (Cambridge: The MIT Press, 1991), 6.
19 Mukherjee, "Deepa Mehta's Film *Water*," 40.
20 Buck-Morss, *The Dialectics of Seeing*, 18.
21 Ibid., 23.
22 To view this sketch, go to www.youtube.com/watch?v=MSR5b1Jxa6A, "*Top Lista Nadrealista* Season 3 Episode 20" [video] from 25:09, accessed March 22, 2016.
23 During the times of socialism in Yugoslavia, between the end of WWII and the 1990s, nationalist identities were simply in the background, while socialism and service to the party were the main focus of daily life. This allowed people of mixed ethnicities to get

married, and have families. In this particular sketch, the *Nadrealisti* were superimposing the conflict and the fight for land on top of a family context, transposing a macro division into the micro unit. The absurdity of the image, when viewed by the audience in the late 1980s, was replaced by something else when the conflict witnessed the actual break-up of various marriages and families as individuals chose to align themselves within their ethnicity rather than their domestic unions.

24 "Under the apartheid racial categorisations, 'Cape Coloured' was the name given to the racial grouping identified as 'mixed race'. Cape Coloured are the majority ethnic group in the Western Cape, are generally bilingual (English and Afrikaans) speakers, and may have heterogeneous origins, often being of Indonesian, Malaysian, Madagascan, Mozambican, and European descent. The term 'Coloured' itself is not derogatory [...]" explained in Amy Jephta, "On Familiar Roads: The Fluidity of Cape Coloured Experiences and Expressions of Migration and Reclamation in the Performances of the Kaapse Klopse in Cape Town," in *Performing Migrancy and Mobility in Africa: Cape of Flows*, ed. Mark Fleishman (London: Palgrave Macmillan, 2015), 178.

25 To view this sketch, go to www.youtube.com/watch?v=wtl20YjeHjk, "Top Lista Nadrealista Season 3 Episode 19" [video] from 04:13, accessed March 22, 2016.

26 Rhodes was a British imperialist whose politics, businesses, and mining empire had irrevocably influenced the Southern African region through his "seizing" of the land and its resources between 1870 and 1906. The statue of Rhodes was erected in 1931, placed at such a prominent location due to Rhodes's estate bequeathing the land for a national university in 1928. By 2015, the statue had become a symbol for the lack of educational transformation taking place at the institution, with the overall majority of professors being Caucasian and the curriculum not displaying enough progress in its journey towards decolonization. This event was the culmination of the #RhodesMustFall movement, initially started by a member of the UCT Student Representative Council (who threw human feces on the statue), which grew to encompass a large number of the student body who identified the statue as an oppressive symbol of colonization and had petitioned the power of the university to remove the statue. After a month of open debates, deliberations, protests, and meetings, the UCT council had accepted their petition. Later on in 2015, the #RhodesMustFall movement would merge with the #FeesMustFall nationwide movement across the country campaigning for the reduction in fees for tertiary tuition.

27 Rustom Bharucha, *Theatre and the World: Performance and the Politics of Culture* (London: Routledge, 1993), 241.
28 Ibid., 248.
29 Ibid., 241.
30 Ibid., 34.
31 Ibid., 5.
32 Ibid., 248.
33 Ibid., 242.
34 Ibid., 67.
35 Ibid., 41.

Chapter 12

Resignifying Multilingualism in Accented Canadian Theatre

Diana Manole

As a teenager interested in theatre in the 1980s in Romania, when I discovered the work of Polish director Jerzy Grotowski, I was immediately fascinated. Given the widespread fear of communist censors and leaders that experimental art is always an action against the regime by its very nature, information about his work was scarce and surrounded by an aura of danger and the mystery of a secret society. Thus, when I managed to sneak into a showing of video recordings of his work at the University of Film and Theatre in Bucharest, I expected nothing less than a quasi-religious experience. I watched a monologue performed by one of his actresses in what the professor of that class identified as an "invented" language. As there were no subtitles, and I did not understand Polish, whether the language was an "invented" one or simply Polish would not have made a difference to me. But I was still eager to experience a deep transformation. When the lights came up at the end of the screening, I felt nothing special and was rather embarrassed by what I perceived as my inability to understand the work of a great artist. That feeling lasted until I tried to stand up, but could not do so. My knees were weak and I felt cold. I came to the conclusion that my subconscious had reacted deeply to my first encounter with one of Grotowski's experiments, despite my inability to understand the meaning of the words.

Multilingual Theatre in Exile

My pleasure in watching and listening to theatre without being able to understand what is being said on stage has grown over the years, and has enabled me to see and enjoy shows in languages I did not know, both in Romania and abroad. The decision to immigrate to Canada in 2000, in particular to Toronto, one of the world's most multicultural cities, has again changed my attitude towards verbal communication. I have gotten used to living in a multilingual environment where I do not always understand the words spoken on public transportation, in stores, and even at the theatre. Perhaps it is as a result of these experiences that the re-enactment of exilic experience in accented and multilingual theatre has become one of my main research interests.

The critical discourse on multilingual theatre is still in the making, while the treatment and definition of multilingual theatre differs greatly in relationship to the context in which it occurs.[1] In the 2016 English edition of the updated *Dictionary of the Theatre*, Patrice Pavis emphasizes the pragmatic and/or socio-political reasons for such productions. On one hand, he notes that "[g]iving roles to actors speaking different languages will make it easier for the performance to go on tour."[2] On the other hand, Pavis mentions "the case of 'postcolonial'

performances by authors-actors-storytellers writing in the language of the colonizer (English, French, etc.)," who "sprinkle" their lines with words and jokes "in one or more 'local' languages"[3] that most of the spectators do not understand. The complicity among the bilingual spectators is intentional on the part of the artist(s), as it effectively subverts the authority of the imperial language, and, implicitly, grants the natives an ephemeral superior position.

For my purpose in this chapter, I define multilingual theatre as the theatre in which a significant part of the play is written and performed in other language(s) than the official language(s) of the country where it is produced. I do not consider the plays in which foreign words occur only occasionally as belonging to this category.

Taking into consideration the English-Canadian context, this chapter analyzes the treatment of multilingualism and untranslated non-dominant languages in *My Name Is Dakhel Faraj* (*MNIDF*),[4] written and directed by Syrian-born Nada Humsi[5] for the Kitchener-Waterloo Arab-Canadian Theatre (KW-ACT) in Arabic, English, and American Sign Language (ASL). Considering dramatic discourse as "a network of complementary and conflicting illocutions and perlocutions: in a word, linguistic interaction, not so much descriptive as performative,"[6] this chapter investigates four aspects of the interaction between languages as a multilayered performative means. First, I explore Humsi's objectives of including three languages in her show, as well as the performative strategies she employed. Second, I examine how the absence of accented speech dismantles the stereotypical perception of exiles as discriminated against, or, at least, misunderstood audible and cultural minorities. Third, I investigate the ways in which the parallel presence of English and Arabic without simultaneous translation challenges local and international language hierarchies, while restoring the spoken languages' capacity to express emotion beyond the codified meaning of words. Finally, I discuss the inclusion of ASL as a means to expand the concept of a language from the sound to the visual and sensorial levels, and frame this type of non-verbal communication as a means closer to the specific nature of theatre. My main objective is to investigate how this production challenged the concept of exilic identity by deconstructing artistic, cultural, and political stereotypes in the representation of internal and external exiles, hearing-impaired people, and political refugees.

Saying Your Name in Different Languages

Dakhel Faraj is a theatre artist from Iraq who was forced to flee his homeland. As a political refugee, he chose to settle in Kitchener, Ontario, Canada in 2010, because he had heard about MT Space, a theatre founded in 2004 by another immigrant, Lebanese-born director Majdi Bou-Matar, and hoped that the existence of this company might afford him the opportunity to return to his chosen profession in his new country of residence.

During an informal feedback session[7] with artists and audience members, Humsi explained that when she and Faraj met in Kitchener, she was very moved by his relating of his tragic experiences. As she had recently co-founded KW-ACT, and is one of its two

artistic directors, she decided to create a production inspired by Faraj's life and produce it, benefitting from the administrative and artistic support of MT Space, with which she is an artistic associate. Based on many hours of research interviews, *MNIDF* re-enacts Faraj's family history: childhood memories with his parents and siblings in Baghdad before the war; his life as a soldier during the Iran-Iraq war; being a student of fine art; getting married and having three daughters (Sarab, Sarah, Zaman) and two sons (Ehab, Karam); life during Operation Desert Storm; the tragic death of his sons (Ehab at sixteen years of age and Karam at eight years of age) and father, shot by American soldiers who mistook them for enemy fighters. The play is dramaturgically framed as a story-within-a-story, and starts with Faraj and his family at a Canadian lawyer's office, hoping to hire him to seek justice for the death of their loved ones. Because characters start talking simultaneously, "overlapping each other," the lawyer requests that he be told "the story from the beginning."[8]

Dakhel Faraj, the main character, is split into three roles, played by three actors who each communicate in only one language: Arabic, English, or ASL. According to Humsi, the same story is being told in all three languages, sometimes including different details, although no simultaneous translation or surtitles are offered. In the 2015 unpublished playscript, Humsi identified each character by their spoken language and name of the performer:

DAKHEL FARAJ: American Sign Language/ASL: Modela Kurzet[9]
DAKHEL FARAJ: Arabic/ADF: Addil Hussain
DAKHEL FARAJ: English/EDF: Varrick Grimes[10]

In this discussion, to make a distinction between the character and the real-life individual, I refer to "Dakhel" as the character and Faraj as the actual person.

In addition to the three "Dakhel" characters, Canadian-born Gary Kirkham performed the role of Canadian Lawyer, and Iraqi-born Mohammed Mohammed Fakhri portrayed several minor characters, as needed, including a salesman in the market (speaking Arabic), and one of the American soldiers (speaking English), though his main role was to provide live Arabic musical accompaniment.

In the way Humsi wrote and directed *MNIDF*, the three languages are integral components of the story, and choosing each of them was determined by cultural, socio-political, as well as artistic reasons. First, Humsi decided to include Arabic because, in her words, "it is the language of the story itself, it is a story about an Arab person, Dakhel Faraj, in an Arabic country, Iraq. It is the language of his memory, pain, and words."[11] She further intended this use of Arabic to help Arab-Canadian audiences relate to Faraj's story on a deeper level, and feel that they belonged to a familiar community, despite living away from their homeland: "This is a language that many immigrants and/or political refugees understand, they all have experienced the same stories, the same pain in the same language, they need to hear it in their tongue to feel the authenticity of it."[12]

The reasons for including English in the play are numerous. Humsi categorizes English as a language that is part of the authentic story of Faraj's life, as "the American soldiers who killed

Faraj's family speak, sing, and listen to music in English."[13] In addition, when Faraj told her his story, he used English to reproduce the words of American soldiers and of the Canadian lawyer. Furthermore, the last word of the American soldier, as he "looked at Karam dead in his mother's arms; he stretched his hand with a chocolate for her," and of the Canadian lawyer after he explains that he cannot help "Dakhel" seek justice, is "Sorry," which is also the last line of the play,[14] and summarizes the play's main message. Finally, *MNIDF* catered to the audiences in Kitchener, an "audience of multicultural backgrounds, Asian, Latin American, Italian, African, etc."[15] all of whom presumably spoke and understood English.

The choice to introduce ASL as a third language in the show was determined by Humsi's artistic vision: "For me as a writer, I first felt it in my heart, the language of silence, then it brought to me [an untitled] poem of Al-Mutanabbi,[16] an Arab poet from ancient times: 'I am the one whose words can be seen by the blind / And whose wisdom can be heard by the deaf.'"[17] As this image suggests, Humsi was so impressed by Faraj's story that she wanted it to "fly as far as it could go,"[18] and reach as many spectators as possible across cultural, language, and sensory barriers. Instead of having "a person standing on the side or on the screen translating," Humsi integrated ASL into the show by creating a character who used this language to enact the narrative, "not as a neutral translation of the play but as an essential part of it."[19]

Through the ASL transmission of the narrative, Humsi also perceived and wanted to express the significance of silence. On one hand, through the ASL performer, she metaphorically embodied the silenced cries of the victims who "couldn't scream up their story, but they live it physically every day. Just like the ASL, a silent language for silent people, to be told physically and with effort."[20] On the other hand, she felt the need to assert silence as a means of communication, and as the most appropriate language to declare a personal tragedy that will never make the news: "This story is so loud, although it has been said silently, it is so painful and so present, it is the story of millions who are having silence to tell their stories with."[21] As the presence of ASL in the play symbolically gives voice to the silenced victims in front of an audience generally able to speak, the presence of an Arabic-speaking character in a country where Arabic is not an official language becomes a metonymic representation of an exilic narrative. Furthermore, the use of a language without translation becomes a strong artistic and political statement with multiple consequences on the levels of both cultural and performative semiotics.

Multilingual Love and Pain

The term "accent" is commonly understood as a "distinctive way of pronouncing a language, especially one associated with a particular country, area, or social class."[22] Marvin Carlson reminds us that "anyone with an ear trained to notice verbal distinctions is aware of what linguistic theory stresses, that no one speaks without an accent."[23] In many countries, a unanimously accepted "standard, neutral, and value-free"[24] accent is usually disseminated

through the news broadcasts of the main and typically state-funded national television and radio networks, the public education system, and mainstream theatre. Research indicates that people are very sensitive to accent differences and can perceive a foreign pronunciation in less than a second.[25] Thus, the accent remains "one of the most intimate and powerful markers of group identity and solidarity, as well as of individual difference and personality."[26] No matter *what* a second-language speaker says,[27] *how* it sounds becomes more important for their listeners on the emotional level. As Murray J. Munro[28] notes, this can lead to misjudging the non-native speakers' personality, "e.g. kindness and sociability,"[29] to actual infringements of human rights, such as discrimination in employment and harassment.[30] This likely explains why most Western artistic re-enactments of displaced persons presuppose and/or explore the negative side of being a non-native and therefore an accented speaker in one's new country.

Faraj is a foreign-born political refugee who speaks English as a second language with a heavy accent, as I noticed when I briefly talked with him in Kitchener. In the 2015 production of *MNIDF*, each character representing one of the three linguistic versions of "Dakhel" was re-enacted on stage by performers using their own *unaccented* first languages. Hussain, "Dakhel" (ADF), is a professional actor born in Iraq, whose mother tongue, like that of Faraj, is Arabic, while Grimes, the English-speaking "Dakhel" (EDF), is a Canadian from the Atlantic province of Newfoundland, whose mother tongue is English. In addition, Kurzet, who performs "Dakhel" in American Sign Language (ASL) was "born deaf to deaf parents."[31] Hence, she is not a person who has learnt ASL as an extra/second language. According to the National Institute on Deafness and Other Communication Disorders (NIDCD), this type of circumstance increases the similarities between a spoken mother tongue and ASL: "A deaf child born to parents who are deaf and who already use ASL will begin to acquire ASL as naturally as a hearing child picks up spoken language from hearing parents." In addition, "ASL has regional accents and dialects. Just as certain English words are spoken differently in different parts of the country, ASL has regional variations in the rhythm of signing, form, and pronunciation."[32] From this perspective, Kurzet's ASL can also be considered unaccented, similar to Hussain's and Grimes' mother tongues.

Among many other Canadian scholars, Ric Knowles and Ingrid Mündel note the attempt of "ethnic," multicultural, and intercultural theatre "to 'encourage,' not simply acknowledge difference [...] to forge new *hybrid and diasporic* subjectivities [...] in representing culture as fluid and interconnected, rather than atomized and fixed – as a response to the dehistoricized and tidily demarcated representation of ethnicity in Canada's official policy of Multiculturalism."[33] I argue that Humsi takes one step further in *MNIDF*. Representing Faraj through three unaccented characters challenges the construct of exilic identity itself, particularly the stereotypical perception and re-enactment of exiles as second-language speakers who have difficulties understanding and making themselves understood in their new countries. The multilingual three-headed "Dakhel" is a son, husband, father, artist, and victim of international politics. He is not part of an audible and cultural minority defined by alienhood, which, according to Katarzyna Marciniak, is "always envisioned as the opposition

Performing Exile

to the self and conceptualized as undesirable difference."[34] The absence of accented speech in English, Arabic, and ASL in the production also reminded the audience that each of us speaks at least their mother tongue without an accent, and that foreign-tinged pronunciation is proof of the effort and the ability to learn a second language.

Humsi's allegorical treatment of multilingualism goes beyond the prejudices against exiles' accented speech. On one hand, *MNIDF* strives towards linguistic realism: if it is common for exiles and/or people belonging to ethnic minorities to use their mother tongues without being understood by everybody else who might hear them in everyday life, then it is only "natural" for them to speak in their language of origin on stage in order to re-enact reality with authenticity. On the other hand, the script does not note any difficulties in communicating across language barriers. In fact, it ignores the issue. For example, the native English-speaking character, named simply "Canadian Lawyer," never acknowledges the absence of what in reality would have been "Dakhel's" foreign accent, although he has trouble writing down the Arabic name:

EDF and ASL:	Hello Mr. Lawyer. My name is Dakhel Faraj.
ADF:	Dakhel Ali Faraj Al-Bahrani
LAWYER:	How do you spell your name?[35]

Subsequently, not only the Canadian Lawyer character, but also the three performers of "Dakhel" ignore the fact that they talk to each other in languages they do not understand: Kurzet, Grimes, and Kirkham do not know Arabic, and only Kurzet knows ASL. Despite knowing only the general content of each other's lines, they continuously interact as if they understand everything that is being said: "They continue each other's story, each one is a part of each other's story because they all play one and the same story."[36] For example, in the wedding scene, EDF, impersonating young "Dakhel," comments and/or directly answers in English to the lines ADF, portraying his father, delivers in Arabic. In addition to breaking linguistic barriers, Humsi also defies conventional realistic theatre where a performer often embodies only one character at a time: Kurzet plays the shy bride, and at the same time tells the story in ASL, in the "voice" of "Dakhel." Humsi selected the following section, in which she translated the Arabic lines not included in the English performance script (designated here and in subsequent excerpts by text within square brackets) for the purposes of this discussion:

Scene 8: Marriage, Children, Love (Sarab, Sarah, Zaman, Ehab, Karam)

EDF and ASL:	(ASL *becomes a bride*) All my sisters got married / I had to fend for myself
ADF:	[In the army, I washed my clothes by myself. At home, I washed my clothes myself]
EDF:	My father said:

ADF:	[Son, why don't you get married?]
EDF:	I said: Okay.
ADF:	[I got married in 1984.]
EDF:	He found me a bride.
	(*VIDEO PROJECTION: Photo of bride as young woman.*)
ADF:	[I was 21 years old. Sabrieh was 18.]
	(*They exchange rings and walk to their room.*)
EDF:	I got married in April 1984. I was 21, Sabrieh was 18. She was beautiful. (*To musicians*) Shabab Shesawee!
ASL:	I (*as Dakhel*) was 21, Sabrieh was 18. She was beautiful.
	(EDF *shuts the door and locks it with a key.* EDF *and* ASL *as the bride walk happily, she is shy, he sees her face, they giggle, hand game.*)[37]

In *MNIDF*'s paradigm, understanding each other despite linguistic differences allegorically returns communication to a biblical pre-Babel Tower age when all people supposedly spoke the same language. The mixture and treatment of languages also challenge the relationship between English and Arabic in the linguistic hierarchy on a global level and in Canada, with Arabic being placed, in this context, in a privileged position. In addition, the inclusion of ASL as the third language reasserts the power of communication beyond the auditory/visual divide.

Challenging Global and Local Hierarchies of Spoken Languages

In his discussion of race and colonialism, Frantz Fanon argues that to speak means "to be in a position to use a certain syntax, to grasp the morphology of this or that language, but it means above all to assume a culture, to support the weight of civilization."[38] As I explained, Humsi's decision to use Arabic and English in *MNIDF* was mainly the result of her desire to tell each story in its own language, while also taking into consideration the mainly English-speaking target audience in Kitchener. However, the absence of a simultaneous (sub- or surtitles) or subsequent (by another character) translation of Arabic lines, although the basic information was provided in the texts spoken in both languages, also challenged political and language hierarchies.

Dutch sociologist Abram de Swaan argues, "the multilingual connections between language groups do not occur haphazardly, but, on the contrary, they constitute a surprisingly strong and efficient network that ties together – directly or indirectly – the six billion inhabitants of the earth."[39] Considering the economic, political, and cultural competition between language groups, as well as the number of first- and second-language speakers worldwide, de Swaan identifies four levels in the hierarchy of the global language system:

peripheral, central, supercentral, and hypercentral.[40] According to *Ethnologue*, over 339 million people speak English as a first language and over 600 million as a second language, adding to almost 943 million of users in the world,[41] while being the official language in fifty-two countries,[42] including the United Kingdom, the United States, and the Commonwealth countries. As Johan Heilbron explains, the number of speakers, its wider dispersion than any other language in the world, and the fact that 55% to 60% of all book translations are from English attests to the current position of English as the hypercentral global language.[43] Its 223 million speakers in the twenty-five countries where it is the official or the co-official language,[44] in addition to the speakers all over the world, positions Arabic as supercentral in de Swaan's global hierarchy language system.

According to Statistics Canada, at the 2011 census, English was reported as the mother tongue of nearly 58% of the population (or 19.1 million persons), and as the language spoken at home by 66% of the population. In the same year, more than 200 languages were declared as a home language and/or mother tongue, with more than 20.0% of Canada's population speaking another language, alone[45] or together with English or French, at home. For roughly 6.4 million persons, the other language was an immigrant language,[46] with Arabic in the eighth place in Canada, as almost 400,000 reported it as their mother tongue in 2011.[47]

While English is therefore clearly in a superior position to Arabic on both national and international levels, *MNIDF* reversed the power relationship between them and implicitly between Canadian-born, English-speaking, and exilic audiences. As I mentioned, Humsi decided not to translate the lines in Arabic, but instead ensured that the essential narrative information was offered in all three languages in the play. Yet, the three scripts are not identical, with "the Arabic version being the longest, the English one shorter, and the ASL one the shortest."[48] Thus, the bilingual English- and Arabic-speaking audiences were able to understand everything that was *said* on stage. This temporarily displaced them from the position of an exilic minority of second-language speakers who may or may not understand everything all the time, reminding them that they naturally belonged to a linguistic majority, even if in another culture. The opposite was also true. The monolingual English-speaking Canadian audience was briefly stripped of its privileged status as the linguistic majority, while the speakers of English as a second language who did not understand Arabic, like myself, lost the advantage usually acquired by the ability to communicate in one of the two official languages in their new country. In the words of Julie Byczynski, English lost its "position of the dominant language *as* dominant" in an English language theatre with English-speaking patrons by "denaturalizing it – undercutting its 'taken-for-grantedness.'"[49] This demotion was further increased by the fact that the Arabic playtext was longer than the English one.

Theories of translation commonly agree that translation involves transcultural adaptation, as "[c]ontext conditions meaning [and] the adapters seek the 'right' resetting or recontextualizing."[50] The differences between the English and Arabic scripts were determined by the cultural codes and knowledge shared by the artists and spectators

with an Arabic cultural background, but not by the other audience members. As Humsi explained to me, even though the relevant information is eventually provided in all three languages, the Arabic version includes additional colloquial interjections and jokes, as well as particular allusions and references to the Iraqi culture. The Arabic-speaking audiences gained linguistic privilege through Humsi's decision to include more culturally specific references in the Arabic script, as well as the emotional experience of being part of an exilic community united by shared cultural roots:

> As audience, those Arab immigrants or refugees, share the same experiences and national codes, not only in the language, but also in many aspects of life, codes that have been created through history. As an Arab writer, who also shares the same history, knowledge, and codes, I hoped to create a flood of emotions and memories in the hearts and the minds of the Arabic audience. So, adding one extra word or sentence or a piece of poem to the Arabic script enriches the story, makes it more authentic and true to the Arabic-speaking audience.[51]

In turn, Humsi's choice not to translate most of the Iraqi-specific references into English is also justified more by pragmatic and artistic reasons, not by the apparent desire to deconstruct the linguistic privilege of Canadian-born spectators. In her view, these references would have been incomprehensible to the audiences with different cultural backgrounds, while explaining them as part of the script would have taken too much time, diverting the attention from the main plot and breaking the play's natural rhythm and flow.[52] As an example of the type of differences between the two performance scripts, Humsi selected the following excerpt, in which she translated the Arabic dialogue not included in the English performance playscript (designated by square brackets) for the purposes of this discussion. In this scene, "Dakhel" visits his Uncle Salman, a communist who was imprisoned for his political beliefs, and has a library filled with books written by authors who were executed by Saddam's regime. The culturally specific details refer to religion, intellectuals, and politicians who would be well-known in Iraq but not internationally.

	(*Musician* MOHAMMED *joins* ADF.)
	(*Musician recites Quran.*)
	[Read, read by the name of God, God who created humans and taught them what they didn't know.]
	(EDF *shows his book.*)
ADF:	[Muzaffar al-Nawwab. We passed by Hamad, while riding the train of the night. We heard the coffee been smashed by *mihbaj*. We smelled the *cardomon aruma*. Oh, the train screams, the love screams. He was imprisoned and he ran away.]
EDF and ASL:	Imprisoned. […]
	(EDF *shows a book.*)

ADF:	[Muhammad Baqir al-Sadr, the creator of (our economic) theory, they executed him by firing squad.]
	(ASL *shows another book.*)
ADF:	[Fahd (Yusuf Salman Yusuf), the founder of the communist party in Iraq, he was hanged.]
EDF and ASL:	Hanged.[53]

Humsi's attitude highlights the differences between the political endeavour to re-empower the colonized in relationship to the colonizer, and the emotional attempt to empower the exile by giving them the feeling of belonging to a cultural community in their new country.

Auditory versus Visual Multilingual Exilic Theatre

According to the 2011 Canadian census, the number of people reporting sign language as the language spoken at home was nearly 25,000 persons (15,000 most often, and 9,800 on a regular basis).[54] Thus, Humsi's belief that by including this third language the show would become accessible to more spectators proved realistic, as she met ten deaf audience members who attended the play and enjoyed it.[55] Beyond that, treating ASL as a language in the same way as Arabic and English deconstructs the perception of hearing-impaired people as a physically challenged minority[56] within their birth communities, and reasserts their own self-perception, as declared by the World Federation of the Deaf: "Deaf people don't consider themselves as disabled but rather a cultural group with their own traditions and culture."[57]

However, the ASL also required a special translation of the script and an adaptation of the staging to accommodate Kurzet. For example, the adaptation Humsi created of the dialogue had to take into consideration the mechanics of expressing meaning in ASL: "Her [Kurzet's] script is not the exact script. You hear it [the story] all but some of the details are missing."[58] For example, the English lines "This is my cat Noosa. Red and white. If I sleep in, she bites my toes. When we barbeque she sits and watches. Never steals. So we all feed her. At night she sleeps between my wife and me. We both love her" became, in ASL, "She is Noosa, cat, red white. Dakhel sleeps. She bites toes. Barbeque. Sits. Watches. We feed her. She is cute."[59] Also, Kurzet asked the other performers "to play to her so that she can see the lips"[60] and "read" sounds. In turn, as Kirkham explained during the informal feedback session, the other actors actively responded to her lines in ASL: "We didn't understand [her] but we agreed vocally 'Oh yeah, oh yeah!'"[61]

From the perspective of performative semiotics, the inclusion of ASL in the show also pointed out that nonverbal communication is closer to the true nature of the theatre. Drawing on J.L. Austin's theory of language as a mode of social action, Elam points out that even in text-based theatre the "language of the drama calls for the intervention of the actor's

Figure 1: (L-R) Addil Hussain, Modela Kurzet, Varrick Grimes, and Gary Kirkham in *My Name Is Dakhel Faraj*, KW Arab-Canadian Theatre, September 23, 2015 at the Registry Theatre, Kitchener, Canada, as part of the *IMPACT 15* Theatre Festival, produced by MT Space Theatre. Photo credit: Diana Manole.

body in the completion of its meaning."[62] From a similar point of view, Humsi describes ASL as "a language that stands alone and it has its culture, form and listeners, they listen with their eyes and they talk with their bodies"[63] and is thus closer to performers' specific way of expressing meaning on stage.

The presence and treatment of ASL also altered the balance in *MNIDF*'s representation of language hierarchy once more. First, the Arabic-speaking spectators lost their linguistic privilege as both they and the English-speaking spectators likely did not understand ASL. Second, it successfully challenged the prejudice that a traditional language would be superior to the visual system of communication used by the hearing-impaired people. The visual-auditory intermedial process of translation and interaction among the performers implicitly validated not only interlingual but also the intermedial communication as possible, breaking one more boundary. In this way, *MNIDF* uses multilingualism to empower two types of external (political refugees) and, respectively, internal (deaf people) exiles.

Listening and Watching in Tongues

According to Byczynski, the most common reactions when spectators cannot understand the languages spoken on stage are: "frustration at having paid for a performance that one cannot understand; bewilderment at not being able to follow the action on stage; alienation as a result of feeling excluded from exchanges between actors or between the actors and other spectators who appear to understand."[64] Some of *MNIDF*'s monolingual English-speaking Canadian spectators expressed similar feelings during the informal feedback session with the audience members. One of them, for example, admitted that multilingualism required a higher degree of focus due to the need to shift perception depending on which of the three languages was being spoken. A few admitted that they occasionally felt confused, especially given the non-linear dramaturgical structure of the show: "I got a little frustrated at times. I wished I got more. There are a lot of threads and I was spending too much energy trying to find the thread."[65] Humsi herself acknowledged the fact that the shorter English lines "went quickly" while the incomprehensible Arabic lines were longer in fact, as well as in perception.[66]

However, most of the *MNIDF*'s spectators considered watching the play an engaging experience: "Because I only understood English, I was wondering how much I didn't understand. But that enhanced the experience and I think it was great that I didn't understand everything."[67] While it was obvious that linguistic abilities determined diverse receptions of the show, some of them even appreciated the differences: "I just loved the interaction of the three languages. And it was a lot of fun to hear people who knew Arabic in the audience laugh and I didn't know why."[68]

As an audience member, I also did not feel frustrated not knowing Arabic and ASL, as expected in situations when language is unable to fulfil its function of representation: "The rupture between being and meaning has a shock-like effect: something is exposed with the urgency of suggested meaning – but then fails to make the expected meaning recognizable."[69] For example, when ADF was expressing his pain in Arabic after the death of his father and two sons, I was able to relate to his feelings on a sensorial level in more depth, without having to decode linguistic and/or socio-political signifiers on an intellectual level. The staging heightened the scene's emotional weight. ADF stood down stage centre, directly addressing the audience and desperately repeating some of his lines, as if trying to make himself understood, by both the American soldiers and the spectators. At the same time, EDF and ASL summarized his lines, "The bus is burning with my father and son inside [...] Sabrieh blows air in Karam's mouth. A fountain of blood,"[70] while also impersonating the American soldiers, dancing, roaming, and laughing around him, indifferent to his tragedy. Strong drumming intensified the moment's tension. As I was empathizing with ADF's emotional pain, despite not understanding his words, my reaction reminded me of my teenaged experience when I encountered Grotowski's work for the first time.

The inability to understand everything that was being said on stage acted as one of the most effective artistic means to heighten the ability of verbal communication to express

emotions, not only meaning that has become essential in postdramatic performance. As Lehmann wrote: "From sense to sensuality is the name of the shift inherent to the theatrical process. And it is the phenomenon of the live voice that most directly manifests the presence and possible dominance of the sensual within sense/meaning itself."[71] In my view, my and other spectators' incapacity to understand the lines in Arabic and likely the inability of most if not all of us in the audience to comprehend ASL provided us with a theatre experience closer to theatre's roots in ritual by transforming, in Richard Schechner's words, an audience of "occasional, paying customers" into a community of viewers.[72]

As a performance that does not provide translation for the languages of minorities, *MNIDF* also reaches one of its objectives: to render multilingualism as "normal." It does not re-enact second-language speakers as victimized, but rather it empowers both internal (deaf) and external (political refugees and immigrants) exiles. Indeed, Humsi's treatment of multilingualism and usage of three languages have made the exilic voices both heard and seen.

Notes

1 Multilingual theatre is still rare in Canada but not in other countries. John B. Weinstein, "Multilingual Theatre in Taiwan," *Asian Theatre Journal* 17, no. 2 (2000): 269.
2 Patrice Pavis, "Multilingual Theatre," in *The Routledge Dictionary of Performance and Contemporary Theatre*, trans. Andrew Brown (London, UK: Routledge, 2016), 144.
3 Ibid.
4 My analysis refers to the show I saw in September 2015, as part of *IMPACT 15*, an annual festival, produced by MT Space in Kitchener, Ontario, Canada. The name of the festival is an acronym for the International Multicultural Platform for Alternative Contemporary Theatre. Further, the producing theatre name is an acronym for Multicultural Theatre Space.
5 Nada Humsi was born in Syria and has won several national and international acting and writing awards. Since 2008, when she joined the company, Humsi has participated in most of MT Space's productions.
6 Keir Elam, *The Semiotics of Theatre and Drama* (London and New York: Routledge, 2002), 159.
7 The informal feedback session took place on September 23, 2015, in Kitchener, during the *IMPACT 15* Theatre Festival, addressing the previous night's performance of *MNIDF*.
8 Nada Humsi, "My Name is Dakhel Faraj" (unpublished manuscript, Sept. 19, 2015), 5.
9 According to Humsi, she cast a female performer as the ASL "Dakhel" in order to use her to portray the women characters in the play. Nada Humsi, e-mail message to Diana Manole, March 26, 2016.
10 Humsi, "My Name is Dakhel Faraj," 1.
11 Humsi, e-mail message to Diana Manole, March 26, 2016. No edits have been made to Humsi's e-mails to preserve their authenticity.
12 Ibid.

13 "Let the Bodies Hit the Floor," by American rock band Dead Pool, for example, was one of the popular songs among the US soldiers while invading Iraq. Humsi, e-mail to Manole.
14 Humsi, "My Name is Dakhel Faraj," 55, 57.
15 Humsi, e-mail message to Diana Manole, March 24, 2016.
16 "Abu at-Tayyib Ahmad ibn al-Husayn al-Mutanabbi (in Arabic أبو الطيب أحمد بن الحسين المتنبّي Abū aṭ-Ṭayyib Aḥmad ibn al-Ḥusayn al-Mutanabbī) (915–23 September 965) was an Arab Iraqi poet." To view full page, go to http://www.poemhunter.com/abu-at-tayyib-al-mutanabbi/biography, accessed March 26, 2016.
17 Humsi, e-mail message to Diana Manole, March 24, 2016.
18 Ibid.
19 Ibid.
20 Ibid.
21 Ibid.
22 "accent," *Oxford Dictionaries*, http://www.oxforddictionaries.com/definition/english/accent, accessed August 22, 2014.
23 Marvin Carlson, *Speaking in Tongues: Language at Play in the Theatre* (Ann Arbor: University of Michigan Press, 2006), 11.
24 Hamid Naficy, *An Accented Cinema: Exilic and Diasporic Filmmaking* (Princeton: Princeton University Press, 2001), 23.
25 Murray J. Munro, "A Primer on Accent Discrimination in the Canadian Context," *TESL Canada Journal* 20, no. 2 (2003): 39.
26 Naficy, *An Accented Cinema*, 23.
27 According to Munro, linguists agree that "the acquisition of a second language after early childhood almost inevitably results in speech that differs from that of native speakers […] largely because knowledge of the sound system of the first language (Ll) influences the perception and production of the phonetic patterns of the second." Munro, "A Primer on Accent Discrimination in the Canadian Context," 38.
28 According to his own testimony, Munro is the first to "examine accent discrimination cases in Canada in an attempt to understand how this phenomenon directly affects people's lives." Ibid.
29 Ibid., 39.
30 Ibid., 38.
31 KW Arab-Canadian Theatre, *MNIDF Programme* (Kitchener: The Registry Theatre, 2015).
32 "American Sign Language," *National Institute of Deafness and Other Communication Disorders*, last modified June 24, 2015. To view full page, go to https://www.nidcd.nih.gov/health/american-sign-language, accessed April 12, 2016.
33 Ric Knowles and Ingrid Mündel, "Introduction: 'Ethnic,' Multicultural, and Intercultural Theatre," in *"Ethnic," Multicultural, and Intercultural Theatre*, eds. Ric Knowles and Ingrid Mündel (Toronto: Playwrights Canada Press, 2009), xii.
34 Katarzyna Marciniak, *Alienhood: Citizenship, Exile, and the Logic of Difference* (Minneapolis and London: University of Minnesota Press, 1999), 9.
35 Humsi, "My Name is Dakhel Faraj," 3.
36 Humsi, e-mail message to Diana Manole, April 13, 2016.

37 Humsi, "My Name is Dakhel Faraj," 29–30.
38 Frantz Fanon, *Black Skin, White Masks* (New York: Grove Press, 1967), 18.
39 Abram de Swaan, *Words of the World: The Global Language System* (Malden: Polity Press, 2001), 1.
40 According to de Swaan, 98% of the world's languages are peripheral or minority languages, spoken by less than 10% of the world's population within a particular area and are in danger of becoming extinct. About one hundred languages are central languages, spoken by 95% of the world's population and generally used in education, media, and administration as official languages. Supercentral languages are thirteen widely spoken languages that serve as connectors between speakers of central languages: Arabic, Chinese, English, French, German, Hindi, Japanese, Malay, Portuguese, Russian, Spanish, Swahili, and Turkish. They were once imposed by a colonial power and after independence continued to be used as the official languages of the former colonies. The hypercentral language connects speakers of the supercentral languages. Currently, it is English. De Swaan, *Words of the World*, 4, 6.
41 Paul M. Lewis, Gary F. Simons, and Charles D. Fennig eds., "Summary by Language Size," and "English," *Ethnologue: Languages of the World*, 19th ed. (Texas: SIL International, 2016). To view these pages, go to http://www.ethnologue.com/statistics/size, and http://www.ethnologue.com/language/eng, accessed March, 2016.
42 Irene Thompson, "English," *About World Languages*, October 14, 2013. To view full page, go to http://aboutworldlanguages.com/english, accessed April 12, 2016.
43 Johan Heilbron, "Structure and Dynamics of the World System of Translation" (paper presented at UNESCO, International Symposium "Translation and Cultural Mediation," February 22–23, 2010), Centre européen de sociologie et de science politique de la Sorbonne (CESSP-Paris) and Erasmus University Rotterdam. To view full page, go to http://portal.unesco.org/culture/en/files/40619/12684038723Heilbron.pdf/Heilbron.pdf, accessed March 26, 2016.
44 Irene Thompson, "Arabic (Overview)," *About World Languages*, July 20, 2013. To view full page, go to http://aboutworldlanguages.com/arabic-overview, accessed April 12, 2016.
45 According to Statistics Canada, only 6.2% of the population reported at the 2011 census speaking a language other than English or French as their only home language.
46 "Linguistic Characteristics of Canadians," *Statistics Canada*, last modified December 22, 2015. To view full page, go to http://www12.statcan.gc.ca/census-recensement/2011/as-sa/98-314-x/98-314-x2011001-eng.cfm, accessed April 12, 2016.
47 "Number of Canadians Whose Mother Tongue is One of the 22 Immigrant Languages Reported by More than 100,000 Persons, Canada 2011," *Statistics Canada*, last modified November 6, 2015. To view full page, go to http://www12.statcan.gc.ca/census-recensement/2011/as-sa/98-314-x/2011003/fig/fig3_2-1-eng.cfm, accessed April 12, 2016.
48 Humsi, e-mail message to Diana Manole, March 24, 2016.
49 Julie Byczynski, "'Word in a Foreign Language': On Not Translating in the Theatre," in *"Ethnic," Multicultural, and Intercultural Theatre*, ed. Ric Knowles and Ingrid Mündel (Toronto: Playwrights Canada Press, 2009), 68; original emphasis.
50 Linda Hutcheon, *A Theory of Adaptation* (New York and London: Routledge, 2006), 145–46.

51. Humsi, e-mail message to Diana Manole, March 26, 2016.
52. Ibid.
53. Humsi, "My Name is Dakhel Faraj," 25–26.
54. "Linguistic Characteristics of Canadians," *Statistics Canada*, last modified December 22, 2015. To view full page, go to http://www12.statcan.gc.ca/census-recensement/2011/as-sa/98-314-x/98-314- x2011001-eng.cfm, accessed April 12, 2016.
55. Humsi, e-mail message to Diana Manole, March 26, 2016.
56. Article 30, paragraph 4 of the United Nations Convention on the Rights of Persons with Disabilities recognizes Deaf culture in the following statement: "Persons with disabilities shall be entitled, on an equal basis with others, to recognition and support of their specific cultural and linguistic identity, including sign languages and Deaf culture." "Deaf Culture," *World Federation of the Deaf*. To view full page, go to http://wfdeaf.org/our-work/focus-areas/deaf-culture, accessed April 12, 2016.
57. "Deaf as a Linguistic and Cultural Group," *World Federation of the Deaf*. To view full page, go to http://wfdeaf.org/human-rights/crpd/deaf-as-a-linguistic-and-cultural-group, accessed April 12, 2016.
58. Humsi, e-mail message to Diana Manole, April 13, 2016.
59. Humsi, "My Name is Dakhel Faraj," 14.
60. Humsi, e-mail message to Diana Manole, April 13, 2016.
61. Manole, personal notes.
62. Elam, *The Semiotics of Theatre and Drama*, 142.
63. Humsi, e-mail message to Diana Manole, March 26, 2016.
64. Byczynski, "Word in a Foreign Language," 69.
65. Manole, personal notes, audience responses.
66. Humsi, e-mail message to Diana Manole, April 13, 2016.
67. Manole, personal notes, audience responses.
68. Ibid.
69. Hans-Thies Lehmann, *Postdramatic Theatre*, trans. Karen Jürs-Munby (London: Routledge, 2006), 146.
70. Humsi, "My Name is Dakhel Faraj," 54–55.
71. Lehmann, *Postdramatic Theatre*, 148.
72. Richard Schechner, *Performance Studies: An Introduction* (London and New York: Routledge, 2002), 72.

Notes on Contributors

Tara Atluri has a PhD in Sociology. In 2016, she was a Visiting Research Fellow in the Department of Geography, Environment, and Development Studies in the Institute of Humanities at Birkbeck College, University of London, United Kingdom. She is also a Lecturer in the Faculty of Liberal Arts and Sciences and School of Interdisciplinary Studies at the Ontario College of Art and Design University in Toronto, Canada. Her post-doctoral research and interviews about sexual politics in India following the 2012 Delhi gang rape case and the 2013 decision to criminalize queer desire form the basis of her book, *Āzādī: Sexual Politics and Postcolonial Worlds* (Demeter Press, 2016).

Tania Cañas is the Arts Director at RISE Refugee, Australia's first refugee and asylum seeker organization to be run by and with the community (http://riserefugee.org/). She is also a PhD student at the Centre for Cultural Partnerships, Victorian College of the Arts, University of Melbourne, and sits on the Editorial Board for the *International Pedagogy and Theatre of the Oppressed* academic journal.

Cañas' research and work focuses on theatre as self-determination, working primarily with Community Cultural Development frameworks to develop performances with participants, particularly within refugee and asylum seeker communities. Throughout 2014, she facilitated theatre workshops with newly arrived migrants and refugees in Melbourne, through a RISE and Melbourne Polytechnic partnership.

Recently Cañas spent three weeks in South Africa to deliver a workshop on Theatre of the Oppressed Dramaturgy at Rhodes University. She also completed an artist residency at *3to6*, an educational bridging program for asylum seeker youth in Johannesburg, SA.

Her monodrama *Untouchable* was published with Currency Press Australia (2013). She has performed the script at Australian Centre for the Moving Image, as well as toured the piece to the Performing the World Conference in New York, and the Mixed-Race-Studies Conference in Chicago. Her play *Three Angry Australians* was included in Apocalypse Theatre Company's 2015 quick-response season.

Originally from Spain, **Elena García-Martín** is an Associate Professor at the Department of Languages & Literature of the University of Utah. Teaching and research areas include drama, theatre, performance studies, and the contemporary Latino and Latin American

stage. Her interest in theatre began in Puerto Rico, where she volunteered to be the faculty advisor for the student theatre group and did research on the work of local performers like Aravind Adyanthaya, Myrna Renaud, and Teresa Hernández. Current projects include the study of the work of local performer Jorge Rojas in Salt Lake City, Utah. Her approach to performance ranges from cultural politics and identities to phenomenology and forms of knowledge production.

Seunghyun Hwang is an Assistant Professor in the Department of English Language and Literature at Kyonggi University, Suwon-Si, South Korea. He earned a PhD in Theatre at Ohio State University. His articles have appeared in *Canadian Review of American Studies*, *American Studies in Scandinavia*, the *Journal of Modern English Drama*, *The New Korean Journal of English Language and Literature*, and *English 21*. Dr. Hwang has presented at major conferences including the American Society for Theatre Research, the International Federation for Theatre Research, Association for Theatre in Higher Education, Mid-America Theatre Conference, and III International Conference on American Theatre and Drama.

As a native Romanian writer, **Diana Manole** has published nine collections of poems and plays and has won fourteen literary awards. Since making Canada her new country, in 2000, she has published poems written in English or co-translated with Adam J. Sorkin in *The Nashwaak Review, Maple Tree Literary Supplement, grain,* and *Event* in Canada; *Absinthe: A Journal of World Literature in Translation, The Lunch Ticket, Third Wednesday,* and *The Chattahoochee Review* in the United States; and *POEM* in the United Kingdom. In addition, her translations of Canadian poetry were printed in the Romanian magazines *liternet, Luceafarul,* and *Viata Romaneasca*, while her poems written in Canada, but in Romanian, were printed in the most important Romanian magazines. Her academic articles and book chapters focus on postcolonial and postcommunist theatre, exilic theatre, the performance of national identity, directing, transcultural adaptation, and globalization. Her article, "Accented Actors: From Stage to Stages via a Convenience Store," was published in *Theatre Research in Canada* (2015), pioneering foreign accents in theatre and performance as a new field of research. A scholar, writer, and theatre director, she earned a PhD from the University of Toronto's Graduate Centre for Study of Drama, a Masters in Broadcast Journalism from Carleton University, an Hons. BA in Theatre Directing from the University of Theatre and Film, Bucharest, and an Hons. BA in Russian and Romanian from the University of Bucharest. She has taught at University of Guelph, Trent University, and Queen's University in Canada.

Lillian Manzor is Associate Professor and Chair of Modern Languages and Literatures, Founding Director of the Cuban Theater Digital Archive at the University of Miami (www.cubantheater.org), and curator of Cuban Culture on the Edge (http://www.miamiobservatory.org/cuban-culture). She is widely published in the field of Latin American and Latino/a

theatre and performance studies. She is currently finishing a book manuscript titled *Marginality Beyond Return: US Cuban Performance and Politics*. As a leader in the development of Digital Humanities, she has directed the filming and editing of over 150 theatre productions, in Cuba and the United States. She has published "Cuban Theater in Miami: 1960–1980" (http://scholar.library.miami.edu/miamitheater/), and *El Ciervo Encantado: An Altar in the Mangroves* (http://ciervoencantado.tome.press/). She is also working on *Sites that Speak: Miami through Its Performing Arts Spaces in Spanish* (http://scalar.usc.edu/hc/sites-that-speak/index). As a community engaged scholar, she has been involved in the development of cultural dialogues between Cuba and the United States using theatre and performance since 1993. Her research has been funded by the National Endowment for the Humanities, American Council of Learned Societies, the Andrew W. Mellon Foundation, the Rockefeller Foundation, the Cuban Artist Fund, and Puentes Cubanos.

Elena Marchevska is an interdisciplinary artist and Senior Lecturer in Performance Studies at London South Bank University. Originally from Macedonia, her research is strongly informed by transformation of the ex-Yugoslavia cultural landscape after the conflict in the 1990s. Through exploring performances that brought together screen, somatic practice, and autoethnography, she has increasingly turned her attention to relationships between performance, maternal body, and digital writing. She is a key organizer of the international Motherhood and Creative Practice conference and writes about the intersection between the maternal, creativity, and activism. She co-edited a special issue for *MAMSIE-Journal on Studies in Maternal* on "Maternal structure in creative practice" (Spring 2016). Dr. Marchevska is also working on research about radical self-organized performance practices in South East Europe and their urban manifestation. As part of this research, she is collecting and archiving interviews and documentation of self-organized choirs in the Balkan region.

Yana Meerzon is a native speaker of Russian, who works in the bilingual English/French environment of University of Ottawa, in Canada. Her research interests are in drama and performance theory, theatre of exile, and cultural and interdisciplinary studies. Her book publications include *A Path of the Character: Michael Chekhov's Inspired Acting and Theatre Semiotics* (2005); and *Performing Exile – Performing Self: Drama, Theatre, Film* (2012). She has co-edited several books on similar topics, including *Performance, Exile and 'America'* (with Dr. Silvija Jestrovic, 2009); *Adapting Chekhov: The Text and Its Mutations* (with Dr. J. Douglas Clayton, 2012); *History, Memory, Performance* (with Dr. David Dean and Dr. Kathryn Prince, 2014); and *The Routledge Companion to Michael Chekhov* (with Dr. Marie-Christine Autant-Mathieu, 2015). Her articles appeared in *New England Theatre Journal, Slavic and East European Journal, Semiotica, Modern Drama, Theatre Research in Canada, Journal of Dramatic Theory and Criticism, Canadian Theatre Review,* and *L'Annuaire théâtral.* Her most recent contribution is a special issue of *Theatre Research in Canada* journal on the theme of theatre and immigration in Canada (2015).

Bosnian-born **Sanjin Muftić** mastered directing at the University of Cape Town. He has directed heightened texts, intermedial productions, and designed videography. He was awarded the 2011 Gordon Institute of Performing and Creative Arts fellowship and currently serves as the Head of Acting at CityVarsity. Currently completing his PhD at University of Cape Town, South Africa on Bricolage and Theatrical Images, he directed *A Day, Across* (2014) as part of the Cape Town Fringe. His published work includes a playscript/chapter in *Performing Migrancy and Mobility in Africa* (edited by Dr. Mark Fleishman). He has developed performances for *Infecting the City Public Arts Festival* in Cape Town, and presented papers at conferences of the International Federation of Theatre Research, and the International Society for Intermedial Studies.

Judith Rudakoff has worked as a developmental dramaturg with emerging and established playwrights and artists throughout Canada, and in Cuba, Denmark, South Africa, England, and the United States. Her books include *Dramaturging Personal Narratives: Who am I and Where is Here?* (2015); *TRANS(per)FORMING Nina Arsenault: An Unreasonable Body of Work* (2012); *Between the Lines: The Process of Dramaturgy* (2002, co-editor Lynn M. Thomson); *Questionable Activities: Canadian Theatre Artists in Conversation with Canadian Theatre Students* (2000); *Fair Play: Conversations with Canadian Women Playwrights* (1989, co-editor Rita Much). Her articles have appeared in many journals, including *The Drama Review (TDR), TheatreForum, Theatre Topics,* and *Canadian Theatre Review*. She is the creator of The Four Elements and Elemental Lomograms, transcultural tools for initiating live performance, written work, and visual art. She was the first Canadian honoured with the Elliott Hayes Award for Outstanding Achievement in Dramaturgy for her work on South Asian choreographer Lata Pada's multidisciplinary work, *Revealed by Fire* (2001). In 1999, she was the first foreigner designated an Honourary Member of Cuba's acclaimed Teatro Escambray. Rudakoff is a member of Playwrights Guild of Canada, and Literary Managers and Dramaturgs of the Americas. She is a Professor of Theatre at York University in Toronto, Canada.

Yamit Shimon holds an MA with distinction from the program in Cultural Studies at the Hebrew University, Jerusalem. Her thesis, titled "Space in Action: Site Specific Performance as a Platform for Spatial Exploration," focuses on national and gender Otherness in the Independence Park in Tel Aviv. She has participated as a lecturer in conferences in Israel, including the international workshop of "Urban Systems and Heterotopias" at the Technion, Haifa. Shimon is a researcher and content editor of exhibitions, cultural events, workshops, and walks in Tel Aviv.

Evi Stamatiou is a Lecturer in Musical Theatre at the University of Portsmouth, and a PhD Candidate at The Royal Central School of Speech and Drama, University of London. She is a theatre-maker with ten years of international experience. She has worked and trained in the United Kingdom, Greece, Germany, Estonia, Poland, Brazil, and New York. She is a

member of Lincoln Center Theater Directors Lab, NY; Actors Equity, UK; The International Federation of Theatre Research; and The Theatre and Performance Research Association. She is a Higher Education Academy Fellow.

With twenty years of professional dance experience in over twenty-nine countries around the globe, researching, educating, creating, performing, and producing dance, Iranian-Canadian **Sashar Zarif** has extensive experience in practice in academic, community, and rural environments. Among many other fields (Zarif has studied various forms of dance and music, including Uzbek, Tadjeek, Persian, Georgian, Chechen, Afghan, Middle Eastern, Flamenco, Bharatanatyam, and Lezginka), he specializes in the field of Sufi and Shamanic dance rituals of Near and Central Asia. His accomplishments in this field have brought him opportunities such as his collaborative project/performance with internationally renowned singer Alim Qasimov from Azerbaijan and Rizwan-Muazzam Qawwali, the prodigious nephews of legendary *qawwali* master, Nusret Fateh Ali Khan. His research interests are identity, memory, globalization, and crosscultural collaborations. In 2011, he received the honorary titles of Master of Dance from Uzbekistan State Institute of Choreography in Tashkent, as well as Honorary Faculty Member at this institute for his work and contribution to dance in Uzbekistan in the second half of 2011. In 2012, Sashar Zarif was awarded a Queen Elizabeth II Diamond Jubilee Medal.